Athens and Attica

Athens and Attica

A Phaidon Cultural Guide

with over 260 colour illustrations
and 6 pages of maps

Phaidon

Editor: Dr Marianne Mehling

Contributors: Prof. Dr Evangelos Konstantinou, Dr Marianne Mehling, Gerhard Rebhan

Photographs: Gunda Amberg, Prof. Dr Evangelos Konstantinou, Maria Linhart, Franz N. Mehling, Hans Joachim Schwerdhöfer

Maps: Huber & Oberländer, Munich

Ground-plans: Herstellung + Grafik, Lidl

Phaidon Press Limited, Littlegate House, St. Ebbe's Street, Oxford, OX1 1SQ

First published in English 1986
Originally published as *Knaurs Kulturführer in Farbe: Athen und Attika*
© Droemersche Verlagsanstalt Th. Knaur Nachf. Munich 1984
Translation © Phaidon Press Limited 1986

British Library Cataloguing in Publication Data

Athens and Attica.——(A Phaidon cultural guide)
 1. Attica (Greece)——Description——Guide-books
 I. Knaurs Kulturführer in Farbe, Athen und
 Attika. *English*
 914.95'1 DF261.A8

 ISBN 0-7148-2388-0

Translated and edited by Babel Translations, London
Typeset by Hourds Typographica, Stafford
Printed in West Germany by Druckerei Appl, Wemding

Cover illustration: Athens, the north porch of the Erechtheion on the Acropolis (photo: A.F. Kersting, London)

Preface

Attica is the southern part of the Greek peninsula. To the east of it lies the Aegean, to the south the Saronic Gulf. It includes the islands of Aegina, Póros, Hydra and Spétses, and the plain of Pedion, on which Athens is set, the Thriasian plain and Eleusis, and also the plains of Mesogeia and Marathon.

For as long as man can remember, Attica has sent ships to neighbouring islands as far away as Crete, and to the north coast of Africa and Anatolia and the east coast of Italy and Sicily. The energetic Hellenes settled in these places from the earliest times and founded new colonies. Greece, and Attica in particular, were ports of call at the time of the migration of the peoples, for both refugees and conquerors; this was a reason for their early cultural development and one of the essential ingredients of the period of cultural supremacy. In the fifth century the culture of this country, above all in the field of sculpture, reached heights which have never been equalled. The country's situation made it accessible to much of the world, and this coupled with an almost ideal climate gave the Hellenes great suppleness of mind and a readiness to accept new ideas.

The legends of ancient Greece, such as the stories of the heroic deeds of Heracles and Theseus, have made us familiar with what used to be the rich forests and fertile soil of Attica. Since those days the forests have seen centuries of merciless plunder. Storms and rain met with no resistance, and blew and washed away the fertile soil to the extent that the modern traveller, particularly the air traveller, finds tracts of stony desert. Throughout the long summer the blazing sun dries out the stony soil. The few watercourses trickle away to depths which are increasingly difficult to reach. Attica has 300 days of sunshine each year, 122 of these cloudless. In the few fertile regions the farmers, whose task is harder here than in most parts of the world, wrest corn, tobacco, vegetables, olives, grapes, citrus fruits and cotton from the sparse soil. Otherwise, the only vegetation to survive is scrub on the mountain slopes, a few hardy species of tree, particularly olives, carob, mulberry and cypress, firs on the northern slopes of Parnassus, poplars and planes by the sea, reeds in the marshes of Marathon and broom, thyme, juniper and heather in the mountains. Not until the coming of the autumn rains can grass and flowers grow with any vigour; almonds begin to blossom and the corn is sown; the harvest is brought home early the next Spring, and in June the great drought begins again.

In the last decades the ancient capital, set in the middle of this barren countryside, has grown into a metropolis of gigantic proportions. A third of the entire population of Greece lives in Athens and Piraeus, a teeming anthill set in a desert, an illogical juxtaposition of endless rows of buildings and skyscrapers and in the midst of it all the ruins of the Acropolis assert the almost overwhelming memory of the past. These columns and fragments of sculpture tell us more about the cultural past, and history and art, than whole countries may in other latitudes. Anyone who wishes to understand Attica and is looking for traces of historical events will find here the cradle of European culture and the inheritance of Christian-Byzantine art, but also a present which since the nineteenth century has, at least in Athens, swamped this people which history had for centuries overwhelmed, destroyed and then almost forgotten. Despite all this the ruined beauty of the past is still an unforgettable experience.

As with other guides in this series, the text is arranged in alphabetical order of place names. This gives the book the clarity of a work of reference and avoids the need for lengthy searching. The link between places which are geographically close, but which are separated by the alphabet, is provided by the maps on pages 256–9. This section shows all the places mentioned which are within a short distance from any given destination and which, therefore, it might be possible to include in a tour.

The heading to each entry gives the name of the town, in both modern and ancient forms, and a reference to the map section, giving page number and grid reference. Within each entry the particular sites of interest are printed in bold type, while less significant objects of interest appear under the heading **Also worth seeing** and places in the immediate vicinity under **Environs.**

The appendices consist of a glossary of technical terms and an index of all the towns and places of interest mentioned in the text.

The publishers would be grateful for notification of any errors or omissions.

This triangular island *c.* 32 square miles in area is in the Saronic Gulf about an hour by ship from the harbour of Piraeus. Aegina has about 10,000 inhabitants and is a popular summer resort for the Athenians and a great tourist attraction.

History: There are traces of habitation on the island dating from the 4th millennium BC. It is assumed that the original population was part of the Aegean (Carian-Cretan) culture. Thus the island, along with Salamis (q.v.), was one of the N. bastions of the 'cultural bridge' in the Aegean, by means of which culture (religion, the idea of the state, art, language, writing etc.) spread from S. to N. The myths of name and origin with which the island is surrounded refer to this. The water-nymph Aegina and her sister Salamis are said to have been the daughters of the Boeotian river god Asopos. Taken by Zeus to the island of Aegina, originally called Oinóne, or Oinopía, she there bore him the mythical King Aiakos. Even in his lifetime the king had the reputation of being a most just judge, for which reason he was made a judge in the Underworld (Hades), alongside the Cretan kings Minos and Rhadamanthys. Aiakos is considered to be the father of the hero Achilles and the Myrmidons. His other son Telamon was the founder king of the neighbouring island of Salamis and father of the tragic hero Aias (Ajax), who fell on his own sword.

After Helladic, Mycenean and early Ionian settlement, Aegina was conquered by the Dorians *c.* 950 BC. The island was a member of the Peloponnesian Amphiktyonie (federation of states) of Kalaureia/Poros and was economically very successful in the 7&6C BC. Aegina had trade connections at great distances, including Naukratis on the Nile and in Spain (silver trade). It was the most successful Dorian trading centre, and the first Greek coinage was minted and put into circulation here *c.* 650 BC. This epoch-making invention of an equivalent value to goods, especially for cattle (the Latin pecunia: 'money' actually means 'cattle') originated in Asia Minor (Lydian ur-coin). The Aeginian silver stater (stater: 'weight') stamped with a tortoise became the currency for the whole Peloponnese. There was no real competition until the introduction of the Athenian 'owl coins' (tetradrachmas).

Bronze statues and ceramics from Aegina were also famous. A cultural peak was reached with the building of the great temple of Aphaia in the E., for which the poet Pindar wrote a festival hymn (*c.* 480 BC). Subsequently bitter rivalry developed between Aegina and the emergent sea power Athens, ending *c.* 455 BC with the victory of Athens over Aegina. The 'suppurating sore outside Piraeus' (Perikles) had been removed: the fortifying walls were pulled down, the once mighty fleet of triremes, which had made a major contribution to the defeat of the Persians at Salamis (480 BC) was dispersed and large sums were demanded as tribute. From then onwards, and particularly after the Aeginians left the island *c.* 431 BC, Aegina had lost its significance for ever. It was later bought by Perga-

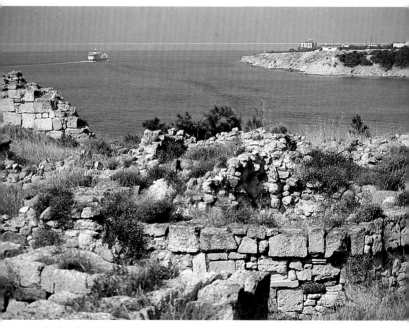

Aegina, foundation wall of the tomb of Phokos

mon, and fell to the Romans in 133 BC. In the Byzantine period it was frequently plundered by the Saracens; the capital was moved into the interior (now Palaiochóra). From 1204–1317 it was Frankish-Venetian, until 1452 it was Catalan and then until 1715 Venetian. In 1537 it was raided and plundered by the Algerian pirate Cheireddin Barbarossa. In 1715 the last fortress of the Venetians fell to the Turks, until liberation in 1826. The founder of the new Greek state, Count Kapodistrias, declared Aegina his seat of government for a short time in 1828 (later Návplion/Nauplion and finally Athens).

Aegina town (*c.* 5700 inhabitants): The capital of the island stands more or less on the same site as the ancient town of the same name, which was founded *c.* 2500 BC (traces remain on the town hill). Very little remains of

the former town and harbour installations.

Naós Apóllonos/Temple of Apollo: The remains of the oldest temple on Aegina are on the NW coast, about ten minutes on foot from the town, on the artificial mound of Cape Kolónna. The Dorian temple with 6 by 12 columns dates from *c.* 520 BC. Nothing has survived but the remains of a column (without capital), from which the present name 'Kolónna' derives, and also some fragments of polygonal poros masonry. A capital fragment which was part of the earlier 7&6C BC building, fragments of acroterion, altar and altarpiece are in the museum in Aegina. German excavations in 1924 produced remains of a still older *sacrificial pit* and late Mycenean *house foundations*, (square house with three rooms). SE of the temple are remains of the foundations of an ancient *propylon*. Further to the SW are traces of

Bay of Aegina

two smaller *temples* and parts of the foundations of a *circular building*, presumably the *tomb of Phokos* mentioned by Pausanias (2C AD). Nearby, to the N., are sparse remains of a *Bouleutérion* (council building). The *Attaleion* in the SW was dedicated to King Attalos of Pergamon, who owned the island for a time. *Ancient harbour installations:* The modern harbour includes the ancient commercial harbour in the SE, the present shipping harbour with round moles and the former war harbour (Kryptós Limén) in the NW, below the Apollo precinct. The original foundations are under water. The *moles* in the commercial harbour were rebuilt by Kapodistrias *c.* 1828 on the old foundations, and the S. mole is on the boundary of the old town (with town wall).

Archaiologikó Musio/Archaeological museum: This museum N. of the

harbour was the first of its kind in modern Greece. It contains finds from the third millennium BC to the late Roman period. The collection of *figurines* and *ceramics* from the prehistoric, Mycenean and classical periods (3500–450 BC) is particularly full, and gives a good picture of the history of settlement on the island. There is also an interesting collection of *oil lamps* (600 BC–AD 500); also bronze objects, terracotta, fragments of grave reliefs and temple sculptures, especially the *Sphinx of Aegina* (6C BC). There are also fragments (recent finds) from the famous *Aphaia temple*; the finest pieces of the so-called *Aegina collection* were bought by King Ludwig I of Bavaria (after 1811) and are in the Glyptothek in Munich.

Environs: Agii Theódori, also known as *Omorfi Ekklisía* (beautiful church) (about 4 km. E.): This was founded in 1282 (foundation inscription on the S.

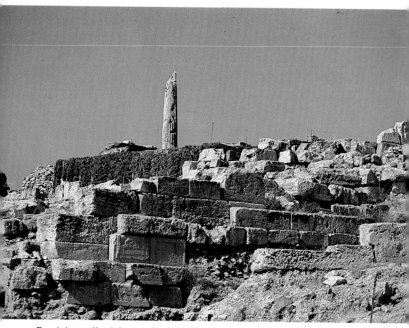

Retaining walls of the temple of Apollo

side) and is dedicated to the two saints Theodore. The tunnel vault has fine *frescos* (New Testament scenes: Birth of Christ, Crucifixion, Resurrection): on the apse is the Panagia.

Monastery Agios Nektários (about 6 km. E. in the Palaiochóra direction): The much-venerated Archbishop Nektarios (*c.* 1920) used to live in this handsome 19C monastery; he is the most recent orthodox saint, canonized in 1961.

Monastery Panagía Chrysoleóntissa (about 2 km. E.): This monastery with the imaginative name of 'Madonna in the golden lion's pelt' dates from the 16C, with extensions in the 18C. The *monastery church* (extended in 1806) has a fine carved *iconostasis* with scenes from the Old Testament, saints and angels. The rediscovered *Icon of the Panagia Deoméni* (Praying Madonna) on the iconostasis is attributed to Saint Luke.

Palaiokhóra ('old village') The former capital of the island is on a hillside in the interior, about 8 km. from the town of Aegina. It was founded in the 9C as a refuge from the Saracen pirates and fortified with *defensive works*. A number of little whitewashed Byzantine *churches* and *chapels*, some of which are in good condition, and tumble-down ruined houses make a melancholy and atmospheric picture. Palaiokhóra was often destroyed and rebuilt in the course of its 900 year history; it was not finally abandoned until after the liberation of Greece in 1821, when its inhabitants settled in the ancient harbour of Aegina again. It is dominated by a ruined *Venetian castle* of 1654 (acropolis), and very few secular buildings are still standing, but most of the twenty and more little churches are still in good condition. Most of them are tunnel-vaulted chapels in grey

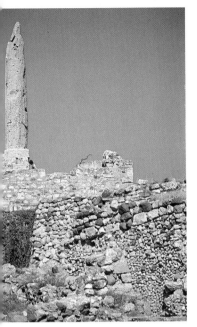

Column from the temple of Apollo

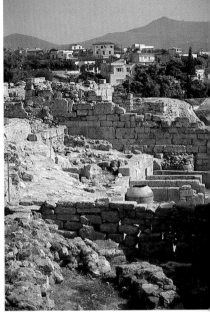

Ruins of ancient houses

natural stone (painted white). *Episkopí church* (former principal church on Aegina): This contains fine 17C frescos and a good *16&17C icon of the Panagía* (Madonna). St.Dionysos of Zante (Zákynthos) lived here, and his *monk's cell* has survived in the courtyard. Above the monk's cell a path leads via the chapel of *Agios Nikólaos* to the former Venetian *mountain fortress*. Other interesting features are the little *Stavrós basilica* (Holy Cross) at the foot of the hill and the church of *Agios Georgios Katholikós* with a paved yard in front of it, used by the Venetians as a Catholic church; also the ruins of the monastery of *Agia Kyriakí*, abandoned in 1830, with the neighbouring church of *Zoodóchos Pigí* ('life-giving spring'). This has interesting 16C *frescos*. Next is the church of *Agios Ioánnis* (Theológos), 14C with later frescos. The church of *Agios Nikólaos* is considered to be the

oldest in the village; it was dedicated to St.Nicholas by the sea-loving people of Aegina. The little church of *Agios Euthýmios* has frescos in the Peloponnesian style. Next comes *Agios Geórgios* (with frescos of St.George and St.Dominica as a Byzantine princess) and *Agios Stéfanos*, which takes you back to the beginning of the village.

Environs: Roughly 5 km. from Palaiokhóra is *Suvála*, a little port with a thermal bath on the N. coast of Aegina.

The highest mountain in the middle of the S. of the island, the *Profitis Ilias* ('Prophet Elias') is 1752 ft. high and offers fine views. Remains of the foundations of an early archaic *shrine to Zeus* were discovered here (now the Profitis Ilias chapel); also remains of an *altar*, presumably for Zeus Panhellenios. On the N. slope are ancient *terraces* with steps and the little

church of *Ton Angélon* ('angels' church). Remains of a Mycenean settlement with right-angled *foundations of houses* were discovered on the S. slope.

Temple of Aphaia (modern Greek: Naós Afaías): This Doric temple built *c.* 480 BC and still in good condition is beautifully sited on the summit of a wooded hill (about 10 km. N. of the town of Aegina, above the port of Agía Marína). There is a splendid view across the whole of the Saronic gulf to Attica. The building is on the site of an earlier temple, built *c.* 570 and destroyed in 510BC. This earlier building is also said to have been dedicated to the legendary local goddess Aphaia. Aphaia, a daughter of Zeus mentioned in almost no other tradition, is said to have fled by fishing boat from Crete to protect her virginity from King Minos, and to

have landed on the island of Aegina. This establishes a link with Cretan-Aegean culture. The later Doric temple was built on an artificial terrace on the foundations of the earlier 6C BC temple in antis. In the old building, which was covered in rubble, the archaeologist Adolf Furtwängler (father of the conductor Wilhelm Furtwängler) found in 1901 an altar and an ivory statue of Aphaia and also an important inscription with the name of the 'unknown' goddess (6C BC). He thus considered himself to have disproved the old tradition that this was a Doric temple of Athene. The classical temple, of which 23 of the 32 columns around the cella have survived, or have been reconstructed, is a Doric hexastyle peripteral temple with 12 by 6 columns. The local limestone was covered with a skim of stucco and painted; for optical reasons the corner columns

Palaiokhora, view from the acropolis towards Suvála

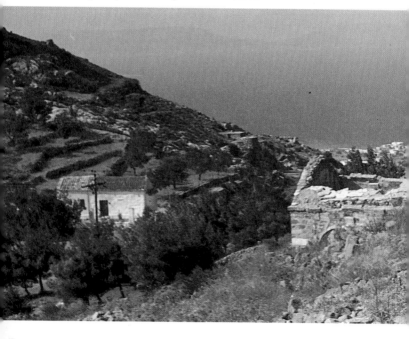

were made somewhat thicker, while the others are 3 Doric feet in diameter at the base and 8 feet apart on the axis. All the columns shafts are monolithic, with the exception of three drum columns on the N. side. The *architrave* has survived in good condition; the triglyphs, metopes and cornices have been restored to a certain extent. Most of the columns on the *peristasis* are still standing (16 ft. high), and seem to be more slender than in other early-classical Doric temples. The *cella* had rooms both in front of and behind it, i.e. a pronaos and an opisthodomos, and three interior aisles. The central aisle (about 10 metres wide) was edged by two rows of columns; the floor of the narrow side aisles was slightly raised. The *cult statue* (of the goddess Aphaia) was placed before the back wall, between the last pair of pillars but one. On solemn occasions it was moved out of the cella

(the holy of holies) to the open-air altar. The *roof decoration* and the *pedimental figures* were made of Parian marble. They are now largely in the Glyptothek in Munich, taken there by Ludwig I of Bavaria after acquiring them when they were first discovered *c.* 1811. There are other fragments in the National Museum in Athens and in the Aegina museum. The sculptures, like the temple walls, were coloured; the background of the pediment was presumably blue (imitating the sky). The older W. pediment dates from *c.* 510 BC: it represents the conflict of the Aeginian-Salaminian heroes Aias and Teukros. They were the sons of King Telamon of Salamis and grandsons of the legendary King Aiakos of Aegina. In the middle, between the fighting men, is Pallas Athene, armed, as the patron goddess of the Greeks. On the later E. pediment, which was recon-

Palaiokhora, view of the acropolis

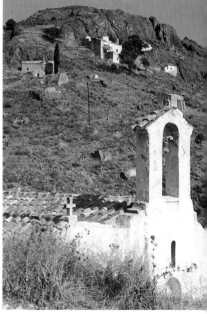

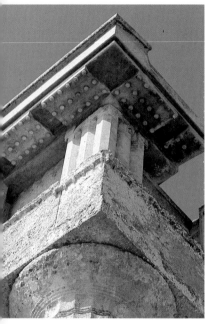

Capital in the temple of Aphaia

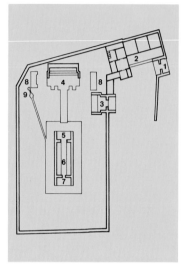

Aegina, Temple of Aphaia 1 Outer propylon **2** Hall of columns and priests' rooms **3** Inner propylon **4** Sacrificial altar **5** Pronaos (vestibule) **6** Cella **7** Opisthodomos (enclosed section at rear of temple) **8** Bases of statues **9** Cistern

structed after the loss of the older figures, is the defeat of Troy, featuring Telamon, the father of Aias and the hero Herakles. Pallas Athene is again actively involved in the struggle. Architecturally the temple is related to other late archaic sacred buildings, such as the temple of Ceres (the original Athenaion) in Paestum (Poseidonia) in S. Italy and the temple of Herakles in Agrigento, Sicily (both *c.* 500 BC).

Temple precinct: The temple precinct was made a uniform composition *c.* 480 BC, after the brilliant victory of the Athenian-Aeginian fleet over the Persians. The entire temenos was enclosed within a rectangular wall and balanced to the N. and E. by a solid *terrace wall.* The entrance to the sacred area (peribolos) was in the SE. Between two gatehouses, the outer and inner *propylon* were the extensive *priests' rooms.* Foundations of the col-

umned hall (stoa) and the living rooms behind it can be seen. By the inner propylon were cult *purification rooms* for the pilgrims. Beyond the the inner gate was a *ramp* between the temple and the *altar for burnt offerings* (in the E.).

Afídnai/ΑΦΙΔΝΑΙ

p.258☐E 3

The little town of Afidnai (also known as Afídna) is 34 miles N. of Athens, just off the motorway. It was a demos in ancient Attica, from which a *castle mound* with fragments of walls has survived (Kotróni hill). This site, like the whole area, was already settled in the Mycenean period. It is said that Theseus took the community into the Attic League of Twelve Cities (Dodekápolis) *c.* 1000 BC. The Attic

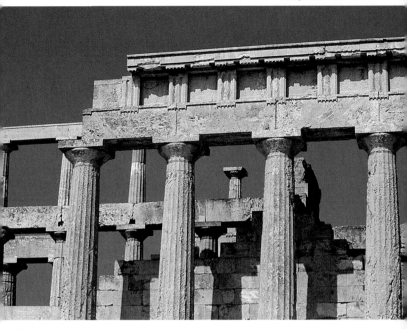

Temple of Aphaia

version of the legend holds that The-
seus took Helen, the future cause of
the Trojan War, away from here to be
his bride. Helen's brothers, however,
the heavenly twins Castor and Poly-
deukes (Pollux) freed the thirteen-
year-old girl and took her, along with
Theseus' mother Aithra, who became
Helen's slave, back to their home
town of Sparta. This legend points to
the formation of and conflict between
the 'Mycenean' Peloponnese (Sparta,
Argos and Mycenae) and ancient
Attica (Athens), which became appar-
ent from the earliest times.

**Environs: Marathon reservoir/
Límni Marathónos:** This impres-
sive lake extends to the S. of the town.
It was created in the Thirties by dam-
ming the Marathon mountain streams
of Charádra and Várnava. The reser-
voir is now the principal source of
water for the Greater Athens area.

The dam wall is 177 ft. high (*c.* 1000
ft. long) and clad in marble for part of
its length. Below it is a copy of the
Athenian treasure-house in Delphi.

Aigósthena/Pórto Germenó/ ΑΙΓΟΣΘΕΝΑ
p.258□A 3

This little port and holiday resort on
a charming bay surrounded by moun-
tains in the E. of the Gulf of Corinth
is about 70 km. N. of Athens. Until it
reverted to its classical name recently
it was known as *Portó Germenó* (pro-
nounced Yermenó).

History: According to myth Alkyone
mourned her husband Keyx, who was
lost at sea, so intensely that the gods
were moved to pity and turned the
couple into alkyons (ice birds), and
thus reunited them. This peaceful bay

and the 'Alkyonid islands' in it were named after them.

Historically the ancient harbour town of Aigósthena came under the influence of the mighty port of Mégara (q.v.) on the Saronic Gulf.

Fortress of Aigósthena: The well-preserved ruins of the Megaritic coastal fortress (4C BC) are the emblem of the port. The acropolis is outside the village, just over 500 yards E. of the sea. It is one of the finest surviving fortresses in Greece. The impressive walls enclose a rectangle of about 1950 by 650 ft. The *E. wall* has survived in the best condition; it is partly in polygonal stone and has 4 *rectangular towers* in regular quarry stone. The 4C BC *defensive tower* at the SE corner is *c.* 45 ft. high and is an interesting example of Greek defensive architecture. The Spartans retreated here after the defeat at Leukra (near Thebes) in 371 BC. Within the fortress are remains of a Byzantine *monastery* (cell buildings) with a 12C *church*. By the N. wall (on the coast side) the foundations of an early Christian *basilica* were discovered in 1954; it dates from the 6C and is 82 by 65 ft. in area. It was a building with nave, four aisles, main apse, narthex and baptistery. A cruciform *Panagia church* was built over it in the 12C (St.Mary); this once belonged to the monastery. Remains of the *mosaic floor* of this church have survived.

Environs: N. of the bay are the legendary **Kithairon mountains**, about 4590 ft. high at the summit. According to myth this is where the Theban King Laios left his new-born son Oedipus to die. The oracle of Delphi had prophesied to him that his son would take away his life and his kingdom. However, a shepherd found

Aegina, temple of Aphaia

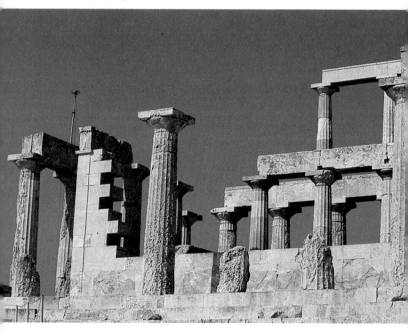

the helpless little boy and brought him up, so that finally the oracle was fulfilled. It is presumed that the lonely Kithairon range was used by the Thebans when they wished to leave sick and crippled infants to die, in the same way that the Spartans used the Taygeton range. As the tragic poet Euripides (5C BC) shows in his play 'The Bacchae', the hectic dances of the Maenads also took place on Mount Kithairon. When Pentheus, King of Thebes, watched these immoral rites, dressed as a woman, he was discovered and dragged from his hiding-place in a tree. The crazed women tore him to pieces.

Akharnaí/AΧAPNAI

p.258□D 4

This little town with almost 12,000 inhabitants is about 12 km. N. of Athens near the S. foothills of the Parnis mountains. It is now part of Greater Athens.

History: The ancient Attic country deme of *Akharnaí* played an important role in the Athenian hinterland in ancient times. The Acharnians, as members of the community (phyle) of Oneís, provided a significant contingent of the Athenian army.

Town fortifications: Remains of the ancient fortifications and some medieval ruins on an earth mound.

Mycenean beehive tomb (Menidi tomb): A Mycenean *tholos tomb* (tumulus) was discovered and excavated by the German Archaeological Institute *c.* 1879. It is on the Likótripa site (near the cemetery). The tomb was 26 ft. high and in diameter,

Aigósthena, Chapel of the Theotokos

Aigósthena fort, SE tower

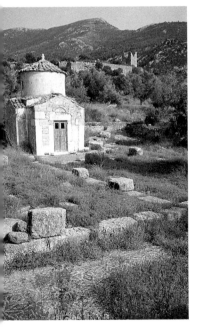

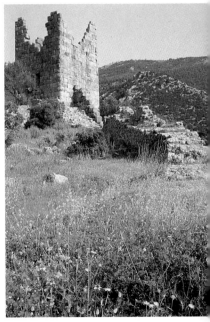

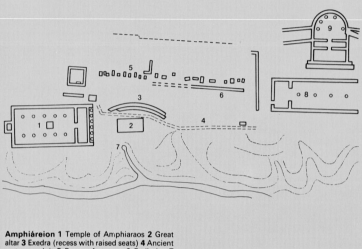

Amphiáreion 1 Temple of Amphiaraos **2** Great altar **3** Exedra (recess with raised seats) **4** Ancient water conduit **5** Bases of statues **6** Peribolos **7** Sacred spring **8** Enkimitirion/Dormitory **9** Theatre

and had a dromos (grave passage) 85 ft. long.

Environs: N. of Akharnaí are the foothills of the **Párnis** mountains (q.v.). 15 km. of road with hairpin bends lead to the summit of Mount Parnis (4635 ft.), known as a place of worship in the early antique period; there is a splendid view.

Amfiárion/Amphiáreion/ ΑΜΦΙΑΡΕΙΟΝ p.258□E 2

On the N. coast of Attica (about 45 km. N. of Athens), between the villages of Kálamos and Oropós, are the excavations of the ancient oracle and healing centre of Amphiáreion.

History: The wise seer Amphiaraos, to whom the holy place is dedicated, lived in the kingdom of Argos (Peloponnese) in mythical times. By a cunning trick he was compelled by Polyneikes, one of the sons of Oedipus, who had been driven out of Thebes, to take part in the fateful campaign of vengeance of the 'Seven against Thebes'. His wife Eriphyle, whom he had chosen to adjudicate in cases of dispute, allowed herself to be bribed by Polyneikes with the miraculous bridal gown and necklace of Harmonia (unity). She decided that her husband must take part in the campaign, although he had a presentiment that he would be killed. When he was pierced by an enemy arrow before the walls of Thebes, Zeus, who loved him, had him disappear, together with his horse and chariot, into a crack in the earth. According to legend Amphiaraos was brought back to life as a demi-god and returned from the Underworld

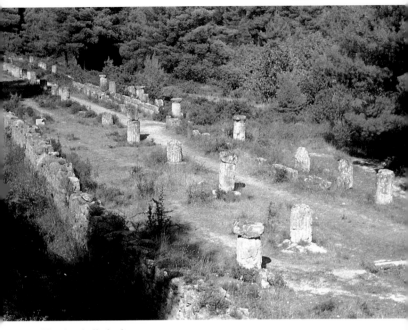

Amphiáreion, hall of columns

through a spring at the shrine which now bears his name. Probably because of the death and resurrection of the 'holy' man it was hoped that the spring would heal sickness and distress. The spring was most extensively used during the Hellenic and Roman periods.

Excavation site: The sacred precinct, which was excavated a century ago (1884–93) by the Greek Archaeological Society, runs from SW to NE on the left bank of a winter torrent (Chimarros). It is a peaceful site well suited to a spa.

Temple of Amphiaraos: The Doric building dates from the 4C BC; it has a raised supporting terrace to the S. (bank of the stream). The temple in antis is about 45 by 72 ft. and consisted of a pronaos with six Doric poros columns, a cella with two rows

each of five columns and a small additional building in the SW. In the *cella* were a *sacrificial altar* and in the background (W.) a *statue* of Amphiáraos, god of healing; the base and fragments of the statue survive.

Great altar: Near the temple (to the NE) are remains of the foundations of an old *altar*. Sacrifices were made to various gods: Zeus-Herakles-Apollo, the heroes, Hestia (goddess of the hearth), Aphrodite-Athena and also Pan and the Nymphs. Presumably the kid (tragos) which those seeking a cure had to bring with them was also sacrificed here, and then the healing sleep was taken on its skin. Beyond this, at the foot of the hill, there was a curved *flight of steps* (exedra) and the ancient *water system* which ran through the whole shrine. Then came a *terrace* (NW) with about 30 *bases* for statues and votive gifts (4C BC and later). At the N. end is a *peribolos wall*

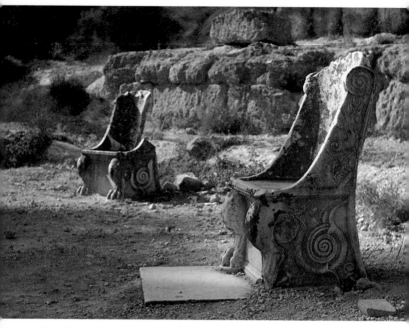

Amphiáreion, marble seats for guests of honour

and in front of it (to the NE) ruins of a *row of benches* with marble feet.

Sacred spring: Between the Great Altar and the torrent is the *sacred spring*, from which Amphiaraos is said to have risen after he fell before the gates of Thebes.

Enkimitirion/sleeping hall: In the NE section are remains of the foundations of a 4C BC *stoa* 360 by 36 ft. On its open long side to the S. the hall had a row of 44 *Doric columns*. The interior was divided into two long *galleries* by 17 Ionic columns. Some of the marble feet have survived of the *longitudinal bench* on the N. wall. This was where the therapeutic sleep (enkimisis) took place, in a kind of day dormitory with stone couches (klines) and benches.

Theatre: The Hellenic theatre behind the sleeping hall (in the NE of the precinct) has fine acoustics; it was used for competitions in the festivals which took place here every four years from 332 BC. The lower (front) rows of steps of the amphitheatre built for about 300 spectators are in the best condition. The only other buildings were the circular *orchestra* and the *stage building* (skene; about 40 ft. in diameter). In the orchestra there are still 5 *marble seats of honour* (thronoi) with dedicatory inscriptions and snorkel ornaments.

Also worth seeing: NE of the sleeping hall and the theatre was the old *spa area* of which mainly Roman foundations have survived. On the right bank of the Chimarros torrent (in the SE) are traces of a late-antique *settlement* with various *pilgrim and priests' houses* (doctors' houses) with *columned corridors*, which show how popular the spa used to be. Building on the right bank began in the 4C BC and continued until the Roman period. Near the brook are remains of

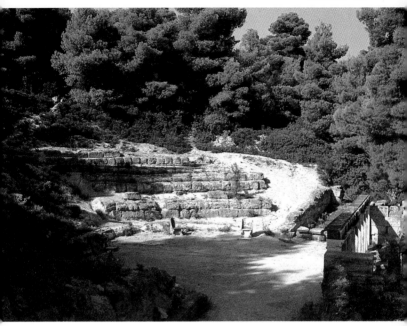

Amphiáreion, theatre

a *clepsydra* (ancient water clock) with water container and drain.

Museum: The little museum (near the sleeping hall) contains various *fragments of sculpture*, part of the ancient temple, and stone inscriptions.

Athínai/Athens/AΘHNAI

p.258□D 4/5

Athens is the nirvana of all those interested in art and antiquity, but anyone with such interests arriving in the city for the first time, whether by aeroplane, train, bus or private car, will at first be very disappointed. After travelling through a barren and desolate landscape one reaches one of the most unpleasant conurbations in Europe.

Continued on page 26

Alphabetical index of the sights of Athens

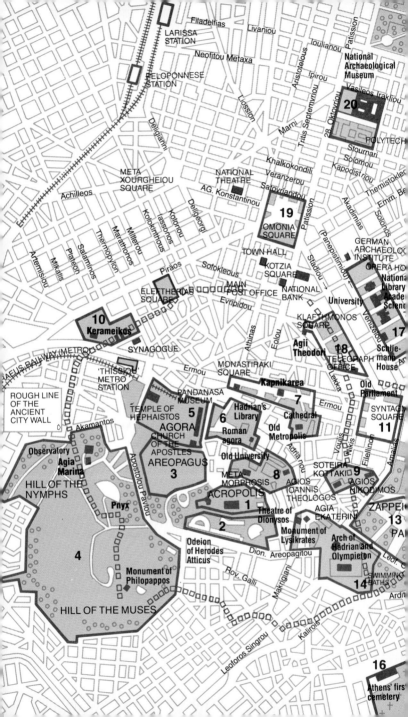

LARISSA
STATION

Filadelfias Livaniou

Neofitou Metaxa

Ioulianou

PELOPONNESE
STATION

Deligianni

Aristotelous

Ipirou

National
Archaeological
Museum

Vasileos Irakliou

20

POLYTECH

Tritis Septemvriou

28 Oktovriou (Patision)

Stournari

Solomou

Kapodistriou

Achilleos

META
XOURGHEIOU
SQUARE

NATIONAL
THEATRE

AG. Konstantinou

Khalkokondili

Veranzerou

Satovriandou

Themistokleous

Akadimias

GERMAN
ARCHAEOLOG
INSTITUTE

Emm. Be

Artemisiou

Mikalis

Plateon

Thermopylon

Salaminos

Marathonos

Millerou

Kolokinthous

Kolonou

Iassonos

Deligeorgi

Patision

OMONIA
SQUARE

19

TOWN HALL

KOTZIA
SQUARE

Stadiou

NATIONAL
BANK

OPERA HO

National
Library

Academy
Scient

Piraos

Sofokleous

ELEFTHERIAS
SQUARE

MAIN
POST OFFICE

Evripidou

Athinas

University

KLAFTHIMONOS
SQUARE

Venizelou (Panepistimiou)

10
Kerameikos

SYNAGOGUE

Eolou

Agii
Theodori

18
TELEGRAPH
OFFICE

17

Schlie-
mann
House

PIRAEUS RAILWAY (METRO)

'THISSIOU'
METRO
STATION

Ermou

MONASTIRAKI
SQUARE

Lekka

Old
Parliament

ROUGH LINE
OF THE
ANCIENT
CITY WALL

PANDANASA
MUSEUM

TEMPLE OF
HEPHAISTOS

5

Kapnikarea

7

Ermou

SYNTAGMA
SQUARE

Hadrian's
Library

6

Cathedral

Voulis

Akamantos

AGORA
CHURCH
OF THE
APOSTLES

Roman
agora

Old
Metropolis

11

AREOPAGUS

3

Old University

META-
MORPHOSIS

8

SOTEIRA
KOTTAKID

Filellinon

Observatory

Agia
Marina

HILL OF THE
NYMPHS

Apostolou Pavlou

ACROPOLIS

1

AGIOS
IOANNIS
THEOLOGOS

9

AGIOS
NIKODIMOS

Amalias

ZAPPEI

Pnyx

2

Theatre of
Dionysos

AGIA
EKATERINI

13

PA

4

Odeion
of Herodes
Atticus

Monument of
Lysikrates

Arch of
Hadrian and
Olympieion

Leof. O

Dion. Areopagitou

Monument of
Philopappos

Rov. Galli

14

SWIMMING
BATHS

HILL OF THE MUSES

Makriyanni

Ardit

Leoforos Singrou

Kaliros

16

Athens' first
cemetery

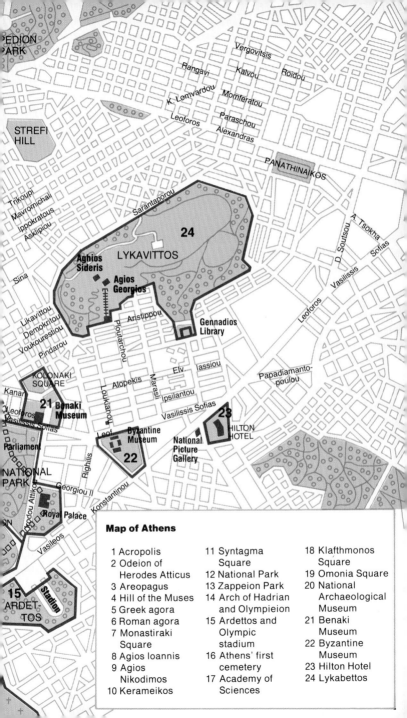

Map of Athens

1 Acropolis
2 Odeion of Herodes Atticus
3 Areopagus
4 Hill of the Muses
5 Greek agora
6 Roman agora
7 Monastiraki Square
8 Agios Ioannis
9 Agios Nikodimos
10 Kerameikos
11 Syntagma Square
12 National Park
13 Zappeion Park
14 Arch of Hadrian and Olympieion
15 Ardettos and Olympic stadium
16 Athens' first cemetery
17 Academy of Sciences
18 Klafthmonos Square
19 Omonia Square
20 National Archaeological Museum
21 Benaki Museum
22 Byzantine Museum
23 Hilton Hotel
24 Lykabettos

The streets are lined with skyscraper after skyscraper, and cars tear along in four and even six lanes, polluting the atmosphere. A teeming mass of anonymous humanity; in many places there are poverty and decay; the wealth of high technology is found in others. Streets, nothing but streets, noise and dust. Isolated palms stand at entrances which are seldom cared for, every so often there is a roof garden among the endless garages and workshops. Athens is dominated by the motor car. No wonder—a quarter of the total population of Greece lives here in the capital, where there are factories and work. The city has two and a half million inhabitants; in the 18C it had 4000. To this figure the countless number of visitors must be added, asking for the Acropolis, the Agora and the Kerameikos. The principal means of transport are buses and the underground, and the taxis, which you hail from the pavement. The tourist industry is one of the city's principal sources of income. The visitor arriving from the airport and driving along the well-tended beach promenade recovers from the first shock as he catches a glimpse out across the sea from time to time. Then, in the heart of the city, high above the desert of buildings, towers the Acropolis. The majesty of the Parthenon makes it possible to be reconciled with Athens. But only if you are prepared to work through the excavation sites and antiquities in a systematic way, without allowing yourself to be bewildered by the masses of people, will you discover slowly what Athens really is, and what it was. A hint: visit the Acropolis early in the morning, when you can still be relatively alone, and spend the evening in the Plaka, the old town, in which much of the magic of medieval Athens has been preserved and where you will be pursued by hordes of homeless half-starved cats on the look-out for sympathetic strangers. This is not the international metropolis, but Athens, and an Athens full of lively and sensitive Athenians who love life and colour. Anyone who troubles to get to the bottom of this town will not be disappointed, but delighted. Athens has far more charm than most big cities, but that charm must be sought out.

CHRONOLOGY

5000 BC
The oldest finds suggest a settlement in the Stone Age on the Acropolis and on its N. and S. slopes. These were probably the first settlers, and were known as Pelasgians.

3500 BC
Excavations have shown that the Pelasgians, who started to plant olive trees and vines, also dug wells.

1900 BC
Ionians immigrate to Attica. They were called Hellenes.

1400 BC
In the Mycenean period a fortress was built on the Acropolis.

1259 BC
A new castle, the last Mycenean building with curtain wall (mistakenly called the Pelargikon) was built on the Acropolis. The whole of Attica was united under Athens (legendary King Theseus).

1200 BC
The Dorian migration passed Athens by, but the city did receive many refugees from the Peloponnese. The population grew, and this gave rise to emigration to Asia Minor and the nearby islands.

1100 BC
Raids by foreign tribes compelled the Athenians to fortify the city further. The Enneapylos with its nine gates was built S. of the Acropolis.

Athena Varvakion ▷

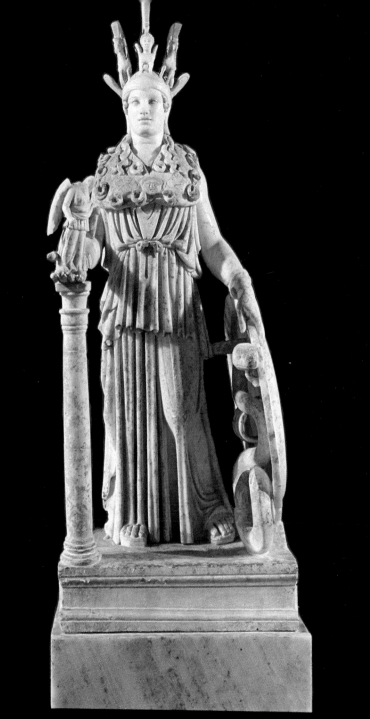

800 BC
From this time onwards the Greeks used the Phoenician sea routes.

700 BC
The first gold and silver coins were struck in Lydia, and shortly afterwards trade with money replaced barter in Greece.

686 BC
There were revolts in the population, especially among the farmers (most of Attica made its living from farming; peasants who could not pay the taxes demanded from them by the nobility were enslaved).

683 BC
Collapse of the kings and distribution of power among the nobility. 9 noblemen, the archons, at first chosen for life, then annually, shared power.

630 BC
Kylon's revolt against the aristocracy.

624 BC
Drakon's legislation (strict new constitution, with a particularly severe penal code).

594 BC
Solon created new laws which broke the hegemony of the nobility and abolished serfdom. He divided the people into four classes according to their ability to pay taxes, and involved all classes in the administration of justice.

561 BC
After Solon had left the city new difficulties cropped up. The poorest members of the population, the small farmers from the surrounding area, revolted. They made Peisistratos their leader; he was a nobleman from Braurón, and occupied the Acropolis in 561 with the assistance of his bodyguard. He was forced to flee, but returned, and from 546 to his death in 528 he ruled as absolute tyrant, but according to Aristotle one who was democratically inclined, and one to whom Athens owed a great deal, particularly in the cultural sphere.

514 BC
Hipparchos, a son of Peisistratos, was murdered in the Agora by Harmodios and Aristogeiton, because of a personal vendetta, and yet at a later date both the sons of Peisitratos, Hippias and Hipparchos, were celebrated as liberators from the yoke of tyranny. In 510 Hippias too, who finally had ruled as a tyrant in the modern sense, was driven out by the Alkmaionides.

510 BC
The fall of the tyrants was followed by a crisis. The alliances with Thessaly, Argos, Macedonia and Sparta collapsed. After the fall of Polykrates in 522 the Persians extended their empire to the W.

507 BC
Kleisthenes, the spokesman of the Alkmaionides, announced a new democratic constitution. He divided Attica into 10 phyles (tribes). The senate was made up of 500 members chosen by lot. Executive power was in the hands of 9 archons, also chosen by lot.

500 BC
The Persians continued to make every attempt to expand their empire.

499 BC
Athens sent a war fleet to the Ionian colonies to ward off the influence of the Persians, which provoked the Persian king Darius to attack Greece itself.

490 BC
The Persians landed in the Bay of Marathon, but the Athenians, with the assistance of the Plataians, were able to drive them back. In the meantime Themistokles expanded the Athenian fleet by the addition of 200 warships.

The State under Solon's Constitution

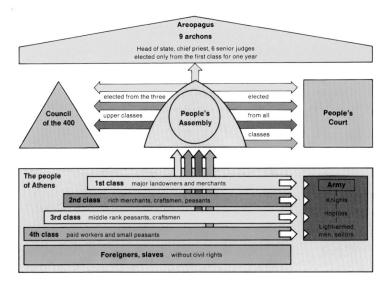

483 BC
Rich silver mines were discovered near Laurion; this enabled Athens to finance its mighty war fleets.

480 BC
Darius' son Xerxes led another attack by the Persians. The population was evacuated and Attica was left to the enemy. The Persian commander-in-chief Mardonios had the fortress on the Acropolis destroyed, and archaic Athens was totally laid waste. The population of Athens had fled to Salamis. In 480 Themistokles, with his entire fleet, met the Persians in the narrows there, after they had occupied the whole of Attica. The Persians were so heavily defeated that Xerxes returned to Asia Minor.

479 BC
Xerxes' commander-in-chief Mardo-nios attacked Plataia in Boeotia with a large land force and he, and the Persian fleet at Mykale, were heavily defeated.

478 BC
The first Attic Sea League was formed, with Athens in a leading role. The new harbour of Piraeus, which had been built by order of Themistokles, became an important commercial centre. Athens became the leading economic power in Greece. Themistokles protected the city with a wall, which stood until AD 300.

471 BC
Themistokles ostracized. He fled to Persia in 465. Like Themistokles, his successor Kimon, the son of Miltiades, much loved for his generosity, devoted himself to rebuilding the town.

The Democratic Constitution of Athens since Kleisthenes

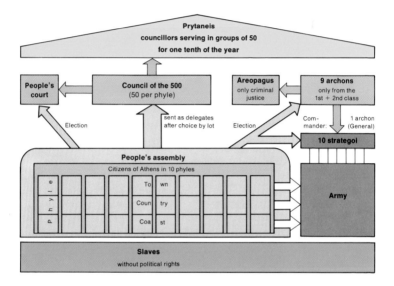

465 BC
Kimon broke the Persians at sea once and for all by his victory at the battle of Eurymedon. After being banished for a time he died in 449 BC.

462 BC
Perikles broke with the polis on the Peloponnese. The conflict with Sparta split the entire country into two camps and was the cause of many wars. Athens expanded. Its war fleet enabled it to found many colonies. Perikles was also very active in internal politics and introduced democratic reforms and many new laws.

461 BC
After the banishment of Kimon, Perikles made himself the first man in the state, a position which he held until his death in 429. It was he who commissioned Pheidias to redesign the buildings on the Acropolis. The Age of Perikles has always been synonymous with the high point of Athenian culture, the first high European culture after Crete, and for many the high point of culture anywhere. For this reason the Age of Perikles has also been called the 'Golden Age'. From 461 to 429 Athens experienced an incomparable period of achievement in the fields of external and internal politics, but above all in the cultural sphere.

445 BC
Peace with Sparta.

431 BC
The Peloponnesian War, which was to be the downfall of Athens, broke out. Sparta was no longer prepared to recognize Athens' leading role. The

*Organization of the Athenian State in the Period of Rule by Kings
and Aristocracy*

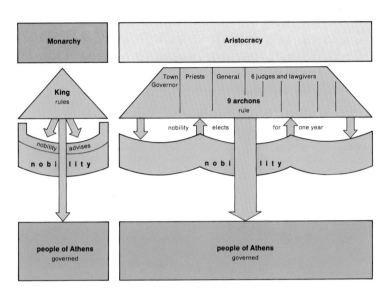

two city states fought many battles between 431 and 404. First Alkibiades won two victories for the Athenians over the Spartans, and then he was defeated himself.

406 BC

Now the Athenian fleet under Konon defeated the Spartans. After 405 the Spartans were successful under Lysander and Nearchos.

404 BC

Athens had to capitulate. Lysander pulled down the ramparts at Piraeus and the 'Long Walls'. Athens, in which the plague had broken out (Perikles had died of plague in 429), had lost her fleet, and thereby her power. Sparta, who also sustained heavy losses in this war, took over hegemony in Greece. The year 404 marks the end of the Peloponnesian

War and for the time being the end of democracy. Athens was ruled by 30 tyrants.

403 BC

Thrasybulos reintroduced democracy in 403. Athens grew more powerful again, and defeated the Spartan fleet at Knidos in 394.

378 BC

An alliance with Thebes signalled the inception of the Second Attic Sea Alliance. Athens' hegemony at sea was once again secure, but the changing patterns of alliances which Athens now pursued in order to maintain her position of power served to weaken, rather then to strengthen her.

351 BC

In the mean time Macedonia, under Philip II, had gained a position of

precedence. Demosthenes in his speeches (First Philippic) had set himself against Philip II, and was later condemned to death.

338 BC

The Athenians were defeated by the Macedonians at Chaironeia.

336 BC

Philip's son Alexander, later Alexander the Great, came to power. He was to take into his hands the fate not only of Macedonia, but of the whole of Greece, and even that of Asia Minor and W. Asia as far as India and Tashkent, and of part of Africa. Athens became more and more dependent on Macedonia.

322 BC

Athens occupied by the Macedonians, but Alexander showed himself susceptible to Athenian culture.

300 BC

The 3rd century, the so-called Hellenic period, brought Athens a more changeable fate; her power and cultural influence were on the wane, and the city was alternately independent or in the power of another state.

266 BC

After the Chermonideic War (266–263) Athens once more came under the power of Macedonia.

220 BC

Philip V of Macedon attacked Athens. Attalos I of Pergamon and (for the first time) Romans appeared to defend the city. From this time onwards the Romans felt that Athens was under their protection.

217 BC

Athens attacked by Aetolian-Cretan pirates.

168 BC

The Romans defeated the Macedonians at Pydna and at the same time raised Athens to the status of 'libera

civitas'. The kings of Pergamon also took Athens under their protection.

146 BC

Greece becomes a province of Rome.

88 BC

The Senate voluntarily subjugated the town to Mithridates VI of Pontus and supported him until the outbreak of war with the Romans. He ruled with great cruelty. The Romans were swift to take their revenge.

86 BC

The Roman general Sulla attacked the city and destroyed it. From now on Athens was totally without political significance, but for the Romans it retained its cultural importance. Roman art, Roman philosophy and the whole of the spiritual side of Rome developed under the influence of Athens. Gifts from Rome, but also from Asia Minor and Syria made good the damage which Sulla had inflicted. Even then Athens was living off the memories of the Periklean Age, and off the admiration afforded to its ruins, as it still does today.

27 BC

Under Augustus the city became a free city allied with Rome.

AD 49

The Apostle Paul came to Athens. From that time the number of Christians in the town slowly but steadily increased.

124

Between AD 124 and 131 the Emperor Hadrian came to Athens three times. This ruler, who was very open to the influence of art, became a great supporter of the city, and indeed extended the city E. of the gate of Hadrian by a quarter of its area.

Children boxing, fresco dating from around 1500 BC, National Archaeological Museum ▷

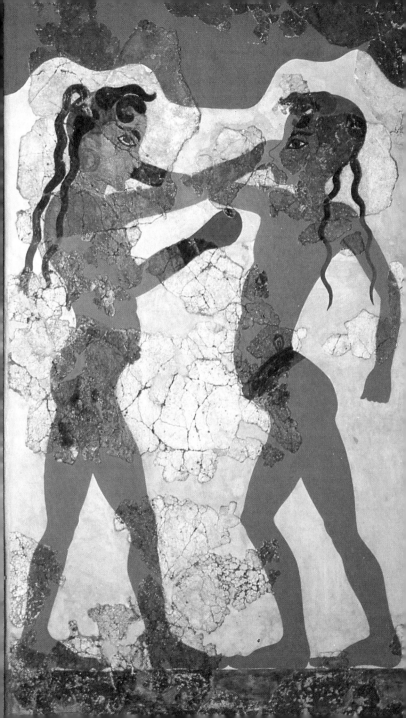

150
After Emperor Hadrian the Rhetor Tiberius Claudius Herodes Atticus of Marathon became the patron of Athens, and commissioned new buildings.

267
After the Kostobokes had attacked Athens in AD 170 the Goths and the Heruli attacked in 267 and overran the city, but were driven off by Herenios Dexippos.

330
Under Emperor Constantine the Great (306–37), and later under Theodosius II (408–50), art treasures were removed from Athens to Constantinople, which became capital of the Byzantine empire in 330.

375
The city was damaged by a major earthquake.

393
The Olympic Games were forbidden by Theodosius I, but the Panathenaia continued to be held.

396
Alaric, who reached the gates of Athens with his troops, was so impressed with the sight of Athena Promachos that he withdrew without attacking the city.

426
The Christian Emperor Theodosius II of Ostrom ordered the closing of the ancient places of worship. Temples were turned into churches, and the first Christian churches date from this time.

529
Justinian closed the University of Athens and Plato's Academy. Greek works of art were also removed from Athens under this Emperor, including the Athena Promachos, which was still standing in Constantinople in the 9C. More and more buildings dedicated to the gods of antiquity were christianized.

733
Athens detached itself from the Roman church and joined that of Constantinople.

Owl, 5C BC, Acropolis Museum

Athena, 460 BC, Acropolis Museum

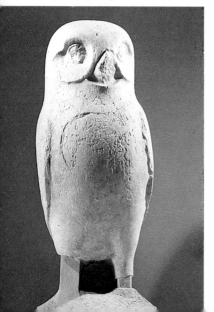

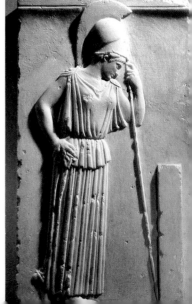

797

In this year the Athenian Irene and in 807 the Athenian Theophano became Empresses of Byzantium.

841

Athens became the seat of an archbishop. The Parthenon became a cathedral.

915

The population of the city rose against the imperial administration. From the 11C more and more churches and monasteries were built in Athens and the whole of Attica. The city of Athens itself was now a mere village.

1025

The Byzantine ruler Basileios II visited Athens.

1147

Piraeus occupied by the Normans.

1204

Athens conquered by French Crusaders. After Constantinople had been conquered by the Franks in 1204, Athens, Boeotia and Megara were handed over to the knight Othon de la Roche.

1260

Athens became a Frankish duchy.

1311

The Catalans took possession of Athens.

1387

The Florentines (Acciaioli patrician family) conquered Athens. The dukes of Florence built their palace in the Propylaia of the fortress and began building work on the Acropolis. Athens became the ducal seat.

1397

Athens occupied by the Turks for the first time.

1456

Three years after the fall of Constantinople the Turks under Muhammad II conquered Athens and held the city for a long period. They were to retain

Philosopher, found near Antikythera, 2C BC, N.A.M.

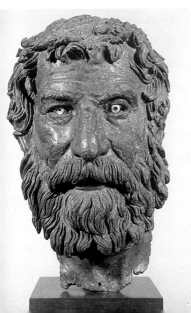

Poseidon, 140 BC, N.A.M.

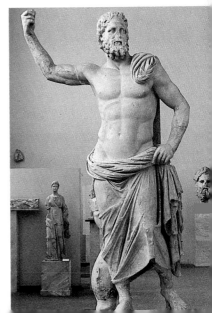

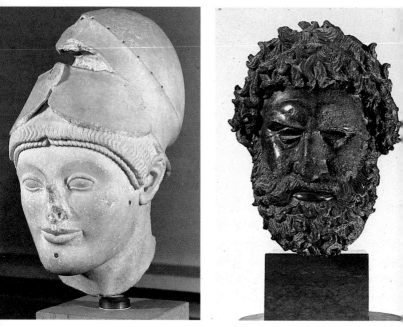

Warrior from Aegina, c. 500 BC (L.); boxer from Olympia, middle of the 4C BC (R.); both from the N.A.M.

their dominance here, except for attempts to reconquer the city by the Venetians in 1466 and 1687, until the 19C. The Parthenon now became a mosque, having served as a cathedral, and the Propylaia became the house of the Turkish commander, who kept his harem in the Erechtheion.

1645

After the Acropolis had been badly damaged by two accidents in the 16C, a powder magazine in the Propylaia was struck by lightning and this damaged the upper part of the building.

1687

The Parthenon collapsed because of the explosion of a powder magazine. Collectors destroyed other individual works of art or took them away and Athens became less and less

important. In 1687&8 the city was occupied by the Venetians; the Turks set fire to it as they were driven out.

1718

Many citizens had fled with the arrival of the Venetians, and it was not until they withdrew that a few inhabitants trickled back into the empty city.

1821

At the time of the Wars of Liberation the Athenians joined in revolution and in 1822 forced the Turks to capitulate.

1832

France, Great Britain and Russia declared Greece a sovereign kingdom.

1833

After cruel fighting between the

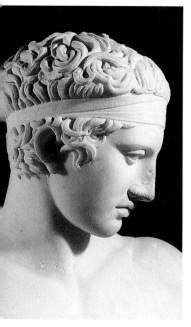 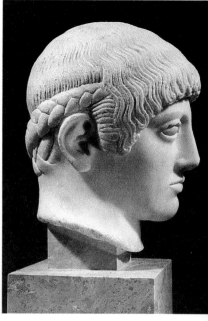

'Diadoumenos' of Polykleitos, Roman copy (L.); head of a blonde youth, c. 480 BC (R.)

Greeks and the Turks King Otto of Bavaria entered Athens as its ruler.

1824
Otto made Athens the capital of the new Kingdom of Greece.

1862
King Otto I deposed.

1863
The Glücksburgs under King George I took over from the Bavarian Wittelsbachs. As a result of archaeology, neoclassicism and the resultant rediscovery of antiquity Athens became the spiritual, artistic and political centre of Greece. It also experienced rapid economic growth. The population, no longer pure Greek, but drawn from many places, continued to increase. In 1839 it had about 2,500 inhabitants, in 1928 there were

already 70,247; Athens now has 2.5 million inhabitants.

1896
The first Olympic Games of the modern era took place in Athens.

1900
In the late 19C and early 20C the history of Athens was no less turbulent. There were changes of government, revolts and clashes with the East.

1913
George I murdered in Thessaloniki.

1920–1922
In the Graeco-Turkish War (catastrophe of Asia Minor) 2.5 million people were forced to flee from Asia Minor, and 600,000 Greeks living there lost their lives.

1924
Deposition of George II; Greece declared a Republic.

1935
Restoration of the Greek monarchy, reinstatement of George II.

1936
Dictatorship of Metaxas.

1940
Greece overrun by Mussolini.

1941
Hitler's troops march in.

1944
Armed revolt of communist resistance fighters.

1947
Paul I mounts the throne.

1949
Papagos ended the civil war and remained Prime Minister from 1952–5.

1955
Papagos' successor, Karamanlis, held the office until 1963; in 1974 he was elected again in the first democratic elections held in the new republic.

1964
Papandreou made Prime Minister.

1967
King Constantine II, who succeeded his father Paul, went into exile after a military putsch in 1967 and was deposed in 1973.

1967
Papadopoulos became Greek dictator.

1973
Papadopoulos deposed by the armed forces. Greece votes to become a republic.

1974
Return to democracy under Kara-

manlis (Prime Minister from 1974 to 1980).

1975
New republican constitution.

1981
Greece joins the EEC.

CULTURAL HISTORY OF ATHENS

5000 BC
The earliest traces of a settlement date from the New Stone Age. They were discovered on the Acropolis and on its N. and S. slopes.

3200–1100 BC
Between 3200 and 1100 BC the so-called Cycladic culture developed on the islands off the Greek mainland; this produced extraordinarily expressive ceramics, carved figures, utensils and also wall paintings.

3000 BC
Definite traces of Pelasgian settlement on the Acropolis, on its N. and S. slopes and in the area of the present Agora.

2600–1425 BC
At the same time an early culture came into being in Crete, which led to an extraordinarily developed high culture *c*. 1500 BC.

2300–1850 BC
The simple early Helladic culture on the mainland remained relatively untouched by this.

1850–1600 BC
The middle Helladic culture developed as a result of the peaceful settlement of the mainland by foreign tribes.

1600–1150 BC
During the late Helladic period, in

Priestess sacrificing, 1500 BC, N.A.M. ▷

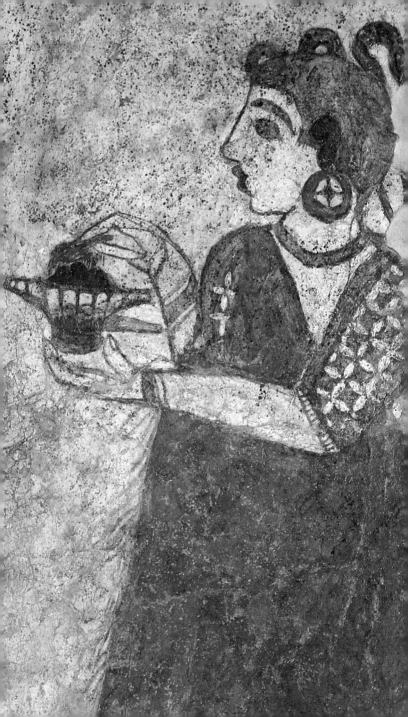

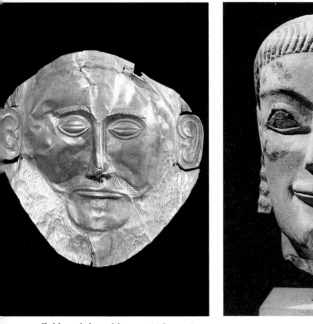

Gold mask from Mycene, 16C BC (L.); kouros from Ptoon, 6C BC (R.), N.A.M.

which a fortress was built on the Acropolis, (1400 BC), a high culture developed in Mycene at the same time.

1600 BC
From this time the fertility religion and the old Zeus cult were mixed in Crete, leading to a religion in which several gods ruled alongside each other, and which spread throughout Greece from 1300 BC.

1300 BC
Cretan and Mycenean myths fused together with a new sense of history, which later made possible the epics of Homer. The Acropolis, with the shrines of Athena and Poseidon, became the central shrine in Athens.

1259 BC
The last Mycenean fortress with cur-tain wall (Pelargikon) was built on the Acropolis.

1200–1000 BC
During the migration of the Greek peoples, the so-called 'Dorian mig-ration', the city of Athens was largely spared. Iron replaced bronze as the material for weapons. The Phoeni-cian script was adopted, and the Greeks developed their alphabet from this.

1100 BC
The dead were buried in the Kera-meikos in Athens from the 11C BC. Grave goods from the geometric period were later discovered here.

1000–900 BC
Protogeometric period. The tradi-tions of Cretan and Greek art became impoverished, and this resulted in a

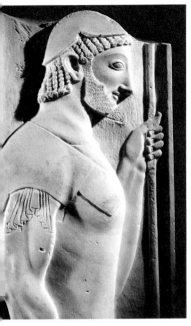 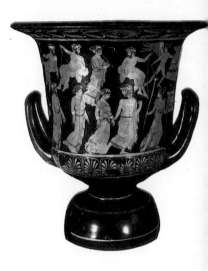

Stela of Aristion, 500 BC (L.); red figure krater, 5C (R.)

simple geometrization of design. Attic crafts began to develop.

900–700 BC
Geometric period. Vessels, vases, amphoras were decorated with simple geometric lines (meander, semicircle).

776 BC
The first Olympic Games in honour of Zeus took place. These sporting competitions, like drama, had their origin in worship and religion.

700 BC
In the 7C the Thracian belief in Dionysos, god of wine, established itself. Olympus now had its full quota of gods. Various mystery cults, including some involving foreign gods (e.g. Egyptian) developed. Greece, and Attica in particular, was very open to oriental influence from the 7C.

700 BC
The first monumental stone sculptures excavated in Athens date from *c.* 700. Attic vases became more and more important and were exported from the 7C, along with oil and wine.

700 BC
Homer is said to have lived *c.* 700; it is probable that he existed, but not quite certain. He is considered to have been the earliest epic poet of the West; it was once thought that he lived in the 9C. He was the author of the 'Iliad' and the 'Odyssey'.

600 BC
European philosophy began *c.* 600 when thinking began to detach itself from mythological tradition.

600–595 BC
Poetry of Sappho.

600–500 (or, to set the broadest limits, 700–480) BC

The archaic period, which started in Corinth and reached its zenith in Athens; Delphi, Samos, Naxos and Delos also became artistic centres. Strictly formal art was followed by a monumental style. Ornament based on fronds, bands, braids, bows and even narrative friezes replaced the strict linear style. Stone buildings (Doric temples) took over from the original wooden ones.

580–500 BC

Pythagoras of Samos concerned himself with mathematics, physics, music, astronomy and political theory.

570–488 BC

Anakreon of Theos, who wrote famous love songs (to boys) and drinking songs.

560 BC

From this time the black figure style of vase painting developed, usually representing myths (peak under Amasis and Exekias, 550–520).

From 546 BC

Numerous buildings and statues came into being under Peisistratos. Ionian artists introduced Parian and Naxian marble to Athens. Peisistratos encouraged the cult of Dionysos and initiated the feast of Panathenaia and the tragic agon (competition) at the great Dionysia.

536 BC

Thespis was the first director of the games, and was the first to perform a tragedy at the great Dionysia. The age of Greek tragedy had dawned.

530 BC

From this time on the red figure style of vase painting developed (most famous exponent: the Athenian Euphronios).

529–519 BC

Peisistratos built the Temple of Athena Polias in Athens. The Propylaia were redesigned.

525 BC

Birth of Aiskhylos, the first great tragic poet. Only 7 of the *c.* 90 plays

Jockey, middle of 2C BC, N.A.M.

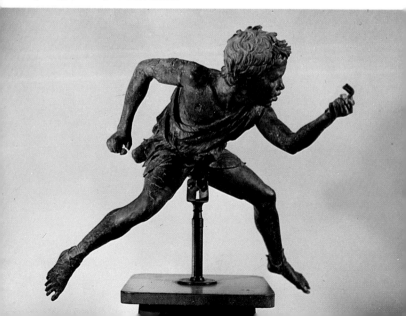

which he wrote have survived in full. The best known are the 'Persians', performed in 472 (after the Persian Wars) and the 'Oresteia' tetralogy of 458.

518 BC
Birth of the lyric poet Pindar near Thebes.

515–510 BC
The Olympieion, one of the largest temples of antiquity, was started but not completed. The Temple of Dionysos Eleuthereus was also built near the site of the present theatre of Dionysos.

c. 500 BC
Foundation of a school of philosophy in Elea, the first of many schools of this kind.

500 BC
From this point vases with figures on a white ground appear.

496 BC
Birth of Sophokles, the greatest tragedian of his time. He was also a politician and a general, and defeated Aiskhylos in an agon in 468.

484 BC
Birth of Kratinos, along with Aristophanes and Eupolis one of the most important comic writers of antiquity. He died in 419.

480 BC
Birth of Euripides, the third of the great tragic poets. His treatment of mythological material allows his heroes to show disillusionment, and this meant that his stage figures were able to demonstrate psychological insight. Women's roles also became more important.

480–330 BC
Classical period. The human being is the measure of all things (Protagoras), and is portrayed in all his natural beauty. Perfect harmony in architecture is also based on him. Doric, Ionic and finally Corinthian temples were built, marble and bronze statues were brought to perfection and the laws of classicism are also seen at work in the realm of crafts.

Bronze horse with jockey from Artemision, middle of the 2C BC, N.A.M.

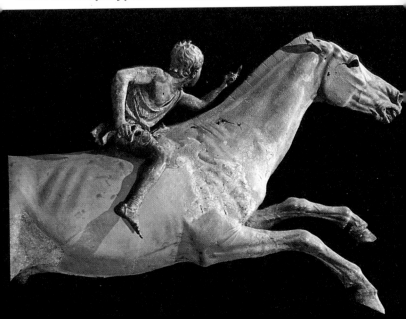

480–450 BC

Early classical style, in which the stiffness of late archaic design was overcome, but plainness and simplicity still predominate. Doric and Ionic temples with pediment decoration and metopes (Temple of Zeus in Olympia, 468–460), and also bronzes have survived.

479 BC

Rebuilding of the town began immediately after the Persian Wars, also the establishment of Piraeus as the port of Athens and the extension of the city walls by Themistokles.

476 BC

'The Phoenician Women' by the Athenian Phrynichos (pupil of Thespis), an important tragic poet before Aiskhylos, was performed.

475 BC

Like Themistokles, his successor Kimon was concerned with the rebuilding of the city. He commissioned the rebuilding of the Agora and in 475 had two walks and the Stoa Poikile ('Painted Hall') built. The reconstruction of the Acropolis wall was also his work. 'The Persians' of Aiskhylos was performed in the theatre of Dionysos in 471, Pindar wrote his odes and Polygnotus, Mikon and Panainos painted the Stoa Poikile, all in the reign of Kimon.

c. 470 BC

Birth of Sokrates, one of the greatest philosophers. He is considered to be the founder of anthropological philosophy. By the inductive method (causes the pupil to perform thought processes by means of carefully formulated questions) he enables perception of the general and leads from this to perception of the correct way in which to act. In 399 he was condemned to commit suicide for the introduction of new gods and seduction of youth. He was compelled to drink a cup of hemlock.

460 BC

Birth of the historian Thukydides in Athens.

c. 460 BC

Birth of the mathematician Hippocrates on Kos.

450–400 BC

High classical period, art flourished, particularly in Perikles' Athens. A high culture which has not been surpassed today (including mastery of perspective). High points in architecture and sculpture (often only surviving as Roman copies). Metopes and friezes on the temples, cult statues, grave stele, votive reliefs. So-called Rich Style in vase painting (Zeuxis, Agatharchos, Apollodorus, Parrhasios). Perikles had commissioned Pheidias to rebuild the Acropolis. The Age of Perikles has always been synonymous with the high point of Athenian culture, the first high European culture after Crete and for many the high point of culture anywhere. The Age of Perikles has also been called the 'Golden Age'. In external and internal politics, and above all in the realm of culture, Athens reached the absolute peak of her achievement between 461 and 429.

447–431 BC

Parthenon constructed by Pheidias, assisted by architects Iktinos and Kallikrates.

446 BC

Birth of the comic poet Eupolis.

445 BC

Birth of Aristophanes, the Athenian comic poet, who died here c. 385. 11 of his 40 plays have survived. The best-known include 'The Clouds' (423), 'The Wasps' (422), 'The Peace' (421), 'The Birds' (414), 'Lysistrata' (411) and 'The Frogs' (405).

Figure of Zeus from Artemision, 460 BC, N.A.M. ▷

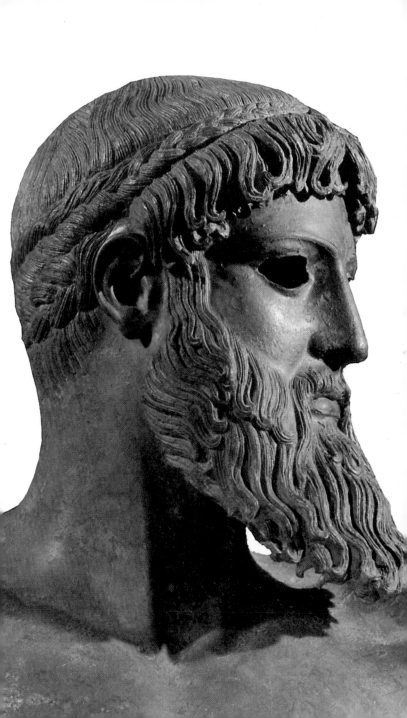

445 BC

Birth of Lysias, a famous Athenian orator, who also wrote rhetorical theory.

444–440 BC

Temple of Poseidon built on Cape Sounion.

438 BC

Dedication of the gold and ivory statue of Athena Parthenos by Pheidias. His Athena Promachos and other famous works date from just before this: Athena Lemnia, Aphrodite, Apollo, Zeus. Along with Polykletes of Argos (gold and ivory Hera for Argos, 423 BC, Doryphoros, c. 440) Pheidias was the most famous sculptor of the high classical period.

430 BC

While the plague, of which Perikles himself was to die, was raging in Athens, the historian and writer Xenophon, a pupil of Sokrates, was born.

428 BC

Birth of Plato (d. 349), a pupil of Sokrates. He described the conversations between the teacher and his pupils in his works, and so set down the teachings of Sokrates. He himself developed from the concepts laid down by Sokrates the theory of Platonic ideas. The perceived world participates in the ideas, often through recollection, but only corresponds very inadequately with the actual world, the world of the Ideas. Among the writings of Plato, which are concerned with science and contemporary history, politics and law, as well as philosophy, the most important are the 'Apologia', 'Kriton', 'Symposium', 'Phaidon', 'Politeia' and the 'Laws'.

427–424 BC

Temple of Athena Nike built on the Acropolis.

421–405 BC

Erechtheion built.

421 BC

Dedication of the Hephaistion. Building of the Erechtheion continued. A new temple appeared in the Dionysos precinct, and in 420 the Asklepios and Hygieia shrine was constructed on the S. slope of the fortress. Comedy reached its high point in Aristophanes, and philosophy with Sokrates and Plato, and later with Aristotle. The 4C was also the century of the great orators, Isokrates, Lysias, Isaios and Aischines were followed by Demosthenes. Sculpture enjoyed a second heyday with Kephisodotes and his son Praxiteles, Leochares, Skopas and Euphranor. Painting flourished under Pamphilos and Parrhasios.

420 BC

Sophokles introduces the Asklepios cult in Athens.

400 BC

From this date the artistic quality of the vases left much to be desired. They were either mannered and heavy, or tried to imitate metal vessels.

400–330 BC

Late classical style. Art becomes more individual and refined. Large temples, theatres and mausoleums were built. Famous sculptors: Kephisodotes, Praxiteles, Skopas, Leochares and Lysippus. Painters: Apelles, Nikias and Philoxenos (creator of a lost painted panel from which the Alexander mosaic was copied). There were also smaller artefacts, such as terracotta work which served for votive gifts, as jewellery or as toys (Athens was the centre of pottery), or bronze objects of all kinds, metal vessels, gold and silver jewellery, gems and rings.

384 BC

Birth of the orator Demosthenes, who opposed Philip of Macedon in his

Horse, 490 BC, Acropolis Museum ▷

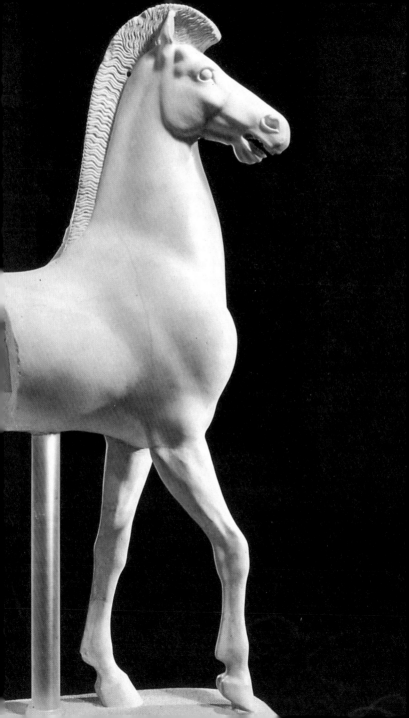

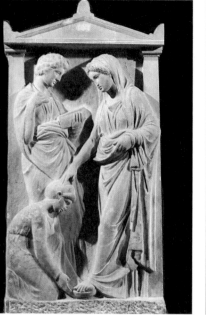 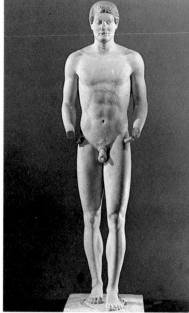

Stela of Ameinokleia, 4C BC (L.); funerary figure of Aristodikos (R.), N.A.M.

speeches (First Philippic, 349) and was later condemned to death by suicide.

384 BC

Birth of Aristotle in Stageira. Aristotle embraced all the learning of his time. He made individual philosophical disciplines autonomous, and founded new branches of knowledge. By analytical thought, empirical method and speculative construction he brought philosophy to a peak of achievement and laid the foundations for the whole of the later history of philosophy. He was the founder of the classical philosophical tradition of the West. From 368 he lived in Athens. In 342 he was called to the Macedonian court, where he became tutor to the thirteen-year-old Alexander (later the Great). In 335 he returned to Athens and taught in the 'Lykeion', the gymnasium named after Apollo Lyk-eios. His own school 'Peripatos' was a later foundation.

350–100 BC

Hellenistic period. As Athens gradually lost her superior position, particularly in relation to Macedonia (the Athenians had been defeated by the Macedonians at Chaironeia in 338, Alexander the Great came to power in 336), Hellenism had been a dominant force in Greece since *c.* 350 BC. The distinguishing features of the style were realistic, life-like features, related to the drama of the baroque. In architecture the Corinthian style began to assert itself. Large fortresses, cities and markets were built, baths, gymnasia and libraries. The artistic centres were Priene, Pergamon, Rhodes, Alexandria and Ephesus.

343 BC

Birth of Menander in Athens. He

wrote at least 105 comedies and performed them successfully (some have survived in versions by Terence). Menander died in Athens *c.* 290.

341 BC
Birth of the philosopher Epicurus of Samos, who was the founder of Epicureanism, and who taught the control of desires and sensibilities through understanding, and fearlessness in the face of the gods and death. He died in 271.

335&334 BC
The monument to the choregos (leader of the chorus and director of the play) Lysikrates was set up; it still stands in the Plaka.

333 BC
Birth of the philosopher Zenon in Kition (Cyprus). He founded the older stoa in Athens in 301, which saw the purpose of life to be in renouncing actions based on emotion, false judgements and the striving after possessions, and attempting to live in harmony with oneself and nature.

322 BC
Athens occupied by the Macedonians, but Alexander was responsive to Athenian culture. He had already had the monument to the Tyrannicides (by Antenor), which the Persians had removed, brought back to Athens.

321 BC
Demetrius of Phaleron's luxury law forbade the excessively splendid tombs at the Dipylon.

320 BC
Birth of Aristarchus of Samos, who taught that the sun is the centre of the world (Earth revolves around the sun) and that the Earth turns on its axis.

319 BC
Monument to the choregos (chorus

Kittylos and Dermys, 6C BC,
N.A.M. ▷

leader and director of the play) Nikias in Athens.

c. 310 BC
Birth of the poet Theokritus in Syracuse.

301 BC
Zenon founded the stoa.

300 BC
Friendship with Egypt brings the cult of Sarapis to Athens.

287 BC
Birth of Archimedes of Syracuse, the most important Greek mathematician and physicist.

197 BC
Eumenes II (197–159) and Attalos II (159–138), Kings of Pergamon, appeared in Athens as patrons of building.

175 BC
Antiochos IV, Epiphanes of Syria, commissioned the Roman architect Cossutius to restart work on the Olympieion, which had remained incomplete since the time of Peisistratos. It was still not completed, however, and Sulla later had columns from the temple taken to Rome.

168 BC
The Romans defeated the Macedonians at Pydna and at the same time raised Athens to the status of 'libera civitas'. The Kings of Pergamon also offered protection to Athens. They even ordered continuation of work on the Olympieion, but the independent culture was at an end.

86 BC
Athens overrun and destroyed by the Roman general Sulla. From this time Athens lost her political importance, but the city continued to be of cultural significance for the Romans. Roman art, Roman philosophy, and Roman religion developed under the influence of Athens. Gifts from

Rome, but also from Asia Minor and Syria made good the damage done by Sulla. But even at that time Athens was living, as it does today, on the memory of the Age of Perikles and on the admiration which it attracted for what had survived from this period.

27 BC
Greece became a province of Rome.

Around the time of the Birth of Christ
At the time of Emperor Augustus the classicism adapted by the Romans from the Greeks prevailed. Athens had lost its political importance; it became a free city allied with Rome and even then was a significant city for its university and for travellers. The Roman Emperor Augustus had a new Agora built by the Tower of the Winds and later Agrippa endowed a large theatre for the old Agora. A round Temple of Augustus and Rome was built on the Acropolis. The deification of the Emperors of Rome was now also a fact in Athens.

AD 25
Birth of the philosopher Epictetus, who lived for a long time in Rome.

49
Visit of the Apostle Paul to Athens. From this time the number of Christians in the town slowly but steadily increased.

124
The Emperor Hadrian visited Athens three times between AD 124 and 131. Hadrian was a patron of the arts; he extended the city E. of the Gate of Hadrian by a quarter of its total area.

161
c. AD 150 the Rhetor Tiberius Claudius Herodes Atticus of Marathon appeared as a patron of Athens. He equipped the Panathenaic stadium,

Kouros from Antikythera, 340 BC, N.A.M. ▷

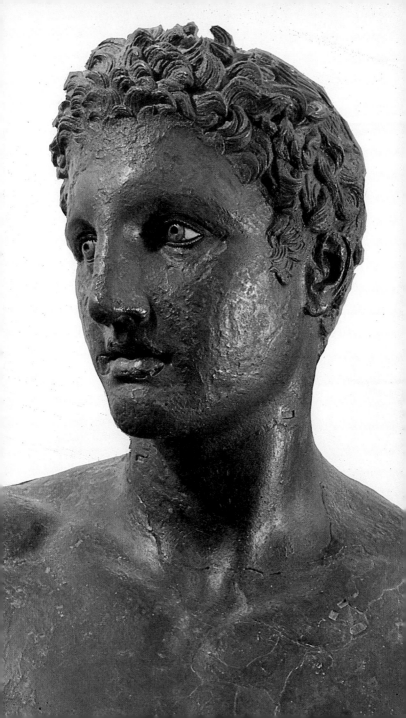

and built a Temple of Tyche and a theatre on the SE slope of the Acropolis (after 161), in which performances can again be seen today.

Early 2C
Under the Emperor Trajan the tomb of the Commagene Prince Antiochos Philopappos was built in Athens; he was a great patron of the city under this emperor.

2&3C
In this period the Egyptian city of Alexandria, founded by Alexander the Great, took over the leading role. The astronomer Ptolemy, the travel writer Pausanias, the author Lucian and finally in the 3C the philosopher Plotinus expanded the ancient world picture.

Early 3C
Thessaloniki became the capital of the Eastern Empire, thus further reducing the importance of Athens.

330
Under the Emperor Constantine the Great (306–37) works of art were taken from Athens to Constantinople, which in 330 became the capital of the Byzantine empire.

391
Destruction of the Serapion in Alexandria.

393
Last Olympic Games. The Panathenaia continued to be held.

396
Alaric arrived with his troops before the gates of Athens, but was so impressed by the Athena Promachos that he withdrew without attacking the city.

400
The Agora was built on the ruins (destroyed by the Heruli in 267) of a large gymnasium, seat of the philosophers' school.

Early 5C
Under Theodosius II (AD 408–50) statues from the Temple of Ares, a

Red figure vase, 430 BC, N.A.M.

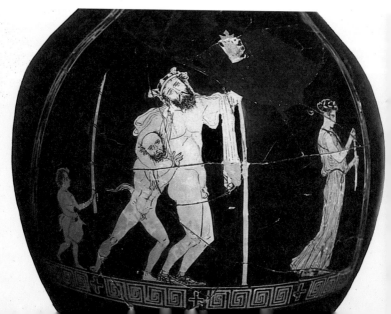

monolithic column and even the Athena Parthenos were taken to Constantinople.

529

Under the Emperor Justinian the Themistoklean wall was once again rebuilt. Justinian closed the university of Athens. Greek works of art were also removed from Athens under this Emperor, including the Athena Promachos, which was still standing in Constantinople in the 9C. Increasing numbers of buildings dedicated to the ancient gods were christianized. The Parthenon was first dedicated to Hagia Sophia, later to the Panagia. The Erechtheion became a chapel and the Temple of Hephaistos a church.

733

Athens detached itself from the Church of Rome and accepted that of Constantinople.

857

Athens became the seat of an archbishop. The Parthenon became a cathedral. From the 11C more and more churches and monasteries were built in Athens and Attica.

1204

French Crusaders conquered Athens.

1204

The Archbishop of Athens lost the Acropolis to the Frank Boniface of Montferrat, who was King of Macedonia and Thessaly.

1387

Athens conquered by the Florentines. The dukes of Florence established their palace in the Propylaia of the fortress and building began on the Acropolis again.

1456

Three years after the fall of Constantinople Athens was conquered by the Turks under Muhammad II; the Turks were to rule here well into the 19C, with the exception of Venetian attempts at conquest in 1466 and 1687. The Parthenon, having served as a cathedral, now became a mosque. The Turkish commander lived in the

Decoration on the inside of a bowl, c. 500 BC, Agora Museum

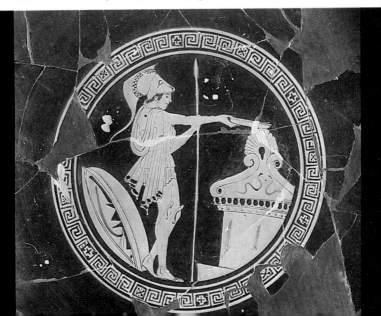

Propylaia, and his harem was housed in the Erechtheion.

1645
The buildings on the Acropolis were badly damaged by 2 accidents in the 16C, and in 1645 lighting struck a powder magazine in the Propylaia, damaging the whole of the upper part of the building.

1687
The Parthenon was destroyed by the explosion of a powder magazine. Collectors damaged individual works of art, or took them away, and Athens continued to decrease in importance. 2 of the Turkish mosques have survived, without their minarets: Syntrivani in the Monastiraki Square and Fetjeli Tsami by the Tower of the Winds.

1691
Olympieion and Propylaia damaged by earthquakes.

1802&3
Lord Elgin acquired the Parthenon frieze and placed it in the British Museum in 1812.

1832
Otto of Bavaria became King of Greece. In 1834 he made Athens the capital of the new kingdom. The population of the city grew once more. Otto was only interested in ancient Athens, and had many medieval and later buildings pulled down. K.F. Schinkel was to build a new royal palace on the Acropolis, but the archaeologists won the fight to protect the ancient ruins. Finally a town plan by Klenze was accepted as the basis for future building in 1834.

1834–8
Old Royal Palace (now Parliament) built by F. von Gärtner.

Acropolis, Odeion of Herodes Atticus (bottom L.) and Stoa of Eumenes (bottom R.) ▷

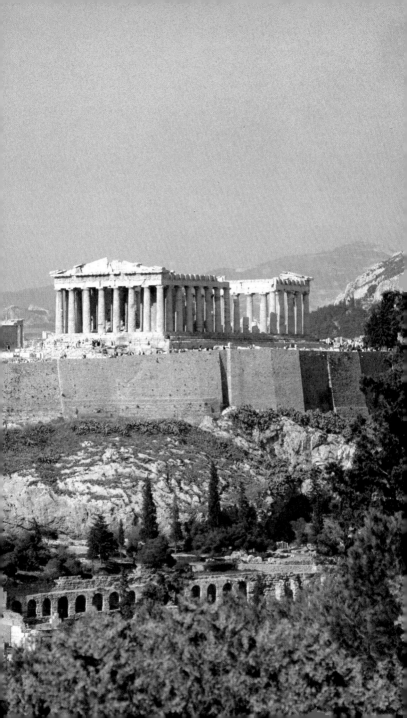

1863

Bavarian Wittelsbach kings replaced by the Glücksburg line under King George I. The Danes C. and T.Hansen took over from the German architects and continued to build in the neoclassical style. C. Hansen was responsible for the plans for the university, built 1839–49, T.Hansen designed the Academy, built 1885–91. The neo-Renaissance and neo-baroque styles also found favour. Athens was once more the spiritual, artistic and political centre of Greece. Research into antiquity, but also the economic success of the city itself, led to a rapid increase in the population.

20C

Despite all the political confusion nothing could stop Athens' rapid development as a modern metropolis. Athens is now dominated by skyscrapers and the motor car. The principal cultural attraction is still the buildings of antiquity, the excavation sites of the Agora and those at the Ilissos and the Dipylon, and still, above all, the Acropolis.

ACROPOLIS

Masses of human beings pour off buses or climb out of the countless cheap taxis under the burning midday sun to drag themselves in queues up to the Acropolis. The Acropolis ('peak of the city') is still the chief attraction in Athens. The limestone rock on which it stands is 511 ft. high, 885 ft. long and over 511 ft. wide.

Owners of refreshment stalls or individual traders with brochures and books offer their wares vociferously and often pushily. It is worth buying a panoramic map, showing the Acropolis with S. slope, N. slope and Agora, and all the buildings in a clear and vivid fashion. As you climb over the dusty slabs of stone, with only barren, dust-laden broom, crippled pines and cypresses, thorn bushes and occasional olives on either side, it is immediately clear that Athens is in one of the areas of Europe most short of rain. It hardly rains at all. Sometimes strong winds blow over the land, and sweep the old columns and walls clear of dust. If you are afraid

Parthenon

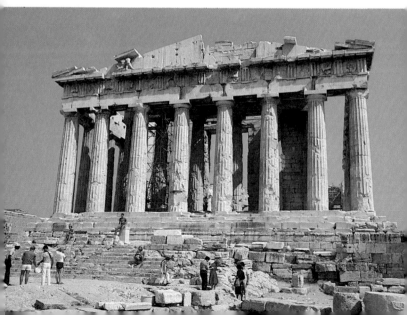

that the violence of these gusts of wind might topple the towering columns, just remember that they have defied the storms of almost 2,500 years. Usually though the air is clear and the sky is dazzling blue behind the whiteness of the Parthenon. This whiteness, which we now consider one of the hallmarks of ancient buildings, is pure deception. The buildings were originally coloured, indeed as far as we can ascertain, brightly painted. The view from the western side is dominated by the Acropolis rock with its rugged cliffs rising above the plain. It was the ideal site, first for a fortified castle and later for the temples of the gods. The Acropolis was apparently settled as early as 3000 BC. Round about 1500 BC this high settlement was surrounded with a rampart, with a main gate opening to the W. In the NE of this rampart a gate led through a tower and gave access to the castle within the walls. W. of the Acropolis by the Klepsydra spring Mycenean dwellings have been excavated.

Towards the end of the 13C the so-called Cyclopean Wall (also known as Pelasgikon or Pelargikon) was built to replace the old ramparts (remains of this can be seen S. of the Parthenon). Instead of the NE gate underground steps were built on the N. side.

Under Peisistratos and his sons the W. entrance to the Cyclopean wall was replaced with a propylon. In 510 the Delphic oracle announced that the Cyclopean Wall was a source of misfortune, and so much of it was pulled down.

When the Persians attacked in 480 the shrines on the Acropolis were destroyed. Later Themistokles rebuilt the rampart to the W. and N., incorporating some of the ruins of the earlier buildings. Subsequently Kimon enlarged the Acropolis plateau to the S. and built the E. and S. ramparts. Again ruins of the earlier buildings, the so-called 'Persian rubble', were incorporated.

Finally under Perikles the buildings which are still famous today were added: the Parthenon, the Propylaia,

Acropolis (after J.Travlos): The numbers in this diagram are referred to in the text.

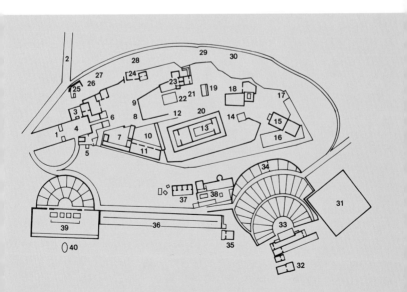

The Panathenaia
This great festival in honour of Athena, patron goddess of the city, is said to have taken place on July 28, thought to be the birthday of the goddess. Erichthonios, the snake-like son of Hephaistos and Athena, one of the legendary kings of the city, is said to have been the first to set up the wooden cult statue of the goddess and thus to introduce the Panathenaia. Another version suggests that Theseus was the originator of the festival. Panathenaia means the all-embracing festival of Athena. There was a Great and a Lesser Panathenaia. The Lesser Panathenaia took place annually, the Great Panathenaia only every fourth year. From the time of Peisistratos (new foundation 566 BC) and Perikles onwards the Great Panathenaia was celebrated with especial ceremony. Theatrical and sporting competitions were held. The victors received Panathenaic prize amphorae, large clay vessels with two handles filled with oil, with a portrait of Athena on one side and a picture of the competition on the other. The actual festival began with youths and girls dancing on the Acropolis. On the next day came the great procession, in which the sacrificial animals, bulls and sheep, were led up the Panathenaic Way to the temple of the goddess. They were followed by maidens with sacrificial vessels, metics with sacrificial gifts and musicians and old men with olive branches. In the middle of the procession came the magnificent peplos, the mantle of the goddess, drawn on a cart, and woven for months in advance by maidens in a special workshop. The high point of the celebrations was the dressing of the statue of Athene in the new and magnificently-coloured peplos.

the Temple of Athena Nike and the Erechtheion.

During the Roman period respect for these works of classical architecture guaranteed their survival. Under the Turks the ancient buildings suffered from explosions of gunpowder, particularly the Parthenon in 1687.

In the 19&20C the influence of neo-classicism and increasing archaeological expertise made it possible to begin to restore the Acropolis to its original condition. In our day the ancient buildings are threatened with being destroyed once and for all by vibration from the ever-increasing streams of visitors, by the effect of aircraft and by exhaust gases. For this reason UNESCO has launched a 15 million dollar programme to rescue the Acropolis. Protected zones are being closed to visitors. Protective floors, ceilings and scaffoldings are being installed. Aircraft are now forbidden to fly over the Acropolis and tourists are obliged to respect the regulations governing a visit to the site.

1. Beulé gate: One of the means of access to the antiquities of the Acropolis is the so-called Beulé gate on the S. slope. It was built in AD 267 from the ruins of earlier buildings after the raid by the Heruli. It was surrounded by a wall under the Turks. In 1853 Ernest Beulé removed this wall and so discovered the gate, which originally served as a bastion before the Propylaia.

2. The Panathenaia: Panathenaic Way. The remains of the walls with diagonal ramps which originally sup-

Temple of Athena Nike on a spur in the SW part of the Acropolis, on the platform known as the Pyrgos ▷

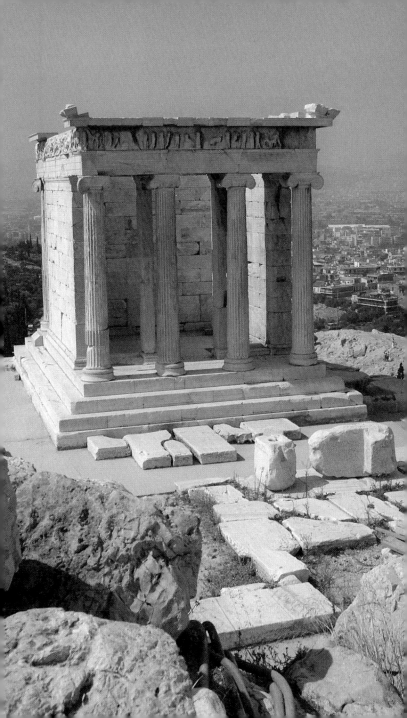

ported the Panathenaic Way can still be seen today. The great Panathenaic procession to the Temple of Athene on the Acropolis started in the Agora. The Panathenaic Way was built specifically for this purpose, when the old paths became too narrow for the numerous participants in the festival. The present Way winds out to the Propylaia, leading first to the Temple of Athena Nike.

3. Agrippa monument: Opposite the Temple of Nike the Hymettos marble base of the monument to Agrippa was discovered on the left-hand side; it was built in the 2C BC. The platform was erected by Mnesikles in the 5C BC.

4. Steps: In the 1C AD a monumental staircase led to the Propylaia. These steps started before the Beulé gate and were removed in the 19C.

5. Temple of Athena Nike: On the right is the perfectly proportioned Temple of Athena Nike, set on a spur at the S. end of the Acropolis, the so-called Pyrgos, in front of the S. section of the Propylaia. The Ionic columns and the frieze with its rich relief are particularly fine. The reliefs on the E. and S. façades have been replaced. The other sections of the frieze are in the British Museum in London and have been replaced with copies. The E. frieze depicts a meeting of the gods on Mount Olympus. Originally the temple was lavishly painted with floral patterns. The entire temple was pulled down by the Turks and used in various other buildings, but was restored to its original condition in 1835. In 1935 and 1939 the individual sections were restored and it was once more rebuilt. Below the present Temple of Nike there must have been a temple to Ath-

Temple of Athena Nike

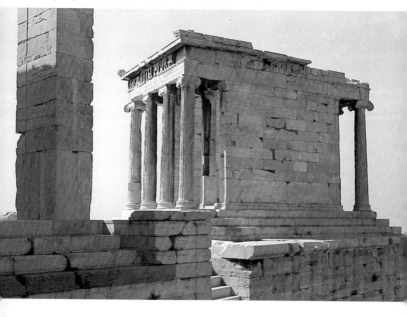

ena Nike, the Athenian goddess of victory, as early as 550 BC; it was destroyed by the Persians in 480. Traces of the old altar can be seen on the paving of the cella. The present Temple of Nike was begun in Pentelic marble from 447 BC by the architect Kallikrates; it was completed *c.* 427. In 425 or 421 the wooden cult statue of Athena Nike was consecrated. According to an old description the goddess held a pomegranate in her right hand (the symbol of fertility) and her helmet in her left hand. The wings of this Athena Nike had been removed, as if to compel her to remain. A marble balustrade was built around the temple *c.* 410 BC; this is to be found in the Acropolis Museum.

6. Propylaia: The way now leads directly to the famous Propylaia. Propylon means vestibule, entrance to the temple. The original Mycenean gate before the shrine of Athena was a propylon. It is assumed that a new propylon was built in the 6C BC on the occasion of the Panathenaia. Another new building was erected from 490, and destroyed by the Persians in 480. So the architect Mnesikles was given the task of building yet another new propylon. He hit on the notion of the Propylaia, monumental entrances leading to the Parthenon. In 437 he started the building which was to become the pride of Greece. In the late 4C the Theban general Epaminondas said that his countrymen would never break the self-confidence of the Athenians unless they stole the Propylaia and set it before their own fortress walls. Although the Propylaia seem perfectly harmonious, they are in fact slightly uneven. The S. section is restricted by the Athena Nike temple and the Pyrgos hill, and thus much narrower than the N. section.

Nike
Nike is victory personified, a goddess usually associated with another deity, hence Athena Nike. Nike is usually portrayed winged, with a long robe, wreath, headband, twig or shield and helmet. There are also representations of more than one figure of Nike at a time, as on the balustrade of the Temple of Nike. Portraits of Nike in action appear on coins and vases. The most famous sculptures were by Phidias: the Nike with Athena Parthenos and the Nike with his Zeus in Olympia. Paionios of Mende created a flying nymph at Olympia. Later, in the Hellenic period, she was often portrayed in flight, as for example on the great frieze at Pergamon. In Roman art Nike became Victoria, and in later Christian art she was often taken as the model for representations of angels.

Monument to Agrippa

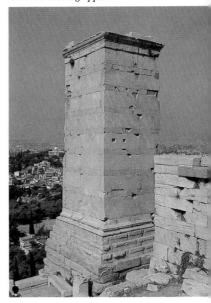

Aigeus

It is from the platform on which the Temple of Nike now stands that Aigeus is said to have thrown himself into the depths when he saw his son Theseus' ship sailing home with black sails.

When Aigeus was King of Athens Minos was the ruler of Crete. Legend has it that Androgeos, the son of Minos, had been cunningly murdered in Attica. For this reason Minos had declared war on Attica, and the gods had punished it by unleashing drought and plague. The Athenians begged the oracle of Apollo for mercy, and he announced that they should ask Minos for peace. Minos would only grant peace on the condition that every nine years seven youths and seven maidens were sent to Crete. On the island lived, in an impenetrable labyrinth, the stepson of Minos, the Minotaur, a monster, half man, half bull. The young Athenians were sacrificed to this Minotaur, who killed them mercilessly. Minos had demanded his sacrifice for the third time, and on this occasion Theseus, the son of Aigeus, had volunteered to accompany the unhappy youths and maidens, who were chosen by lot, to Crete. Aigeus was afraid for Theseus, and Theseus promised him that he would set white sails, should he return. If he were to be killed, his sailors would return under black sails.

In Crete Ariadne, the daughter of Minos, fell in love with Theseus and gave him a hank of yarn to take with him into the labyrinth. Theseus slew the Minotaur and found the way back out of the labyrinth for himself and the youths and maidens with the assistance of the hank of yarn. He sailed for home with Ariadne. On the way they anchored at the island of Naxos, and there the god Dionysos told Theseus that he had long before chosen Ariadne for himself, and carried her away. In mourning for his lost beloved, Theseus forgot to hoist the white sails, and so the ship returned to Athens with black sails. Aigeus, who was watching from afar, threw himself into the sea from the Acropolis in grief for his lost son. From that time the sea between the Balkan peninsula and Asia Minor, down as far as Crete, has been known as the Aegean.

The overall effect of this building, enormous for a gate, is decidedly majestic. It was the largest and most beautiful of its time. A wall pierced by five doorways, originally with wooden doors, was built in Pentelic marble. The largest is the central opening, through which the Panathenaic procession passed with priests and sacrificial beasts. It is higher, and the bay of columns is one metope wider, than the entrances on either side. The two outer entrances are narrower still. Unusually high steps lead in a double flight through the doors to the precinct of the temple. The steps in the largest entrance are shallow, for the sacrificial beasts. They have been cased in wood (because of the countless visitors) since 1970. To the W. there is a vestibule; its façade has six Doric columns, which originally supported the pediment. The way to the main gate is lined with 3 Ionic columns on either side. The W. vestibule is of monumental proportions: almost 60 ft. wide and over 40 ft. deep. It originally had a marble coffered ceiling, with blue panels decorated in gold. To the E. is a further vestibule, much less high and deep, but also with a façade with 6 Doric columns.

Buildings were added to the left and right of the W. vestibule; the S. build-

ing has only one room and is smaller, the N. leads through an ante-room into the Pinakotheke. In the 2C AD Pausanias, in his guide to Greece (I,22,6), told us that numerous pictures could be seen here, presumably painted on wooden panels, some of which had Homeric motifs. The pictures have since been lost. It seems that the Pinakotheke was originally a resting place, where the pilgrims could sleep on couches.

In and around the Propylaia there were originally numerous places of worship. Pausanias tells of two equestrian statues in the W. vestibule. Outside the Propylaia were Hermes Propylaios, the Charites and a Hektaion. In front of the S. side of the E. vestibule the round base of the bronze Athena Hygieia has survived, also ruins of a sacrificial table and a marble altar.

History of the Propylaia: The Propylaia was so admired that it survived in its original state until the 12C AD. Although a bishop lived there from the 12C, it changed very little in the 13C. The dukes of Athens raised the

> *The bear goddess*
> Artemis Brauronia means 'bear goddess'. Her cult comes from Brauron, the birthplace of Peisitratos. The shrine was presumably built under Kimon, and later altered while the Propylaia were being built. Pregnant women offered jewellery to this Artemis after a successful delivery, and it was stored here. It is assumed that the Trojan horse cast in bronze in the late 5C and mentioned by Pausanias once stood in the shrine proper. The base with holes for the horse's feet has survived.

N. section. Finally the Florentine Nerio Acciaioli built a palace in the Propylaia for himself and his mistress and added a tower above the S. section. Their illegitimate son ruled Athens in peace for thirty years.

Turkish rule began in 1458, and the Turkish commander moved into the Propylaia palace. The central vestibule was covered with a dome, and an

On the Acropolis

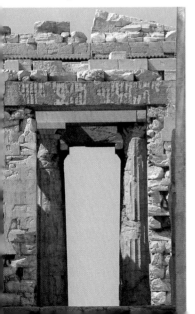

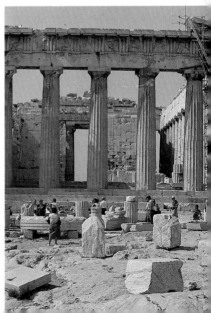

armoury and powder store was established.

In 1645 the powder magazine in the Propylaia was struck by lightning, destroying the building and killing the commander at the time, Isouf Agha and his family. Later the powder magazine was transferred to the Parthenon, and exploded there in 1687.

In 1833, when Otto I of Bavaria entered Athens, the Acropolis had to be cleared up. It was not possible to start restoring the Propylaia in stages until 1909. Important figures involved were N.Balanos and A.Orlandos. It is strange that the buildings on the Acropolis, originally brightly painted, have lost all their paint and in their whiteness give us a false impression of antiquity's passion for colour.

7. Artemis Brauronia: Between the Propylaia, the Parthenon and the Chalkothek was the shrine of Artemis Brauronia, above a trapezoid area. Today only the boundary wall in the rock survives, in places up to three feet high. There are also steps cut in the rock, which led to the former entrance. The hollows in which the steles stood can still be made out at the foot of the wall.

8. Bronze Quadriga: Opposite the entrance to the shrine of Artemis Brauronia there used to stand a bronze quadriga erected by the Athenians in 506 after their victories over the Boeotians and the Chalcidians. The base has survived.

9. Athena Promachos: About 40 yards further to the NW, almost directly in front of the entrance to the Propylaia, the square base, all that now remains of Phidias' early statue of Athene Promachos ('champion'), is set in the rock; it was consecrated *c.* 454. Only fragments of the inscription remain; it read 'The Athenians built her with the Persian booty'. It is assumed that the statue was cast to celebrate the deflection of the Persian threat. Niketas Chomates, a Greek historian, described it *c.* AD 1200. The statue must have been enormous, almost 30 ft. high, and wore a helmet with a horsehair bush; she carried a shield in her left hand and a spear in her right. She was taken to Constantinople under Emperor Justinian in the 6C AD. In 1204, when the Crusaders attacked Constantinople, the inhabitants thought that Athene was inviting the Athenians into Constantinople with her outstretched hand, and smashed the statue to pieces.

10. Athene Ergane: By the base of the Parthenon, six feet above the Brauronium, was the shrine of Athena Ergane (Athena of the craftsmen). Steps led from here to the terrace of the Parthenon.

11. Chalkothek: Further S. by the Acropolis wall used to be a storehouse and arsenal, the so-called Chalkothek, built *c.* 450 BC; fragments of its foundations have survived. Weapons and bronze votive vessels were stored in it.

12. The Sacred Way: The Sacred Way used to lead from the Propylaia to the former Temple of Athene. Fragments of the road, which now runs N. of the Parthenon, have survived, including an inscription in the rock at a point dedicated to the goddess of the fertile earth (Gai Karpophoros; now behind a railing behind the seventh column of the Parthenon).

13. Parthenon: The site of the present Parthenon, the most famous building in Greece, must have been used for the worship of Athena long before the present temple was built.

a) A 7C or 6C early archaic temple is assumed to have existed.

b) A different building, the Hekatompedon, is associated with the inception of the Panatnenaia *c.* 560 BC. Hekatompedon means '100 ft.

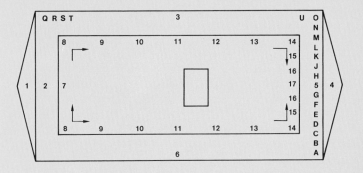

Parthenon, pediment, metopes and friezes

The sculptural decoration of the Parthenon is known throughout the world. The 92 Doric metopes (2,3,5,6) date from 447–440. They were carved by various artists in their own workshops and mounted on the temple (14 on the W. and one on the E. façade, 32 on each of the N. and S. façades). Only 40 of the original 92 metopes, all from the W. and E. sides, 13 from the N. and only one from the S., have survived, and some of these are badly damaged. 15 are in the British Museum in London, 1 in the Louvre in Paris and 3 in the Acropolis Museum. The 2 badly damaged metopes in the W. show the battle with the Amazons.

The Battle of the Giants is represented in the E. (5). From S. to N.: Hermes (A), Dionysos (B), Ares and giant (C), Athena (D),) Amphitride as charioteer (E), Poseidon slaying the giant Poly-botos (F), Hera driving Zeus' war chariot (G), Zeus (H), Apollo fighting (I), Artemis driving Apollo's war chariot (K), Herakles (L), Aphrodite fighting a giant (M), Hephaistos (N). Helios' sun chariot (O).

On the S. façade, which shows the Battle with the Centaurs, only one metope has survived, showing a centaur strangling a Greek (P). The N. metopes (3) show the battle for Troy. Depictions of meet-ings of the gods have survived (Q-S) and Selene with the beast, then scenes from the Trojan War and in the NE Helios' sun chariot.

Inside, the outer walls of the cella are decorated with Ionic friezes more than three feet high. They too now exist only as fragments. The majority of the original friezes are now in the British Museum in London and in the Acropolis Museum, with one in the Louvre in Paris. The friezes are pre-sumed to be later in date than the metopes and show the perspective introduced by Pheidias, who transferred his architectural experience to his sculpture. The frieze was again the work of many artists, but they were all directed by Pheidias. The whole frieze represents the Panathenaic procession, which passed from the gymnasium on the Dipylon across the Agora to the Acropolis every four years. The procession was preceded by maidens with sacrificial vessels (14), followed by sacrificial animals (bulls and sheep, 13), youths (12), musicians (11), old men with olive branches (10) and finally the magnificent woven peplos, drawn to the goddess Athena on a chariot. The people of Athens brought up the rear. The W. side of the outer wall of the cella shows preparations for the Panathenaic procession. Most of the horses have survived, and give a remarkable sense of movement. The festival procession is then shown on the S. and N. sides with riders (8), chariots (9), the whole sequence leading to the E. side, where the Panathenaic procession is received by an assembly of the gods, shown in happy conversation (16 and 17). The two pediments (1 and 4) on the Parthenon were clearly the last to be provided with marble sculptures, in 432 BC. All the evidence suggests that the designs are by Pheidias, but that several artists were involved in carrying them out. Perspective is again an important feature, and it is used here particularly to enhance the move-ment of the figures and their relationship to each other. Little has survived of the original sculpture on the pediments. Most of it is in the British Museum, the Louvre in Paris, the Vatican in Rome, and some pieces are in the Acropolis Museum and the National Museum in Athens. The sculptures remaining on the Parthenon have suffered heavily from weathering. Some parts, such as a horse's head and the recumbent figure on the E. pediment are copies. The W. pediment originally showed the battle between Athene and Poseidon, and the E. pediment (4) the birth of Athene from the head of her father Zeus.

building'. Some remains of this temple, removed in 488 to make room for the stereobate of a new temple, were found in the N. Acropolis wall E. of the present Parthenon. The Hekatompedon was built of poros, but the metopes and cornices were island marble; they and the poros pediment sculptures are now in the Acropolis Museum.

c) Another temple, on its own marble stereobate, was built on the site of the Hekatompedon in 488. When the Persians destroyed the Acropolis in 480 this temple with 6 by 16 columns was still under construction.

d) In 468, in the reign of Kimon, work started on the temple again. The stereobate was enlarged, using some fragments of the sculptures which had been destroyed; this was known as the 'Persian rubble'. Work ceased on the death of Kimon in 450 BC.

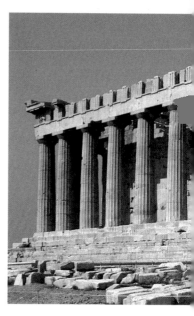

e) Finally, under Perikles, new building work began on the temple in 447 BC. The operation was supervized by Pheidias, assisted by the architects Iktinos and Kallikrates. The numerous figures on pediments, metopes and friezes were executed by the best sculptors in Athens. The building, one of the finest in the world, was completed in 9 years, by 431 BC. The building, a classical Doric temple, is in Pentelic marble, with a limestone stereobate.

The entire columned temple (peripteros) is surrounded by a peristyle 101 by 228 ft. The 8 by 17 columns are 34 ft. high. The proportions are monumental in the extreme, but the building is by no means oppressive, but powerful, majestic, lucid and, because of the relative slenderness of its columns, it gives the impression of being almost weightless.

The stroke of genius in the building is that the architects did not make the

Parthenon (above); Parthenon frieze (below) ▷

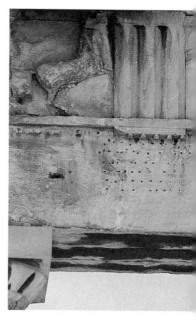

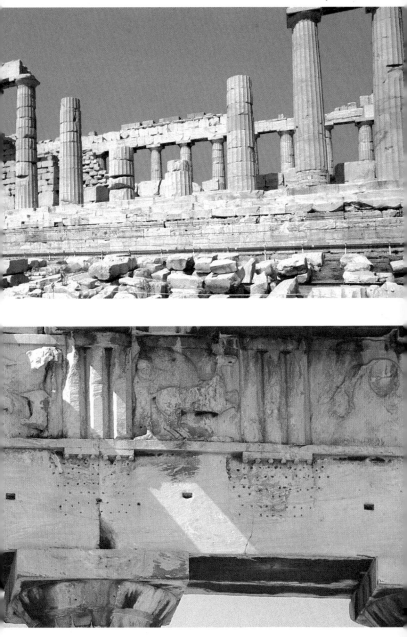

columns absolutely erect. Although they seem straight to the eye, they are inclined slightly inwards, which meant that the rest of the temple is extremely complex in construction; the angle of the columns helped to counteract the uneven nature of the floor and reduced the danger of destruction by earthquake. The drainage is excellent because the floor is raised slightly in the centre. Every part of the Parthenon is designed to defy the elements and to last.

Equally the building has been designed for the maximum visual effect, sometimes, as in the case of the columns, by means of optical illusion (the corner columns, which would have seemed smaller, are slightly larger in diameter); this technique was not to come into its own until the baroque period in theatrical architecture and painting. But above all the Parthenon is a temple of perfect balance and beauty.

In front of and behind the cella are vestibules with six columns (pronaos in the E. and opisthodomos in the W.). The cella, surrounded by solid walls and enormous for its time, yet entirely coherent because of the arrangement of its columns, is divided into an E. section with the cult statue of Athena Parthenos and the smaller W. room with 4 Ionic interior pillars, the actual Parthenon.

The marble decoration of the entire Parthenon was unbelievably lavish: 92 metopes representing among other things the Battle of the Centaurs, the Trojan War and the Battle of the Gods and the Giants; the pediments have reliefs of teams of horses. On the E. pediment the birth of Athena is portrayed, and on the W. pediment the battle between Athena and Poseidon. A relief frieze ran around the cella; this showed the Panathenaic procession in the presence of the gods.

The most striking difference between the original Parthenon and the

Detail of Parthenon frieze ▷

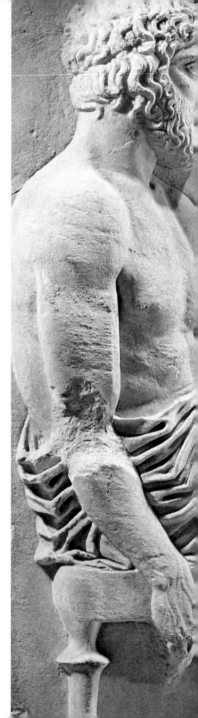

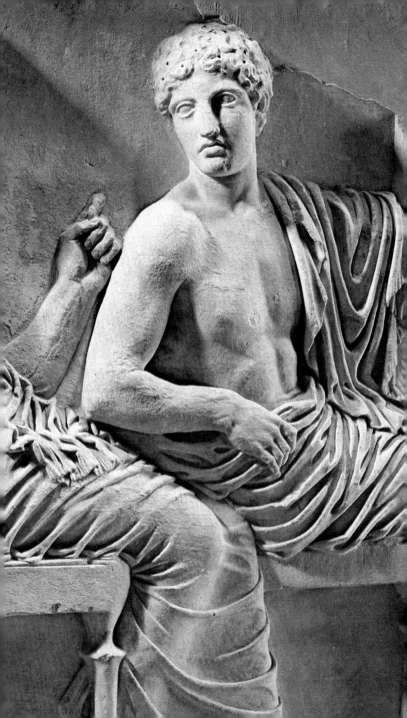

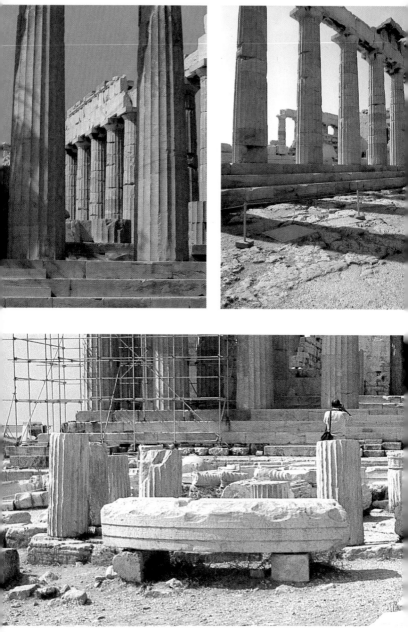

present building was that it was originally painted. The marble coffered ceiling of the cella was decorated with roses and leaves. Its interior walls were painted red. Bronze and gold were used for the decorations, and the temple itself (triglyphs, metopes, and presumably the columns and capitals as well) were painted, mainly in blue and red.

The point at which the Athena Parthenos stood in the cella of the Parthenon is still discernible on the floor as a slightly concave tufa slab. In the National Archaeological Museum (Room 20) is a small and certainly rather crude 3C AD copy of the statue, the so-called *Athena Varvakion*.

The history of the Parthenon is a chequered one. In the Hellenic period it was damaged by fire and rebuilt. The Athena Parthenos was given a new base at that time, and the columns of the cella were rebuilt. The Parthenon was respected as the temple of the goddess Athena until well into the Roman period. In 334 BC Alexander the Great presented 300 suits of Persian armour as a thanks offering for his victory at the river Granikos, and numerous other votive gifts were dedicated to the Parthenon. But belief in the old gods gradually declined. In 305 BC King Demetrios, who had himself worshipped as a demi-god, quartered his courtesans in the W. part of the temple and held wild feasts there. In 298 Lachares stole the gold decoration from the temple. In 39 BC the Roman general Antony celebrated a supposed marriage to Athena. Further desecration followed, until the cult statue of Athena Parthenos was finally taken away in AD 426. In 437 Theodosius II ordered the purification of the old temple and the abolition of idolatry. The Parthenon was dedicated to Holy Wisdom and became the church of Agia Sofia. In the course of these alterations the E.

Above: Details of the Parthenon.
Below: To the E. of the Parthenon, in front of the entrance

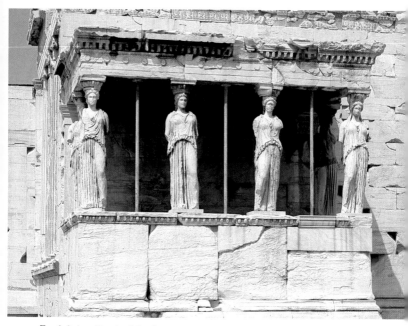

Erechtheion, Porch of the Caryatids

Athena Parthenos

The principal attraction in the Parthenon used to be the *Athena Parthenos*, made by Pheidias himself and said by some sources to have been almost 40 ft. high. Detailed descriptions by Pausanias, Pliny, Plutarch and Lucian have recorded what the statue looked like. It was made of gold and ivory, and apparently decorated with all the attributes of Athena known from legend and myth. This Athena was built with money from the treasury of the Attic-Delian League, and over 1,000 kilos of pure gold were used. Not all the allies approved of the Athenians' use of this money for works of art, and much of the gold had to be melted down again at a later date. Those jealous of Pheidias even spread the rumour that he had used some of the gold intended for the robe of Athena for his own purposes. The gold plates were taken off the statue and weighed, proving the innocence of Pheidias. But the Athena Parthenos was destined to be Pheidias' downfall: he had immortalized himself and Perikles in the form of small statues on the figure of Athena. This was considered to be sacrilege. Tradition has it that Pheidias was thrown into prison and finally died there. The statue itself remained undamaged until 295 BC, when the tyrant Lachares took away the golden cloak. In the first half of the 5C it was seen by the Greek historian Zosimus. In 426 it was taken away to Constantinople, and it is assumed that the

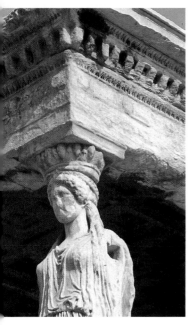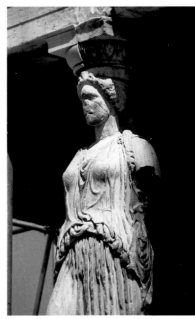

Erechtheion, Caryatids

figure was destroyed there. Our knowledge of the appearance of the statue comes above all from the descriptions of ancient authors. There is a very famous Roman copy of the statue of Athena, the Athena Varvakion, in the National Archaeological Museum.

pediment was destroyed by the building of an apse. In the 10C the Parthenon was dedicated to the Panagia Athiniotissa—it became a church of the Virgin Mary. At this time the interior walls were decorated with Christian wall paintings. In 1018 the Byzantine Emperor Basileios II presented to the Parthenon a golden dove which had long been worshipped and a gigantic decorated oil lamp. Under the Franks the Parthenon served as a Roman Catholic fortress church. After 1466 it became a mosque under the Turks, and a minaret was built in the SW corner.

The final catastrophe occurred on September 26 1687. A cannon ball fired in the course of an attack by the Venetian F.Morosini hit the Turks' powder magazine in the Parthenon. The magazine exploded and the temple was torn apart. Another mosque was built among the ruins. In 1799–1802 Lord Elgin appeared on the Acropolis. He removed to England a large number of statues, 56 of the sections of the frieze (including some of the finest) and 15 metopes. They are still on show as the 'Elgin Marbles' in the British Museum's antiquities section. From 1834 the

Parthenon was restored under L. von Klenze; important figures also involved were E.Beulé and N.Balanos, who rebuilt the N. row of columns in 1922.

14. Temple of Rome and Augustus: About 25 yards E. of the E. façade of the Parthenon are the almost square poros foundations of a Temple of Rome and Augustus, built between 27 and 14 BC, a circular temple in white marble. It was used for Roman emperor-worship and was the first building on the Acropolis since the Age of Perikles, in other words after a gap of almost 500 years. The open interior of the temple, surrounded only by pillars, was just over 25 ft. in diameter.

15. Ergasterion: To the SE of the Temple of Rome and Augustus are the remains of a rectangular building, the so-called Ergasterion, originally divided into two rooms. This is assumed to have been a workshop used by Pheidias and his fellow artists.

16. Acropolis Museum: The Acropolis Museum was built in 1878 across the foundations of the Ergasterion; its collections consist mainly of objects excavated from the 'Persian rubble'; it was extended in 1886, and rebuilt and reopened after the Second World War.

17. Belvedere: N. of the museum, at the NE corner of the Acropolis, is the Belvedere built over a Turkish tower by Queen Amalie, the wife of Otto I, in the 19C. It affords a splendid view of the city.

18. Zeus Polieus: Remains of a shrine presumably dedicated to Zeus Polieus were found between the Temple of Rome and Augustus and the N. Acropolis wall. W. of that, at the highest point of the Acropolis, are tufa foundations, the former temenos of Zeus Polieus, which contained the altar and a stable for the sacrificial animals. There was a great sacrificial ceremony here in honour of the beloved father of the gods every year in the summer.

Theatre of Dionysos, seat

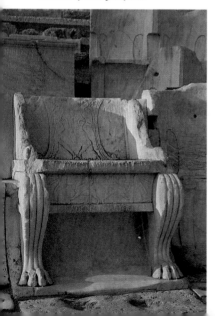

19. Altar of Athena: The enormous altar of Athena formerly stood between the shrine of Zeus-Polieus and the Erechtheion. Bulls were sacrificed to the goddess here.

20. Old Temple of Athena: The so-called Old Temple of Athena stood behind the Hekatompedon (see above) and later between the Parthenon and the Erechtheion. It was built c. 520 BC on the site of an older Temple of Athena from the geometric period, destroyed by the Persians in 480, partially rebuilt after that, then burned down in 406 and was not rebuilt, as the Parthenon and the Erechtheion now stood on the site. Some of the foundations are still visible.

Parts of the poros building were discovered. Fragments of sculpture (some painted) and pediment carving from the temple are now on display in the Acropolis Museum. Recent research suggests that the N. vestibule of the Erechtheion is identical with the entrance to the Old Temple of Athena.

21. Royal Palace: The castle was built on the site of the Temple of Athene, before the geometric temple, in the Mycenean period. It was connected with the Pelasgikon steps N. of the Acropolis wall. Pre-archaic ochre castle foundations in limestone, dating from the 15C BC, were found in the Erechtheion. Written tradition suggests that this castle was the palace of the kings of Athens. Kodros for example, who gave his life for the people, must have lived here.

22. Pandroseion: Pandrosos was one of the three daughters of Kekrops, whose tomb, the so-called Kekropion, is partially preserved under the S. portico of the Erechtheion. Pandrosos' shrine no longer exists, but was formerly linked to the Erechtheion by a small staircase. An altar of Zeus Herkaios was also discovered here. It is possible that the Pandroseion was the shrine of the goddess Pandrosos, who was worshipped from 2000 BC.

23. Erechtheion: An archaic Erechtheion in polychrome tufa was des-

Theatre of Dionysos

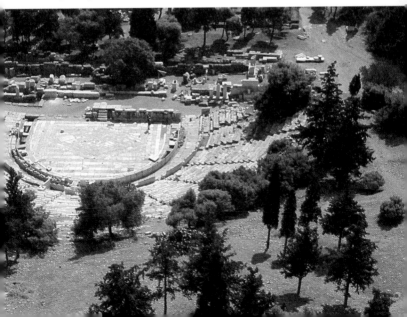

troyed by the Persians in 480. The present Erechtheion, alongside the Parthenon the principal building on the Acropolis, was built in marble between 421 and 406 under Perikles, largely by the architect Philokles. The outbreak of the Peloponnesian War interrupted work from 415–409. Together with the Parthenon, but in a quite different way, it is one of the most beautiful buildings of the classical Greek period, with its irregular polygonal ground plan, the slenderness of its pillars, the grace of the

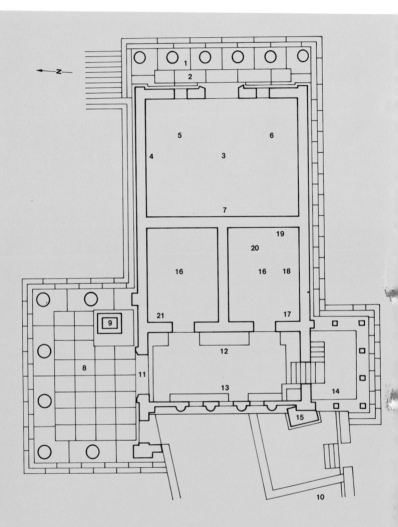

caryatids and its different levels (the foundations of the S. and E. walls are almost 10 ft. lower than those of the N. and W. walls). Where the Parthenon is striking in its strict articulation, massive design and overall harmony, the Erechtheion impresses with its complex and almost tender beauty, though it is possible that this complexity was a product of the fact that many shrines already existed and the architects of the new building did not wish to impair them, and so the uniquely charming solution which

Erechtheion (after J. Travlos) **1** Eastern portico with six Ionic columns on a stylobate of three marble steps. There are no sculptures on the pediment **2** Altar of Zeus Hypatos **3** Eastern cella **4** Thrones of the priests **5** Altar of Hephaistos **6** Altar of the hero Boutes **7** Altar of Poseidon and Erechtheus **8** North porch with coffered ceiling and six Ionic columns which lean inwards slightly. The floor contains marks which were probably caused by a stroke of lightning and were believed to have been left by Poseidon's trident or by a thunderbolt from Zeus **9** Altar of the Thyekhoos **10** There was a passage from the North Porch to the Pandroseion, which contained the sacred olive of Athena (there is an olive-tree there today) **11** Doorway famous for its precious Ionic decorations (parts of which are now copies) **12** This part of the Western cella is on a higher level **13** Hole through which the 'Sea of Erechtheus' could be observed. This was a well containing a spring of salt water which was supposed to have gushed when Poseidon hurled down his trident here in fury at his defeat in his contest with Athena **14** The Porch of the Caryatids, possibly built as a kind of canopy over the supposed tomb of Kekrops. This is one of the most beautiful pieces of architecture ever constructed, and incorporates

six caryatids, or statues of maidens larger than life-size, whose heads support the roof of the porch. They are wearing long tunics and standing in a charming pose, radiating an unbelievable peace, harmony, grace, and, with it all, solemnity. Some individual korai, dating almost without exception from the second half of the 6C and the beginning of the 5C BC, have been excavated in the area around the original hekatombon from the rubble left by the Persians when they destroyed the place. These were votive statues whose figurative purpose was to guard the temple; they were probably intended as a replacement for the servant-girls who guarded the shrines in earlier times. Various researchers have accepted that the caryatids in the Erechtheion are korai. Those in place today are copies; the original caryatids, whose faces have been eroded over the centuries by an environment which is now especially threatening, are housed in the Acropolis Museum **15** Tomb of Kekrops **16** Eastern Cella **17** Kallimakhos' lamp, containing the eternal flame, stood here **18** The booty captured during the Persian Wars was kept here **19** Adyton or megaron containing the cult image of Athena Polias **20** The cult image of Hermes was kept here **21** Site of the alleged tomb of Erechtheus or Erechthonios.

Theatre of Dionysos

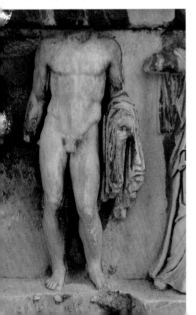

they found may be the result of the need to overcome these difficulties. From the E. the Erechtheion looks like an Ionic prostyle temple, but behind the façade it is seen to be a rectangle with porticoes on either side. The Erechtheion was named after the tomb of Erichthonios, but was originally called the 'Temple of Athena Polias' or 'Temple with the Old Statue'. The ancient cult statue of Athena, carved in olive wood, the Xoanon, is held by legend to have fallen from heaven, and was worshipped from 480 BC. The Panathenaic procession made pilgrimage to this statue, to dress it in a new peplos. Previously the Xoanon had stood in the Old Temple of Athene. In the year in which the Erechtheion was completed the Old Temple of Athene burned down. The Erechtheion was also damaged, and this damage was not made good until 394. It survived in its original form until the 7C AD, but was then turned into a church, and much modified in the process. In 1463 the Turkish commander of the time housed his harem in the Erechtheion. In 1801 Lord Elgin took away

Erichthonios:
According to legend Erichthonios was the son of Hephaistos and Athena (or Gaia, in another version). Athene is said to have placed the new-born Erichthonios, who had the form of a snake, in a covered basket. This she gave to the daughters of King Kekrops, and ordered that they were on no account to open the basket. Aglauros, Herse and Pandrosos, the daughters of Kekrops, could not control their curiosity and looked into the basket. They were all three so terrified by the sight of Erichthonios that they leaped from the Acropolis rock into the sea. Despite his snake-like form, or so the legend tells, Erichthonios became King of Athens. The Erechtheion is considered to be his tomb.

Theatre of Dionysos

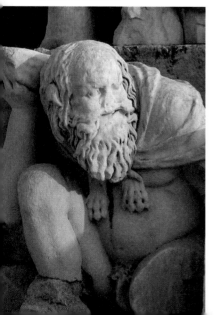

one of the caryatids, among other things; it was replaced with a copy. The Erechtheion also suffered in the Wars of Liberation. In 1838 work started on clearing the rubble away from the walls, in 1842–4 Paccard restored the Hall of the Caryatids, and in 1852 the façade was badly damaged by a storm. The Erechtheion was finally rebuilt by Balanos in in 1903&4. The caryatids were replaced with copies in the course of the restoration; the originals are in the Acropolis Museum.

24. House of the Arrephoroi: Between the Erechtheion and the Acropolis wall are remains of old shrines with tufa supporting walls and the ruins of a Turkish cistern. The ruins include the square foundations of a 5C BC building which was originally the home of the Arrephoroi; these were seven- to twelve-year-old girls from the best families in Athens, who assisted the priestess of Athena in the weaving of the peplos which

was offered to the goddess annually. 2 flights of steps led from the House of the Arrephoroi, one to an ancient underground grotto, and the other presumably to the Peripatos, the path which led round the Acropolis. Excavations are again in hand on this site.

ALONG THE PERIPATOS (25–40)

If you follow the Peripatos, which can also be reached from the exit to the Acropolis, in the NW, at the point at which the Panathenaic Way joins the Peripatos, you come across the

25. Clepsydra, the most important source of water in the fortress, which was in use in the Neolithic period. 22 little wells, connected with an underground spring, date from this period. A well house was built in 500 BC, and the water was gathered in a basin. Above the well house is a cave with carved rock steps, intended as seats.

26. Apollo Hypokraisos: A little further to the NE, to the right of the Peripatos, are the caves of Apollo Hypokraisos; Hypokraisos means 'among the caves'. There were

originally niches with votive tablets to Apollo let into the rock walls.

27. Caves of Pan: Next comes a cave worshipped as the shrine of Zeus Olympios, and finally the Cave of Pan. The cult of Pan was not introduced in Athens until after the Battle of Marathon. It is clear from the walls where the votive gifts were placed.

28. Cave of Aglauros: Further to the E., diagonally under the House of the Arrephoroi, with which it was connected by a secret passage, is the Cave of Aglauros. It was not rediscovered until 1937.

29. Shrine of Eros and Aphrodite: About 100 yards further E., on a little rocky plateau, was the shrine of the two gods, also called 'the Shrine of Aphrodite in the Garden'. In Pausanias (I,27,3) we read of two Arrephoroi who lived by the Old Temple of Athena, and who had to carry sacred objects on their heads along the underground passage.

30. Inscription: There is a Peripatos

View of the Acropolis from the Theatre of Dionysos

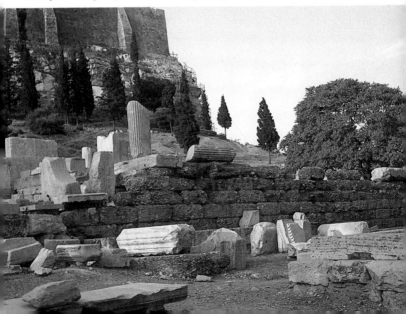

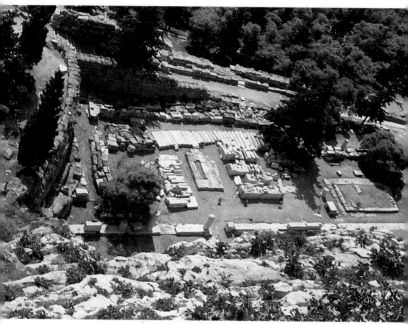

Excavations next to the Theatre of Dionysos

inscription a little further E. by the side of the path. The Peripatos, with many cult caves above it, now leads round the E. slope of the Acropolis and finally to the S. side.

31. Odeion of Perikles: Here to the SE of the Acropolis and about 25 yards S. of the Peripatos was the Odeion of Perikles. It was built under Perikles in 442 BC as the first covered concert hall and as a rehearsal room for performances in the Theatre of Dionysos, and was for a long time considered to be the most beautiful concert hall in the world. Very few of the once lavish furnishings have been excavated. In 86 BC the Odeion was set on fire by the Athenians themselves in the face of Sulla's approaching troops. In about 60 BC the gigantic columned hall (90 columns) was rebuilt on a square ground plan with a pyramid roof. In the Middle Ages

the ruins of the Odeion of Perikles were used for the fortification of the Rizocastro wall of the Acropolis.

32. Temple of Dionysos: The Peri-

> *Dionysos*
> Dionysos, the son of Zeus and Semele, is a god of vegetation, a god of intoxication, of ecstasy, a god of transformation, of disguise and of masks. Festivals, the so-called Great Dionysia, were held every year in the Spring with dithyrambic dances and choruses. The games had directors. Thespis, one of the first, set a single actor against the chorus, thus creating a new art form which became the basis of dramatic competitions, and these attracted spectators in increasing numbers.

patos now cuts through the famous Theatre of Dionysos. In front of the entrance to the theatre in the S. was the 6C BC first Temple of Dionysos, which housed the statue of the god from Eleutherai in Boeotia, where the god was worshipped before he came to Athens. The statue was displayed in the Dionysia processions. S. of this are the ruins of the second, larger Temple of Dionysos Eleutheros, built in the late 4C.

33. Theatre of Dionysos: The Dionysos theatre was built in 9 phases from the 6C. It was the first theatre building in Europe, and the cradle of antique tragedy. According to tradition Thespis was the first to take a troupe of actors and the now legendary wagons around the country; he performed the first drama ever when he—presumably on the Agora in the first place—allowed a single actor to enter into dialogue with the chorus. Dramatic performances of this kind initially took place in honour of the god Dionysos; the site of the festival was moved from the Agora to the Temple of Dionysos. At first the spectators sat on the slopes of the hill and watched the players on a circular area which had been stamped firm (orchestra). Then wooden seats were built on the hillside, the so-called theatron, which originally only referred to the area in which the spectators sat. The skene now consisted of a wooden platform beside an altar and a tomb. Wooden sets and painted scenery were added. Increasingly large numbers of contestants became involved in the dramatic competitions. Finally Aiskhylos, Sophokles and Euripides won more and more first prizes. In about 500 Pratinas appended the satire as a postlude to the tragedies, in 472 Aiskhylos intro-

The Dionysia

The Dionysia were held in March or April and lasted up to 8 days. On the evening before they started the cult statue of Dionysos was set up in the orchestra. At sunrise on the next day the procession of sacrificial beasts and maidens carrying baskets containing sacred vessels began. The spectators arrived, dressed in solemn white, metics in scarlet, choregoi in purple and gold. There were phallus bearers and heralds with laurel and vine leaves.

Now the dramatic competitions began, with each performance lasting three or four hours. The choregos, a well-to-do citizen, was responsible for the entire performance. He, like the poet, was rewarded or condemned if the piece did not appeal to the public. The actors, who were employed by the state and assigned to the playwrights by lot, were often held in higher esteem than the writers.

The actors wore masks, and were always men. They also played the female roles. Guests of honour had special seats at the performances. Women were only allowed to watch from the last few rows. The priests of Dionysos sat in the front row in marble chairs with arms. On the sixth day of the Dionysia there were lively discussions about the plays. On the seventh or eighth day the official prizegiving took place. Poets received laurel wreaths, choregoi could win prizes, usually tripods with sacrificial vessels. Officials were responsible for maintaining quiet and order throughout the festivities. There was sometimes offensive or insulting behaviour on stage, for which fines had to be paid. The public too could infringe the rules. If they did not like the performance they bombarded the actors with goat's cheese and figs.

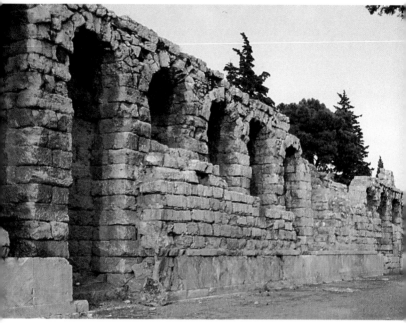

Stoa of Eumenes

duced a second actor in the 'Persians', and Sophokles then included a third. Tragedy reached a high point of achievement. Comedy had been a feature since 485; Kratinos and Aristophanes distinguished themselves in this sphere. Later the skene became a long, rectangular stone area. The altar was set in the centre of the orchestra. Behind the skene was a wall with three gates. The so-called steps of Charon represented the way into the Underworld. Flying devices and cranes enabled the gods to appear. A platform, the theologeion, could be let down from the roof to give the surprising appearance by a god later known as the 'deus ex machina'. Acoustic and visual effects were achieved with artificial thunder and painted lightning. Tradition has it that the mask was introduced by Thespis, but it is more probable that Aiskhylos was responsible for this

innovation. The theatre developed remarkably rapidly to a unique high point, known to us mainly for the achievements of its dramatists. Because the festivals rapidly increased in popularity, the stage and the auditorium had to be increased in size, and improved. Under Lykurgos, *c.* 330 BC, stone benches were built in the theatre, 67 rows accommodating about 17,000 spectators and divided by walks into three sections; the lower 13 wedges have steps between them. In the first row in the middle is the seat of honour, which has survived; the seat of Dionysos Eleuthereus, decorated with reliefs and in Roman times probably covered with a canopy. The Emperor Hadrian's seat of honour was behind it. In the Roman period the paved orchestra was separated from the auditorium by a stone barrier. The reliefs on the much-rebuilt stage building S. of the

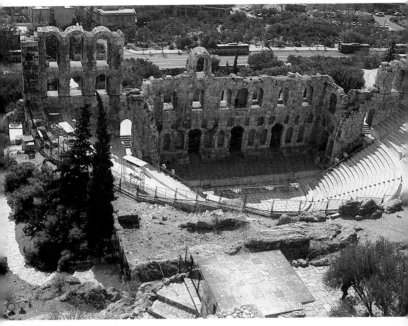

Odeion of Herodes Atticus

theatre, showing scenes from the myth of Dionysos, date from the 1C AD.

The early performances in the 6&5C BC were heavily bound up with religion, and introduced by festive processions and lasted up to eight hours.

In the Roman period the theatre was used for dramatic performances, but also for other purposes. There were gladiatorial combats, aquatic games and, in the opinion of some experts, animal fights. In the late 5C AD the orchestra became the courtyard of a Christian basilica. In the 17C archaeologists began to show interest in the site. From 1837 the Greek Archaeological Society began to excavate the Theatre of Dionysos, which drew attention to its enormous importance in the history of culture.

34. Thrasyllos monument: N. of the Theatre of Dionysos there is a point at which there used to be a large number of monuments to choregoi (chorus leaders responsible for putting on plays) who had won competitions. On this site, directly against the Acropolis rock the columns which supported the monument to Thrasyllos, erected in 320 BC, can still be seen. Under this is a cave used as a chapel of the Panagia Spiliótissa. The monument was destroyed by the Turks in 1827. The tripods won by the choregoi in the competitions were usually placed on a marble base inside these monuments.

35. Nikias monument: W. of the Dionysos theatre is the rectangular base of the monument to the choregos Nikias, set up in 319 BC and destroyed shortly after 267 BC. Its stones were used, along with others, in the building of the Beulé gate.

36. Stoa of Eumenes: Further to the W. of the theatre is the Stoa of Eumenes, 178 yards long; it was once a two-storeyed colonnade used as a promenade for theatre visitors. It was endowed by Eumenes II, King of Pergamon, *c.* 160 BC. The exterior columns were Doric, the interior columns in the lower storey Ionic and in the upper storey Pergamene. The lower walls and arches have survived; they were originally clad in marble.

37. Old Asklepion: It is said that there was originally a shrine dedicated to the god of water on the site of the Old Asklepion. The Asklepios cult, the cult of the god of healing, originated in Epidaurus and was introduced in Athens in 420 BC. Here the Old Asklepion was built W. of the Theatre of Dionysos, at the foot of the S. slope of the Propylaia and N. of the Peripatos. Today there are ruins of the Old Asklepion W. of the larger New Asklepion. Parts of the 91 ft. Ionic stoa have survived, which originally had 4 square rooms, and also remains of a temple in antis with ruined altar and the spring with a square cistern. The building existed into the 6C AD. S. of this is another cistern of later date from the Turkish period.

38. New Asklepion: The ruins of the New Asklepion, built in the mid 4C between the Old Asklepion and the Theatre of Dionysos, are more striking. There are still remains of walls, the altar base, sparse remains of the 164 ft. portico, which in antiquity was used as a two-storey dormitory for the sick, and in the E. a cave with spring, which continued to be considered to have powers of healing; the cave became a chapel. In the W. is a round, roofed sacrificial pit, and S. of the porticus another porch was built in the Roman period, and ruins of this have also survived. Later, in the early

Agora with Byzantine church and Hephaisteion ▷

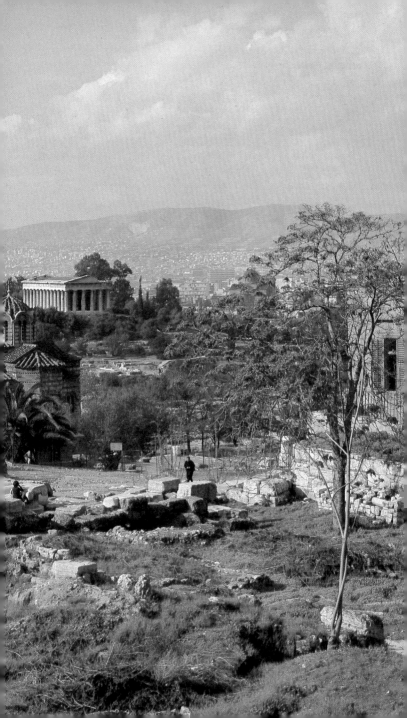

The Treasure of Herodes Atticus
The father of Herodes Atticus is said to have found treasure in an old house, and immediately told the Emperor about it. The Emperor granted him the treasure, which enabled him to bring up his son Herodes in an extremely civilized fashion. He achieved high office and dignity, increased his wealth and endowed a great deal in the city. In memory of his late wife Regilla he built a gigantic Odeion which could accommodate 5,000 spectators in

AD 161. The façade alone was over 90 ft. high. The walls were built of poros ashlar clad in marble. Floors, stairways and vestibule were decorated with mosaic. In front of the three-storey theatre was a colonnade. There were porches in front of the entrances. The stage wall had three entrances and eight niches. Three steps connected the stage with the orchestra. The steeply ramped auditorium was roofed in cedar wood.

Christian period, a basilica was built on the ruins of the Asklepion, and parts of the walls of this building have survived.

39. Odeion of Herodes Atticus: The theatre is on the SW edge of the Acropolis slope; it was rebuilt in the 20C but dated originally from the 2C AD.
In AD 268 the Heruli destroyed the Odeion, presumably by burning it down. It was used as a bastion by the Turks. Excavations began between 1848 and 1858. The theatre was restored in the 20C. It became world famous in 1955 when the Athens Festival was inaugurated. Great artists from all over the world sang, danced and played here, and modern audiences were as impressed as the contemporaries of Herodes Atticus by the unique acoustics, which enable the slightest sound to carry undistorted throughout the enormous theatre. The Odeion was also an important factor in the revival of ancient tragedy in modern Greek.
In 1960&1 the seats were remade in Pentelic marble and the orchestra was paved with blue and white slabs.

40. Shrine of the Nymphs: For most of its route the Peripatos runs parallel with a modern path around

the Acropolis, but they are sometimes contiguous and sometimes cross each other. You leave the Peripatos at the Odeion of Herodes Atticus if you wish to see a Shrine of the Nymphs S. of the theatre; it was excavated in 1955–9. Votive gifts and jugs from the 7C BC were discovered here; they are now in the Acropolis Museum. The vessels were originally used for fetching water for the wedding bath. After

Agora with Byzantine church

the wedding the bride brought the jug back to the Shrine of the Nymphs as a votive gift.

THE HILLS OF ATHENS

The Athenian hills with the most ancient buildings on them—Philopappos, Pnyx, Areopagus, Hill of the Nymphs and Hill of the Muses—are quite close together to the W. of the Acropolis. It is easiest to park on the Hill of the Muses, and this is also convenient for a visit to the Agora.

1. Areopagus: The Areopagus (377 ft.) rises directly to the NW of the Acropolis on the Peripatos, or on the a continuation of a walk round the Acroplis on the Peripatos, or on the modern path which has replaced it. Between the Acropolis and the Areopagus is a saddle (now a car park). It may be that this was the site of the oldest, the archaic, Agora, but as yet no excavations have been made. Steps cut in the rock lead to the Areopagus. The Areopagus has a very long history. In 1939 and 1947 Mycenean grave chambers were excavated here.

Criminal justice in mythology
The Areopagus was the hill of judgement from time immemorial. It is said that judgement was passed on Ares here for his murder of Halirrhotios. The 7C council of elders was composed of Eupatridai and responsible for criminal justice, and was known even then as the Council of the Areopagus. Solon made the members of the Areopagus protectors of the constitution and guardians of the law. These rights were later withdrawn, but from the 4C it was responsible for the condemnation of treachery and corruption. Orestes had to defend himself here for the murder of his mother.

The rich finds suggest royal graves dating back to *c.* 1400 BC.
But even apart from this the history of the Areopagus goes back a very long way. It is said that the Amazons camped here, in 480 the Persians mounted their attack on the Acropolis

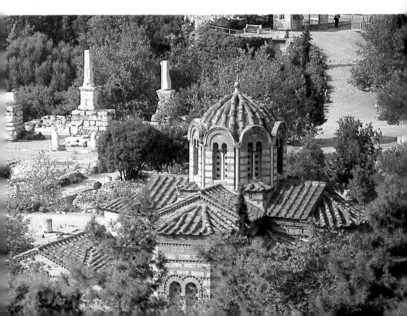

from here. In AD 51 the Apostle Paul preached in the court here, and converted the Senator Dionysios to Christianity; as Dionysios Areopagitica he later became the patron saint of Athens. The ruins of his 16C church can be seen by looking down on the N. slope from the hill.

The summit of the Areopagus has been artificially flattened. From here there is an ideal view of the Agora and across to the Propylaia. The little building of which some walls remain on the summit of the Areopagus was probably connected with the administration of justice. Directly below the hill in the SW old buildings have been revealed, the *Amyneion* (shrine of a god of healing). Excavation of the NW slope revealed rich finds from earlier settlements, for example the so-called *Geometric House* on an elliptical ground plan or a polychrome votive slab dating from the 7C BC. The *well* here has always been considered to have healing powers and the caves were a sacrosanct *asylum* for murderers and runaway slaves. The *tomb of Oedipus* was here. On the E. side of the Areopagus a path leads to the *Cave of the Furies*, which some scholars hold to be on the NW slope. From here the S. gate leads to the excavations on the Agora, or you can return to the path leading to the Acropolis and climb the Hill of the Muses from there.

2. Hill of the Muses· This 480 ft. hill was once dedicated to the Muses. The Macedonian King Demetrios Poliorketes built a citadel here in 294 BC. There is now a *Philopappos monument* on this site, a tomb built by the Romans between AD 114–16 in memory of a Syrian prince who was a benefactor of Athens. The view of the Acropolis from here is famous.

3. Hill of the Nymphs: The Hill of the Nymphs, W. of the Areopagus, can be reached from the Hill of the Muses. Ancient cave dwellings have been discovered here cut into the rock between the slopes of the 4 hills; they were still lived in in the 5C BC. The *Tomb of Kimon* was also discovered here, and the presumed *Prison of Sokrates*, though the latter has never been conclusively identified. This was the point at which the 'Long Walls', the city wall connecting Athens with Piraeus, began. There is an observatory on the Hill of the Nymphs.

4. Pnyx: In ancient times the citizens' meetings empowered to make popular decisions took place on the Agora, and later the Pnyx became the meeting place of Athenian democracy. The word Pnyx means 'a place where you stand packed tightly together'. Originally the people looked down on a speakers' tribune set on a natural rock. In the late 5C the area used by

Muses
The Muses, originally three, later nine, were, according to mythology, the daughters of Zeus and Mnemosyne. They almost always live by mountain springs and are considered to be the patron goddesses of the arts, especially of poetry and all the activities of the mind. Kalliope, with wax tablet and stylus, is the Muse of epic poetry, Melpomene, with tragic mask, the Muse of tragedy, Thalia, with comic mask, the Muse of comic poetry, Euterpe, with aulos, a kind of shawn, the Muse of lyric poetry, Terpsichore, with lyre, the Muse of choral verse and dance, Erato the Muse of love poetry, Polyhymnia the Muse of hymns, Klio, with papyrus roll and stylus, the Muse of history, Urania, with globe and pointer, the Muse of astronomy.

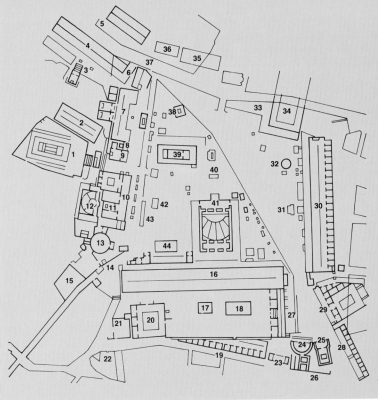

Greek agora (after J. Travlos): The numbers in the diagram are referred to in the text.

the people was moved to the N., and steps were built to give access to the semicircular terraces which were built there. In the second half of the 4C the site on the NE of the hill, which has a retaining wall 279 ft. long, was again altered and extended. Steps, walks and monumental balustrades were built, but they survive only as ruins. The great terrace resembles an amphitheatre, and is 230 ft. deep and 390 ft. wide, and affords an overwhelming view of the Acropolis. Behind the tribune is another block of rock, considered by some scholars to be the *altar of Zeus Agoraios*. There are niches in the rock wall which were part of a Roman shrine of *Zeus Hypis-*

tos. A little further away are foundations of buildings set in the rock, such as the base of the famous *sundial of Meton* (433&2 BC). Meton calculated that a year lasted 365 and 5/19ths days; this is only half an hour too long.

THE AGORA

If you go down the steep, stony path between the fences past the Areopagus to the Agora you are glad of every pine, every thorn bush, every hollow which affords even the slightest

shade. Even in September everything is dusty and dry. Facing you now is the gigantic excavation site of the old Greek Agora. There is an entrance by Agii Apostoli, the little Byzantine church, but it is worth going round this building and taking the W. entrance of Kolonos Agoraios. From here you have a better overall view, and the older buildings start at this point.

When you enter the site today there is museum-like quiet among the few green areas and the antiquities which are spread around. It is worth closing your eyes and imagining what it looked like here 2000 or 2500 years ago. Life in the city centred around this place. It must have been noisy and colourful. Speeches were made, philosophical discussions were held, the first courts were here, and from here the Panathenaia and Dionysia started. Here, among the old plane trees, markets were held, vegetables and spices were sold. Potters' workshops were opened, tradesmen offered their wares with the volubility and volume of the South. Slaves were even sold here. Amidst all this officials would appear to check on weights and measures, and the quality of the goods on offer. Moneylenders also set up shop here. Gods were worshipped at altars, open political discussion and persuasion were permitted, wars were declared and peace was celebrated. The old Agora was the centre of Greek life.

The rediscovery: The old Greek market place was excavated between 1931–41 and 1946–60 by American archaeologists, after small-scale attempts in the 19C and early 20C. An entire section of the town had to be cleared and then pulled down.

It is clear from the stones and buildings which have been revealed that all this effort was worth while. Entire historical epochs can be reconstructed from the finds, particularly with the help of writers like Pausanias.

History of the Agora: Theseus' Old Agora, which seems almost certain to have been S. of and above the present Agora, became too small for its purpose, and so in the early 6C Solon commissioned a new city centre. It

Agora, torso of the Emperor Hadrian (L.); torso (R.)

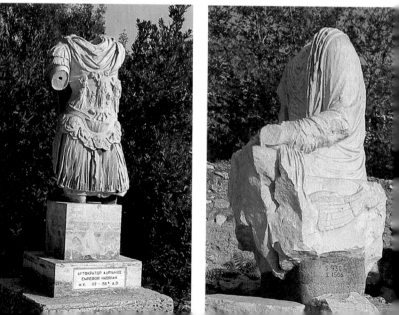

was moved to a site NW of the Acropolis, which since the Mycenean period had been used as a burial place. The oldest buildings of what was then the New Agora were built in the W. at the foot of the Agora hill. From this point onwards this area was for millennia the centre of the town. It was not until later that the place for citizens' assemblies became the Pnyx, the administration of justice was transferred to the Areopagus and the Dionysia moved to the Theatre of Dionysos. The Panathenaic procession used the specially-constructed Panathenaic Way from the Agora to the Athena Polias on its way to the rites which from time immemorial had centred on the Areopagus. The Agora remained the centre for the state authorities, and the scene of cultural, political and philosophical contests and decisions, but above all the trade and market place, to which all important roads led. No wonder that spectacular new buildings kept appearing, often at the expense of older ones.

The altar of the 12 Gods, the House of the Tyrants in the SW corner and the Enneakrunos Fountain in the SE corner date from the time of Peisistratos, *c.* 530. In about 508 BC, after the reform of Kleisthenes, the Heliaia court building, the large drainage channel in the W., the old Bouleuterion and the little Metroon Temple were built. After destruction by the Persians in 480 BC the Agora was rebuilt and much altered. The Tholos was added, and later the temple of Hephaistos, the Hall of Zeus and the Stoa in the S., among other things. After 350 BC the shrines of Apollo Patroos, Zeus Phratrios and Athea Phratria were built. The Stoa of Attalos, a new Metroon and the S. and Middle Stoa date from the Hellenic epoch in the 2C BC. In 86 BC much was destroyed by Sulla's campaign. In the reign of Augustus the Odeion of Agrippa in the middle of the Agora and the Temple of Ares next to it were rebuilt. The Pantainos Library came into being in the 2C AD. In 267 the Heruli occupied Greece and set fire to Athens. The Wall of Themistokles was replaced by a new one, the Wall of Valerian, which did not include the Agora. For over 100 years

Agora, Corinthian capital

there were only ruins here, until rebuilding began *c.* 400. A gymnasium was built, and a new Tholos. The Temple of Hephaistos became a Christian church. In 529, when the Emperor Justinian ordered the closure of all schools of philosophy, instruction in the gymnasium ceased and *c.* 550 the Agora as such had entirely lost its significance. From the 11C Byzantines, Franks and Turks slowly began to build their dwellings here, and it remained a residential area until excavations of the antique Agora began.

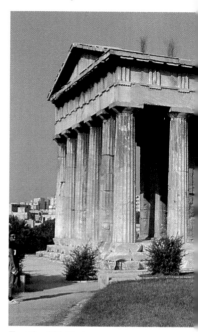

Temple of Hephaistos

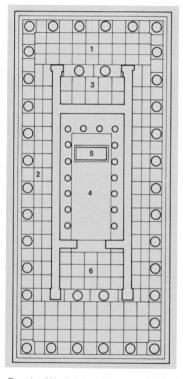

Temple of Hephaistos 1 W. entrance **2** Hall of columns **3** Pronaos **4** Cella **5** Cult images **6** Opisthodomos

WESTERN PART OF THE AGORA

There are three entrances to the Agora. It is best to use the W. one, as it affords a splendid view over the romantic ruins and across to the Hymettos mountains. The two most interesting sights on the Agora are the Temple of Hephaistos and the Museum.

1. Temple of Hephaistos: At the W. extremity of the field of ruins is the Temple of Hephaistos, which has survived in good condition; it was built between 449 and 444 BC. The Athenians tend to call the temple the Theseion, although it has never been dedicated to Theseus, but from its ancient beginning to Hephaistos, the god of potters and smiths, and the goddess Athena. The two bronze cult statues of Hephaistos and Athene are

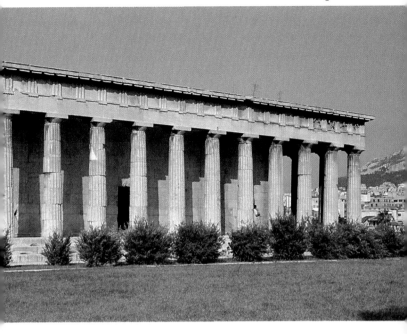

in the cella of the temple, as they always were. They are the work of Alkamenes, a pupil of Pheidias, and date from between 421 and 416 BC. This temple has survived wars, attack and plunder, and also being rebuilt as a church of St.George in the 5C AD, although the latter alteration was quickly made good. The temple was built earlier than the Parthenon, and has nothing like as much harmony and power. The brilliance of the perspective design is missing, although the widely-spaced 6 by 12 Doric columns of the Hephaisteion are also inclined slightly inwards and the entablature rests just as lightly on the columns. The cella was enclosed by a peristyle of 4 by 7 columns. Some scholars maintain that the same architect was responsible for the Temple of Hephaistos, the Temple of Ares in the

The Mythology of the Hephaisteion
The entire Agora, but particularly the Hephaisteion, is steeped in Greek mythology. The temple itself was built to the gods Hephaistos and Athene, but the metopes and friezes represent an unorthodox collection of the deeds of Herakles and Theseus. They were blood relations, as their mothers were said to be cousins. Theseus modelled himself on the older Herakles, and the two heroes went from strength to strength together. There is even said to have been an occasion on which Herakles rescued Theseus from the Underworld.

Agora and the Temple of Poseidon on Cape Sunion. Some ornament and painting has survived in the temple, above all the metopes with a Herakles cycle and the friezes on the E. side. The metopes on the N. and S. side depict the deeds of Theseus. Fragments of the Pentelic marble gable sculptures were rediscovered between 1931 and 1948 in the course of excavations on the Agora. In the 3C BC the area immediately around the Hephaisteion was made into a garden. The sacred temple precinct was clearly separated from the rest of the grounds by a surrounding wall.

2. Hellenic peristyle: There was formerly a Hellenic building with a three-aisled peristyle N. of the Hephaisteion.

3. Temple of Aphrodite Krania: N. of this peristyle on the N. slope of the hill, are remains of an early Roman temple; its N. section was cut off by the underground railway to Piraeus. When this railway was being built in 1892 fragments of Doric architecture were discovered; these were part of the temple, which is presumed to have been dedicated to Aphrodite Krania. The sculptor Phidias created a cult statue for the building which preceded the present one. There is a copy of this statue and an altar in Hymettos marble, which like the altar was discovered near the temple, in the Agora Museum.

4. Roman hall: There used to be a Roman hall N. of the Temple of Aphrodite Krania.

5. Panathenaic Way and Eleusinion: The Panathenaic Way, on average just over 30 ft. wide and paved in parts, along which the annual procession for the goddess Athena used to pass, originally ran parallel to this hall. It started in the W. at the so-called Sacred Gate (Dipylon) and ran diagonally across the entire Agora to the Acropolis.

When the Panathenaic Way was being investigated the **Eleusinion** was discovered S. of the Agora, about 150 yards S. of the Stoa of Attalos; the Eleusinion was a 6C BC archaic shrine which had been rebuilt c. 490 and which had apparently served for a time as a bouleuterion (place of assembly for the council). The shrine was destroyed in 267 AD when the Heruli overran the city.

6. Portico of Basileus: In 1970, during excavations E. of the Roman hall by the Piraeus underground railway, foundations of the Stoa of the archon Basileus were found. The Doric portico with 8 columns in the façade, used as a public building, was built c. 530 BC and destroyed by the Heruli in 267 AD.

7. Stoa of Zeus Eleutherios: This U-shaped peristyle, which can be made out in outline on the ground, is S. of the Portico of Basileus. The N. end of the side section was cut off by the underground railway. The stoa was built in the second half of the 5C BC and must have housed a work of art which has now been lost, the *wall paintings of Euphranor*, which date from after 362 and which portrayed the 12 gods, Theseus and the Battle of Mantineia. A 6C BC *Temple of Zeus* and *altar of Zeus* were excavated under the hall. In the 1C AD rooms for emperor worship were built in the stoa. An *armoured torso* of the Emperor Hadrian, which can be seen outside the hall, was associated with this cult. E. of the temple is the base of the altar of Zeus.

8. Temple of Zeus Phratrios and Athena Phratria: Between the Stoa of Zeus Eleutherios and the Temple of Apollo Paroos to the S. of it is the small shrine of Zeus Phratrios and Athena Phratria, dating from the mid 4C.

Temple of Hephaistos, colonnade ▷

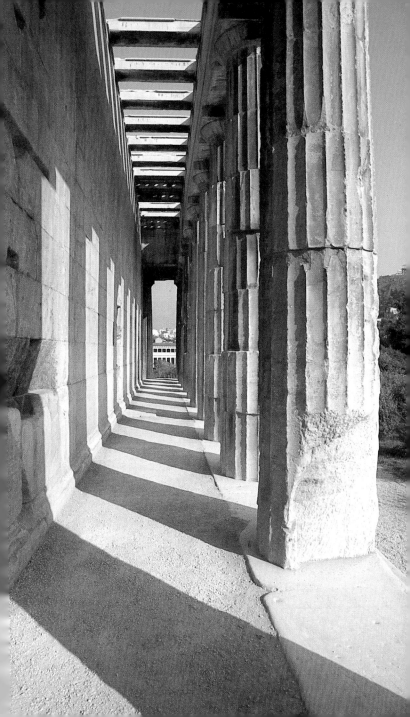

Herakles

The greatest of the Greek heroes, who at the end of his life was taken among the immortal gods, was said to have been the son of Zeus and Alkmene, the wife of Amphytrion, King of Tiryns. Hera, the wife of Zeus, hated her rival and therefore spitefully sent 2 snakes to the new-born child, but the infant Herakles was already endowed with such great strength that he was able to strangle them with his bare hands. At the age of eighteen Herakles was the strongest man in Greece, handsome and enterprising. He performed many heroic deeds, above all supporting his father Zeus in his struggle againts the Titans, the fearful sons of Gaia. It was Herakles who destroyed them, earning for himself the gratitide of the gods.

Eurystheus was King of Mycene in Argos. Through a trick played by Hera, Herakles had to serve him, and an oracle prophesied that he would have to complete 10 labours for Eurystheus. Herakles was not suited to service, so was beside himself with fury; Hera transformed his rage into madness, with the result that he killed his own children, two sons of himself and Megara. He also wished to kill his cousin Jolaos in his rage, but calmed down, and gave Megara to Jolaos to be his wife, as she no longer wished to live with Herakles.

Herakles was now so desperate that Eurystheus' labours now meant little to him. The latter, who at the bottom of him was afraid of Herakles, thought up the worst tasks he could, in order to get rid of him. But Herakles was able to perform all these labours. He smothered the terrible Nemean lion, which could not be wounded by humans, and made armour from its skin and a helmet from its neck. He killed the many-headed Hydra, and dipped his arrows in her blood, to make them poisonous. He captured the beautiful Hind of Kerynaia, which had golden antlers and bronze hooves, and also the wicked Boar of Erymanthus. By a trick he was able to clean out in a single day the stables of Augias, King of Elis, which contained 3,000 oxen and had not been mucked out for years. He diverted two rivers through the stables, and thus washed away the filth. He drove off the dreaded birds of prey of Stymphalus, tamed a mad bull owned by King Minos of Crete and brought the man-eating horses of Diomedes to Mycene. Herakles also fought against the Amazons, and was given the girdle of Hippolyte. On his way back to Mycene he freed Hesione, the daughter of Laomedon, King of Troy, who had been chained to a rock by Poseidon in his search for revenge against Laomedon, and was to be devoured by a monster. Laomedon promised Herakles the speedy horses of Ares as a reward for the rescue of his daughter, but he did not keep this promise, and paid for breaking his word by the loss of his own life, and those of all save one of his sons.

On the journey which the hero had to make to acquire the oxen of the giant Geryones, Herakles covered half the world. But Eurystheus refused to accept two of his ten heroic deeds. He still wanted the Golden Apples of the Hesperides. Herakles was only permitted to bring these to Mycene after taking over from Atlas for a time as the bearer of the heavens. In exchange for this Atlas had put to sleep and killed the dragon which guarded the tree, and then stolen the apples. The final labour set by

Eurystheus was that Herakles should go down into the Underworld and bring back Cerberus, the Hound of Hell. When he had done this, after unspeakable toil and adventure, Herakles was at last free.

He returned to Thebes and began to look for a wife. In a new fit of madness which Hera brought upon him he killed one of his best friends. To atone for this he gave himself into slavery and looked after the oxen of King Admetos, who was happily married to Alcestis in Thessaly. Once when Alcestis was about to offer her life in exchange for that of her beloved husband, Herakles saved her from death by attacking Thanatos, the ruler of the dead, on the grave mound and wresting his prey from him. Herakles, however, remained in slavery to atone for the death of his friend, this time in the service of Omphale, Queen of Maioneia. After many more experiences,

heroic deeds and acts of vengeance Herakles came to Aetolia, and there he won the king's daughter Deianira as his bride. She bore him his son Hyllos. Wife and child accompanied Herakles on a journey to Calydon. On the way they had to cross a mighty river, which normal mortals could only pass on the back of the centaur Nessos. Herakles stepped into the water first, while Nessos bore the beautiful Deianira on his back. In the middle of the river he began to molest her, as he found her attractive. Deianira called for help, and Herakles killed Nessos with an arrow. The dying Nessos commended his blood to Deianira, as a means of binding Herakles to her for ever, and making him immune from any other love.

Herakles lived in happiness with Deianira for a long time. But one day, when she thought that she had grounds for jealousy, she smeared her husband's robe with

Lion from a tomb in the Kerameikos, second half of the 4C BC, N.A.M.

the blood of the centaur. When Herakles put on the robe it stuck to his body with deadly firmness, causing him fearful pain. Deianira committed suicide, and the hero, as the oracle of Delphi had fore- told, had himself conveyed to Mount Oeta, where a funeral pyre was lit. He walked into the fire, and immediately Herakles was taken to Olympus by Zeus, to live among the Immortals.

Theseus

This hero and later King of Athens was the son of Aigeus and Aithra, the daughter of King Pittheus of Troezen. He was brought up by his grandfather and his mother, who only revealed the name of his real father when he grew up. So that the father could recognize him, she showed her son the sandals and sword which Aigeus had once hidden with her under a heavy rock. The strong young man rolled back the rock with ease, put on the sandals, took the sword and and set off on the dangerous overland route to Athens, to look for his father. He underwent many adventures on his way. He killed the footpad Periphetes, known as the club-swinger, with his own weapon. On the isthmus of Corinth he tore Sinis to pieces by tying him between two pines and then releasing them, as Sinis himself had done to so many people. Theseus rescued Perigune, the innocent daughter of Sinis, and later gave her to a prince to be his queen. Next Theseus slew Phaia, the evil sow of Crommyon, and in the house of Megara he hurled the robber Skiron from a high cliff into the sea, the fate of many passing travellers at the latter's hand. He defeated the highwayman Kerkyon, and finally also Damastes, who was known as Procrustes the limb-tearer, because he put small travellers into a large bed, and wrenched their limbs until they fitted it; larger travellers were placed in a small bed, and had their limbs cut off. So now Theseus fitted the giant Procrustes into a little bed, which caused the latter's death. By the river Kephisos Theseus met men who received him in a hospitable fashion, and cleansed him of the blood which had been shed. When he arrived in Athens, Medea handed him a cup of poison. But his father recognized sword and sandals, knocked over the goblet of poison and drove Medea away. He acknowledged Theseus as his son and successor, and Theseus now slew the Minotaur in Crete, to save the lives of young Athenians. His father committed suicide, because he thought Theseus dead, and so the latter came to the throne. He was said to have been a good ruler, and brought Athens to a position of power, in which the city was much admired. But then he stole Hippolyte from the Amazons, and made her his queen. She bore his first child, the boy Hippolytus. The Amazons armed themselves for war against Athens, to avenge the theft of Hippolyte. Hippolyte stood by her husband, but was killed in the battle, and after losses on both sides peace was concluded.

For many years Theseus lived without a wife. He became a friend of Peirithoos, a strong and famous hero. Theseus defended him in a battle against the centaurs, who wanted to steal his new bride Hip-

podameia. As an older man Theseus married Phaidra, the daughter of the King of Crete, the younger sister of Ariadne. She bore him two sons, Akamas and Demopheon. But then Phaidra fell in love with her stepson Hippolytus, who was nearer to her in age than Theseus. When Hippolytus rejected her, Phaidra hanged herself, but left a letter for Theseus, saying that Hippolytus had pursued her, and that suicide had been the only means by which she could save herself. Theseus banished Hippolytus whose horses, terrified by a sea monster, shied, and dragged him to his death. In the mean time Peirithoos' wife had died, and now the two friends, Theseus and Peirithoos made their way to Sparta, where they both fell in love with Helen, the daughter of Zeus and Leda. Helen fell to Theseus by lot and he hid her at the house of his mother. As compensation for Peirithoos, Theseus and his friend now attempted to steal Persephone, the wife of Pluto, from the Underworld. The attempt failed, and Peirithoos had to remain in the Underworld. Theseus was rescued, after long imprisonment, with the help of Herakles. In the meantime Castor and Pollux, the brothers of Helen, had tracked their sister down and taken her back to her home. But in Athens Menestheus, a great-grandson of Erechtheus, was at work. He stirred up the people against Theseus in such a way that he had to flee with his sons almost as soon as he arrived home. He landed in Skyros, where Lykomedes, a secret friend of Menestheus, was king. Lykomedes lured Theseus

The Nessos amphora, 620 BC, N.A.M.

on to a high cliff and deceitfully threw him into the sea. Centuries later Kimon, under the instructions of an oracle, is said to have found the bones of Theseus; he took them back to Athens, where they were solemnly buried.

9. Temple of Apollo Patroos: The Athenians originally thought themselves to be descended from the Ionians. The god Ion was the mythic ancestor of the Ionians, and he was said to have been a son of Apollo, and so this temple was dedicated to Apollo in the late 4C BC. The Temple of Apollo Patroos had two predecessors, a Temple of Apollo built in the 6C BC, destroyed by the Persians in 480, and a 4C temple, the foundations of which have survived intact. In the 2C BC the portico of the E. cella was added. The *colossal statue of Apollo*, now in the Agora Museum, came from the last temple and was probably made in marble by Euphranor. In the spacious pronaos of the temple there were probably other bronze statues mentioned by Pausanias, said to have been the work of Leochares and Kalamis.

10. Metroon: Tradition has it that in 430 BC a priest of the mother of the gods was murdered. To atone for this the oracle of Delphi demanded the dedication of a shrine to Cybele in what was then the Bouleuterion, and as a result of this the Metroon (Temple of the Mother of the Gods) was built within the precinct of the Bouleuterion. The last Metroon, which was built in the 2C BC, had three rooms, and was built directly above the old Bouleuterion. The N. room was added, and also the pronaos. The foundations and parts of the building have survived. The statue of the mother of the gods, which was part of the old Bouleuterion and then the Metroon, was considered to be the work of Pheidias. The base of the cult statue and an altar in front of the temple have been discovered. In the Roman period the N. room of the Metroon was rebuilt and altered. In AD 267, after destruction by the Heruli, a basilica was built here. In the 5C AD the floor of the N. room was decorated with mosaic.

11. Bouleuterion: The late 5C Old Bouleuterion, which had been destroyed by the Persians, and over the ruins of which the Metroon was later built, had two predecessors, one dating from the 7C and one from the 6C BC.

12. The New Bouleuterion, built in the late 5C, was destroyed by the Heruli in AD 267, but restored later. The Bouleuterion, one of the most important buildings on the Agora, was the meeting-place of the Senate, originally created by Solon. Only the poros walls of the New Bouleuterion have survived. The seats in the orchestra, which had 12 rows, were made of wood, and later of stone. The Propylon in the E. by the portico of the Metroon dates from the 3C BC, and its foundations have survived.

13. Tholos: S. of the Bouleuterion was another state building, the Tholos, also called Skias, in which the Prytaneis took their meals under a shady roof. The Tholos is often called the *Prytanikon*, after an earlier building on the site, dating from the 6C BC. The Tholos, a circular building with a diameter of 60 ft. dates from 465 BC and was rebuilt after being destroyed on many occasions, until it was obliterated by the Heruli in AD 267. It was rebuilt for the last time in the 4C AD. The entrance, the marble floor and the columns which supported the conical roof date from this period. Some of the bricks, originally painted, are to be found in the Agora Museum. In the Tholos, which had a system of wells, the official oak and ritual vessels were stored.

Roman agora, Tower of the Winds ▷

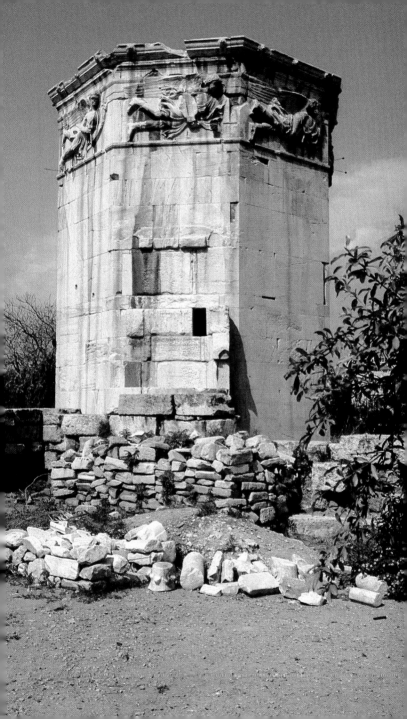

14. Great Drain: E. of the Tholos parts of a drainage system about three ft. wide and three ft. deep have been discovered; it was used to carry rain-water N. to the Eridanos brook from the hills in the S. and W. The channel was originally lined with marble, and dates from the 5C BC, and was not the only one: two more channels were dug in the area of the Agora 100 years later.

15. Strategeion: A little to the SW of the Tholos is a building which some evidence suggests is the Strategeion, the building used by the Strategos, the supreme military commander; it was a public building, like the Tholos and the Bouleuterion.

SOUTHERN PART OF THE AGORA

16. Middle Stoa: SE of the Tholos was a huge two-aisled Doric columned hall. It ran precisely from E. to W., and was built in the 2C BC.

17. W. Temple/18. E. Temple: S. of the Middle Stoa, in other words between the Middle and the S. Stoa, were two buildings which have been excavated but not fully explained. They are the so-called E. Temple and the smaller W. Temple next to it.

19. S. Stoa: The S. Stoa was built in the Hellenic period and ran across a 5C banqueting hall; it had 15 rooms with couches, on which food could be eaten; some of the foundations have survived.

20. Heliaia: The Heliaia was the original place of justice. All that has survived are remains of a square surrounding wall with a columned courtyard of the archaic period.

21. and 23. Wells: To the E. and W. of the S. Stoa 4C BC well buildings have been discovered.

22. Abaton: A small 5C BC abaton was discovered S. of the W. well building.

24. Nymphaion: A 2C BC semicircular Nymphaion was discovered NE of the E. well building.

25. SE Temple: Next to this in the SE was the SE Temple, built in the reign of Augustus..

26. Church of the Apostles: The 11C AD church of Agii Apostoli now stands on the site of the original Nymphaion.

27. E. building: If you now turn S., back to the Agora, you pass the building which formerly connected the S. and the Middle Stoa; it consisted of a hall and two rooms with columns and an entrance to the area between the Middle and the S. Stoa.

EASTERN PART OF THE AGORA

28. SE Stoa: The principal building to the E., which has been reconstructed, is the Stoa of Attalos. S. of

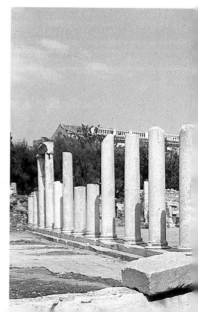

this and positioned obliquely to it was the Library of Pantainos, and further to the S. the SE Stoa. This dates from the 1C AD and ruins have survived. It is assumed that the tightly-packed rooms behind a portico were shops.

29. Library of Pantainos: This former library was, as an inscription confirms, built in AD 100 by Titus Flavius Pantainos and his children. In AD 267 the building was destroyed by the Heruli.

30. Stoa of Attalos: The Stoa was reconstructed in 1953–6. King Attalos II of Pergamon (159–138 BC) endowed the Stoa in the first place. It had two aisles and was two storeys high. In earlier times there was a Mycenean necropolis on the site of the Stoa of Attalos, then a 5C, then a 4C building. The present Stoa like the original one is 367 ft. long, 37 ft. high and 64 ft. wide, and has in its lower storey 45 Doric columns, fluted only in their upper parts. In the interior are 24 Ionic columns. The upper storey has Ionic columns on the outside and Pergamene columns on the inside. E. of the halls there used to be 2 by 24 almost square rooms, which were presumably used as writing rooms and shops. Steps led to the upper storey on both sides of the Stoa. In 1931 American archaeologists decided to reconstruct the ruins and establish a museum. They only retained a very few of the square rooms, the others were knocked together to form a hall. Excavations on the Agora produced so many finds that it seemed sensible to build a specialized Agora museum. When the reconstruction of the building was complete, the finds could be exhibited here, and the building also provided office, storage and working space.

31. Bema: There was a speakers' tribune (bema) in front of the Stoa of Attalos even in the Hellenic period.

32. Well house: A circular-roofed Roman well house was discovered in front of the Stoa of Attalos.

33. NE Stoa: The so-called NE Stoa was excavated at an oblique angle in the NW corner of the Stoa of Attalos.

Roman agora, fragments of columns and Tower of the Winds

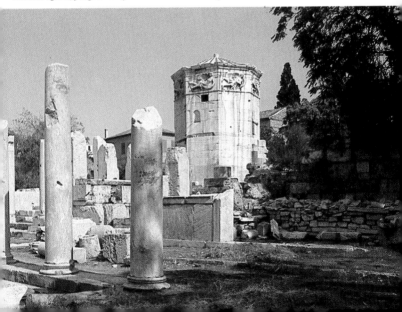

NORTHERN PART AND CENTRE OF THE AGORA

34. Basilica: A large basilica with columned narthex was built later across the ruins of the NE Stoa by the present Underground building.

35. Stoa Poikile/36. Stoa of Hermes: The foundations of two large buildings were discovered N. of the Underground, the Stoa of Hermes and the Stoa Poikile; they are presumed to date from the 2C AD.

37. Hippomachia Gate: Remains of the Hippomachia Gate were discovered SW of the Stoa of Hermes.

38. Altar of the 12 Gods: In the late 6C BC the famous Altar of the 12 Gods was dedicated; it was in the Stoa of Hermes and its ruins were excavated in the course of work on the Underground in 1891. It was not identified until 1934, when it had been largely covered up again. This altar was considered the central point in ancient times: all distances in Attica were measured from here. In the Roman period it served as the Altar of Pity. The needy, beggars and impecunious strangers met here and found sanctuary.

39. Temple of Ares: S. of the Altar of the 12 Gods was the Altar of Ares, erected in 435–420 BC. The archaeologist Dinsmoor speculates that the temple was originally in Acharnai or on the Roman Agora, and was not brought to the place in which it was discovered until about the time of the Birth of Christ. Pausanias writes of Alkamenes' cult statue of Ares in AD 165. There are fragments of sculpture from the temple in the Agora Museum. The site of the temple is marked only by a slight rise in the ground.

40. Base of the Tyrannicides: N. of the Odeion of Agrippa is the presumed site of the statues of Harmo-

dios and Aristogeiton, who murdered the tyrant Hipparchos in 514 BC (see under Chronology), and were considered heroes in the struggle for freedom by the Athenians, and therefore honoured with a monument. Originally Athenor made a bronze sculpture of the pair in 506 BC, but

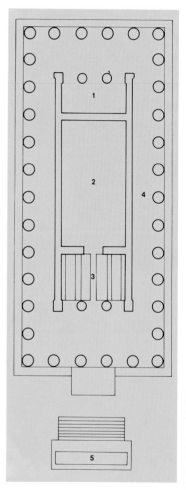

Temple of Ares 1 Pronaos **2** Cella **3** Opisthodomos **4** Hall of Columns **5** Sacrificial altar

this was removed by the Persians in 480, and Kritios and Nesiotes made a new monument shortly after this. Under Alexander the Great the original statue was brought back to Athens from Persia, and the two monuments were placed together in the centre of the Agora.

41. Odeion of Agrippa: Tradition suggests that the dramatic and musical competitions which were later transferred to the Theatre of Dionysos originally took place on the Agora. It is said that it was not until the little wooden stage on the Agora collapsed that the new theatre on the S. slope of the Acropolis was built. On the site where the old orchestra stood the massive Odeion of Agrippa, measuring 169 by 142 ft., was built *c.* 15 BC. It was a theatre or lecture hall with 1,000 seats (in 10 rows) and completely surrounded by two-storey halls. What now remains are pilasters and capitals from the columns, and also the orchestra and walls from buildings added in the 2C and 5C AD. In the N., at the entrance to the former Odeion, are 3 colossal statues:

2 tritons and 1 giant on enormous plinths, dating from the 2C AD.

42. Altar of Zeus Agoraios: W. of the N. portico of the Odeion of Agrippa are the lower part with steps and remains of the Altar of Zeus dating from the 4C BC. The lavish ornamentation is of particular signifi-

Ares
The god Ares is a legitimate son of Zeus and Hera. His brother is Hephaistos. Homer's description does not show this Thracian god of war in a very favourable light: Ares loved fighting for its own sake, often out of sheer lust for killing, and the intelligent Athene repeatedly tricked him. Ares fathered Eros and Harmonia on Aphrodite, and Penthesilea on the Amazon Queen Otrere. In early art he is portrayed as a bearded old man, later as a shining youth. Hellenic art often shows him with Aphrodite.

Shrine with Geometric patterns, 850 BC, Agora Museum

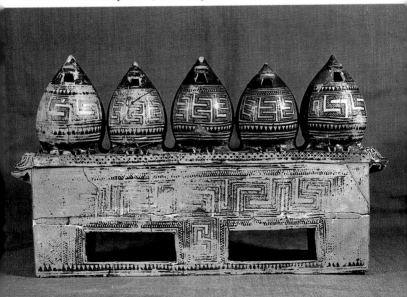

cance. This altar was moved to the Agora from the Pnyx. Here the archons took their oath of office.

43. Monument of the Eponymous Heroes: SW of the Altar of Zeus, opposite the Metroon, there used to stand the enormous monument to the Eponymous Heroes of Attica. Laws, but also complaints could be written on the walls of this building. 10 bronze statues of the Heroes stood on a base between 2 tripods. The surviving fragments date from the 4C.

44. SW Temple: The building which stood in front of the Middle Stoa SW of the Odeion of Agrippa, the so-called SW temple, built *c.* 430 BC, is thought to have been a Temple of the Eponymous Heroes which preceded their Monument.

ROMAN AGORA AND ENVIRONS

Not far from the Stoa of Attalos N. of

the Acropolis and S. of Monastiraki Square is the excavation site of the Roman Agora. It is not easy to find behind the mass of stalls selling lace and embroidery, sandals, lavishly embroidered blouses and hand-knitted sweaters, often very ugly copies of ancient Greek vases, and some charming metalwork. Then, cutting across the shopping streets behind a side alley with little restaurants and street cafés, partially fenced in and with little gardens and a Byzantine church, the Roman Agora somewhat surprisingly appears; the 367 by 315 ft. rectangle is not striking at first. It was originally connected with the Greek Agora, and was a trading centre for a time. You now go round the outside of the building. In the E., in Panos Street, is the entrance, and next to it the principal attraction of this Agora, easily recognisable from the Acropolis above, the Tower of the Winds.

1. Tower of the Winds: this octagonal tower, almost 40 ft. high, was built in the 1C BC and was originally the *Horologion of Andronykos Kyrrhestes.*

Roman agora (after J.Travlos): the numbers in the diagram are referred to in the text.

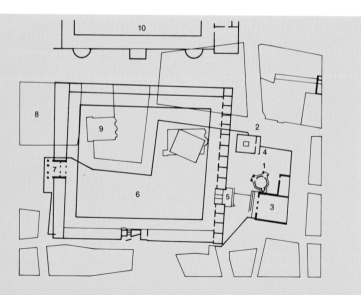

The time was read from the level of water in a pipe. The sides of the tower indicate the eight points of the Athenian compass. The eight winds associated with these points are represented allegorically on the marble frieze which runs around the tower: Boreas in the N., Kaikias in the NE, Apeliotes in the E., Euros in the SE, Notos in the S., Lips, corresponding to the Italian scirocco, in the SE, Zephyros in the W. and Skiron in the NW. A bronze triton who turned like a weathercock on the pyramidal roof, has been lost. The tower was used not only as a water-clock and sundial, but also, it is presumed, as a planetarium. The tower was taken over by a Mohammedan sect *c.* AD 1750, and they put coloured wooden panels with sayings from the Koran on the interior walls.

2. Medrese: Opposite the Tower of the Winds is a fine arched gateway which originally led to the Muhammadan Medrese school, built by the Turks in 1721. The gate is now boarded up, and the school no longer exists.

3. Agoranomion: S. of the Tower of the Winds are foundations of a 1C AD building dedicated to Athena Archegetis and Divus Augustus. The name Agoranomion (market police, presumed to have been based here) has nothing to do with the original function of the building.

4. Latrine: N. of the Tower of Winds are ruins of a gigantic 1C AD marble Roman latrine with accommodation for almost 50 people.

5. E. Gate: Access to the ruins of the Roman Agora is via the E. Gate, a 2C AD Roman propylon.

6. Roman Agora: Between 1892 and 1966 the ruins of the Roman Agora, presumably built from the end of the Hellenic period onwards, have been excavated. In the first half of the 2C the two-storey columned walks in the S. and W. came into being, and also the row of shops to the S. and E. behind these halls.

7. W. Gate: The monumental propylon in the W. of the Agora was built

Roman agora, Byzantine church (L.); West gate (R.)

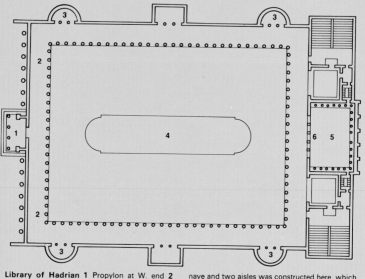

Library of Hadrian 1 Propylon at W. end **2** Huge hall of columns **3** Exedrai **4** There was originally a pool here, over which in the 5C an apse was built; then, in the 7C, a basilica with a nave and two aisles was constructed here, which in the 11/12C became the old church of the Megali Panagia **5** Library proper **6** Niches for book-scrolls

Library of Hadrian, columns

in the late 1C BC on 4 columns. This Doric gate was also called the Gate of Athene Archegetes (leader) or in the Middle Ages the Porta tu Staropazar (Cornmarket Gate).

8. Byzantine church with 9 domes.

9. Columns and remains of the Forum of Trajan.

10. Library of Hadrian: In the N. of the Roman Agora is a fenced-off excavation of considerable size, not open to the public at the moment. It is possible to look down at the excavations from the outside, however, from the point at which the isoka player offers his instruments for sale, playing Greek tunes but also, astonishingly, throwing in a few skilfully executed bars from Mozart's 'Magic Flute'.

This library, endowed by the Emperor Hadrian in AD 132, with

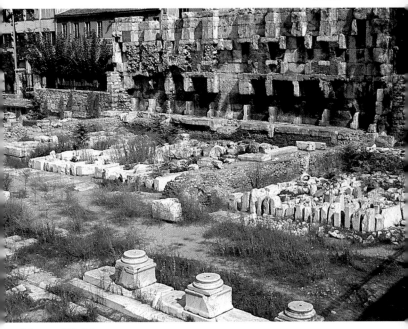

Library of Hadrian

lecture and music rooms and a theatre, as well as books, was not discovered until 1882. It consists of a columned courtyard 400 by 269 ft. The outer walls are broken by exedrae. A propylon and Corinthian columns have survived on the W. side, and large parts of the E. section are still standing. The library was in the middle room, and the niches for storing the book-scrolls can still be seen. In the courtyard was a large well surrounded by gardens. In 1969 a little theatre with a multi-coloured marble floor was discovered. In the 5C AD a building with 4 apses and in the 7C a basilica with a nave and two aisles were built over the ruins of the library, and remains of them can still be seen.

PLAKA

Immediately adjacent to the Roman Agora, on the N. slope of the Acropolis, is the Old Town, the Plaka. There is disagreement about the meaning of the word Plaka. It is derived either from the Greek plaka (flat), or is Albanian in origin, and therefore means something like 'old'. Supporters of the 'old' interpretation suggest that Albanian immigrants brought the name to Athens in the 16C. The suggestion of an old town is certainly not misleading, as there are still numerous old houses and churches in the Plaka.

Until 1950 this was an idyllic craftsmen's and artists' quarter. Shoemakers and tailors had settled down here, along with the owners of little tavernas, tradesmen of all kinds in tiny shops with washing lines instead of windows, which were set up in front of the buildings with the goods on offer hanging on them. The tavernas and shops are still there today.

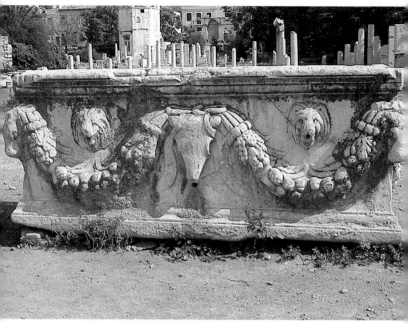

Roman agora, altar. Right: Tower of the winds, details of frieze

The Athenians play tavli in the Kafeneion as they always have. But the craftsmen and the hurdy-gurdy players have disappeared, along with the 13,000 inhabitants of the Old Town who have moved out since 1960. At that time the Plaka was flooded with tourists, and cunning businessmen pulled down old houses and villas and built modern hotels in their stead. Noisy discotheques were opened and garish modern neon signs covered the old, painted façades of the houses. In the meantime a local pressure group opposed to the loss of the old Plaka has made a lot of headway. The government of Athens is spending a great deal of money on the restoration of the Old Town. Some buildings were given the status of ancient monuments. Loudspeakers and neon signs were kept in check, cars were not allowed to use the narrow streets, little gardens were planted with great difficulty in among the concrete. And now the Plaka is very attractive again, particularly for tourists, a noisy, lively, colourful world of higgledy-piggledy, somewhat tumble-down houses, hidden balconies, homely inns, public roasting houses, street cafés and tavernas, which you can find tucked away in every corner of this part of the town. Here you can buy retsina wine, often straight from wooden barrels, white bread, black olives, goat's cheese, stuffed vine leaves, Greek salad, pastitsio, moussaka, keftedes (a kind of meat dumpling with mutton or fish) and finally, as an aid to digestion, ouzo and Greek coffee from tiny little metal pans. Everywhere there are purring hordes of thin but tough cats; they look like Nefertete and steal the hearts of tourists eating their meals. But anyone who takes pity on them quickly regrets it when the poor little

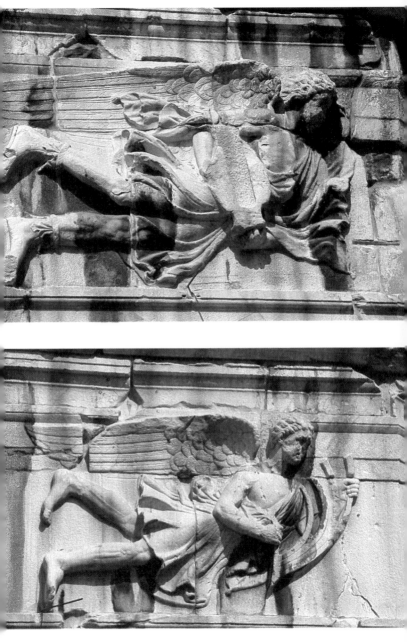

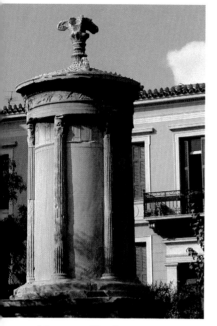

Monument of Lysikrates

Arch of Hadrian

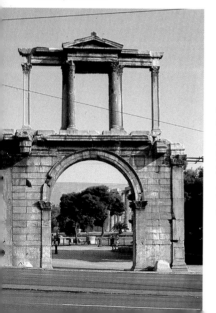

kitten which is being fed with a piece of meat introduces his seven brothers and sisters; to have the whole pack rubbing around your legs, coming closer and looking at you with longing eyes can become rather unpleasant. But the cats are just as much a part of Athens as the noisy tradesmen and street musicians. If they were not there, some of the magic of the Plaka would be lost.

The Plaka shows itself at its maddest during the carnival, which, like most Greek festivals, is at a rather different time of year from similar N. European celebrations. All Athens seems to gather here to whistle, rattle, rampage, throw confetti and generally carry on as if they have taken leave of their senses. But in the middle of this crowd one feels almost Dionysiac exuberance.

Monument of Lysikrates: Alongside the little Byzantine churches and the few surviving, rather dignified neoclassical houses in the S. of the Plaka, not far from the Theatre of Dionysos, and near an excavation site is an ancient monument, a circular building in marble, over 9 ft. in diameter, built in the second half of the 4C, which used to bear, over a marble acanthus flower, which is still there, a bronze tripod won as a prize at the Dionysia in 335/334 BC by the choregos Lysikrates. It is the only ancient choregos monument to have survived intact. Its circular marble frieze represents a Homeric hymn to Dionysos. The Corinthian columns on the monument are considered to be the oldest of their kind in Athens. In 1669 Capuchins bought the monument for their monastery and took it there. During the Wars of Liberation this monastery was burned down, and in 1845 the monument was excavated by French archaeologists.

THE MOST IMPORTANT
SQUARES IN ATHENS

1. Monastiraki Square: NW of the

Library of Hadrian is the Monastiraki Square, which has an early medieval church and a mosque dating from 1759 which now accommodates the Museum of Greek Folklore.

The Monastiraki Square represents the end of the colourful commercial area. The dead straight, busy Hermes Street (Ermu) connects Syntagma Square in the E. with the Dipylon in the W.

2. Omónia Square: If you follow Athinas Street due N. from Monastiraki Square, you come to Omónia Square (Unity Square), built in the 19C as part of Schaubert and Kleanthes' town plan; it was to have been the site of the castle. Streets lead symmetrically in all directions from here. Piraeus Street runs to the SW, to the SE Stadion Street and later, parallel to it, Venizelos Street. The

The ancient Ilissos area largely coincides with the modern National Park. **1** Arch of Hadrian **2** Remains of houses **3** Roman bath **4** Roman building with semicircular hall **5** Olympieion **6** precinct of Kronos and Rhea. The ruins date from Roman times and were excavated in 1892 **7** Temple of Apollo Delphinios. The ruins of the Doric peristyle date from the 5C AD. There had probably been a Mycenean temple of Apollo on this site originally, as some finds indicate **8** Law court of the Delphinion **9** Panhellenion **10** Kodros **11** Python, or Temple of Apollo Pythios, dating from the 6 or 5C BC **12** Aphrodite in the gardens, an area of gardens famous in ancient times for its beauty **13** Altar **14** The Ilissos. In 1956-67, when this stretch of the river was covered and channelled underground, the river-banks were excavated by archaeologists **15** An inscription was found here bearing the name of Kynosarges **16-17** Gymnasion of Kynosarges, dating from the 6C BC. This was one of the three most famous gymnasia in Athens, and was excavated in 1896. The Cynics are supposed to have worked out their ideas and view of life here **18** Relief of Pan carved out of the rock and now virtually unrecognizable. Possibly a

5C BC sanctuary of Pan **19** Kallirrhoe Spring, from which holy water was drawn for cult ceremonies. Maidens about to be married also drew water from this spring for their pre-nuptial bath **20** Crossing of the Ilissos **21** Small temple of Artemis Agrotera which was discovered and mapped in 1751-55, and may be an early work by the architect Kallikrates. It was destroyed by the Turks in 1778 **22** Metroon in Agrai **23** Stadium **24** Sanctuary of Pan **25** Temple of Tykhe **26** Probable site of the tomb of Herodes Atticus **27** Roman bridge **28** This was the site of the Lykeion, which was one of the three most celebrated gymnasia in Athens, together with the Academy and the Gymnasion of Kynosarges **29** Foundations of the Temple of Apollo Lykaios, from which the Lykeion later drew its name **30** Gymnasion building, where Aristotle taught in the 4C BC. The covered walk in this building was called the peripatos, which is why his pupils were called the Peripatetics **31** Lykeion bath **32** Gardens of Theophrastos. It was on this site, in the centre of the modern city, on Syntagma Square, that the Botanical Gardens of Theophrastos, the successor of Aristotle, were discovered **33** Eridanos

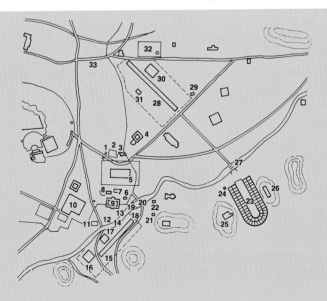

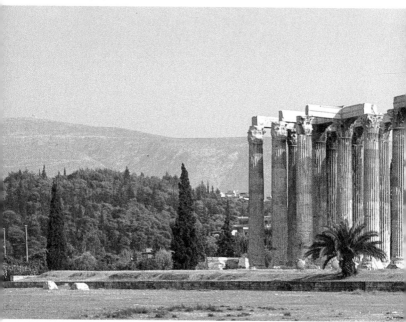

Olympieion

area between Monastiraki Square and Omónia Square is the modern business centre.

3. Syntagma Square: SE of the Plaka is Syntagma Square, near to which there are a number of early medieval churches. The square itself contains early-19C public buildings. Cafés were built over a 11–5C BC cemetery, and next to them are a modern post office, travel agencies and insurance buildings. The monumental building on the E. side of the square, the old *Royal Palace*, built 1836–40 for the Bavarian King Otto, and later used as the *Parliament*. In the centre of the square is a park, an oasis which affords some protection from the noisy traffic roaring around the square. This must have been the site of the *Botanical Garden* of Theophrastos, mentioned on an inscribed boundary stone from the

Shrine of the Muses N. of Syntagma Square. On the N. side of the square, opposite the Royal Palace, is the *Hotel Grande Bretagne*, built in 1867 by the Danish architect Hansen. The façade of the lower storey of this building, planned as a private house, is still original; it became an hotel in 1874, and the upper storeys were added in 1960.

NATIONAL PARK AND ILISSOS AREA

Immediately behind the Royal Palace the national park (former People's Park) begins. It was originally the royal park, and from 1836 it was planted with 15,000 rooted trees from Genoa. Here the botanist Karl Froos, at the request of Queen Amalia, created huge areas of parkland which were tended for years by chief court gardener Schmidt. They are now a

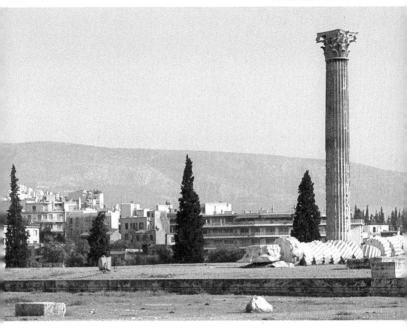

peaceful recreation area in the middle of the city, with their many benches, tennis courts, the duck pond and children's playground. The national park overlaps with the Ilissos area; its ancient buildings, ruins and sites are numbered on our plan, and it is to this that the numbers in brackets in subsequent entries refer. In parts of the park there are excavated remains and fragments of columns, particularly of the Olympeion.

Lykeion (30): Here, near Syntagma Square, must have been the site of the Lykeion, the gymnasium founded by Aristotle. The Lykeion was between the two rivers, the Eridanos in the N. and the Ilissos in the S.; the rivers were covered over in about 1950 because of the traffic and now run underground. It is presumed that the Eridanos provided water for the baths attached to the Lykeion. The ephebes

(conscripts between the ages of 18 and 20, who were also students) could relax here after their physical training. Nothing has survived of the Lykeion.

Arch of Hadrian (1): In contrast with the Lykeion the Arch of Hadrian is still an imposing sight today, even though it is outside the boundaries of the National Park, and looks a little lost beside the inexorable traffic driving past in eight lanes on the Leophóros Amalias. The Arch of Hadrian was built in the 2C AD on the site of a 6C BC town gate. It is built of Pentelic marble, and on the Acropolis side bears the inscription 'Here is Athens, the ancient city of Theseus' and on the other side 'This is the city of Hadrian, and not of Theseus'. The area around the river Ilissos, which begins here, was settled in prehistoric times, particularly on the banks of the river.

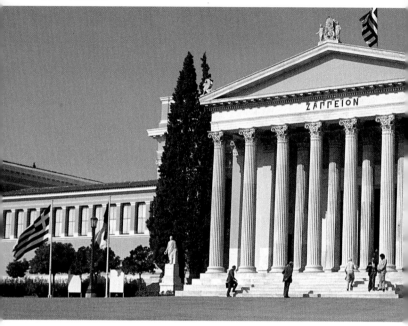

Zappeion

Excavations have revealed ruins from all epochs.

Olympieion/Temple of Olympian Zeus: SE, behind the Arch of Hadrian, but within the area enclosed by the National Park, are the colossal remains of the Olympieion. The massive columns with Corinthian capitals, the gigantic column drums on the ground in the N. section are still overwhelming in their size. It took 647 years to build this temple of Zeus Antiochus, and it was finally completed under Hadrian in AD 131&2. In 515 BC Peisistratos started a monumental building in Cara limestone on the site of an earlier temple. The fall of the Peisistrides prevented further building. In 174 BC Antiochos IV, Epiphanes of Syria, commissioned the Roman architect Cossutius to rebuild the temple. He extended its area and altered its alignment. The 15

surviving columns in the SE corner date from this period. Altogether there were 104 columns in Pentelic marble, 20 columns in double rows in the N. and S. eight sets of three one behind the other in the E. and W. After the death of Antiochus IV the building remained incomplete from 165 BC. Sulla had columns from the temple taken to Rome. The building was finally completed under Hadrian, who built a temenos wall with propylon and set up a gold and ivory statue of himself in the cella alongside that of Zeus; the temple measured 362 by 143 ft.

Stadion: In a natural dip in the ground and surrounded by trees between two hills in the National Park on the opposite side of Konstantinou Street is the horseshoe-shaped stadium which can accommodate 70,000 people. It was built in 1869–70, with

an endowment by the Greek Averoff, as the site of the first Olympic Games of the modern age in 1896, almost 1500 years after the ancient games. It was commissioned by Baron de Coubertin from the architect E.Ziller. The astonishing fact is that the rebuilding of the old Greek stadium undertaken by Herodes Atticus in 139–43 was the fairly exact model for this modern stadium. In many ways the practicality and beauty of classical architecture have never been surpassed. In order to keep the Athenian tradition despite the Olympiad the stadium was called 'Panathenaic Stadium'.

Zappeion: In the middle of the National Park, not far from the Olympieion, are the neoclassical exhibition buildings endowed by the Zappa brothers, in which the Council of Europe now meets. Close by natives and visitors recover from the summer heat and the bustle of the city in a café under the shadow of the fine old plane trees.

Royal Palace: The former palace in Herodes Atticus Street, NE of the Zappeion on the edge of the national park, in front of which an evzone (Greek soldier) in national costume still salutes at his sentry-box, was built between 1890 and 1898 by Ziller. In front of the Old Palace by Syntagma Square 2 evzones with their red caps and short white skirts stand guard over the tomb of the Unknown Soldier.

Karaeskakis: Between the Zappeion, Royal Palace and the modern stadium, in the SE corner of the park, is a square containing the momument to the national hero George Karaeskakis of 1827; he fought for the freedom of

the Greek people. Here the love of the Greeks for mythology even in the 19&20C is clear. The mother of Karaeskakis is said to have been a nun, so the legend still runs, and she bore her son without ever having been with a man. 'Now I die' it says on the monu-

ment 'and you must stand together to defend the country!'.

DIPYLON AND KERAMEIKOS

About 550 yds W. of Monastiraki Square, down the busy Hermes St.

Dipylon and Kerameikos. The numbers in the diagram show where the remains of the appropriate monuments stand, or used to stand. **1** Old city gate, known as the Dipylon **2** Sacred Way **3** NW. gate of the Dipylon **4** Boundary stones at the beginning of the Sacred Way **5** Kerameikos **6** Altar of Zeus, Hermes, and Akamas **7** SE. gate of the Dipylon **8** Fountain house **9** Pompeion **10** The river was vaulted over here **11** Eridanos **12** Propylon of the old Pompeion **13** Great gate of the new Pompeion **14** Sacred Gate **15** Various phases of construction can be clearly distinguished at this point on the wall S. of the Sacred Gate. The bottom layer is Themistokles' city wall, built of small stone blocks in the 4C, which has been excavated. Above it is the base of the wall, consisting of two rows of square blocks, which was built under Demosthenes and Lykurgos, after the defeat of Athens at Chaironaia in 338. The covered roads and fortified trenches around the city wall were constructed at the same time **16** Trench **17** Burial mound dating from the 4C BC **18** Burial mound dating from the 5C BC **19** State tomb of the Lakedaimonians and tomb of the generals Chairon and Thibrakhos, who were killed at the Piraeus in 403 BC **20** Hellenistic tomb **21** State tomb dating from the 4C BC **22** Agia Triada **23** Steam bath **24** Shrine to an unknown deity **25** Tombs for envoys from foreign countries **26** W. road **27** Sacred Way **28** Tritopatreion. This was a small temple to deities known

as the Tritopatreis, probably built in the 5C BC **29** Classical bridge **30** Classical tombs **31** Tomb of Antidosis **32** Lekythos of Aristomakhe **33** Loutrophoros of Olympikhos **34** tomb of Eukoine with a relief of renowned beauty which includes the figure of a woman holding a bird **35** Altar of Hekate **36** Tomb of Lysimakhides of Akharnai. This dates from the second half of the 4C BC and incorporates a relief depicting Charon and a votive tablet showing a funeral feast **37** Funerary column of Bion and base of a stela **38** The famous stele of Hegeso (5C BC). The original is in the National Museum **39** Tombs dating from the Geometric period **40** Tomb of Dionysos of Kallytos (4C BC). This incorporates a naiskos and depicts a bull **41** Tomb of a family from Herakleia Pontike **42** Funerary altar of Hipparate (about 500 BC) **43** Tomb relief of Dexileos of Thorikos, who was killed in the Corinthian War in 394/393 **44** Archaic burial mound **45** Tomb of Demetria and Pamphile (around 350 BC). This plot incorporates a burial mound, the stela of Dorkas of Sikyon, and a relief depicting Pamphile sitting next to her mother Demetria, as well as the loutrophoros of Hegetor, the base of the stela of Demetria, the stela of Glykera, and the memorial slab of another Demetria **46** Tomb of a family from Messene **47** Tomb of Isidoros and Zosime **48** Funerary pillar of Sosibios **49** Kerameikos Museum **50** Modern entrance to the Kerameikos area

Guard (L.), statue at the Olympic stadium (R.)

Perikles' speech
Perikles' famous speech about Athens was delivered in 431 BC, at a ceremony held at the Dipylon in honour of those killed in the Peloponnesian War. This is what he had to say about Athenians:
'We love the beautiful within the bounds of what is right, and we love wisdom without surrendering to softness. We act to turn wealth to good use, rather than boast of it in idle words. It is not shameful to confess to poverty; yet to fail to overcome it by hard work is more than shameful . . .'

'We base our actions on our own judgement and convictions. We do not consider that discussion endangers action; the danger rather lies in taking action without having been instructed by discussion . . .'
'Our views also differ from those of most people on the virtue of good deeds: for we win friends by helping others, not in seeking to be helped.'

(Thukydides, Book II of the Peloponnesian War).

(Ermou), or—even closer—crossing the railway from the Greek agora and entering Hermes St. from the S., one arrives in a dirty, grey and bare industrial zone surrounding the excavation areas of Dipylon and Kerameikos. These lie at a very much lower level than the street and thus, once entered, allow one to forget their ugly setting. The entrance is on Hermes St. in the NW of Kerameikos, right by the museum. It is worth pausing here awhile to take in the very special atmosphere which this ancient cemetery still exudes, with the church of Agia-Triada in the background, in spite of all the development, roads and unpleasant surroundings; before walking back into the half-ruined necropolis, past patches of coarse grass,

Olympic stadium

oily, green-covered pools of water, bleached dogs' skulls, between clumps of reeds and flowers, which bloom by the Eridanos stream, over ancient stony paths eastwards to the Dipylon, where one then follows the guide. First, however, one should enjoy the silence under one of the cypresses, which—in spite of the incessant distant, honking of car horns—is broken here only by the chirping of crickets, the soft scurrying of a lizard or a toad, the rustling of a snake or the sound of a giant tortoise burying itself in the leaves. Tiny ants, large, black-flecked red beetles and—here too—starving cats pass softly under olive trees, between oleander bushes, large clumps of orange lilies rise amidst the hard, pricking grass. Through these flutter splendidly coloured butterflies and larks soar up, straight as an arrow, into the deep blue sky with the blazing sun, which mercilessly parches the earth, bleaches the stones and alters the shadows of the tombs.

In this spot, seldom visited by foreigners, surrounded by famous tombs—although most are copies—it is not hard to quietly imagine oneself back in antiquity. There was once a road here, which led out of the city and bore the official name of Kerameikos, as shown by inscriptions on tombs. Here, in the depression of the Eridanos, potters had settled with their workshops since time immemorial and it is to them that the road owes its name.

Dipylon: But let us now return to the Dipylon (1), the ruins of which are still impressive and which in antiquity was the most important of the city's 15 gates. A wide through road, now built over, once led directly to the agora. There was also a military road leading from the Dipylon to the Academy, a fork of which led to the port of Piraeus, crossing the Sacred Way (2). The Dipylon was also the starting point for the Panathenaia. Here began the procession which led through the agora to the Shrine of the Goddess on the Acropolis. In the outer Kerameikos, in front of the Dipylon to the W., the citizens of Athens annually gathered for the public tomb inspection.

Kerameikos, stone vase (L.); funeral monument with bull (R.)

The site of the Dipylon was originally occupied by the *Thriasian* or *Keramic gate*, built in 479 under Themistokles. The present Dipylon, the ruins of which remain today, was finally built at the end of the 4C and extends over an area of 131 ft. by 65 ft. To the NW stood the gate (3) guarded by two massive flanking towers covering an area of almost 86 sq. ft. Thick ramparts surrounded the court. In front of the SE entrance, with two wide, closable gateways also flanked by massive towers, stood the *altar of Zeus Herkaios* (6). E. of the entrance, within the city walls, there was an ancient *fountain-house* (8), of which a few steps survive.

Pompeion (9): W. of the Dipylon and adjoining it, but within the city walls, stood the Pompeion, a building erected in the 4C BC as a kind of storeroom and preparation place for the festival processions. It was built around a court and surrounded by a colonnaded hall. On the N. and W. sides of the building, ruins of which still remain, there were dining rooms. The Pompeion was originally adorned with painted portraits of poets and a bronze statue of Sokrates by Lysippos. Diogenes is also supposed to have stayed here. The original Propylon can still be discerned to the E. (12). The Pompeion was destroyed by Sulla during his siege of Athens in 88 BC. A new Pompeion was built under Hadrian and ruins of its *magnificent gate* (13) can still be seen. This new Pompeion was destroyed by the Heruli in AD 267.

Sacred Gate (14): SW of the Pompeion stood the Sacred Gate, which spanned both the *Sacred Way* (2) and the Eridanos stream. The complex, 115 ft. by 40 ft. and flanked by two corner towers, originally dated from the 5C BC, but was continually rebuilt.

Kerameikos: In the NW foothills between the Dipylon and the Sacred

Dipylon and Kerameikos (above)
Sacred Gate (below, L.)
Stele (below, centre)
Torso (below, R.)

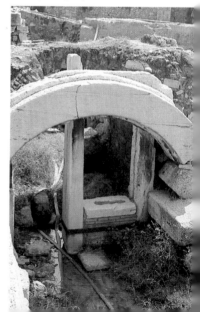

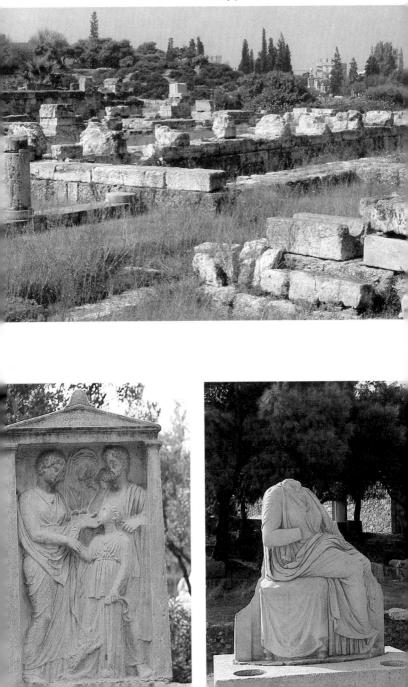

Gate lie the extensive site of the ancient burial place, the Kerameikos. The Kerameikos area served as a burial site as early as the 12C BC, first in the N., later in the S. At first, during the post-Mycenean period, the dead were laid in tombs lined with slabs. Buried with them were small ceramic objects decorated with geometric motifs. After 1100 the Doric custom of cremation prevailed. Ceramic funerary relics continued to be found, documenting the astonishing development of Attic pottery up to the famous huge Dipylon vases of the 8C. Beginning in 1871 the tombs in the Kerameikos area were uncovered by archaeologists, and despite all the destruction and infilling, they can be reconstructed as far back as the 12C BC. In the 7C the dead were buried in pit-graves, from the 6C under high grave mounds, and later (from 350) under mounds of pebbles instead of earth. From the 5C onwards the Kerameikos cemetery became famous for its monumental and splendid funerary treasures. Under Kimon it became the state burial ground. The best artists were required to make sarcophagi, stele, small temples, funerary tables, statues, epigrams and other monuments. From the early 4C the cemetery was enlarged and from then on there were also burials S. of the Eridanos. The appointments of the tombs became truly luxurious, so that—following a law in the 2nd half of the 5C ordering all burial objects to be cremated—during the rule of Demetrios of Phaleron (317–307 BC) magnificent tomb monuments were forbidden altogether. From then on only *Kioniskoi*

Four reclining lions (typical tomb sculptures in ancient times), which can still be seen in the Kerameikos. Nearly all the sculptures still standing on the site of the ancient cemetery have been cast from the originals, which are now housed in the Kerameikos Museum or, more especially, in the National Archaeological Museum ▷

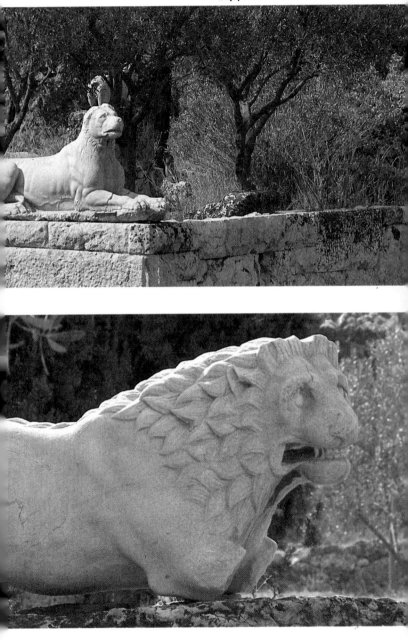

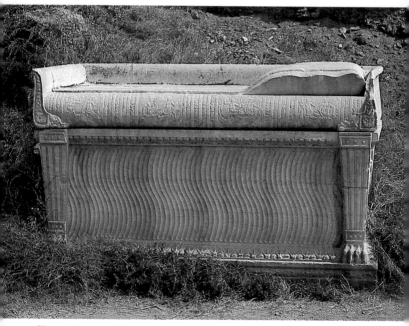

Kerameikos, sarcophagus

(small, unadorned columns) were permitted. The Kerameikos cemetery was destroyed on several occasions, notably in 480 BC by the Persians, in the 3C by Philip V of Macedon and in 86 BC by Sulla. It was often rebuilt and enlarged. In the 2nd half of the 1C houses were even built here, but these soon gave way to tombs again. The Kerameikos nevertheless remains impressive, even though the monuments now standing there are copies. The surviving original monuments are in the National Museum and the Kerameikos Museum (49), which should definitely be visited after the cemetery.

Academy and Kolonos Hill: Following the Ermou NW upon leaving the Kerameikos one reaches Plato's Academy. The exceptionally broad Kerameikos Road of antiquity led directly over the mile from the

Dipylon to the Garden of Epikouros, where the philosopher, born in 341 BC, taught. Here too Plato established his school, the Academy. This former garden suburb is now unfortunately a hideous industrial zone.

Academy: The entrance to the excavation area of the Academy is on the corner of Kratylou and Thinai and is usually closed. Furthermore, the remains of the complex are no longer very impressive. Excavations begun in 1929 revealed that the area was inhabited as early as the Neolithic period. Before the time of the Academy the area was a kind of sanctuary of the hero Hekademos, in whose honour a *heroon* was built. A house dating from around 2000 BC, which may be connected with the hero, was discovered here. In 1966 evidence of the original Academy was uncovered in the form of a boundary

Agia Triada and the Kerameikos

stone, the *Horos tes Hekademeias*, from the 5C BC. The name Academy, properly Hekademeia, is supposed to be derived from the word Hekademos. In the 6C Hipparchos built a wall around the Hekademos area. It is said of Kimon that he turned the originally arid site into a well-watered and fertile grove (Plutarch, Kimon, 13). Plato taught here from 387 BC, and his pupil Aristotle used the spot as a gymnasium. The foundations of a Hellenistic gymnasium have been found along with parts of a square court, ruins of long halls to the E., S. and W., bases for pupil's tables and fragments of honorary decrees and writing-tablets. The remains discovered here date from 500 BC to the 6C AD.

Plato taught here and so did the philosophy schools up until the time of Justinian. The Academy was closed in 529 and the building fell into decay.

Kolonos: Perikles and Sophokles were born in the Kolonos quarter E. of the Academy and this was the setting of Sophokles's last tragedy, 'Oedipus in Kolonos'.

The Kolonos is an ancient religious site. Here—on the hill amidst pine trees and agaves—there are now two monuments commemorating the archaeologists Chr. Lénormant and K.O. Müller.

THE CHURCHES OF ATHENS

History of the Orthodox churches in Athens: There have been Christians in Athens since AD 49, when the Apostle Paul came to Athens and preached on the Areopagus. The oldest surviving churches date from the 9C. In those days they were very small, so as not to provoke the Muhammadan Turks who ruled Athens.

The Emperor Constantine's Edict of Milan, 313, which legalized the Christian faith throughout the Roman Empire, provided Christianity with the opportunity to develop openly. The Athenians, whose philosophy schools were still the most important in the Roman Empire in the 5C, until Justinian finally closed them in 529 and banned the teaching of philosophy, had long resisted the infiltration of the new faith, through theoretical arguments on the one hand and their links to the old cults on the other. However, from the 6C onwards they embraced Christianity more and more.

The worship of icons corresponded to the old god cults and in many instances the new saints simply replaced the old gods. Thus God the Father was worshipped instead of Zeus, St.Nicholas instead of Poseidon, St.George instead of Ares; there are examples everywhere. The worship of images grew into adoration. Emperor Leo III finally perceived—not incorrectly—a kind of idolatry in the excessive love of these icons. From then on image worshippers were persecuted by iconoclasts. Icons were destroyed, image worshippers punished. It was an Athenian woman Irene, widow of Leo IV, who allowed image cults to begin again, whereafter she was worshipped as a saint by the people. From 815, under Leo V, the iconoclasts again held the whip hand until, from 842, Theodora, the widow of Theophilus, ended the struggle. From that time on the worship of icons was permitted again. Every year on the first Sunday in Lent the Greeks celebrate the settlement of the image dispute with the Feast of Orthodoxy.

Orthodox means true or correct faith. Until 1054 the Christian church had managed to develop relatively uniformly under the supremacy of the Pope in Rome. Then, however, during the Byzantine age two citadels of the church had resulted: Rome and Constantinople. There were differences of opinion concerning the correct interpretation of the faith. These got so extreme that the Patriarch of Constantinople and Pope Leo IX each excommunicated the other. The Patriarch, like the Pope, declared his constitution as orthodox. The splitting of the apostolic church into a Roman Catholic and an Orthodox church was inevitable. Both churches developed their own rites and customs. The Greek Orthodox Church is a self-administrating branch with its own primate, the Archbishop of Athens. Greece is moreover the only country in the world were the Orthodox faith is the state religion. The close relationship between religion and politics here has, in the course of history, not had the most positive results. The Orthodox faith has extended as far as Finland, Japan and America and, with some 150 million followers, is the third largest Christian denomination after Catholicism and Protestantism. So far there has only ever been one ecumenical council of the Orthodox Church and that was back in 787 in Constantinople.

Since then the Orthodox churches in the various countries have developed independently according to their own national needs, without influence from the Patriarch of Constantinople. In Greece some medieval rites still survive. The Holy Liturgy, for example, which corresponds to the Catholic Sunday Mass, can last up to 3 hours; it is sung and recited without instrumental accompaniment in Byzantine Greek, which for most of the faithful today is incomprehensible, and the churchgoers must remain standing (men on the right, women on the left, children in front) throughout the service. Not surprisingly attendances at church have dropped and Athenians, in particular, come and go at any time during the liturgy. Nevertheless, the faithful

Church of the Apostles, the Pantocrator ▷

constantly attend their church—even during the week—to ask the saints for support, pray fervently and, as ever, to kiss icons.

At baptism the newly-born child receives a small cross on a chain, which it will wear for all its life. Only the believer's name-day is celebrated, the birthday being almost meaningless. The Christian festivals—particularly Easter—are faithfully celebrated. The Greeks, the Athenians live with the church. Funerals, marriages, even divorces were, until recently, unthinkable without the consent of the church. But for a certain amount of time now the modern city dwellers, particularly the socialists, have resisted the tutelage of their priests, who mostly come from the country and are often less educated than the churchgoers. It was not until 1983, for example, that civil marriages were allowed. The church here, as in almost all the world's cities at the moment, is losing its influence. Nevertheless, the mentality of the Greek is as much in accordance with transcendental devotion, the belief in powers which determine his life, as

ever. Mythology flourished in Athens. Belief in the oracle in ancient times was replaced from the Middle Ages to the present day by an incredibly widespread belief, particularly here, in fortune-tellers. On an equal par stands the belief in the saints and their helpfulness when summoned with enough intensity. Athens needs its churches, and as the Dionysia and Panathenaia were celebrated in Classical times and even earlier, so the Christian festivals have also been celebrated since the Middle Ages with the same sensual rapture and spiritual incarnation. The Panathenaic processions led from the Dipylon to the Acropolis, today, on Good Friday for example, thousands of candle-carrying believers follow their archbishop and the white-robed priests, who carry Christ's bier, from the cathedral to Syntagma Square and back again. The funeral bells ring, flags flutter at half mast, school children are dressed in mauve and musicians play dirges.

Athens adores spectacle, tragic as well as joyous, and no wonder, for it was born here.

Monastiraki church

Old Metropolis

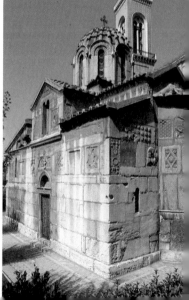

Byzantine church architecture: There are a number of very simple single-roomed churches in Athens, there are also the well-known basilicas, but the ones that most attract the European visitor are the multitude of little cruciform domed churches, the models for which are to be found in Constantinople (Istanbul). The most common amongst these is the four-columned basilica, in which the dome rests on four columns above the crossing of four barrel vaults. The four corner spaces thereby created often acquired their own, usually octagonal domes. Thus many churches present us with a large central and four small surrounding domes. The sanctuary in four-columned churches is formed by 3 apses, which in this kind of church are shut off by a very special kind of choir wall, usually an iconostasis with decorated grille, curtains, small doors, decorative plaques and little columns. Here, on the iconostasis, are placed the icons, usually painted on wood. The blank, stereotyped style of these, like the mosaics, which are to be found above all in the vaults, can nevertheless be extremely artistic and fascinating, and have hardly changed since the early Middle Ages. Many of the old churches were originally frescoed inside but much of the painting has now been destroyed. Some churches have a porch (narthex, or even an exonarthex: outer porch) built in front of the actual oratory as a preparation room. The portals and the little arched windows are mainly undecorated. The often inconspicuous façades and side-walls reward closer inspection. There are relief-like arcades, niches, cornices and patterns created by particular arrangements of the bricks. These churches survive in Athens in different variants dating from the 10C. They were constantly being built up until the 15C, and with a few differences even up to the end of the 18C.

The churches: Very early churches in Athens were built in ancient temples but their ruins were removed during the restoration of the temples and most of these are to be seen in the Byzantine Museum. In the 5C, for example, a Panagia Athiniótissa was built in the Parthenon, a church of

Old Metropolis, entrance (L.); façade decoration (R.)

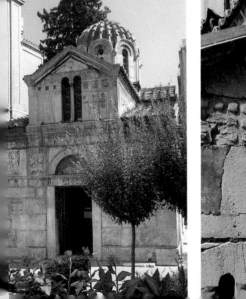

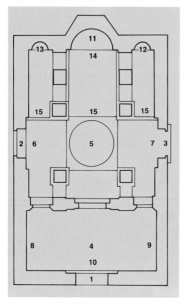

St. George in the Temple of Hephaistos and the Megáli Panagia in the Library of Hadrian. At the foot of the Acropolis there are still two churches to be found (Agios Giorgios tu Vrachu and Agios Simeon).

Most churches in Athens are closed. The key is usually kept by the sacristan in a neighbouring house.

Agia Dynamis: If you follow Mitropolis St. to Syntagma Square you will discover the little church of Agia Dynamis with its tiny porch and reliefs above the portal, which was left intact under a modern office complex that now dominates the church.

Agia Rinula: Almost completely hidden, this little church stands on Navarchor-Nikodemou St. Young girls used to pray here before school exams.

Old Metropolis 1 W. entrance **2** N. entrance **3** S. entrance **4** Narthex **5** Dome (40 ft. high and based on an octagon) **6-13** Barrel vaults. These support saddle and pent roofs **14** Apse **15** Iconostasis

Church of the Apostles 1 Main portal with decorated lintel **2** side portals **3** Narthex with 17C frescos **4** Small half-domes **5** Larger half-domes **6** Main dome depicting the Pantocrator **7** Apse **8** Iconostasis, part of which has been preserved from the original

Church of the Apostles

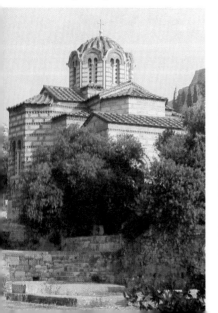

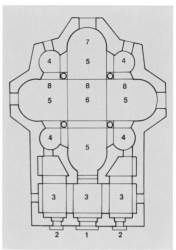

Agii Theodori: Structurally well preserved, this 11C brick and ashlar church stands on Euripides St., where it opens into Klafthmonos Square. It is a cross in square church, the dome of which rests not on columns, but on walls.

Agios Asomatos: About 330 yards W. of Monastiraki Square down Ermou St. towards Kerameikos; one sees, on the right opposite the Theseion station, this recently restored 11C church, which is in the form of a cross in square with narthex.

Agios Giorgios tu Vrachu (St.George of the cliffs): A small church near Epicharmou St., which, with its vaulted nave, probably dates from the Frankish period.

Agios Ioánnis Kolona: About 330 yards further N., parallel to Ermou St., runs Euripides St. Here stands the little 13C chapel of St.John, with a Roman column towering over the roof. John the Baptist is called upon as a healer of all sicknesses of the head. Here the faithful have affixed

votive gifts with wax to the shaft of the ancient column in thanks for help granted.

Agios Ioánnis Theológos: This beautiful 13C cruciform domed church stands at the corner where Erotokritou joins Erechtheus St., in the middle of a small square with a mulberry tree.

Agios Nikólaos Rangava: N. of the Lysikrates monument stands this 11C church (later altered), which originally belonged to the residence of the Rangava family (history informs us that this family spawned numerous Byzantine emperors and patriarchs).

Agios Simeon (right against the Acropolis cliff): Building dating from the Turkish period.

Old Metropolis church: Behind the New Metropolis stands one of the most charming churches in Athens, the Old Metropolis, also known as Panagia Gorgoepikoos or Agios Eleftherios. Tiny in comparison with the great cathedral, it lies at a deeper level

Church of the Apostles, stone relief

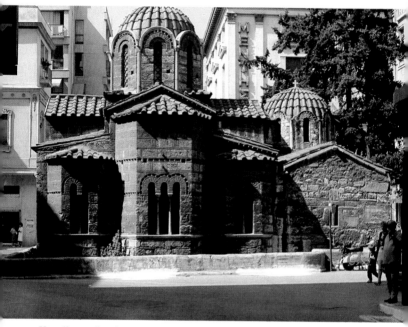

Kapnikarea church

amongst sparse patches of green. It was built in the 12C as a four-columned domed church in the form of a cross-in-square with narthex. Most unusual, but also fascinatingly beautiful in its strange but harmonious combination is the use of ancient relics from the 6&7C. On the W. side there are ancient reliefs depicting the Attic calendar of feasts, in which each feast is characterized by symbolic figures or objects. Not only old building material is used here. The Byzantine architect obviously took pleasure in the antique reliefs and effectively incorporated them into the overall structure of his little church. In 1839–42 the church was used as a library. The numerous frescos that were originally inside have almost all now been destroyed.

Anárgyri church: Lying peacefully in a park, right next to the church of Agios Ioánnis Theológos—a few steps up—is the monastery of the Holy Sepulchre with the Anárgyri church, which has a 17C baroque interior.

Church of the Apostles: This was rebuilt during the excavations in the agora in 1954–6. It was built around or before 1000 above a semicircular nymphaion and originally had four conches. The interior is remarkable with Byzantine paintings and four large and four small half-domes rising symmetrically to the main dome. The frescos in the porch, dating from around 1700, were brought here from the nearby Spyridon church. The church's outer walls are also of interest, consisting of broken masonry with brick decoration.

Kapnikarea church: 220 yards E.of Monastiráki Square along Ermou St. in the direction of Syntagma Square

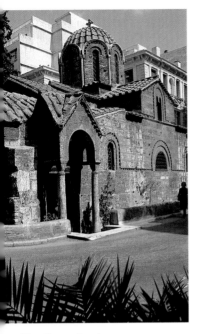

Kapnikarea church

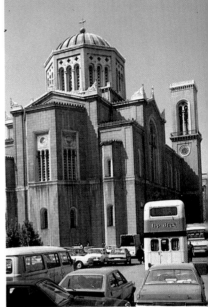

The New Metropolis

there is a beautiful cruciform domed church from the 1st half of the 11C, which was later enlarged in the 13C with the addition of a narthex and a N. side chapel. When the city was being rebuilt in classical style, this church was supposed to be demolished, but Ludwig I of Bavaria had it spared. It now stands surrounded by classical and modern houses with traffic streaming past, like a semi-submerged island in the middle of Ermou St. Of particular interest are the Byzantine *wall-paintings* inside. The mosaic in the narthex above the SW entrance only dates from this century.

Church of St.Catherine: Not far from Sotira Kottáki on Pharmáki St., E. of the Lysikrates monument stands the church of St.Catherine (Ekaterini) in a court with palm trees behind the ruins of a Roman colonnade. The dome and apses are 13C.

Metamorphosis tu Sotiros: The nearby church of the Transfiguration on Theorias St. is most interesting, with its high dome built in the 14C during the reign of the Florentine Acciaiuoli. There is a little side chapel cut into the rock (perhaps originally a grotto); an altar which is an early Christian capital; and fragments of paintings in the apse. Typical features here include the numerous metal votive plaques, lit by burning candelabras above, given by the faithful in thanks for their answered prayers.

Moni Petraki: Not far from Lykabettos there is a church, which belonged to a monastery in the 18C, but which was probably built back in the 10C. Inside the cross-domed church there are frescos by G.Markos of Argos from 1719.

Monustiri tu Pangíu Táfu: On

Erechtheus St. there is a monastery subject to the Holy Sepulchre in Jerusalem. The monastery church of Agii Anargyri (of the penniless saints) originally dates from the 17C. The carved and gilded iconostasis inside is of interest, as is the residence of the exarch (1858) behind the church.

New Metropolis church: SE of the Kapnikarea is Metropolis Square with the old and new Metropolis churches. The large cathedral was built in 1842–62 to plans by Schaubert.

Panagia Chrysokastriotissa: The church of Our Golden Lady of the castle stands at the S. end of Markou-Avriliou St. It is said that when the Turks captured the Acropolis women and children threw themselves down from the cliffs. The wonder-working icon of the Chrysokastriotissa, which is supposed to have come from the Acropolis, saved them all and conducted them unharmed to their houses. Since then the church has been a refuge for women and children in peril.

Pantanassa church: The sunken 10C basilica of the Pantanassa is on Monastiráki Square and was restored in 1911.

Philippos church: This building lies W. of Monastiráki Square.

Church of St.Paul: Near the church of St.Nikodemos on Leophóros Amalias is the neo-Gothic Anglican

Dancing youths, 425–400 BC, Acropolis Museum

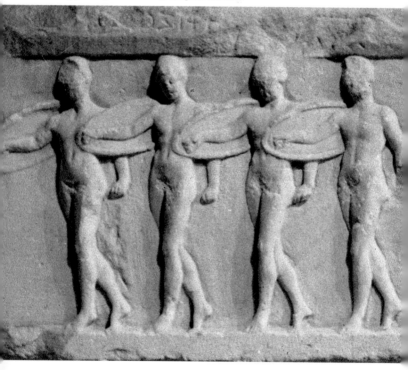

church designed by Kleanthes in the 19C.

Sotira Kottáki: SW of the latter in Kidathinéon street is a 13C church, originally cruciform and domed, but later converted into a basilica with nave and two aisles and restored.

Sotira Nikodímu (Church of St.Nikodemos): This church, built in 1045 (now Russian), stands near the Plaka on Leophoros Amalias and once belonged to the monastery of St.Nikodemos. There are surviving crypts, which to judge from their shape must once have been built on Roman baths. In one of these is the tomb of the founder. The monks' cells were destroyed in an earthquake in 1701 and in 1780 the church was damaged by the Turks. In 1847 it was acquired by the Russian state. The octagonal building with a large dome was rebuilt in 1855 by L.Thiersch and the inside redecorated along the lines of the paintings in the Dafní monastery. During the rebuilding the old material was covered with beautiful patterns made with bricks. Remarkable too is the Byzantine bell tower, which Thiersch rebuilt next to the church.

THE THEATRES OF ATHENS

Athens is the cradle of the theatre and is still home to many productions, particularly the Athens festival in the *Theatre of Herodes Atticus*. During the winter the State Opera plays in the *Olympia Theatre* (59 Odos Akademias). National Theatre productions can be seen in the winter in the *Royal Theatre* (Odos Agiu Konstantinu). In summer the Arts Theatre (Theatro Technis) also plays in the theatre of Herodes Atticus or in the *Attikon* (16 Odos Kodrigtonos), and in the winter in the *Theatro Technis* (52 Odos Stadiu). There are numerous small theatres in Athens, especially on Syntagma Square, Omonia Square and by the National Museum. Here modern pieces and folk plays are performed.

There are a few summer theatres along Leophóros Alexandras. Classical tragedies in modern Greek are also of interest to non-Greeks. Ballet and folk-dancing are performed on the Philopappos Hill, while the main venues for concerts are the *Kotopuli Theatre* (Odos Panepistimiu) and the *Parnassus Hall* (Platia Karytsi).

THE MUSEUMS OF ATHENS

National Archaeological Museum (1 Tositsa St.): The National Museum, one of the most famous museums in the world, lies NE of Omonia Square, with its entrance in Tositsa St. and a park separating it from Patission St.

It has the world's most precious collections of sculptures and pottery from archaic, classical and Hellenistic Greece and all the major finds from ancient Greece are assembled here. Only in Delphi, Olympia and Crete have the excavated finds been left in situ. However, it has recently been decreed that finds be left near the site of their discovery.

Ancient Greece, especially Athens, figured large in the accounts of pre-Christian writers from Homer onwards. Then, in the early 19C archaeology gradually established itself as a branch of knowledge, first for amateurs and then as a science proper. First German, then French, American and in recent times Greeks for the most part began excavating and evaluating the finds.

A first archaeological museum was established in a former orphanage on Aegina in 1829. In 1837 the best antiques from this museum were brought to Athens and set up in the Temple of Hephaistos alongside excavations from Athens itself. The space soon became too small. Buildings on the site of Hadrian's Library and the Tower of the Winds had to be used as exhibition rooms. Finally Eleni Tositsa offered a piece of land on Patission street and financial dona-

tions made the building of a special museum possible. The present building was begun by L.Lange of Darmstadt (1808–68) in 1860 and finished in 1889 in neo-Grecian style under E.Ziller. The building was enlarged with extensions in 1925, then in 1935–8 and again after World War 2.

Summary

On the ground floor, rooms 4–6 exhibit the prehistoric collections, Mycenean art and Cycladic art. In rooms 7–13 archaic art (including the Geometric period) is exhibited. Rooms 14–21 display early and high classical art, rooms 22–31 late classical and Hellenistic art. Room 32 houses the A. and H.Stathatos collection, and room 35 the K.Karapanos collection with finds from Dodona. There are small bronzes in room 36, Roman art in rooms 38–43 and large bronze statues in room 40. On the upper floor are the collections of vases, wall paintings (from Santorini) and exhibits from the National Museum of Cyprus in Nicosia.

Detailed guide to the major works of art (following the plan—from No.4 onwards the numbers on the plan are the same as the room numbers)

1 Entrance

2 Sales kiosk

3 Entrance hall

4 Mycenean collection

After Heinrich Schliemann had made his world-famous discoveries in Mycene (5 shaft tombs) other archaeologists continued to excavate the site. In 1951–4 a further circle of 24 tombs, including 14 shaft tombs, was discovered. Thanks to these excavations and also to known historical events (volcanic eruption of Thera, 1500 BC) three major periods have since been differentiated: Early Mycenean period: 1600–1500 BC, middle Myce-

nean period: 1500–1400 BC, late Mycenean period: 1400–1100 BC.

In the first central room (4) are Schliemann's grave finds from Mycene (right at the beginning in case 3), including the Mask of Agamemnon (No.624). Of particular interest in case 5 is a find from the later circle, a rock crystal vessel (No.8638), which came from the grave of a woman and is shaped like a duck. The varied and elaborate techniques of the Mycenean craftsmen, particularly the metal and ivory pieces, but also, for example, the fragmented wall paintings. The works are not arranged chronologically, but according to where they were found. Room 4, which is devoted to one of the greatest European cultural epochs after the Cretan, the Mycenean, leads into the adjoining room on the left, where the oldest Greek finds are displayed, finds from a primitive culture, which existed long before the Mycenean.

5 Neolithic collection

Thessaly, Phithiotis, Boeotia, Lokris, Limnos, Troy and Attica have yielded the earliest examples of Greek culture: utensils such as tools, e.g. axes, pottery, some already with colour decoration, but also jewellery and idols depicting the deities. The available finds only allow for a very rough, mainly conjectural subdivision of these earliest Greek epochs, but they are generally ordered thus: Pre-ceramic Neolithic period: 6100–5800, old Neolithic period: 5800–4300, new Neolithic period: 4300–2700.

6 Cycladic collection

The ancient Greeks called the islands the Cyclades, because they form a sort of circle around the sacred island of Apollo. In prehistoric times a separate culture developed there, which was quite different from that of the mainland. It was called the Cycladic culture by its investigator, the archaeologist Christos Tsountas. He also divides it into 3 epochs: Early Cycladic: 3200–2000 BC, Middle Cyc-

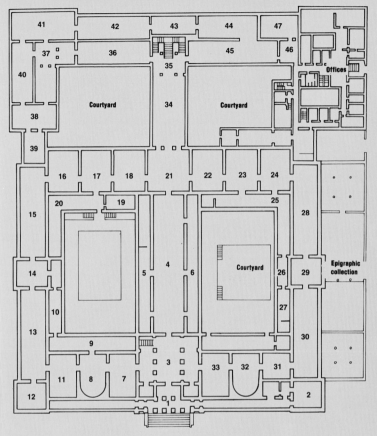

National Archaeological Museum. The numbers
in the diagram are referred to in the text.

The treasures of Mycene

Heinrich Schliemann was a rich businessman able to indulge his hobby of investigating old writings. In the play by Sophokles, Orestes' tutor speaks rhapsodically of 'Mycene rich in gold'; and Schliemann did indeed suspect the existence of golden treasures here. Mycene, whose story had been related by Homer and is still taught in every school, was the setting of the fearful legend of the house of Atreus, which told how Klytemnestra and her lover Aigisthos murdered her husband, King Agamemnon (son of Atreus) on his return from the Trojan War, as well as killing the prophetess Kassandra. In consequence of this, Orestes, the son of Agamemnon and Klytemnestra, murdered his own mother. He was then pursued by the Furies until he found his sister Iphigenia, whom Agamemnon was supposed to have sacrificed at the beginning of the Trojan War, now living on the island of Tauris. Elektra, Orestes' other sister, was left the role of witness and principal victim of these dreadful events.

Man has been moved ever since by the story of this tragedy. In modern times, it has been treated over and over again, from the baroque period until the present day. Examples which might be cited from among many are the 'Iphegenia' of Gluck and Goethe, Richard Strauss's opera 'Elektra', and the 'Orestes' by Henk Bading. So it is not surprising that when Heinrich Schliemann began his excavations, his particular interest was in Mycene. He actually started in Troy in 1871; then he excavated Mycene in 1874 and again in 1876. On this last occasion, he very soon came across some royal tombs which he believed to include the tomb of Agamemnon (a view which he thought was corroborated by Pausanias). Here he dis-

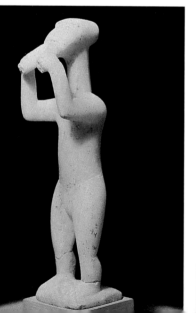

Cycladic marble statue, N.A.M.

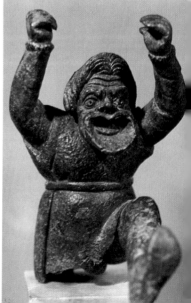

Bronze statue from Dodona, 4C BC, N.A.M.

covered such a rich archaeological treasure that he was led to write 'This treasure alone is enough to fill a large museum, which will be the most brilliant in the world and will attract myriads of foreigners to Greece from every country throughout the coming centuries . . .' Heinrich Schliemann was not altogether wrong, even if it was not necessarily the tomb of Agamemnon.

ladic: 2000–1600 BC and Late Cycladic Culture: 1600–1100 BC. Of particular interest here are the idols, small or large clay or marble figures, symbolizing male or female deities. No.3908, the harp player, and No.3910, the flautist from Keos, are like modern abstract sculptures. These figures were originally colourfully painted. Remarkable too are the so-called 'Cycladic pans', which are flat on the outside and decorated with geometrical and pictorial patterns. The purpose of these implements is still not entirely clear. They were probably of religious significance, but they might perhaps also—filled with water—have been used as mirrors. Next to these are utensils and fragments of wall paintings.

The succeeding rooms show Greek sculpture from around the 8C BC until the Hellenistic period. The Golden Age of the Greek civilization comes back to life in these rooms. In their temples, perhaps also in their painting, almost all of which is lost, but above all in their sculpture, the Greeks, particularly during the classical period, attained a cultural peak not reached again until Michaelangelo in the Renaissance, and otherwise never really equalled.

7 Nikandra Room

Here, alongside early statues from the Daedalic period, an enormous vase from the 8C BC is exhibited, which came from the Dipylon and was used as a funerary urn. The early pottery

Harp-player from Keros, N.A.M.

Archaic metope from Mycene, N.A.M.

Daedalus

Daedalus, the father of Icarus, was described by ancient writers as an outstanding architect and the man who invented statues. His statues were said to have a lifelike appearance. In fact, the wooden xoana, or idols, which were displayed in temples, existed long before Daedalus, as did small statues fashioned out of clay, bronze, and ivory. Large marble statues must also have been known before his time. It is possible, however, that Daedalus was the first sculptor to breathe life into these stiff figures. Perhaps he was the first to give the images of the gods and sphinxes that inimitable smile, at once beguiling and unapproachable, which distinguishes many statues of the archaic period. His name has been used to describe early monumental sculpture in Greece. He must have been a universal genius, like Leonardo da Vinci. His invention of wings is supposed to have brought about the death of his son.

Although Daedalus is a mythological figure, his story, like those of all heroes of legend, may contain some element of truth; he may even have genuinely been a great artist. According to the ancient writers who describe him, his skill and inventiveness had earned him a great reputation. But then he is supposed to have killed his nephew, who had himself invented the saw, dividers, and the potter's wheel, and was expelled from Athens. He fled to Crete, where he was commissioned by King Minos to build the labyrinth at Knossos for the minotaur. According to tradition, he also gave Ariadne the thread which she passed on to Theseus, thus enabling him to escape out of the maze. King Minos punished him for this by imprisoning him and his son Icarus in the closed labyrinth. It was then that Daedalus invented wings and made a pair each for himself and his son as a means of escape both from the maze and from Crete. However, according to the story, Icarus flew too close to the sun, and the wax, by which the feathers had been glued together, melted, causing Icarus to plunge into the sea. Ever since then, the island near this spot has been called Ikaria. A later version of the legend relates that Daedalus landed in lower Italy in a mood of despair and later died there.

art here is as remarkable as the painting of the vase. Three statues, No.776, are from a Dipylon grave and must date from around 750 BC. Along with other statues here there is also the Nikandra of Naxos, which dates from the 7C BC and has an inscription engraved on the left side relating that the figure is an effigy of the goddess Artemis and that the glorious Nikandra family have donated the statue of the goddess.

8 Room of the Kouros of Sounion

Kouros is classical Greek for boy or young man. This expression for the archaic Greek figures of youths was first used by the Greek archaeologist Vasilios Leonardes at the end of the 19C, when an expression was being sought for these comparatively stereotyped figures: naked youths with the left foot forward as if walking. The kouroi and their female counterparts, the kore, were set up on pediments and served as votive gifts or as column figures, as in the Erechtheion, throughout Greece and also in the Greek colonies. Alongside other exhibits there is the colossal kouros

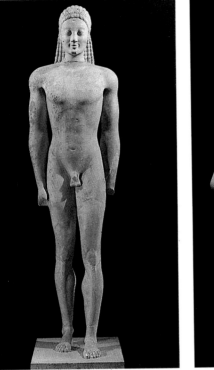 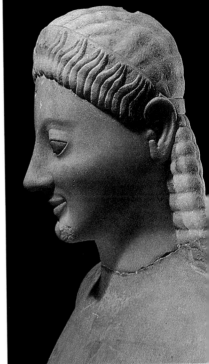

Kouros from Volomandra, 550 BC, *N.A.M.(L.); detail (R.)*

(No.2720), which was excavated at the Temple of Poseidon on Cape Sounion. There it had been buried since the destruction of the archaic temple by the Persians in 480 BC.

9 Phrasikleia Room

Here, alongside others, is a kore (No.4889), which was found in Merenda, Mesoghia in 1972, on the base of which is engraved: 'The tomb of Phrasikleia. I will always be called kore, a name, which the Gods gave me instead of marriage'. This kore, which stood on the tomb of Phrasikleia, was—as can still be seen on a few remnants—painted, as indeed all Greek sculptures probably were.

10 Room of the Kouros of Volomandra

The main feature of this room is the kouros (No.1906), which stood on the tomb of a young man in Volomandra in Attica. It was carved from Parian marble around the middle of the 6C BC and it already shows features of the development of archaic into classical art. The head is particularly accentuated and the muscles are sculpted rather than inscribed, as the older kouroi were. The figure, in short, becomes more life-like. Following the Persian Wars the Athenians—according to Thukydides—at the exhortation of Themistokles hurriedly built a wall around the city. This wall

incorporated old tomb stele from Kerameikos and fragments of these stele have been recovered from the remains of the Themistoklean wall (see Nos.2687 & 2891).

11 Room of Aristion

This room contains the famous tomb stela of Aristion, made by Aristokles at the end of the 6C, as is shown by an inscription on the stela. It depicts a male figure dressed as an Athenian hoplite with chiton, armour and greaves. The stela was found in 1838 in Velanideza, Attica.

The Greek sculptors perfected the elaborate art of the relief as well as that of sculpture in the round.

Also to be seen in this room is a marble mask of Dionysos from around 520 BC, which came from the Sanctuary of Dionysos on Ikaria. It was formerly hung from a tree and robes were draped as if around a body below it, so forming the cult image of Dionysos Dendrites.

12 Room of the running hoplite

The figure on the relief of the 'running hoplite' (No.1959) from the end of the 6C BC, earlier thought to be Pheidippides, the Athenian messenger who brought the news of the victory at Marathon, is now considered to be performing a war dance.

The 'Glyptothek' in Munich contains figures from the pediment of the Temple of Aegina. In 1903 further statues of an even older pediment of the same temple were discovered and brought here (Nos.1933–8).

13 Room of Aristodikos

Exhibits here include a kouros from Attica, which stood on the tomb of Aristodikos (3938). Archaeologists date it back to the year 500 BC and even presume that it may have come from the Acropolis workshop in Athens.The base of another kouros (3476) is remarkable for its reliefs depicting the life of the epheboi in an Athens gymnasium. The kouros belonging to

this base, dating from around 510 BC, probably stood on the tomb of a young ephebos in Kerameikos.

14 Room of the ephebos crowning himself

Of particular interest here is the beautiful relief (No.3344) of a young athlete crowning himself. Coming from Sounion (c. 460 BC), it was a votive gift to the goddess Athena. The metal crown, which originally adorned the athlete's head, was affixed by means of the holes that are still clearly visible in the relief.

15 Room of Poseidon

In this room, containing superb sculptures, the visitors attention is held above all by the excellent, imperious bronze statue of the god Poseidon, which must have been made around 460 BC. It is attributed to the sculptor Kalamis but this is not absolutely certain. In 1926 fishermen from Skiathos found the left arm of the statue in open sea off Cape Artemision, Euboea and in 1928 the remainder was found. It was clearly being carried by ship—possibly to Rome. Did the god hurl the trident, which he had held, and unleash the storm, which caused the statue to sink into the sea for over 2000 years?

16 Room of the Myrrhine

Exhibited in this room are the incomparably beautiful Attic grave monuments—not only sculpted figures and stele, but also marble vessels in the form of lekythoi, such as the Myrrhine (No.4485) with its beautifully carved relief, or loutrophoroi. Sculptures of animals, such as lions, were also placed on the tombs. Of particular interest is the moving grave stela (No.715) from Salamis or Aegina depicting an ephebos.

17 Room of Ramnús

Amongst other items here are the

Tomb of Hegeso, Kerameikos ▷

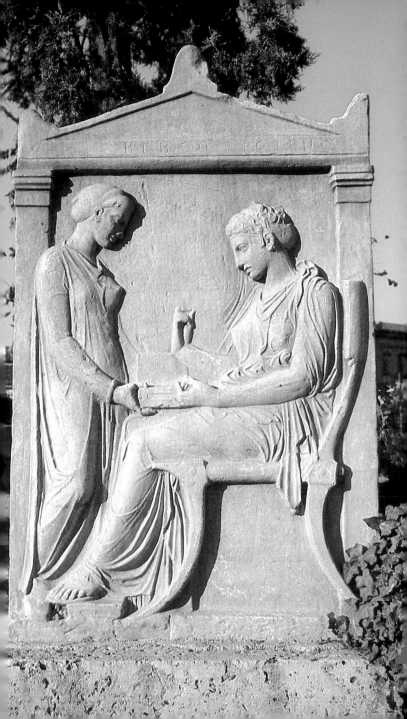

Athena Parthenos
Pausanias provides the following description of this statue, which stood 39 ft. high and was the principal attraction in the Parthenon: 'The statue itself is made of ivory and gold. The helmet is decorated at its peak by a sphinx, with griffins in relief on either side. The statue shows Athena standing erect in a chiton which reaches down to her feet. On her breast there is a medusa carved in relief on ivory. She is holding a Victory in one hand which is roughly four cubits high, and a spear in the other. There is a shield at her feet and a snake near the base of the spear, which must be that of Erichthonios. The plinth of the statue shows a relief of the birth of Pandora.'

Pliny reports that 'there was a relief showing the Battle of the Amazons on the convex side of the shield, and, on the concave side, a representation of the battle between the gods and the giants; on Athena's sandals was depicted the battle between the lapiths and the centaurs.'

Plutarch adds that, in the relief on the shield representing the battle of the Amazons, 'Pheidias introduced the figure of himself, as an older, balding man picking up a stone, and, marvellously executed, that of Perikles fighting with an Amazon.'

remains of ancient Demos, the famous Sanctuary of Ramnús.

18 Room of Hegeso
Along with other funerary monuments, this room houses the famous stela from Kerameikos with the relief of Hegeso (No.3624). The slave girl stands here in front of her dead mistress, whose name is engraved under the pediment: 'Hegeso of Proxenes'.

A charming and also sad image of restrained but deep expressiveness, the stela dates from around 410 BC.

19 and 20 Rooms of the Varvakeion Athena
Displayed in these rooms are antique copies of the best-known works from the 5&4C BC. The most famous of these was probably the statue of Athena by Pheidias, which stood in the Parthenon. The marble copy of this Athena is reduced to one twelfth the size of the original and is known as 'Varvakeion Athena' (No.129). It was made in the 2 or 3C AD and conveys at least a weak impression of the original, which is known to us above all through the ancient poets.

21 Room of Diadumenos
This room, the central room behind Room 4 with the Mycenean collection, contains, above all, an extremely expressive bronze statue (No.15177), which was salvaged from the cargo of a ship stranded off Cape Artemision in ancient times. The statue is of a small boy riding a horse at full gallop; both are in an extreme state of exertion, with all their muscles tensed. This is an extremely expressive, superbly structured sculpture, which was probably made in the middle of the 2C BC. There is also a remarkable copy here from the 1C BC depicting the youth Diadumenos, which was made after an original by Polykleitos from the 5C BC.

22 Epidauros Room
Displayed here are finds from excavations of the famous Asklepieion at Epidauros, which was discovered in 1882–6 by the Greek archaeologists Panayotis and Kavvadis.

23 and 24 Rooms with funerary reliefs from the 4C BC
Particularly beautiful and expressive here are the so-called 'departure stela' (No.870) from Athens and the 'Ilissos stela' (No.869), both from the 4C BC. According to Cicero, as early as the

6C BC the building of over-large, sumptuous funerary monuments in Kerameikos was forbidden. Thus it is not until after the middle of the 5C that we again find grave stele, vessels and sculptures assuming monumental proportions, with entire temples being built around some tombs. No wonder that Demetrios of Phaleron, a Peripatetic philosopher, who ruled Athens from 317 to 307, again forbade excessively luxurious funerary monuments and only small ones were allowed.

25–27 Rooms with votive reliefs and decrees
Here reliefs and, in particular, inscriptions, shed light on antiquity.

28 Room of the Aristonautes
Outstanding among the various funerary monuments here is No.738. 'Aristonautes Archenauto Alaieus' is engraved under the pediment of this stela from *c.* 310 BC, which depicts a hoplite and is one of the last Attic funerary carvings of the 4C BC.

29 Room of the youth of Antikythera
In 1900 the cargo of a sunken ship was discovered at Antikythera, which included works of art from the late classical and Hellenistic periods. After repeated attempts, the parts of a bronze statue, the 'Youth of Antikythera', which had been cast around 340 BC by a great sculptor, were reassembled.

30 Room of Themis
A statue of Themis (first half of the 3C BC; No.231), which was found in a small room, probably dedicated to Themis, goddess of Justice, in the great sanctuary of Ramnús, is displayed here, as are parts of the giant statues made by the sculptor Damophon in the 2C BC in Lykosura. Also note the marble head of the orator Demosthenes, a copy from the 2C AD (No.327) based on an original from the 3C BC.

31 Room of Poseidon of Melos
The ship which sank at Antikythera, the treasure of which was discovered in 1900, was also carrying an interesting bronze head from the 3C BC (No.13400). Many experts believe that the head is supposed to represent the Cynic philosopher Bion. Bion was a slave in Athens, but was freed and then lived in the court of the Macedonian King, Antigonos Gonatas. His main aim was to fight passion and prejudice. The head is expressively and realistically fashioned. In the same room stands the over life-size, but much less impressive statue of Poseidon from Melos (310 BC).

32 Room with the Eleni Stathatos collection
This room contains an excellent collection of jewellery from antique and Byzantine times, which was donated to the museum by Eleni Stathatos in 1957.

34 Room of the Altar of Aphrodite
Contained here are an altar from the 2C BC, votive reliefs and sculptures.

36 Room housing the Karapanos Collection
This collection has bronzes from archaic and classical times. There are also finds from the ruins of the Sanctuary of Zeus at Dodona: fillets, tripods and idols.

37 Room with bronzes from Olympia
There are bronzes here from various places, but particularly from the old religious shrine of Zeus, Olympia; where, from early times (from 776 BC) the Olympic Games were held every four years in honour of the god. The contestants, who gathered from all parts of Greece, brought Zeus bronze votive gifts in the form of human figures, animals, vessels, jewellery etc, which now, following their excavation, are of great cultural and historical value.

38 and 39 Rooms with Roman sculptures

40 Room of the boy of Marathon
Here are the four over-large bronze statues, the marble vase and the tragic mask, which were discovered during excavations at Piraeus in July 1959. The statue of Apollo dates from 520 BC, the sculptures of the three goddesses date from the 4C BC. The mask may have been the work of Silanion (4C BC).
The most significant work in room 40, however, is the bronze statue of the 'Boy of Marathon'. This harmonious, graceful figure, representing the god Hermes, is thought to be the work of Praxiteles. It was discovered in June 1925 by fishermen in the Gulf of Marathon. Pulling their heavily laden nets into land, they found not fish, but one of the most beautiful statues of the 4C BC (No.15118).

41–43 Rooms with collections of sculpture from Roman times
Upper floor
The large staircase leads to the upper floor, which is mainly of interest for its unbelievably lavish collection of vases. After the Greek sculpture on the floor below, Greek pottery and and painting can be admired here. Indeed Greek painting has only survived in the form of vase painting. The collection which greets one at the top of the stairs, the finds from the excavations on Thera, is also extremely interesting.

48 Room with the finds from Thera
Around 1500 BC a massive volcanic eruption destroyed the island of Thera. From 1967–74 the archaeologist Sp. Marinatos carried out excavations on Thera, during which he discovered on Akrotiri a prehistoric town, which had been buried some 3,500 years earlier. Squares, streets, houses with wall paintings, household utensils and other items were unearthed. A culture influenced by

Crete and Mycene, but nevertheless entirely independent, full of life and expression, can be seen from the finds displayed here.

49 Room with Geometric ceramics
Geometric pottery is divided into Protogeometric (1000–900 BC) and Geometric (900–700 BC). The most common form of Protogeometric pottery, ahead of all other kinds of vase, is the amphora, a vessel with two handles. After the comparatively naturalistic Mycenean decoration, here we see parts of the vase painted with black geometrical patterns: semicircles, rhomboids, triangles, straight lines etc. Protogeometric and Geometric vase painting was developed by the Dorians, but actually first flourished in Attica. In Geometric pottery almost the whole vessel is painted with geometrical patterns. The large funerary amphorae also have depictions with several people and animals in connection with the death cult. However, even the figures are purely schematic and usually depicted with the help of geometric forms; the essential feature being the symmetry of the arrangement and the sequential character of the images.

50 Room with Geometric and Orientalizing pottery
Along with Geometric pottery, Orientalizing pottery also established itself, particularly in Corinth. In this form figures, animals and human shapes, often combined to represent mythological events, were etched into the vessel. In the mean time, however, Attic pottery had established itself to such an extent that Orientalizing pottery is only found up until 550 BC.

51 Room with vases from Anagyrus
After the Geometric style Protoattic pottery developed in Attica from about 710–600 BC. In this style black

Black figure vase, 6C AD, N.A.M. ▷

figures were already being painted on light-coloured vases. Geometric and Orientalizing elements were equally influential. Such vases have mainly been found in Kerameikos, but also in Aegina and in Anagyrus, modern Vari, in Attica.

52 and 53 Rooms with black-figure pottery from the 6C

From 600 to 480 BC Attic pottery reached its height. The figures were painted in black on light-coloured vases, incised lines define anatomical details, garments etc. White and purple were already being used to distinguish the ever changing patterns and figures. In cases 35–7 there are also antiques from the Heraion, the sculptures from which are displayed back in Room 17. Other cases exhibit vases from Corinth, Thessaly and Sparta. There are also painted metopes from the Temple of Apollo Thermios in Aetolia, which date from the 7C BC and are the only surviving remnants of great paintings from the archaic period.

In room 53 there are also 2 painted

Black figure jug, 5C BC, N.A.M.

clay sarcophagi from Klazomenai (7 or 6C BC).

54 Room with black- and red-figure pottery

Between 530 and 320 BC red-figure pottery gradually took over from black-figure. Particularly around 500 BC the quality of vase painting increasingly improved. In red-figure painting the figures were drawn with fine black lines on the unpainted surface of the vase. The background was then painted in black, to emphasise the light figures. Vases made between 530 and 480 BC were painted in the 'vigorous style'. Working at that time as masters of vase-painting were such famous artists as the Andokides master, who studied under Exekias and who is supposed to have been the first to produce red-figure vases, Psiakas, Oltos, Euphronios, Euthymides, Smikros, Epiktetos and Duris. After the 'vigorous style' came the 'delicate style' (480–380 BC). Artists such as Hermonax, the Pan painter, the Penthesilea painter and the Achilles painter were then active. In the 4C the slow decline of red-figure Attic vase-painting can be observed and a new style, the 'Kertch style', established itself between 370 and 340 BC.

55–56 Rooms with white ground lekythoi and the Epinetron from Eretria

Along with Attic pottery, the white ground lekythoi had established itself around 470–400 BC. These are tall, narrow, white-painted vases. The outlines of the figures are drawn in black lines on the white ground. The large images of people or objects were then painted in various colours. The white ground lekythoi mostly come from Athens and the rest of Attica, but also from Erétria and a few even from Cyprus and Sicily. The technique of white ground lekythoi was also used sporadically in drinking-cups, for example. Case 81 displays works by the most important masters

Agora Museum. The map is of the great long room in the Stoa of Attalos which houses the exhibition, but there are also statues outside the museum and outside the rooms, on both sides of the peristyle of the Stoa, and they are described here as well. **1** S. of the Stoa of Attalos in the front at the W. corner is the torso of a colossal statue with long chiton. This Apollo Patroios is said to be the work of Euphranor (4C BC) **2–7** There follow from S. to N. in front of the enclosed Stoa building: **2** an Ionic capital, **3** base of the statue of Ilias and **4 and 5** 2 torsos from the library of Pantainos (c. 100 BC), **6** a colossal statue of the Hellenistic period and **7** the statue of a woman from Eleusinion dating from the 4C BC. **8** Further on, working from S. to N. by the central row of columns is an inscribed stela dating from 336 BC. **9** Outside the building a statue of a goddess, c. 400 BC **10** Again by one of the central columns marble base of a sacred tripod from the Hellenistic period. Represented on its three sides: Theseus, Aigeus and Medea. The rest of the numbers relate to the above plan; 20 and 21 are by columns in the central aisle (roughly opposite 17 and 22). **11** Nereid, probably the acroterion of a temple roof. Notable work, close to the style of the sculptor Timotheos (c. 400 BC) **12** Statue, presumably Aphrodite (late 4C BC) **13–14** Statue of Aphrodite with erotes (Hellenic period) **15–19** Fragments of sculptures and torsoes of statues from the Temple of Hephaistos **20** Torso of a youth (c. 500 BC) **21** 2C BC statue of a nymph from the Nymphaion. Copy of a classical model **22–23** Fragments of reliefs from the balustrade of the altar of Ares (440–430 BC) **24** Statue of a goddess with Doric peplos and Ionic chiton. Roman copy of a classical work **25** Inscribed base and relief in honour of the warrior Krates, son of Heortios (4C BC) **26** Portrait of a Greek philosopher. Roman copy of a Hellenic work **27** Statue base of the philosopher Karneades, the founder of the New Academy **28** and **30** are further to the N.; **29** and **28** are opposite by a central column and **31** is in the NW corner of the Stoa **28** 2&3C AD portraits **29** Inscribed stele **30** Colossal head, perhaps a

portrait of Aelius Verus or Septimius Severus (2–3C AD). Description of the objects inside the museum: **32–35** Mycenean vases and idols **36** Mycenean amphoras **37** Vase **38** Grave goods from a domed grave on the Areopagus (1400 BC) and Mycenean grave ceramics (1450–1350 BC) **39** Case with gifts from a Mycenean prince's grave from the N. side of the Areopagus (14C BC) **40** Case with grave goods from a Mycenean prince's grave **41** Protogeometric vases **42** Grave of a little girl from the N. edge of the Stoa of Attalos (c. 1000 BC) **43** Protogeometric ceramics **44** Late Geometric ceramics **45** Model of a granary **46** Late Geometric ceramics **47** Grave goods from a tomb on the E. side of the Agora from the Geometric period **48** Late Geometric ceramics **49** Pyx with horse and other objects from the Geometric period **50** Early Attic vase painting of the 7C **51** Votive offerings from an archaic shrine **52** Clay mould for statue of Apollo **53** Case with bronze court voting plates, stone and metal weights of various eras **54** Sculptures of heads **55** Various inscriptions from the Agora **56** Water clock for checking the time at court (5C BC) **57** Kleroterion, ballot urn, used by the Council of the 12 Phyles **58** Carved vase in the form of an athlete (6C BC) **59** Vases with black and red figures **60** Krater by the vase-painter Exekias c. 530 BC **61** Various late-6C vases, including some with pictures of Epictetus, Gorgos etc. **62** Bronze shield, Atheus' booty from the Spartans in the Battle of Sphakteria (425 BC) **63–64** Ancient child's chair **65** Bronze head of a Nike **67** Shards of Ostrakismos **69** Ancient household goods **70** Case of coins found in the Agora **74–77** Terracotta **78** Vases of the Hellenistic period **79** Various sculptures from the Acropolis etc. **80** Hellenistic ceramics of the 2C AD **81** Ancient masks **82** Byzantine ceramics **84** Ancient portraits **86** and **87** Byzantine ceramics **88** Statue of a satyr with flute. Roman copy of a 3C BC Hellenistic work **90** 3C BC male portrait head **91** Case containing objects found in a deep well in the Agora, and dating from the 1–10C AD

of this technique, the so-called Achilles painter. Also displayed here in case 103, apart from red-figure vases, the funerary stela of Pyraichme, idols and other items, is the famous red-figure epinetron (implement for carding spun wool) of Erétria, dating from 425 BC.

Agora Museum (24 Adrianu St., inside the Agora excavation area): In 1956 King Paul opened this museum in the rooms of the Stoa of Attalos (see entry). Most of the finds made in the excavations of the agora region since 1931 have been assembled here. Statues, terracottas, bronzes,

reach the entrance go down the hill and turn left. Exhibit (1) is in the entrance hall.

I In the first three rooms of the Museum are the finds from the so-called 'Persian rubble' (480), mostly architectural fragments from ancient buildings. There are also remains of coloured painting on sculpture and parts of buildings. **2** Archaic sculpture of a lioness tearing a calf to pieces, dating from the 6C BC. **3** Head of the Gorgon, originally from an archaic temple c. 580 BC.

II Rooms with finds from the 'Persian rubble' **4** Part of a small poros pediment with an archaic relief of the introduction of Herakles to Olympos. Zeus receives his son **5** Pediment sculpture: Herakles fighting the Triton **6** Typhon **7** The calf bearer, one of the most important works of art of the archaic period **8** Archaic quadriga from the pediment of an archaic temple, presumably the old Athena temple on the Acropolis.

III Room of archaic finds **9** Large lion group from the pediment of an archaic temple (c. 570–560), possibly the old Athena Temple on the Acropolis. **IV** Room with works by the sculptor Phaidimos and room of the korai **10** The rider Rampin. Attic work by Phaidimos. Only the torso is on show here, the head is in the Louvre in Paris (56–550). This is the first European equestrian statue, and is in marble. **11** Peplos kore. Very beautiful kore, named after her clothing (she is wearing a peplos over her Doric chiton). She dates from c. 530 BC and is also attributed to Phaidimos. **12** Late archaic kore from the island of Chios **13** Kore dating from c. 500 BC. The famous smile of the archaic period has faded in this mysteriously serious figure. One of the first korai of the classical age.

V Room of the Gigantomachia **14** Monumental statue well over 6 ft. high, the famous kore of the sculptor Antenor, dating from c. 520 BC **15** Gigantomachia. Fight of the goddess Athena with the giants, pediment sculpture from the archaic Temple of Athena, c. 525 BC **16–22** are showcases; **16** Ceramics from the 8–6C BC, mostly tomb ceramics from tombs S. of the Acropolis **17** and **18** vases with black figures from the 6C BC **19** Archaic marble sculptures from the Acropolis **20** Attic black-figure ceramics and idols **21** Red-figured lekyths with white backgrounds from the 5C BC and fragments of lutrophores **22** Small marble and clay sculptures and wooden blocks from the central holes of the Parthenon's column drums

VI Works from the late archaic period and in the 'severe' style **23** The famous carved relief of mourning Athena, found in 1888 S. of the Parthenon and dating from c. 460 BC **24** So-called 'blond head', head of a once-painted marble statue, c. 480 BC (fine portrait, with serious, thoughtful expression) **25** Kritios boy, excellent early classical statue of a youth in Parian marble, found on the Acropolis and dating from c. 480 BC.

VII Room with fragments of the Parthenon sculptures **27** Male figure from the SE corner of the W. pediment, presumably symbolizing the Ilissos river **28** Female torso from the E. gable, probably Selene driving her team towards the sunset **29** Metope.

VIII Room with fragments from the Parthenon frieze. The Parthenon frieze was much admired even in ancient times and was the largest in anti-

Acropolis Museum: The Roman numerals are room numbers, the Arabic numerals identify particular works of art. **1** The Acropolis Museum is on the SE side of the rock, and is set rather low, so that it is not particularly obvious where it is. To

que art. It was over 500 ft. long, and ran around the outer wall of the cella. It represented the Panathenaic procession. The sculptor of the work, one of the greatest in the entire history of culture, was Phidias. **30** Part of the E. frieze of the Parthenon, showing the sacrificial procession with sacrificial animals, athletes, water carriers and musicians, orators, chariots, riders and armed men **31** Sacrificial animals **32** Youths with amphorae **33** Men responsible for order at the festival **34** Marble relief with the famous Nike undoing a sandal from the Temple of Nike, dating from between 409 and 406 BC
IX Room with works from the 5&4C BC. Statue of Prokne by Hekamenes and Leochares' 4C head of Alexander

amphorae and vases, not to mention inscriptions, coins and weights and measures are all housed here. Among the most important exhibits are a standing statue of Apollo Patroos (*c.* 320 BC), a standing statue of Aphrodite (2C BC), a marble Nereid (*c.* 400 BC), a winged Nike (5C BC), a statuette of Apollo (2C BC) and the bronze head of a goddess of victory (*c.* 430 BC). There is an intriguing water-clock (clepsydra) in fired clay (5C BC), which measured the time allotted for the speeches of the parties in law cases. The collection of clay sherds (ostraka) used in ostracism is interesting, and the kleroterion, a machine for

choosing public officials by lot, is unique. On the upper floor of the stoa there are other, less important, sculptures.

Acropolis Museum: Following the first excavations on the Acropolis the finds were initially left in the open, in the picture gallery of the Propylaia, on the wall and in small Turkish buildings. In 1866–73 the museum was finally built on the SE side of the rock and in 1885–90 the excavations by the archaeologist Kavvadias produced so many new archaic finds that the museum had to be extended with the addition of the Small Museum, which housed a limited number of essential exhibits. After World War 2 this small museum was pulled down and the old building lengthened. The exhibits consist almost exclusively of finds from excavations on the Acropolis and very recently the original caryatids from the Erechtheion were also put on display here. The museum conveys the essence of the development of Attic art from the 6 to the 4C BC. New additions to the antiques are limited to just a few plaster casts to

Peplos kore, 530 BC, Acropolis M.

Kouros of Ptoon, 550 BC N.A.M.

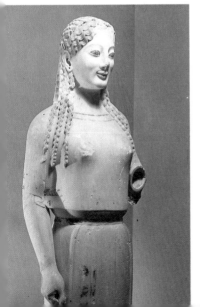

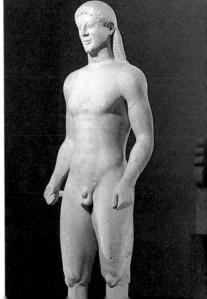

Benaki Museum
Exhibition galleries are marked with Roman numerals, other rooms with Arabic numerals.

1 Neoclassical vestibule
2 Entrance hall
3 Sales area
4 Administration
5 Photographic archives
6 Gallery for travelling exhibitions
7 Gallery for travelling exhibitions
8 Offices
9 Toilets
10 Offices
11 Historical archive
12 Library

I Various ancient Greek exhibits from the Bronze Age from c. 3000 BC to Greek Classicism c. 500 BC

II Various exhibits from the Hellenistic era from the 4C BC to the time of Roman rule to the 5C AD

III Coptic and early Christian art from Egypt

IV Byzantine art. Some very fine pieces, particularly ecclesiastical objects from the 6–14C AD

V Islamic art. Islamic art is also exhibited in galleries **XIV, XVIII** and **XIX.** Gallery **V** houses exhibits from the 7–18C

VI Ecclesiastical art from the 16–19C. Largely ecclesiastical exhibits which the Greeks brought with them when they were expelled from Asia Minor in 1922 after the catastrophe there

VII 15–17C icons. Very fine icons, particularly of the Cretan school. 2 of the pictures are by El Greco (Domenico Theotokopoulos), one dating from his early period (1560) when he painted in the manner of icons. El

Greco was born in Crete in 1541, but reached the peak of his artistic achievement in Spain, where he spent the greater part of his life and where he died in 1614, in Toledo. The second painting by El Greco exhibited here is an Adoration of the Magi and was painted in 1565, shortly after the first picture, but already shows strong Venetian influence. El Greco studied under Titian in Venice until 1570

VIII 15–19C icons. In this corridor leading to gallery IX are some fine 17–19C icons; Western Europeans are always astonished by the consistency of the stylization of this kind of painting over the centuries

IX Eleftherios Venizelos exhibition. Memorabilia of the national hero E. Venizelos, who was a friend of Emanuel Benaki, the father of Antonis Benaki, the minister of agriculture. Venizelos was born in Crete in 1864 and died in Paris in 1936

X 18&19C paintings. Painting by visitors to Greece in the 18&19C, hanging on the walls of the staircase

XI Small exhibits from Western Europe. Small exhibits, mainly from Italy and Spain from the 14–19C, in the corridor leading to gallery XII

XII Paintings of Greek subjects. Most of these pictures date from the 18&19C and were again painted largely by visitors to Greece

XIII Coptic textiles. These Egyptian textiles date from the 3–11C AD. Some of the subjects are from Greek mythology, but some are Christian

XIV Islamic art from the 9–15C.

XV Exhibits from the period of the Greek War of Liberation (1821–9). Various mementoes of the Greek national hero G.Karaskakis and of Lord Byron, who died in

Mesolongi in the struggle for Greek liberation

XVI Exhibits from the reign of King Otto (1833–62). The well-known portrait of the young Prince Otto is by J.C. Stieler

XVII Exhibits from the reigns of George I and Constantine I

XVIII Islamic textiles from the 7–17C

XIX Persian and Indian silk painting. Fine Islamic textiles and also Persian ceramics and jewellery from Egypt, Syria, Persia and Spain.

XX Chinese ceramics from 3000 BC

XXI Greek embroidery. Mainly 17&18C embroidery showing an enchanting wealth of ideas and juxta-position of colours

XXII–XXIV Folk art from the Greek islands. A fine collection of decorated national dress and festive clothes and jewellery

XXV Folk art from Attica and central Greece. Fine costumes, jewellery and household goods

XXVI Folk art from other parts of Greece, the Peloponnese and Asia Minor. Fine ceramics, jewellery, costumes, furniture and similar items

XXVII Helena Stathatou collection. 6–19C folk art. The furniture in gallery **XXVIII** is also from the Stathatou collection.

XXVIII Reception room with N. Greek panelling. The carved wooden panelling from an 18C house in Kozani has been transferred to this room. It shows a high degree of craftsmanship and mastery of the Byzantine tradition

complete the Parthenon frieze and the copy of the cryselephantine statue of Athena. The original exhibits are described in detail in the text accompanying the ground plan.

Benaki Museum: This museum at 1 Koumbrari St. consists principally of the bequest of one man: Antonius Benaki. Benaki's house was built by A.Metaxas at the end of the 19C and in 1910 it was extended by the same architect. This house, which Benaki himself converted into a museum during his lifetime, is a typical and beautiful example of classicism in Athens. Benaki left behind a remarkable collection of antique works of art from Mycenean to Hellenistic times, as well as Byzantine and post-Byzantine art, icons and Greek folk art. Following his death in 1954 further bequests were added: the Venizelos endowment in 1965, the Helena Stathatou collection in 1968 and in 1973 rooms for temporary exhibitions on the ground floor and first floor, a refreshment room and a reading room. Further donations of various items, including, for example, rare books and manuscripts, have been added to the museum, which today enjoys enormous popularity, not least due to its un-museum-like atmosphere. The intimate feel of the house gives one the impression of being a private guest in spite of all the other visitors. This adds to the pleasure provided by such excellent exhibits, especially the Byzantine collection, the folk art and the antique jewellery. Starting from the slightly raised ground floor one ascends to the 1st floor and ends up in the basement. Being only semi-sunken this receives daylight and the museum therefore has three floors at its disposal (see the ground plan).

Byzantine Museum (22 Leoforos Vasilissis Sofias): When the Byzantine museum was founded in 1914 its collections were still housed in the basement of the Academy. In 1840 the Duchess of Piacenza had a villa built for her in Florentine Renaissance style by St. Kleanthes in a green area on the banks of the Ilisos, then still outside the city, which she named Ilissa. In 1930 the museum was able

Poseidon, Apollo, Artemis, Parthenon Frieze, Acropolis Museum

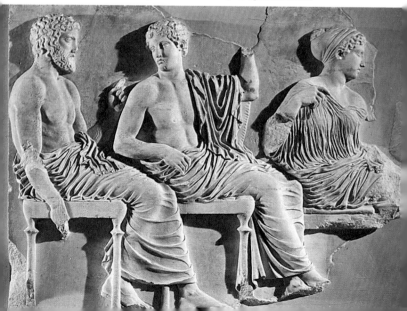

to move into these buildings, which, while still romantic and somewhat secluded, now lies within the city. With the help of the architect A.Zachos the collection was systematically and beautifully housed in these rooms; indeed, the museum incorporates the reproductions of three types of church, namely an early Christian basilica, a Byzantine cross-in-square church, and a post-Byzantine church consisting of a single room. Little by little, endowments to the new museum built up a collection which included objects found in excavations, marble sculptures, fragments of frescos, mosaics, embroideries, icons, manuscripts, and church utensils. A large new room had to be built on to the E. wing in 1951 to house the Coptic inscriptions and fabrics which had been donated by Antonis Benaki. In 1963, a centre for restoring frescos and icons was established here, although it also carries out its work elsewhere.

One feels transformed as soon as one steps inside this museum by its intimate, enchanting atmosphere, where one has suddenly left behind the ruins of the ancient city and the hectic pace of modern Athens to find something more reminiscent of a fairy-tale.

After going in, one finds oneself in a courtyard which looks just like a peaceful old cloister, with a cypress, plane-trees, and a fountain in the middle—and then one sees the exhibits, most of them unbelievably appealing, which include, for instance, the stela showing Orpheus, which was influenced by the ancient style and dates from the 4 or 5C AD, the wonderful frescos and icons, and the triptych of the Tree of Jesse, the vineyard, and the Transfiguration. This unique museum makes it clear, indeed, that, in spite of all the problems which Greece faced between the classical period and the 19C, her art was not allowed to die, but rather flowered in secret, in the secluded setting of churches and private houses. The ground floor contains three rooms which have been adapted to reproduce three types of church, thus showing how the style of church interiors developed over this period. The first few rooms illustrate early Byzantine sculpture, and the

Neckwear from Patmos, 18C; icon panel from Crete, 16C, both Benaki Museum

Entry into Jerusalem, 17C (L.), Archangel Michael (R.), 18C, both Byzantine Museum

later ones contain sculptures ranging from the 9–15C. The most notable feature of the rooms on the first floor is the remarkable collection of icons dating from the 9–17C.

Museum of Greek pottery: There is a collection of Greek ceramics in a former mosque on Monastiraki Square.

National Historical Museum (in the Old Parliament, Stadiu Street): The exhibits illustrate Greek history during the 18&19C with particular reference to the independence struggle of 1821–1830, and include Lord Byron's sword and helmet and mementoes of King Otto and King George I. The Byzantine exhibits in Room I (which also contains the painting of the naval battle of Lepanto in 1571) are especially remarkable.

The most famous items on display in the museum are the twelve paintings by D.Zographos depicting the struggle for independence.

Kerameikos Museum (148 Ermou Street): This is a small museum, situated within the excavated area and containing finds from the ancient cemetery which, though relatively few, are precious. The exhibits include sculptures, reliefs, and late Mycenean grave goods. The collection of ceramics provides a useful survey of the development of the potter's art in Attica and is of notable interest. Bronze, iron, and gold objects are also on display. The most important exhibits are the archaic stele, most notably the poros stela of a man, the base of a stela which has a relief depicting a cavalcade, and the fragment of the stela of a boxer dating

from the middle of the 6C BC. The sphinx dates from the same period. The famous tomb relief of Dexilos, a young man who was killed near Corinth in 394 BC and is shown here trying to defend himself from his adversary with his shield, is also to be found in this museum.

War Museum (Leoforos Vasilissis Sofias/corner of Risari Street): This was built during the military dictatorship. Its exhibits were intended to put into proper perspective the history of Greek armies over the centuries.

Museum of Greek Popular Art (17 Kidathinaion Street): This contains an outstanding collection of embroideries (including Coptic garments from the 2C AD to the present day), 17C processional litter cloths, gold and silver objects from Asia Minor, pottery, icons, and jewellery.

National Picture Gallery/Pinakotheke (60 Vasileos Konstantinou Street): This museum is accommodated in a modern building opposite the Hilton and displays paintings from every period, including four works attributed to El Greco, a Caravaggio, and Delacroix's portrait of 'The Greek freedom-fighter'. It concentrates, however, on pieces from the 19&20C.

Kanellópoulos Collection (Plaka/corner of Theorias and Panou Streets): The collection of Paul and Alexandra Kanellópoulos was bequeathed to the State in 1972, and the museum opened in 1976. It contains antiquities from every period, and some notable sculptures, ancient pottery, and Byzantine icons.

Among the smaller picture galleries which may be mentioned are the Argo Gallery (8 Merlin), the Astor Gallery (16 Karageorgis Servias), the Diogenes Gallery (10 Tsakalaf), the

Icon, Byzantine Museum ▷

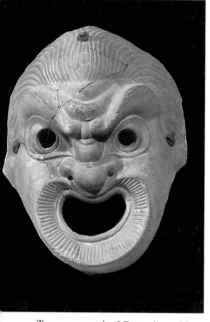
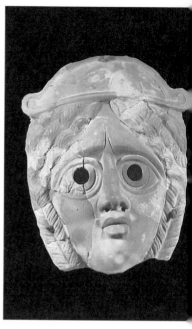

Terracotta masks, 3C BC, Agora Museum

Iolas Zumbulakis Gallery (20 Kolonaki), the Ora cultural centre (7 Xenophontos), the Rotunda Gallery (20 Skufa), the Stoa Tekhnis (13 Solonos), which contains paintings by Greek artists, and the Tholos Gallery (20 Philellinon).

Other art galleries, some of which vary their exhibitions, are the Desmos Gallery (4 Syngrou), the Desmos Art Gallery (28 Akademias), the Diogenes Gallery (12 Diogenes), which contains paintings and sculptures, the Jewish Museum (5 Melidoni), the Art Gallery (4 Glykonos), and the old lyceum for Greek women (17 Dimokritu). The Zappeion frequently houses large-scale visiting exhibitions, as do the Centre for Fine Arts (18 Zaimis) and the Zygos Art Gallery (33 Iofontos).

Athens in the 19&20C

Over the centuries, the city of Athens, whose repute and influence in ancient times had been worldwide, became less and less important. The monuments on the Acropolis were never indeed wholly forgotten, despite the long period of Turkish occupation; but already during the Middle Ages the city had become a provincial town of little consequence. In 1833, when the Turks were driven out, it had a population of barely 3,000. Then, in 1834, King Otto transferred his residence to Athens and made it the capital of Greece. Neoclassical architects, inspired by all the ancient buildings still standing in Athens, set to work, and soon streets, gardens, large public buildings, and a royal palace appeared among the little old houses, some of which by now were half dilapidated. By 1899, the population had risen to 110,000. The first Olympic Games to be held in modern times took place in the new stadium in 1896. Museums,

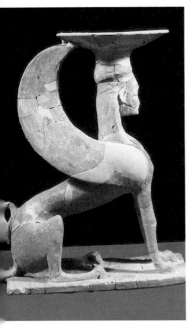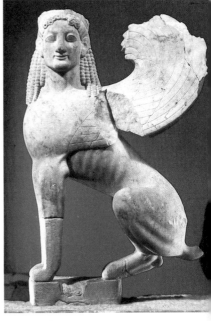

Sphinx, 7C BC; sphinx, c. 530 BC, both Kerameikos Museum

firms and factories were built, and a huge wave of tourism began; by the 20C, the growing population could only be accommodated in hastily constructed high-rise residential blocks. Today, Athens and its suburbs has a population of 2.5 million, and is the biggest and in every sense the most important city in Greece.

Athens' unusual historical development has given it a unique character. The greatness which it enjoyed during the classical period was followed by the Byzantine period, which bequeathed it the small churches which even today look alien and tiny in comparison with the Acropolis and the Temple of Hephaistos. Of the subsequent period nothing has survived. For 1500 years, Athens was virtually without importance, until King Ludwig I of Bavaria, who was an enthusiastic classicist, rediscovered it, and, having taken a leading part in

the liberation of Greece, installed his son, Otto I, as the newly independent country's ruler. It was he who decided that Athens, though at that time a place of no importance, should be raised to the position of the new capital of Greece; he, too, picked out the site of the royal palace (the modern Parliament) and provided the finance for innumerable buildings, even if these projects sometimes surpassed his means. Ludwig I has set his stamp on modern Athens, just as he fathered neoclassical Munich. With its new layout of streets and its new classical buildings put up by Ludwig and his son Otto I (who ruled Greece from 1834 to 1862), Athens was brought back to life—although the Greeks were not always appreciative of their Bavarian dynasty.

The new city was built by one French, two Danish, and a number of German architects; and their achieve-

ment was considerable. The new street plan was begun in 1832 and 1833 by Schaubert, a German from Breslau, and the Greek architect Kleanthes, and continued in the following year by Leo von Klenze on a larger scale; his work was carried on in its turn by F. von Gärtner. Schaubert built the church of the New Metropolis in the classical style near the Old Metropolis, and Klenze the Church of Dionysios on Leoforos Panepistimiou.

The new royal palace on Syntagma Square was designed by F. von Gärtner (who incidentally was also largely responsible for the Ludwigstrasse in Munich). Among the forerunners and practitioners of neoclassical architecture in Athens were two Danish brothers, Christian and Theophilus von Hansen. Christian helped in the reconstruction of the Temple of Nike and himself built the University on Venizelou Street, which was opened in 1837 under the Bavarians, and the Anglican Church. His younger brother Theophilus (who incidentally also designed some of the important buildings in the Ringstrasse in Vienna) built the Palais Dimitriu (which later became the Hôtel Grande Bretagne), the observatory on the Hill of the Nymphs, the Zappeion, and the Hellenic Academy (next to the University on Venizelou Street). This last did not come into being as an academic institution until forty years later, in 1926. He also built the eye hospital in Leoforos Venizelou, also called Panepistimiou (University Street), as an essay in the Byzantine style. The Old Parliament, also near the University, was built by Boulanger in 1871 (and now houses the Historical Museum). Nearby, still on Venizelou and not far from the National Park, is Schliemann's house, known as the Iliou Melathron, which was built by E.Ziller, an architect from Dresden, and now accommodates the Supreme Court of Appeal. Ziller also built the Palace of the Crown Prince, the Melas building

(now the main post office) on Syntagma Square, the Cadets' School, the German Archaeological Institute (N. of the National Library, in Trikupi Street, which runs into Venizelou street), the National Theatre (to the W. of Omonia Square, opposite the church of Agios Konstantinos; like many other neoclassical buildings, this has sadly been demolished since), and the Mausoleum of Heinrich Schliemann in the Central Cemetery). The National Archaeological Museum was built by L.Lange. Many of its exhibits were excavated and discovered by German archaeologists, of whom the foremost, after Schliemann, was Wilhelm Dörpfeld. The Athens branch of the German Archaeological Institute was established in 1874.

After the constructive development which the 19C brought Athens, the effect of the explosive growth which took place in the 20C was almost disastrous. New buildings appeared everywhere with no provisions for parks or gardens and no consideration of the effects on the health and wholesome life of their inhabitants. Brick and cement became an ever more common sight, despite predictions of the consequences. By 1970, the Greek Chamber of Commerce and Industry prophesied that in ten years the inhabitants of Athens would be unable to live any longer with the pollution of their city and would have to leave it. This has not happened, and Athens is still crammed full of people, local and visiting.

The modern Hilton Hotel, which stands among patches of greenery on the intersection of the wide avenues of Vasileos Konstantinou and Vasilissis Sofias, may be seen to some extent as providing a positive solution of modern architectural problems. The best view of the city can be gained from an ascent of the Lykabettos (910 ft.), at whose top stands the church of Agios Georgios, set diagonally above a modern restaurant. From here a good view is offered of the whole city,

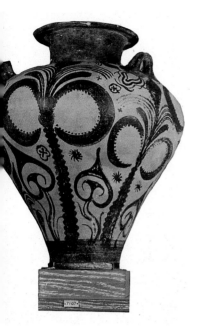

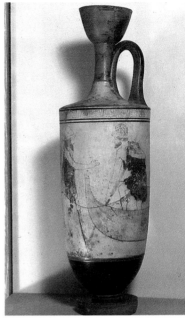

Mycenean vase

Lekythos with white background, 450 BC

Large amphora in the Geometric style

Attic red-figured vase, 4C BC, N.A.M.

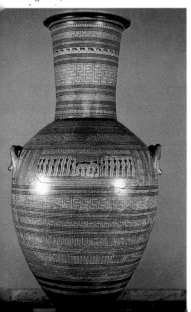

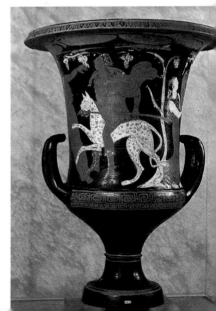

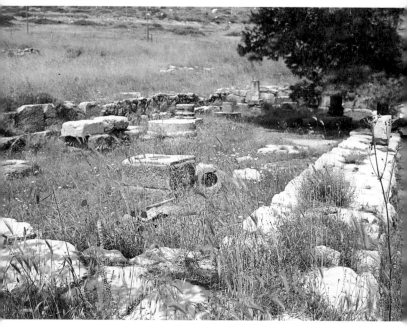

Aulis, shrine of Artemis

from the Acropolis and the excavation sites to the spacious urban planning of the 19C and the concrete jungle of the 20C. The ancients called this hill 'the place of the wolf' (lyki) because it lay outside the ancient city, set in the woods, indeed, the wilds.

Avlís/Aulís/ΑΥΛΙΣ

p.258□C 1

The ruins of the ancient city of Aulis (Avlís or Avlída in modern Greek) are situated on the Bay of Chalkis, just S. of the strait opposite Chalkis, which is known as the Evripos. It is *c.* 75 km. from Athens on the motorway.

History: Homer mentions 'rocky Aulís' (in Book II of the Iliad) as the Boeotian port where the Greek fleet assembled before setting out against Troy under the command of Agamemnon. The tragedian Euripides (5C BC) drew on a legend not mentioned by Homer which also concerns this place. According to this story, the fleet was for a long time becalmed in port and prevented from putting out to sea because of an impious act which Agamemnon had committed. The seer Kalkhas, who served as high priest to the Greek forces, made the fateful prophesy that the goddess Artemis, who had a shrine in Aulis, had been angered by Agamemnon's misdeed and would only be pacified by the sacrifice of his daughter, Iphigenia. Only then would the goddess allow a favourable wind to help the fleet set sail. Euripides' first play on this subject, 'Iphigenia in Aulis', describes how Iphigenia is sacrificed, only to be miraculously rescued by Artemis. Its sequel, 'Iphigenia in Tauris', takes place when the Trojan

War is already over and relates how her brother Orestes comes and finds her and then accompanies her back to Greece. (Goethe's 'Iphigenia on Tauris' uses the same plot). Iphigenia is supposed to have landed at Brauron (Vravróna, *q.v.*), which contained the other important sanctuary of Artemis, and to have become a priestess of her cult. Both plays present a contrast between human and animal sacrifice (e.g. the sacrifice of deer), and reflect, as Goethe also does, the laborious process whereby the barbaric pre-Hellenic ritual of human sacrifice was renounced and eventually replaced by a more symbolical and spiritual form of worship.

Artemísion/Shrine of Artemis: The site of the *Temple of Artemis* (near the little harbour of Mikró Vathy) was discovered in 1941 and has been identified with certainty by an inscription. It was excavated in 1955–61 by the Greek archaeologist Threpsiadis. The main temple dates from the 5C BC (though it was built over earlier structures going as far back as the 8C) and was rebuilt several times during the Hellenistic and Roman periods. It had a row of columns with two columns in antis, which was later rebuilt with four columns. Inside the cella can be seen some smaller stone plinths which probably supported statues of Artemis and Apollo. There are also the remains of a *round altar* incorporating at its base a channel in which the libations could drain away. Near the temple and to the S. traces have been found of *potteries*, with a kiln, and of *pilgrims' accommodation* (katagogion).

Chalkís/ΧΑΛΚΙΣ

p.258☐C 1

Chalkís is the capital of the large island of Euboea (Évia) and is situated on the narrowest point of the Gulf of Euboea (Evoikós Kólpos). It is a lively industrial town and port with a population of about 40,000.

History: Homer describes Euboea in Book II of the Iliad as the homeland of the Abantes, and the island was also known then as *Abantís*. Chalkís derives its name from Chalkodon, the legendary King of the Abantes (who also called themselves the 'Chalkodontides' after him). The town began to flourish during the 8–6C BC, when its harbour made it a centre of communications between Greek cities. Its commercial activities were particularly directed northwards, where it established a number of colonies and the peninsula of *Chalkidikí*, where some 32 settlements were founded by Chalkís, probably took its name from this town. Soon its sea-trade extended to S. Italy (notably Cumae, Naples or 'Neápolis', meaning 'new town', and Sicily). It played a vital role in the cultural interchange during this early period, as for example in the introduction of the Greek alphabet in S. Italy, which was then Etruscan. From this source the Latin script finally made its appearance. But its bitter and prolonged conflict with the neighbouring city of Erétria (*q.v.*) drained Chalkís of much of its strength and importance. From the 5C BC onwards it was part of Athens' sphere of influence and had the task of

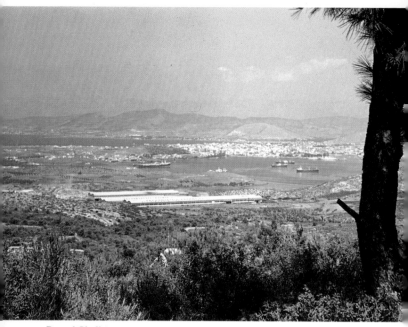

Bay of Chalkís

supplying Athens' food requirements (from Euboea). During the Middle Ages it was occupied by troops of the Latin Franks (from 1207) and the Venetians (1306–1470), who called it *Negroponte* (meaning 'black bridge', a name which was probably derived from the old bridge over the straits). A pasha resided here during the Turkish occupation of 1470–1830. After this long period of Turkish rule, Chalkís and Euboea were restored to the Greek state.

Old town or Kástro: The ancient town centre, important as it was in its day, has been built over and there is now virtually no trace of it. This was the site of the old Venetian-Turkish *fort*, whose walls and moats have since been flattened.

Turkish mosque (on Platía Pesónton Oplitón, literally 'Warriors' Square'): This was originally the principal Venetian church of *San Marco*, and in its interior are assembled a number of *remains* of Venetian and Turkish pieces of architecture. It also incorporates some *ancient columns*.

Church of Agía Paraskeví: About 100 yards distant is the old early Christian basilica of Agía Paraskeví (5–8C), which was converted by the Crusaders (known as 'Franks') into a Gothic church in the 14C. It contains pointed arches above which there is a second row of large arches, the latter being incomplete and having no gallery. The interior contains some beautiful *columns* of cipollino and Hymettian marble with different kinds of capitals. This is thought to have been the site of an ancient *temple* to Leto or Apollo (of which there are virtually no traces).

Chalkís, Evripos bridge

Spíti tu Bailú/Governor's palace:
The old Venetian governor's residence (now in need of restoration) is presently used as a prison.

Also worth seeing: The ancient residential city, of which virtually no trace is left, was situated to the E. of the modern town (there are fragments of a temple in the museum) and the ancient harbour and agora were on the bay of *Agios Stéfanos*. The industrial suburb of *Proástio* (which itself means 'suburb') contains the church of *Agios Dimítrios*, which was once a mosque and still has a bell tower converted from a *minaret*. On *Vathrovúni* hill, at the SE end of town and in the direction of Erétria, are the remains of a Greek or pre-Hellenic *acropolis* with the *foundations of towers* and the remnants of a Pelasgian settlement including walls, roads, houses, and rock tombs.

Evripos Bridge (Jéfyra): The idea of throwing a fixed bridge across the *Évripos* strait off Chalkís, which is the narrowest point in the Gulf of Euboea, has existed from early times, and it was first brought to fruition in 411 BC, when a dyke and a fixed *wooden bridge* were constructed. This gave Chalkís the commercial benefit of being able to enjoy free traffic with the mainland. During the ensuing centuries, it was several times replaced. The first *movable bridge* across the strait (here 130 ft. wide) was built by Justinian in the 5C, and was succeeded, during the period of Turkish rule, by a wooden bridge. Then, in 1856, a wooden *swing bridge* was constructed to allow the passage of shipping, which was replaced in its turn in 1896 by an iron swing bridge. The *bascule bridge* which we see today dates from 1962. The name of the *Évripos* probably means 'changing

current', and its current does indeed change direction 7–14 times a day (the sea-level rises and falls by up to 3 ft.).

Archaeological museum (Odós Aristotélus): The most important exhibits are the *marble sculptures* from the W. pediment of the late archaic *temple of Apollo* in the neighbouring town of Erétria, and date from the end of the 6C BC. They depicted the theme of the battle between the Athenians and the Amazons. The legend was that Theseus defeated these implacable female warriors from the Black Sea region and took their queen, Antiope, to be his wife. The relief which represents this scene is a masterpiece of Greek art, and its figures, which are still graced with the 'archaic smile', have a captivating charm. There are also portions of the relief showing *Athena with the Gorgon's head* and more fragments of Amazons. The main room contains a *votive relief* dating from the 5C BC and *torsoes* of a man and of a youth. Near the entrance is the statue (from Aidipsos) of Hadrian's favourite, *Antinoos*, as *Dionysos*, as well as a *statue of Hermes*, a female *tomb statue* (from Aidipsos), and a *statue of Apollo*. The figure known as the *Persephone of Erétria* comes from a tomb dating from about 330 BC. The display case on the way out contains Mycenean, Geometric, archaic and classical *objects* such as vases, ceramics, and bronze statuettes.

Laografikó Musío / Museum of Popular Art: This displays some rare and beautiful items of popular art, including folk costumes, furniture, tools, and so on.

Museum of Medieval Art (Platía Oplitón): A collection of Byzantine, Venetian, and Turkish works of art, including mosaics, sculptures, and reliefs, has recently been made available to the public in the *Old Mosque*.

Environs: Fýlla (*c.* 6 km. SE): On a hill above the village stands the medieval (Venetian) *Kastéllo*, which was built over an ancient *outer wall*. The village itself contains the house in which Miaúlis, a hero in the struggle for independence, was born. Nearby there are some Venetian *watch towers*. This is the region of the *Lelantine Plain*, long disputed between Chalkis and Erétria. The monastery church of *Agios Geórgios*(to the E.) dates from the 13&14C and was rebuilt in the 17C.

Levkándi (*c.* 14 km. SE): *Magúla* hill was the site of excavations conducted here between 1965 and 1970 which brought to light objects dating from the early Helladic, Mycenean, and Geometric periods (around 700 BC). This is, in fact, a ruined settlement, which contained three cemeteries.

Néa Artáki (9 km. N.): Remains of the old Venetian-Turkish *watercourse*; also various *watch towers*.

Politiká (*c.* 26 km. NW): This contains an old 12C *Monastery of the Panagía* which has a cruciform domed church dating from the 15C (the frescos were added in 1668).

Psakhná (16 km.): Small town with a population of about 5,000. There is a ruined Venetian *fort* on *Kastrí* hill. Nearby (Agía Triáda) are the ruins of an early Christian *basilica* with an atrium and narthex.

Stení (*c.* 35 km. NE): This idyllic mountain village is the starting point from which to climb *Mt. Dírfys* (5,750 ft.) This is the highest mountain in Euboea and offers an enchanting view of the island and the sea. It is densely covered with woods of chestnut, pine, and lime-trees. *Mt. Dírfys* was regarded by the ancients as the home of Hera, the mother of the gods, who was simultaneously Zeus's wife and (older) sister. The myths portray her as being permanently tormented by jealousy of her rivals and striving to protect her conjugal dignity.

Dafní, Christ as Pantocrator ▷

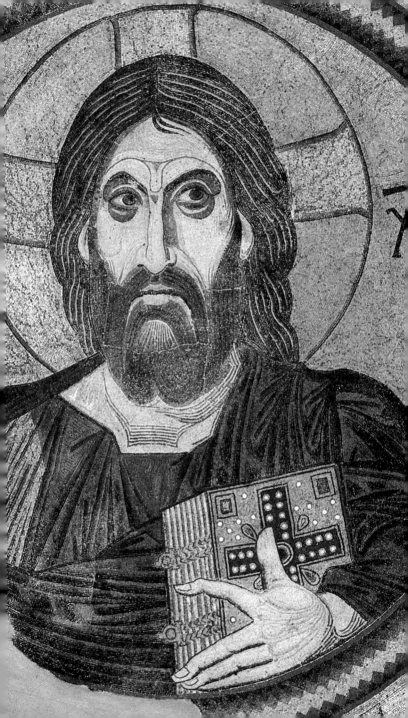

Dafní/Daphní/ΔΑΦΝΗ

p.258☐D 4

This **Byzantine monastery church** occupies a special place in any consideration of the monumental mosaic art of the middle Byzantine period. It is situated about 10 km. from Athens on the Sacred Way to Eleusis, and, according to the present state of research, dates from the end of the 11C. It is dedicated to the Dormition of the Mother of God.

No other monastery is so closely connected by its name to ancient mythology, nor in general to the history of the Frankish occupation. There are various etymological explanations for its name (which itself has various forms, such as Daphnion, Daphnin, and Daphni). One popular tradition links its name to the Temple of Apollo Daphniphoros ('Apollo wearing a crown of laurels') which once stood nearby. Another legend derives its name from a queen called Daphni who was once shipwrecked off this place in the Bay of Eleusis. She was rescued together with her money, which filled twelve coffers, and so, to express her gratitude to the gods, she built the monastery church with the money from seven of the coffers, burying the other five in the monastery's courtyard. Others believe that the church was named after the Monastery of the Panagía tis Daphnis in Constantinople. Others again derive its name from one of Apollo's titles, Apollo Delphinios, who, as god of the sea, took the form of a dolphin and carried the Cretan colonists to Delphi. Of these hypotheses, the one

Monastery of Dafni

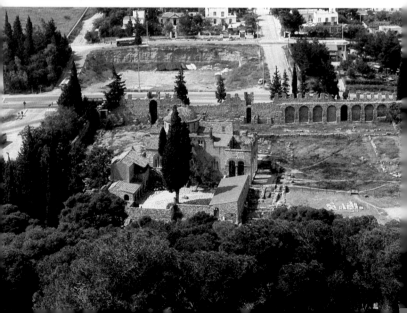

which seems most likely is that which links the name of this monastery with Apollo, the ancient Greek god who wore the laurel crown, for the whole place seems dedicated to him.

The Frankish sources give its name as Dalfinète, Santa Maria di Dalphino, Dalphinum, Dalphino, etc. Four Ionic columns were used in the construction of the exo-narthex of which three were later taken to England by Lord Byron and are now to be seen in the British Museum. The remaining fragments of the fourth were recently discovered in the courtyard of the monastery.

The site of the present monastery church was occupied much earlier by a chapel which was most probably built in the 6C, during the reign of Justinian. Some parts of the sculptures which once decorated this chapel were recently discovered.

After the Frankish conquest of Byzantium in 1204, the Monastery of Dafní came into the possession of the de la Roche dynasty. Otho de la Roche, the first Duke of Athens, transferred it in 1211 to the Cistercian Order, though he bequeathed its huge fortune separately to the Cistercian Abbey of Bellevaux in Burgundy. The 6C chapel had been destroyed some time between the 7 and 9C, and the church which still stands today was erected in its place at the end of the 11C. Dafní was the favourite monastery of the de la Roche dynasty, and it was here, in the crypt beneath the narthex, that they installed their own family crypt. The last ruler of the dynasty was Guido II, and he was buried here on 6 October 1308. His successor, Walter of Brienne, was killed in the Battle of Kiphissos, near Kopais, on 15 March 1311, five days after having drawn up a will in which he expressed the desire to be buried with his forefathers. Boniface of Verona, who had witnessed the will, managed to win the Catalans' permission to inter the unfortunate Duke's body in his family crypt, but his head was not buried until 1347, in Lecce Cathedral.

This is the only Cistercian Abbey to have survived in the East for any significant length of time; indeed, in 1276 it was the only one in Greece. Following the capture of Athens by

Monastery of Dafní, portal

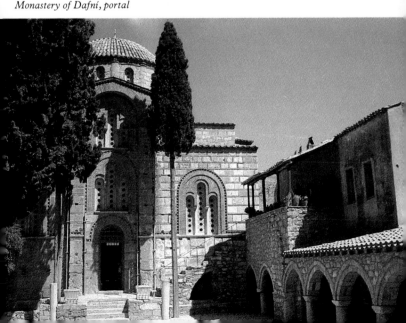

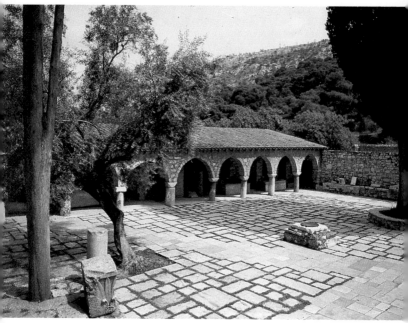

Dafní, monastery courtyard

the army of Sultan Mehmet II, the Cistercian monks abandoned the monastery of Dafní in 1458, and it was repossessed during the 16C by Orthodox monks. The inscriptions which have recently been discovered have revealed to us the names of some of the Orthodox abbots.

In 1821, during the Greek uprising against the Turks, Turkish troops captured the monastery and not long afterwards started a large fire inside the main church, thinking thus to extract the gold from the mosaics. Later on, in 1838–9, a Bavarian military unit set up its billet here. During the Anglo-French occupation of the Piraeus, a division of French troops took refuge here from the epidemic of the plague. The monastery church was severely damaged by the large earthquakes of 1886 and 1889. Since the beginning of the 20C, the church

has officially been a historical monument, which is also why services can no longer be held here.

Apart from the church, which stands at the centre of the site, there are also some remains of the original monastery buildings dating from the 11C, including the *ruined refectory* to the N. of the church, the large *cistern*, and a part of the *outer wall*.

The *monastery church* is built in the conventional Byzantine style, which was widespread in Greece in the 11C. It is a cruciform domed church whose interior is shaped like a (Greek) Orthodox cross with arms of equal length. Its main feature is the large dome which has a low drum and rests on four corner squinches and eight pillars.

Like the other churches in mainland Greece, the church is built of stone. The techniques possessed by Byzan-

Dafní, mosaics, 11C: 'Annunciation' (L.) and 'Assumption' (R.)

tine architects in the 11C made possible the harmonious balance which we see here (as in other Byzantine churches of the same period) between stone and brick, not to mention the decorative effect of the alternation in colour between the redness of the brick and the light hue of the stone.

The interior is divided into four parts, namely the sanctuary ('agion vima'), the central body of the church, the narthex, and the exo-narthex, which was added in the 12C, when the rest of the church was already complete. There used to be an upper storey above the exo-narthex which housed the library and the abbot's living quarters. The Cistercians built doorways into the exo-narthex and thus converted it into a Gothic structure. After the 11C it was most probably used as a side chapel. In 1960, during the restoration, the now ruined exonarthex was also restored, in its original form and without the Gothic details added by the Franks.

The *mosaics* differ from those in the great monastery churches of Néa Moní on Chíos and Hósios Lukás near Stíri, which also date from the 11C. It is in this church that we sense most strongly the influence of the humanism which characterised the middle Byzantine period and had first appeared during the renaissance brought about by the Macedonian dynasty. We have to admire the magnificence of these mosaics and the realism which is their main feature. Their high quality is reminiscent of the mosaics in Constantinople, but we have no definite clues about the origin of the artists who created them. The interior of this church is much brighter than the bigger church of

Hósios Lukás; and the quasi-ancient style of these mosaics is much more distinct than those in either of the two other churches mentioned above. Indeed, the artists who worked in this church seem to have been influenced by the classical art in this district, which derived from Athens. This can be seen very clearly, not only in the graceful and realistic expressions on the subjects' faces, which remind us of ancient sculptures, but even in the folds of their garments. The infinite variations in the shades of colour (which are much brighter than in Néa Móni) also assist this charming and rather freer classical style. The classical features themselves consist of a well-balanced blend of Hellenistic elements, such as the tunic, imation (gown), and sandals, and Syrian and Oriental ones, like the maforion, or head-dress, of the Mother of God and St.Anne. The tesserae which make up the mosaic are also much smaller than usual, and this gives it a much more lively appearance.

Another new stylistic feature in this church is the preference for group portraits; and there is a perceptible harmony in the gestures of the members of these groups. Another feature is the feeling of landscape as space. This is exemplified by the beautiful mosaic depicting the *Birth of Christ*, which reveals a great love of landscape. It shows some very life-like sheep drinking from a stream which is shaded by small bushes; the background consists of hills and a dark mountain range. There are many more group portraits than individual portraits in the mosaics at Dafní. In Hósios Lukás, group portraits account for four of the pictures of the twelve annual feasts in the dome and two of the pictures in the porch, and in Néa Móni on Chíos eight of the pictures in the dome and six in the porch are of groups; but Dafní has 12 group portraits in the dome and six in the porch. All three churches, however, share a common plan of decoration, and together they are an

outstanding example of the monumental mosaics of the middle Byzantine period.

These three churches follow a hierarchical plan of decoration which was based on the mystical order of the 'celestial hierarchy' of Dionysius the Pseudo-Areopagite (this was after the worship of icons had been restored in Byzantium). The central feature in all three churches is the figure of the *Pantocrator*, which is set against the golden background of the *dome* (itself a symbol of Heaven). This is the only figure which does not imitate the style of ancient mosaics, and it actually combines in one person the cosmic power of Christ and God the Father, which is why it is placed in the dome—the highest point inside the church. Unlike the other figures, it has an Oriental severity, conveying the feeling of absolute, limitless power. The golden background is meant to represent the infinity of heaven. The whole work shows us all the awful majesty of God as conceived by the monk (himself an experienced artist) who produced it, which he did, as Runciman points out, without reference to the style then conventional in Constantinople. The picture shows Christ's head and torso. He has raised one hand in blessing, while holding in the other a bejewelled Holy Bible.

The other mosaics show the various degrees of the hierarchy beneath Christ. The next rank down is that of the *prophets*, who are shown on the walls of the drum. The *Mother of God*, flanked by the two archangels, is depicted in the *apse*. The pictures of the feast-days, which correspond to the festivals of the calendar year, occupy an important place. (The church year thus corresponds to the cosmic cycle). The pendentives represent Christ's *birth*, *baptism*, and *Transfiguration*, and the *Annunciation*. In the right arm of the cross are *Doubting Thomas*, Sts. Gourias and Samonas, the *Resurrection*, and the *Adoration of the Magi*. In the left one

we see *Lazarus*, Christ's *entry into Jerusalem*, Sts. Provos, Tarakhos, and Andronikos, the *Crucifixion*, and the *Birth of the Virgin Mary*. On the W. side is the *Dormition of the Virgin Mary*, whose figure is surrounded by Sts. Sergios, Eustratios, Mandarios, Orestis, Eugenios, Gregory, Auxentios, Anempodistos, Zakharias, Elpidoforos, Pegasios, Akindynos, and Bakkhos.

To the left of the altar (in the prothesis) are Aaron, Sts. Stephen and Rufinus, the Archangel Michael, Sts. Silvester and Anthimos, and John the Baptist. In the narthex can be seen *Joachim and Anna praying*, *Candlemas, the Virgin's Presentation in the Temple*, the *Last Supper*, *Jesus washing his disciples' feet*, and His *betrayal by Judas*. Sadly, large portions of these mosaics have been severely damaged. The kind of impression made by these outstanding mosaics on the simple local populace can best be shown by the following traditional verse: 'Mother of God, great is your grace / with the mosaic, the glass, and the pearl'.

In 1889 parts of the mosaics were destroyed by an earthquake. Restoration work followed between 1892 and 1897. The most recent restoration was carried out by the Greek Christian Archaeological Society in 1955–7.

Apart from the mosaics, there are also some remains of *frescos* in the exonarthex and in the pendentives of the prothesis to the left of the altar.

Very close to the monastery there is a pine wood in which a large *wine festival* is held every September: for the price of a ticket one can taste every kind of Greek wine.

Dekélia/Dekéleia/ΔΕΚΕΛΕΙΑ

p.258☐D 4

This small town, which is also known as *Tatoí*, is situated on the E. slopes of Mt. Párnis (*q.v.*), some 25 km. N. of Athens.

History: The Attic deme of Dekéleia was situated on the important mountain road leading across the foothills of Mt. Párnis to Orópos harbour in the Gulf of Euboea. The deliveries of foodstuffs (mainly corn and meat) from the island of Euboea to Athens passed along this road. The high points of the pass were fought over from the period of the Persian Wars onwards. During the last phase of the Peloponnesian War the Spartans built a *fort* here which enabled them to cut off Athens from Euboea.

Palaiókastro (ancient fort; the name itself means 'old fort'): There are some remains of this Spartan fort on Palaiókastro Hill above the village.

Royal Palace at Tatoí: This is picturesquely situated and was built by King George I (1863–1913). It was used for many years as the Royal Family's summer residence. The future kings, George II and Alexander, were both born here (in 1890 and 1893 respectively). Nearby is the *Mausoleum* of George I and Alexander. George II and King Paul are also buried at Tatoí.

Environs To the NW of the nearby town of **Varybóbi** (*c.* 5 km. N.) is a site which is supposed to have been that of *Sophokles' grave*. Some remains have been preserved but these cannot be precisely dated. Sophokles was the most important tragedian of ancient times, perhaps of any time, and was born in 496 BC in the Attic deme of Kolonós (N. of Athens). He lived through Athens Golden Age (the 5C BC) and died in the town of his birth in 406. He was the author of such famous dramas as 'Antigone' and 'Oedipus Tyrannus'.

Diónysos/ΔΙΟΝΥΣΟΣ

p.258☐E 4

This small town is set in a high,

wooded valley on the N. slopes of the marble-bearing Mt. Pentéli (Pentelikón). It offers a worthwhile excursion from Athens (being 26 km. NE in the direction of Marathon).

History: As its modern name still indicates, the town and the area around it were intimately associated from very early times with Dionysos, the god of wine and drunken ecstasy. Dionysos was the son of Zeus and Semele, who was the daughter of Kadmos, King of Thebes. Zeus fulfilled Semele's request that he should appear to her in his true form by showing himself to her as a flash of light. She was killed by its brilliance; but Zeus himself carried her unborn child, Dionysos, in his belly, and gave birth to him.

The actual cult of Dionysos (Bacchus) is thought to have been brought to Greece from the East (from Thrace and Phrygia). According to legend, Dionysos taught an Attic farmer called Ikarios how to grow vines and make wine (by fermenting it and keeping it in casks) in gratitude for the hospitality he had shown him. When Ikarios offered this unaccustomed potion to his neighbours, they were at first enthusiastic, but then, as the wine continued to take its effect, they became confused and anxious, started arguing, and finally killed their host. This story points to the difficulties and the opposition which the relatively young cult (with its ecstatic mysteries) met when it was introduced. In classical times, the *rustic* and *city* Dionysia were extensively celebrated and resembled our own carnivals (with masks, dancing, and inebriation). During the three-day festival known as the *anthesteria* (meaning 'flower festival'), the new wine was opened (on the first day, called 'Pithoigia', which means 'the opening of the wine-jars') and drunk. The *city Dionysia* were centred on the precinct of Dionysos beneath the Acropolis in Athens; the rather Bacchanalian *rustic Dionysia* were probably celebrated in

the sanctuary of Dionysos on the N. slopes of Mt. Pentelikón. Thespis, who was the earliest playwright and theatrical producer whose name has been handed down to us, came from here and presented his first play, a tragedy, at the Dionysia in 534 BC, with a chorus and individual actors. Thespis waggon (in other words a travelling company of actors) remains to this day a symbol of comedy; and the roots of comedy, tragedy, and all later forms of theatre, are to be found here.

Excavations: In 1890, the American School discovered the remains here of a *sanctuary of Dionysos* where (as in Delphi) Dionysos and Apollo were worshipped together. Around the precinct there are still some slight traces of the original old Attic deme of *Ikaría*.

Archaio Théatro/Ancient theatre: The theatre was built in the 6/5C BC. It had no stage house (or skene) and the orchestra was supported to the NE by a straight terrace wall. To the left are the remains of the (conventional) *altar of Dionysos*, where a sacrifice would be held before the beginning of the tragedy. At the entrance there can still be seen fragments of a *stone seat of honour* (where the 'critic' would sit).

Also worth seeing: Adjoining the NW end of the theatre are the foundations of a small *temple of Apollo and Dionysos* (30 ft. × 23 ft.). The *base* of the cult figure in the *cella* has been preserved. Built on to the corner is what was probably a priest's house. In the N. part of the precinct are the remains of another building and a *temenos wall*.

Environs: Some 2 km. E. in the direction of Marathon is the **German military Cemetery** of *Rapendósa*. Nearly all the German soldiers killed in Greece during World War 2 were

Dionysos on a she-panther, mosaic from Dilos ▷

buried here, and there are more than 10,000 graves. The Plain of Marathon can be seen from here; and the shortest route from Athens to Marathon runs past this point. It was along that route that the Athenian army marched to Marathon and back to fight the Persians in 490 BC, and later that a soldier ran back to Athens to report the happy news of victory. Our modern 'marathons' recall his feat.

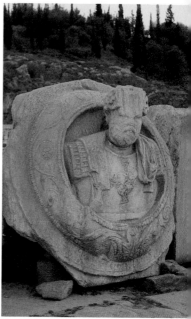

Eleusis, medallion

Elevsína/Eleusis/ΕΛΕΥΣΙΝΑ

p.258☐C 4

This busy modern industrial town lies 20 km. NW of Athens on the Bay of Eleusis, in the Saronic Gulf. It has about 20,000 inhabitants and contains shipyards, cement factories, oil refineries, and other industries. Sadly, this process of industrialization has severely detracted from the charms both of the landscape and of the old village of Elevsína itself (the name is the modern Greek version of 'Eleusis').

History: As has been shown by the archaeological discoveries made on the *Acropolis*, this place was settled in the early Helladic period (3rd millennium BC). The local inhabitants probably developed close commercial relations with Crete and with the pre-Hellenic Aegean culture, just as the populations of Mégara and the neighbouring islands of Salamis and Aegina did. In Mycenean times, a *royal palace* (megaron) was erected on the acropolis which was said to have been built by the legendary king Keleos and his queen Metaneira. Another tradition relates that the town derived its name from the son of a Cretan hero, who was called Eleusis. What determined its future importance, however, was its close connection with the myth concerning the goddess Demeter and her daughter Persephone. Persephone (in Latin, Proserpina) was the daughter of Demeter by the latter's brother, Zeus. Since Zeus had promised to let his brother Hades, the god of the underworld, take Persephone as his wife, Hades kidnapped her one spring when she was still a young girl. In her grief, her mother Demeter (Demeter means

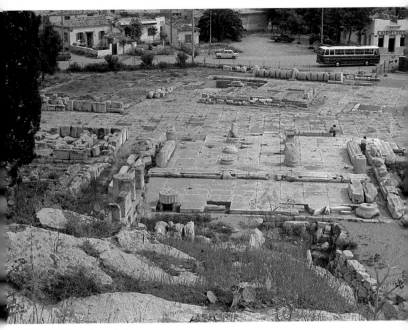

Eleusis, Great Propylaia

'mother earth') wandered all over the earth in search of her. Demeter's travels brought her to Attica, where she stayed with King Keleos of Eleusis. She was so pleased by the hospitality which he and his wife accorded her, which culminated with a kind of beer called kykeón, that she gave permission for her *principal temple* to be built here and the *mysteries* instituted. At the same time, Hades, god of the underworld and now Persephone's husband, agreed to let her live on the earth with her mother while the corn was in the ground, in other words from sowing time in autumn till the harvest in early summer. Thus, she spent the arid summer months underground as 'goddess of the dead', and for the rest of the year was a 'corn goddess', working to ensure rain and good weather so that the plants would grow. It will be seen that the idea expressed by this allegory is in contradistinction to our own concept of Nature dying in the winter and being reborn in the spring.

From the 7C onwards, Athens, which was Eleusis' neighbour and rival, began to establish itself politically and economically, while at the same time Eleusis itself gained increasing importance as a holy place. It became the centre of a kind of popular religion which, in its worship of the principal goddess Demeter as Mother Earth, derived from ancient Aegean forms of the matriarchal fertility cult. Demeter was regarded as the law-giver (thesmophoros) and founder of the settled agricultural community established in early archaic society (note that the ancient Greek word for farmer, georgós, signifies 'earth-worker'). She and her daughter Persephone, generally invoked together, were worshipped as the epitome of all growth, especially of cultivated grain.

The worship of Demeter was regarded throughout ancient times as a force which helped to sustain the institutions of family and state, and not by any means as some bizarre secret cult. Many educated Romans adhered to it, at least formally. Cicero speaks of 'those mysteries which, in elevating us from a brutal rustic life to one of culture, have tamed and ennobled us. We have learned from them not only to live in joy, but also to die in greater hope'. (Cicero, letter to Atticus). There are also some echoes of these ancient values in Goethe's philosophy of life, notably in his ideas about 'becoming through dying'.

Excavations: These lie beneath and SE of the Acropolis. In the 6C the site was protected by a strong *fortified wall*.

Telesterion/Shrine: The NE side of

Eleusis, sacred precinct

Demeter's *shrine* (25) lies on the *rocky terrace* (27) of the *Acropolis* (24). Today, this site consists of ruins dating from many different periods. In the SE corner one can see the remains of the earliest structure, a Mycenean *megaron* (about 1400 BC) whose walls contain what were once antai and periboloi; there are also wall fragments from the Geometric and archaic period (8&7C BC). Over the years the shrine changed and expanded more and more; these fragments indicate how early it first acquired importance. The tyrant Peisistratos (about 540 BC) built a *square structure* (25) (each side being 88 ft. 7 in., with five rows of five columns) on top of the old foundations, and some remains of the paving has been preserved from this building. In 480 BC the Persians, who were busy laying waste to the whole of Attica, including Athens, destroyed the sanctuary;

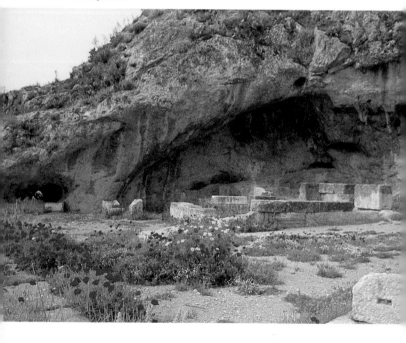

Elevsina, shrine of Demeter (archaeological site): **1** Entrance **2** Artemis temple, altars and eschara **3** Portico **4** Spring house **5** Triumphal arch **6** Kallichoron well **7** Roman baths **8** Great Propylaia **9** Triumphal arch **10** Gate and ancient street **11** Ancient residential quarter **12** Roman cistern **13** Roman houses **14** Inner (Small) Propylaia **15** Peisistratos wall (6C BC) **16** Shrine of Pluto (Plutonium) **17** Altar **18** Sacred Way **19** Panagia chapel **20** Roman Megaron **21** Temple of the kore (Persephone) **22** House of the heralds **23** Medieval castle walls **24** Acropolis (castle mound) **25** Demeter Telesterion **26** Philon Hall **27** Rock terrace with rock steps **28** Perikles wall **29** Round tower **30** Council chamber (Bouleuterion) **31** 'Sacred House' **32** Mithraion **33** Gymnasion **34** Portico **35** Archaeological Museum

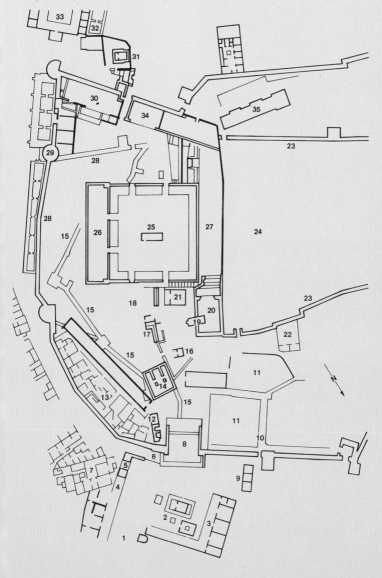

Eleusis, Kallichoron well

but the Greeks built a new and bigger shrine after their victory in the Battle of Salamis. The statesman Kimon (510–449 BC), who was the son of Miltiades, the victorious Athenian general who had defeated the Persians in the Battle of Marathon, now erected a *rectangular hall* measuring 88 ft. 7 in. by 144 ft. 4 in. This new structure had three rows of seven columns. Perikles, who ruled Athens in its Golden Age (*c.* 440 BC), added another hall of equal dimensions, thus restoring the original square ground plan, though now increased in size. It was designed by the famous architect Iktinos, whose other works included the Parthenon on the Acropolis in Athens. During the 4C the architect Philo constructed a long and uncompleted *portico* (the portico of Philo; 26) along the SE front.

The inner colonnade was standardized by the Roman emperors. Two doorways opened into each of the three free sides. The pillars, roughly 20 ft. high, stood on a tufa pavement and supported an upper floor where the 'sacred objects' (the objects used in the mysteries) were kept.

Outer walls and additions: Part of the *outer wall* (peribolos) of Peisistratos (15), which has been partly preserved and lies to the SE, had to be moved to make way for the new *Periklean wall* (28). It is worth seeing the *round tower* (29) in the SE corner, which dates from the same period. In the second half of the 4C BC the *semicircle of walls* was extended to the S. by Lykourgos. Next to this point are the ruins of *shops* and of a *bouleuterion* (council chamber) from the same period (30). It was converted by the Romans into a columned hall. Next to it, on the other side of a gate, is a portico (34) by the side of the rampart, together with more fragments of the walls of Peisistratos and Perikles. A massive foundation structure S. of the telesterion used to support a *gallery* built in the time of Lykourgos. Outside these surrounding walls there was another peribolos (enclosure) of polygonal masonry; this dated from the 6C BC and ran around the remains of a small late Geometric *temple* (the so-called 'Sacred House') which had been built in the 8C BC (31). Next to this again are the ruins of some late *Roman buildings* (32, 33). The *wall of the temenos* wound around the Sacred Precinct in an arc from the E. to the NW, right up to the ancient *town gate*.

Precinct of Demeter-Kore: To the NE of the telesterion, on a *terrace* hewn out of the rock, there are traces of a *temple* which was presumably dedicated to Demeter's daughter, Kore (also called Persephone). Next to it, and to the left of the *Sacred Way* (18), there is a *flight of steps* cut out of the rock which leads up to another *terrace*. There would probably have been an *altar* (17) here with statues of both goddesses. Farther up still, above the remains of a Roman

Eleusis, entrance to Telesterion

megaron (20), which possibly occupied the site of the former temple of Demeter, stands the small *chapel of the Virgin Mary Panagitsa (19)*. It was not by chance that the cult of the mother-goddess Demeter has survived here in the form of the Christian worship of Mary the Mother of God.

Precinct of Hades (Pluto) (Plutonium): At the end of the Sacred Way, in front of the *Lesser* (inner)*Propylaia* and to their left, there are two *grottoes* set into the rock in front of which the remains of a wall and a terrace can be seen (16). This was the site of the sanctuary of Hades, also known as Pluto, who was the god of the dead and of the underworld. By classical times, the Greek Pluton (whom we know as Pluto, the Latin version of the name) was being frequently equated with Plutos (meaning 'wealth'), who was the divine embodi-

ment of wealth. The Eleusinian myth concerning Pluto also combined in his person the two attributes of 'guardian of the underworld' and 'guardian of the treasures of the earth'. Persephone was believed to have returned to earth through the cave behind the *Plutonium*. The festival represented her as disappearing into the underworld every year from this point and later reappearing here again.

Lesser Propylaia (14): The Lesser (or inner) Propylaia enclosed the inner precinct of the temple proper. The structure was erected with a Doric frieze in Roman times (about 54 BC) on the site of an earlier gate dating from the 6C BC. Fragments of the frieze now lie by the gateway and bear recognizable *images of corn* and other subjects connected with the cult of Demeter. There are traces on the ground of the *double doors*. On both

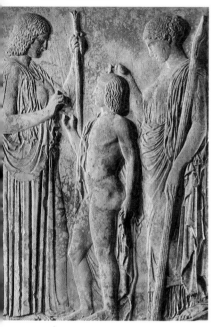

Relief from Eleusis, 430 BC, N.A.M.

tions have been well preserved. The inner enclosure also consisted of a *portico* with six Doric columns. The gateway replaced an earlier entrance and stands next to the remains of the outer wall and the town wall (the wall of Perikles) dating from the 5C BC. Near the main gate (to the E.) are the remains of a Roman *cistern* (12) with a row of steps.

Area of ancient houses (11): In the NW part of the site, inside the ancient wall of Kimon and Perikles (5C BC), there are various remains of *living quarters* and *priests' quarters* with many separate rooms whose foundations are still visible. The *prytaneion* was the premises of the prytaneis, who supervized the festivals, and the adjoining *pompeion* was used to keep safe the objects used in the general procession (pompe means 'procession'). Above these are the remains of the priest's house which belonged to the Kerykes family, which, together with the Eumolpides family, performed the traditional service at the sanctuary. The *house of the Kerykes* (meaning 'house of the heralds'; 22) contains fragments of a Roman painting and a large clay pithos.

sides, fragments of the *wall of Peisistratos*, dating from the 6C BC, can still be clearly recognized. Its foundations consisted of polygonal layers of stone and were about 4 ft. high and supported an embankment of unbaked brick (15).

Great Propylaia (8): These are in the Doric style and make a magnificent outer entrance; they were built from Pentelic marble (from Attica) in the 2C AD by Antoninus Pius, and they are faithfully modelled on the central portion of the Propylaia in the Acropolis at Athens. The main façade comprised a portico with six columns, of which there are fragments in the forecourt. The *pediment* of the structure was reassembled here with its *stone medallion bust* of Marcus Aurelius, the successor of Antoninus Pius. Parts of the thresholds and inscrip-

Great Forecourt: The Sacred Way from Athens ended in the paved forecourt in front of the Propylaia; the buildings here are predominantly Roman.

Kallichoron well: This legendary 'well of the dancing ground' directly adjoins the entrance to the Propylaia on the E. side. It is here that the grieving Demeter is said to have rested and been offered drink by the daughter of the King of Eleusis. Afterwards the village maidens, led by the servant-girl Iambe, came and danced for her to cheer her up. This was supposed to be the origin of the iambic metre so popular in Greek verse. The deeply set *well-head* dates from the time of Peisistratos (6C BC) and, for reasons of piety, was not sig-

nificantly altered by later generations. In the background is the beautiful polygonal structure of the *Wall of Kimon*, with Roman squared stones. Next to it are the remains of a rectangular *tower*, part of the outer wall. In the corner (to the NE) is the *triumphal arch* (5) which led towards the harbour. This was built by Antoninus Pius in the Corinthian style, and its inscription has been preserved. A large part of its marble superstructure has been reassembled nearby. Also nearby is the *fountain* in which the pilgrims purified themselves. The basin of the *spring house* (4) has been preserved. *Temple of Artemis and Poseidon:* This stood in the middle of the forecourt (to the N.). It was built in the Doric style in the 2C AD on the site of an earlier sanctuary dating from the 8C BC. In front of its remains are the plinths of two *altars*. To the NW of the temple are the remains of a Roman *sacrificial site* with a peribolos (surrounding wall) and traces of an earlier sanctuary (7C BC). Behind that are the ruins of a Roman *portico* (3) with a three-sided gallery. Slightly farther to the NW are the remains of a second *triumphal arch* (9), on the road to Megara, which matches the first one.

This was perhaps the most interesting religious centre of all in ancient times. It flourished for roughly 1,000 years, and its importance was felt far and near. It was eventually suppressed by the severe (and unpredictable) Emperor Theodosius in AD 392 and shortly afterwards plundered and laid waste by the mercenaries of Alaric, leader of the Goths, in 395.

Arkhaiologikó Musío/Archaeological Museum (35): This is situated to the SW of the excavations, near the ancient *terrace* which once led to the upper floor of the telesterion. The great majority of the numerous sculpture and architectural fragments which it contains are from the buildings at Eleusis; there are also copies of the art treasures which have been

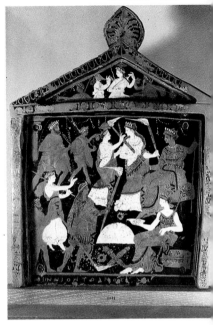

Red-figured vessel from Eleusis, 4C BC, N.A.M.

transferred to the National Museum in Athens.

Entrance hall: There is a *statue of Demeter* by Agorakritos, a pupil of Pheidias, dating from 420 BC. Copy of the famous *telesterion relief*, dating from 440 BC (the 'gift relief'; the original is in the National Museum in Athens). This shows Demeter handing Triptolemos, son of the King of Eleusis, the first (cultivated) ear of wheat; her daughter Kore, or Persephone, stands behind her carrying a torch. A Roman *Persephone*, and a relief dating from the 1C BC which shows the priest Lakratides.

Room to the right: Copy of a panel painting representing 'Demeter, Kore, Iakkhos, and mystai' (4C BC). *Marble boars* (these are typical of the votive offerings made to Demeter). *Statue of Kore* dating from 480 BC. 4C BC relief showing 'Persephone purify-

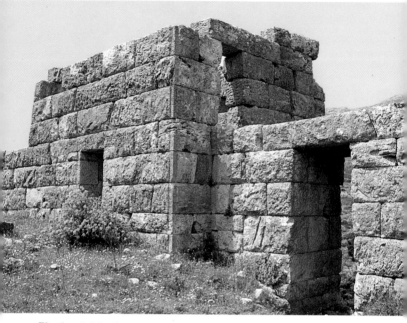

Eleutheraí, defensive tower

ing young mystai' *Dedication relief* showing Athena with citizens of Athens and, on the left, Demeter and Kore (421 BC). Fragments (to wit, pediment decorations) from the telesterion (6C BC). Archaic *torso of kouros* from Mégara (about 530 BC). Reliefs showing Demeter and Kore. *Stele* depicting battle scenes between Athenians and Spartans (late-5C BC). In the middle of the room there is a large protoattic *amphora* from Eleusis (7C BC).

First room to left: (left of entrance): *Statue of ephebos* by Lysippos and archaic *kore* dating from the 6C BC. Archaic-type woman carrying bowl (3C BC). *Statue of Dionysos* dating from the 2C BC and *statue of Asklepios* dating from 320 BC. Two Roman *statuettes of Poseidon* (copies of a 4C BC statue).

Second room to left: Roman sculptures of Hadrian's favourite, *Antinoos*

(2C AD) and of the Emperor *Tiberius* (1C AD); also a good *model of the sacred precinct* of Eleusis (illustration).

Third room to left: *Caryatid* from the Lesser Propylaia (1C AD). *Terracotta sarcophagus* containing the skeleton of a child. *Bronze vessel* with partially burnt human bones (500 BC).

Fourth room to left: *Collection of ceramics* from various periods. Display cases 1 and 2: Minoan vases (*c.* 2000-1600 BC). Also, Neolithic statuette of a woman (*c.* 2800 BC). Cases 3-5: Mycenean ceramics (1600-1100 BC). Cases 6-8: Geometric ceramics (1000-750 BC). Case 9: (Bronze) vases from the 5C BC. Case 12: Corinthian oriental-style vases (750-600 BC). Case 14: Black figure ceramics (600-500 BC). Case 21: Mycenean bronze weapons and jewellery from a tomb near Mégara dating from about 1600 BC.

bridge. The remains of its four large arches were part of the structure built by Hadrian around AD 124.

Elevtheraí/Eleutheraí/ ΕΛΕΥΘΕΡΑΙ p.258□B 3

The road from Athens via Eleusis (Elevsina) to Thebes (altogether about 69 km.) passes through some lovely scenery. About 49 km. NW of Athens are the impressive ruins of the ancient fortress-town of *Eleutherai.*

History: This mountain town was originally part of Boeotia but then passed into the hands of Athens in the 6C BC. Fortifications began to appear beside the Dryoskephalai pass (the name means 'head of oak') in the archaic and classical periods, and in the 4C BC these were extended to form the frontier fortress whose remains can still be seen today.

Ruined fort: At the entrance to the *Kaza Gorge,* on a free-standing rock, can be seen the walls of the fortress together with their two-storeyed towers. The *N. wall,* built of regular square stone blocks that are still well preserved, is up to 11 ft. 6 in. high and is reinforced by eight rectangular *towers* at a distance from each other of *c.* 44 yards. Each of these towers incorporates a gate on the ground floor which led into the inner courtyard (and could also be used as a sally gate) and has narrow embrasures on the upper storey.

Also worth seeing: The remains of two early Christian *basilicas* (each with a nave and two aisles, and dating from the 5&6C) were excavated here on the SE slope. To the N. of the road, the remains of the foundations of a *temple of Dionysos* mark the site of the ancient city of Eleutherai, which was known for its cult of Dionysos.

Environs: Erythraí (9 km. NW):

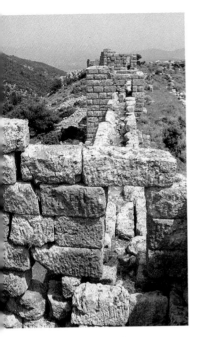

Eleutheraí, N. wall walk

Environs: To the W. of the excavations begins the long slope of the **Acropolis**. At its foot, to the NE, near the *Chapel of the Panagia* (in the vicinity of the telesterion), there are some traces surviving of a *Mycenean structure* of unknown function. To its N. there is a medieval *fortified wall* (23) which defended the Acropolis. The whole range of hills above the roads to Corinth, Thebes, and Athens had been secured from ancient times by scattered *watch-towers*. The ancient *settlement* of Eleusis (residential quarter) lay to the N. and W. of the range of hills; parts of the town walls are still visible. To the S. of the Acropolis, about 1 km. W. of the Museum, traces have been discovered of a prehistoric settlement (1700-1200 BC) and, nearby, of a large *necropolis* (8C BC).

Káto Pigádi (*c.* 2 km. E. in the direction of Athens): Remains of a *Roman*

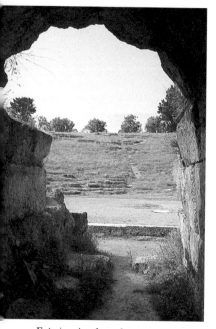

Erétria, view from the stage passage

Also known as Kriekúki. This small town (population about 3,300) is situated on the NE slopes of Mt. Kithairón, on the border between Attica and Boeotia.
Inói (*c.* 5 km. SE): There are some slight traces indicating the position of the old Attic frontier deme of *Oinóe* (Inói in modern Greek). At the S. end of the village are the ruins, which stand 53 ft. high, of a *signal tower* built in the late classical period out of regular square stones.
Víllia (*c.* 5 km. SW): This beautiful mountain village (population *c.* 2,000) is set on the SE foothills of Mt. Kithairón, which towers to a height of 4,593 ft.

Erétria/EPETPIA

p.258□D 2

This small harbour town (population *c.* 2,000) is situated 22 km. SE of Chalkís on the island of Euboea (Évia), on the S. Euboean Gulf (Nótios Evoikós Kólpos). The best way to reach here from Athens is to take the ferry from Oropós (in Attica).

History: Erétria is described by Homer (in Book II of the Iliad) as having been, together with Chalkís, the home of the Euboean Abantes. The importance of Euboea in Mycenean times is shown by the number of towns mentioned there. Erétria became an important sea-trading town which was constantly embroiled in bitter rivalry with its neighbour, Chalkís. It reached the peak of its fortunes in the archaic period (8–6C BC), after which it was several times destroyed, and then flourished once again during the Hellenistic period (3&2C BC). It was first destroyed by the Persians in 490 BC after it had joined Miletus in its revolt against them (500 BC). The last occasion on which it was laid waste was in 87 BC, during the Mithridatic wars; when it was razed by Sulla, after which it never recovered. It was not resettled until 1824, when the inhabitants of the East Aegean island of Psará near Chíos took refuge here from the Turks and founded the town of *Néa Psará* as a 'home in exile'.

Site of the ancient city: Much of the modern town of Néa Psará (which has now been renamed Erétria) lies on a little bay above the ancient city, which was once surrounded by *fortified walls* (surviving in part) and whose ruins are the most important in Euboea. The excavations are divided into three parts: the *shrine of Apollo* in the centre of the modern town (the ancient agora), the *theatre* to the NW (next to which there were two palaces), and the *Acropolis* to the N.
Shrine of Apollo (Odós Apóllonos, in the town centre): The *temple of Apollo Daphnefóros* ('Apollo wearing a crown of laurels') was the most important place of worship in

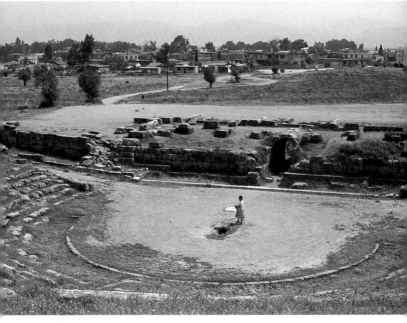

Erétria, theatre

Erétria, Dionysos temple

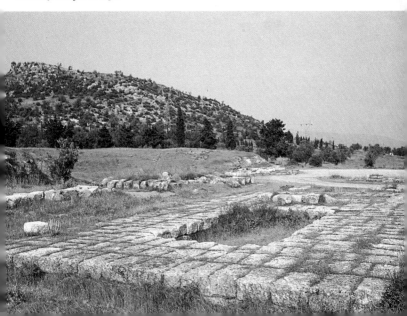

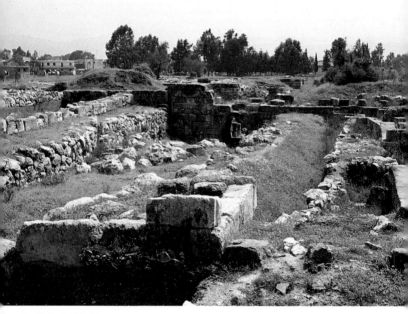

Erétria, W. Gate

Euboea. The oldest finds seem to have been part of a Geometric hekatompedos temple. These temples were so called because they were 100 ft. long (hekatómpedos means 'a hundred feet', and this ancient measurement more or less equates with our modern English foot). They seem to have provided the standard for the first temples built in Greece, for the same dimensions are to be found in the Acropolis at Athens. Traces have also been discovered here of an *apsidal building* dating from *c.* 800 BC which may have been a copy of the legendary laurel sanctuary of Apollo in Delphi (hence also, perhaps, the title accorded to Apollo here of 'Daphnefóros', meaning 'wearing a crown of laurels'). The second oldest temple on this site was an early archaic Ionic *peripteral structure (c.* 650 BC) which was built in the style of the Ionic temple of Hera on Samos and had 6

by 9 wooden columns. The last temple to be built here was a *peripteral temple* dating from the end of the 6C BC (*c.* 520 BC), which had 6 by 14 Doric columns; the remains of its foundations still survive. The cella consisted of three equal parts. The tympana on the W. side were decorated with a frieze of sculptures depicting 'Theseus' fight against the Amazons' and one part of this, 'Theseus' abduction of Antiope, Queen of the Amazons', is of great artistic importance and has been placed in the museum in Chalkis. The cult of Apollo, which, like that of Aphrodite, had probably been imported into Greece from the East via Asia Minor, was soon to play a crucial role in the Greek 'religion'. This 'most Greek of all the gods' was worshipped notably at Delphi, which was considered the seat of Pythian Apollo and the Pythian oracle, but also in a number of

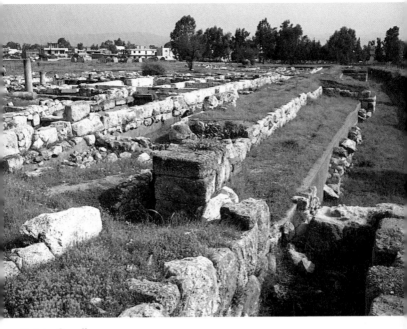

Erétria, S. wall

other shrines, some of them, like those at Súnion (*q.v.*) and Corinth, situated at exposed points in the countryside. As the epitome of light, spirit, wisdom, and art, Apollo has been seen as a symbol of what is truly human (Delphic humanism) right up to modern times (*cf.* Goethe, and Nietzsche's idea of the 'Apollonian principle').

Theatre (to the NW): The part of the ancient city which has been best preserved is the 4C BC *theatre*, which was excavated by the American Institute in 1890–5. The seven lowest *rows of seats* are still extant; the upper rows, which were free-standing, have since been used in the construction of the houses in Néa Psará. Steps lead down from the orchestra to an underground vaulted *passage to the stage-house* (hyposkenion); this passage was used for the sudden appearance of a deus ex machina. In front of the *auditor-ium*, which could house some 6,000 people, there was a semicircular *drainage channel* (about 6 ft. wide).

Ancient W. gate: The old *city wall*, incorporating a *W. gate* which has been relatively well preserved, stood to the W. of the theatre. Various phases of construction can be made out, from the cyclopean walls built in the 7C BC (to the N.) to the Hellenistic *bastion*. Beneath the gate the vault of an underground stream (7C BC) has been preserved, and nearby *graves* dating from the 4C BC have been discovered.

Palaces (S. of the theatre): A kind of *palace* with a peristyle courtyard was built in the 4C on the site of an early Greek *sacred precinct* (8&7C BC) on which there are still the remains of a *heroon* (a shrine for heroes) and other *shrines*. The palace was probably used as a place of worship by a group of nobility connected with the heroon. It

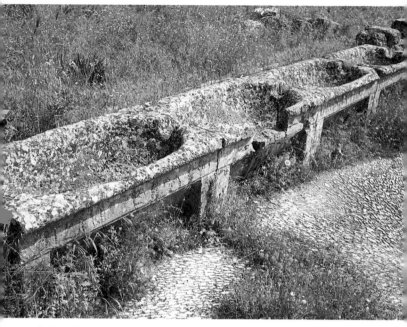

Erétria, Gymnasium, wash basins

is adjoined to the S. by a second *palace* (house with five rooms) which was built somewhat later. Its structure is an enlarged version of the design used for Delian sacred buildings. Both palaces were destroyed by the Romans in 198 BC (and later partially restored). Nearby there are some remains, as yet rather scanty, of a *temple of Ares and Aphrodite*.

Acropolis (N. hill): At the N. and NE end of the excavations is the ancient acropolis (443 ft. high), on which stand the ruins of the *N. wall*. There are few clear traces of the ancient structure; but the place offers a beautiful view over the Gulf, the Lelantine Plain, and the mountains in the background (Mts. Pentelikón, Párnis, Kithæiron, and Parnassós). The most interesting ruin here is that of the 5C *sanctuary of Artemis* (the twin sister of Apollo) on the S. slope.

There was also a well-known shrine to Artemis in Avlís (Aulis) (*q.v.*) on the mainland opposite Euboea. The remains of *temple walls*, an *altar*, and a temenos still stand.

Thesmophorion (SW slope): The (scanty) remains of a *sanctuary of Demeter*, with a flight of stairs and a series of rooms around the cella, show us the diversity of places of worship to be found in Erétria. Demeter ('Mother Earth'), the goddess of the earth and of fertility, was worshipped here, just as she was in Eleusis (Elevsina) in Attica. As 'thesmophoros' ('law-giver'), she was regarded as a protector, notably of rural families. Every autumn, at the time of the sowing of the corn, the women organised the festival of the thesmophoria, from which men were strictly excluded, and whose purpose was to promote the fertility of both corn and woman-

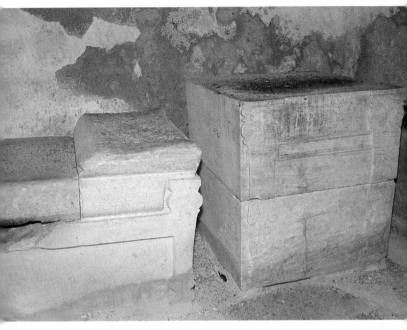

Erétria, Macedonian grave chamber

kind. One such festival was described by the comic playwright Aristophanes (5C BC) in his play 'Thesmophoriazusai'. Nearby are the remains of a *gymnasion* (meaning 'sports ground') dating from Hellenistic times, on which there are bases of statues and inscriptions; this area was excavated in 1895. Below the gymnasion is the site of the *stadium*.

Macedonian chamber tomb: A vaulted *chamber tomb* dating from Macedonian times (around 300 BC) has been unearthed on a hill W. of the theatre. The *dromos* (entrance to the tomb), at the N. end, leads into a square, vaulted tomb chamber containing items of coloured marble, including two marble funeral couches, and two thrones.

Also worth seeing: To the S. of the

shrine of Apollo, towards the site of the ancient harbour, there once stood the old *agora*, which has since been built over by houses. The remains of a round *tholos* can be seen which once housed the harbour administration. Farther towards the sea there are traces of *baths* containing basins (round baths). To the E., by the side of what was the ancient harbour (now dry land), are the remains of a late classical *palaestra* (school for wrestlers), on to which many additions were built. Next to it are the foundation walls of a *sanctuary of Isis*, the principal Egyptian goddess who, like Demeter, was considered to be the source of fertility and growth.

Archaiologikó Musío/Archaeological Museum: This is to the S. of the theatre, near the ruins of the palace. It contains sculptures and cer-

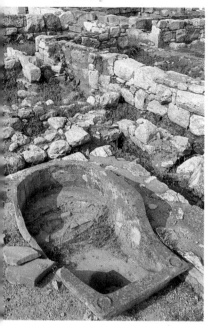

amics from ancient Erétria and neighbouring Levkándi (see Chalkís). The Mycenean and Geometric exhibits are of interest and include the protogeometric clay figure of a centaur dating from the 10C BC. There are also vases from the Geometric, archaic, classical and Hellenistic periods; burial objects, idols, bronze weapons, and ornaments; and numerous stele, tombstone inscriptions, and votive offerings dating from the classical and late classical periods. The main finds from the temple of Apollo here are housed in the Museum in Chalkís.

Environs: Amárynthos (*c.* 10 km. E.): This small town (population about 3,000) originates from the ancient settlement of the same name, of which there are virtually no traces left. Nearby is the monastery of *Agios Nikólaos,* which incorporates a church dating from 1565. The church contains beautiful 16C *frescos* and is decorated on the outside with coloured faience tiles.

Erétria, hip bath

Fáliron/Palaió Fáliron/Pháleron/ ΦΑΛΗΡΟΝ p.258☐D 5

The Bay of Pháleron (Fáliron in modern Greek) lies *c.* 7 km. SE of Athens and just NE of the head-shaped promontory of Piraeus. This was the earliest anchorage used by the Athenian fleet (still small in those days) until the harbour was constructed at Piraeus. Its sandy bay was a favourite swimming resort for the people of Athens until the triangle of land covering Athens, Piraeus (Fáliron) and Eleusis began to be industrialized towards the end of the 19C. The beaches have since been heavily polluted. Only some sparse *remains* of a wall and a mole have survived from the ancient deme of Phaleron.

The modern coastal town of *Palaió Fáliro* ('Old Phaleron'; population *c.* 35,000) is a suburb of Athens, connected to the city centre. It contains a *war cemetery* (near Cape Edem) established in 1961, where several thousand British soldiers are buried.

Environs: Agios Kosmás (*c.* 5 km. SE): This coastal town probably ori-

ginates from the ancient *Koliás*; its modern name derives from a 19C chapel. Excavations conducted in the foothills here in 1930 unearthed the ruins of early and late Helladic houses and cemeteries (showing some kind of relationship with the Cyclades). There was also a fortified village here in Mycenean times (around 1200 BC). Beneath the *chapel of Agios Kosmás* there are some slight traces of the ancient *sanctuary of Aphrodite*. *Athens airport*, which is also the main airport in Greece, is next to the nearby town of *Ellenikón*, after which it is named.

Álimos (*c*. 4 km. SE): It was here, in the ancient *deme of Alimus*, that the historian Thukydides was born in the 5C BC. He was a contemporary of the devastating Peloponnesian War; and, from his place of exile in Thrace, he described the course and causes of the war, for the first time in historiography, in an objective and impartial way. He used the technique of putting brilliantly composed speeches into the mouths of the main characters in order to throw light on them and the events surrounding them (e.g. Perikles' funeral oration).

Fylí/Phylé/ΦΥΛΗ

p.258☐D 3

The modern village of Fylí is situated *c*. 18 km. NW of Athens, on the S. slopes of Mt. Párnis (*q.v.*). In ancient times, the shortest route from Athens to Thebes was a footpath which passed by this point.

History: There were two routes from Athens to Thebes (and from Attica to Boeotia), and both traversed difficult mountain passes. The shorter one passed immediately to the S. of Mt. Párnis, while the other route, which was slightly longer, passed through Eleusis and by the side of what is now called Mt. Pástra (farther SW). Both were secured by strong *fortresses* at the frontier (see also Elevtherai).

Kastro Fylí (ancient frontier fort): A footpath from the village leads to the impressive ruins of the ancient frontier fort, also called Phylé (Fylí in modern Greek). The walk takes about 90 minutes). The fortress (2,130 ft.) offers a beautiful view over the Athenian plain and the steep valleys of Mt. Párnis.

The well preserved *fortifications* date from the 4C BC and were built over some older polygonal fortified walls. It was here that the Athenian general Thrasyboulos established himself with his followers in 404 BC, after his exile in Thebes, and from here that he went on to overthrow the dictatorship installed in Athens by the '30 tyrants'. The *main entrance* is on the E. side. The *enclosure* is pentagonal and is well preserved, except where it has collapsed to the W. and SW. These are strong walls, 8 ft. thick, and constructed of squared blocks. There are also remains of four *square towers*, one *round tower*, and two (originally three) *gates*. Nearby there are traces of fortifications and houses, and about 1.5 km. NE of the fort can be seen the remains of polygonal fortified walls which belonged to outposts.

Environs: Panagía Klistón (*c*. 3 km. NW): Near Fylí is the attractive Byzantine monastery of the Panagía Klistón ('Mother of God of the Gorges'), which enjoys a romantic setting. It was built in the 14C (and rebuilt at various later dates). It is worth seeing the old (cruciform domed) *church*, which contains 18C *frescos* and a collection of valuable *church artefacts*. The *fountain* in the courtyard bears the date 1677. From the terrace, there is a beautiful view down over the gorge formed by the river Guras (Potámi Gúras). The ancient route to Thebes, which was a mule-track, passed along the plateau and the mountain slopes via the mountain village of Pýli and the now ruined Boeotian frontier fort of *Pánakton*.

oné were discovered in the garden of the *Villa Kanelopoulos* at the foot of Mt. Hymettós. At the N. entrance to Glyfáda (between the road and the beach, near the Antonopoulos Hotel), are the ruins of an early Christian *basilica* which is said to mark the spot where St.Paul made his first landing in S. Greece.

Glyfáda/ΓΛΥΦΑΔΑ

p.258☐D 5

This is a popular seaside resort (population *c.* 25,000) situated about 17 km. SE of Athens beneath the S. foothills of Mt. Ymittós (Hymettós) (*q.v.*). Its fortunes, like those of nearby Vuliagméni, have risen markedly since the discovery of *medicinal waters* here in 1920.

History: The modern town probably originates from the ancient Attic *deme of Aixoné* (Aixoni in modern Greek), which was situated slightly farther inland, towards Ymittós. It was part of the district of Kekropís, whose name itself derives from the old, pre-Hellenic word for Attica. Aixoné is supposed to have had a *sanctuary of Demeter* in which the fertility festival known as the Thesmophoria was celebrated annually. As Aristophanes tells us in his comedy 'Thesmophoriazusai' (around 411 BC), only women and girls were allowed to take part in this festival. In the play, the women unmask a man dressed as a woman and almost kill him. It is certain that this shrine was closely connected with the cult of Demeter in Eleusis (Elevsína), even though the latter was far more famous.

Archaeological discoveries: The remains of the ancient theatre of Aix-

Spilaio Nymfón / **Pan's cave** / **Nymphs' cave:** On the S. foothills of Mt. Ymittós, near the town of *Vári* (*c.* 5 km. SE), there is an interesting *cave* which was dedicated to the cult of Pan and the nymphs. It is a limestone cave with stalactites, divided into two chambers by a wall of rock. The larger chamber contains a spring and a *relief* on the rock-face which depicts the artist Archídamos with hammer and chisel (which is why it is also known as the *cave of Archídamos*). There are also a primitive *altar* of Apollo Hersos, a (headless) *seated goddess*, and a *lion's head*, all of which have been carved out of the rock, as well as other reliefs and inscriptions too.
The cave was excavated in 1903, when other interesting finds were made (votive reliefs and offerings) which formed part of the cult of Pan and the nymphs. These show that worship was conducted here from 600 BC to the 4C AD. Pan was the god with cloven feet who ensured the fertility of the flocks and herds and was the patron of shepherds. He was thought to have invented the reed-pipes used by shepherds (symbolized by his pan-pipes). He induced 'panic terror' in enemies and unpleasant trouble-makers.

Environs: Vári (*c.* 5 km. SE): Near this village and beneath Mt. Ymittós are the excavations of the old Attic *deme of Anagyrús*, which include an interesting necropolis dating from the 7–5 BC. There are *inscriptions* extant which refer to shrines of Hephaistos, Athena, and Castor and Pollux, but of these only slight traces are discernible.

Kaisarianí/**ΚΑΙΣΑΡΙΑΝΗ**

p.258□E 5

On the W. foothills of Mt. Ymittós (see Ymittós), set at a height of 1,120 ft., is the *Kaisarianí Monastery* (Moní

Kaisariani, ruined Taxiarch church

Kaisarianís), surrounded by plane-trees, cypresses, and pines.

History: Near the monastery are the source of the mountain stream Ilissós (which, like the Kifissós in N. Attica, still retains its very ancient, pre-Hellenic name) and the ancient healing spring called *Kyllu Pera*. Remains of early *shrines* have been discovered by both these springs. The name of the monastery probably derives from the healing spring, for this was also known as *Kaisarianí Pigi* (or 'royal spring'). The Emperor Hadrian supplied Athens with its water, which was brought there by an ancient aqueduct. It now feeds a fountain on the E. wall of the monastery, where the water still shoots out of a 6C marble *ram's head*. There was once a temple of Aphrodite here of which there are now no remains. An *early Christian basilica* was built on the site of this

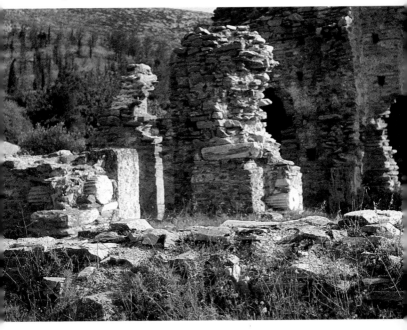

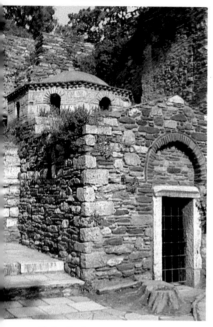

Kaisariani, baths

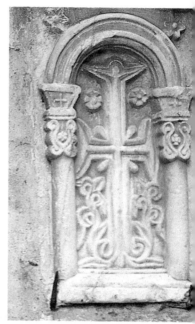

Cross ornament in the monastery church

temple in the 5C, and there are some fragments of it in the courtyard of the monastery; the present *church of Panagia Kaisariani* was built around 1000. During the Turkish occupation, the monastery was able to preserve a certain independence and possessed a library which was then famous far and wide.

Monastery church: This is a cruciform domed church (based on the shape of the Greek cross). Its four supporting interior columns still have ancient capitals and are in harmonious proportion to each other. The masonry consists of alternating stone and brick, in the fashion of late antiquity. The cornice is twice as high, and the dome four times as high, as the distance beween the columns, which are based on ancient models. The *narthex* has a flat dome and the

parekklesion (side building on the right), which has a small *bell tower*, both date from the 17C, when the monastery was quite prosperous.

Wall paintings: Apart from those in the narthex, the interesting wall paintings in the church date from the 16C and are the work of a monk of the Macedonian School from Mt. Athos. The frescos in the *dome* (tholos) depict Christ as *Pantocrator* (which means 'the ruler of all'); the vault of the dome itself symbolizes heaven. Beneath Christ are the *Prophets* and the four *Evangelists*. The *vault of the apse* shows the *Mother of God* (Theotokos) as the queen of heaven and patron of the church, accompanied by the *archangels* Gabriel and Michael. Next we see *Christ as high priest* with the Eucharist, and Sts. Chrysostom, Basil, and Gregory, all Orthodox Doctors of the Church. The frescos in

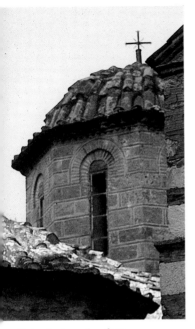

Kaisariani, narthex dome

Kaisariani, steps in the monastery courtyard

the *crossing* depict the *life of Jesus*, beginning S. of the sanctuary, and including His birth, presentation in the temple, baptism, and transfiguration, the resurrection of Lazarus, Christ's entry into Jerusalem, the Last Supper, the Resurrection of the Dead, the lamentation of Christ, Doubting Thomas, the Ascension, and Pentecost.

Monastery buildings: These are worth seeing. They are grouped around the picturesque *courtyard*, which contains a *garden* and *covered walks*. On the W. side are the old vaulted *kitchen* and the old *refectory*, which contains a vault with pointed arches, a small apse, and a beautifully chiselled Roman *door lintel*. This now accommodates a small *museum*. To the S. (left of the entrance to the courtyard) are the remains of a late Roman

bath house dating from the 5C. It consisted of a sweating-room (sudatorium) heated by the passage of hot air through hypocausts, a domed central room containing the hot bath (caldarium), and the frigidarium, which contained the cold bath, and whose *floor* still survives.

Also worth seeing: Near the monastery (*c.* 330 yards SW) can be seen the old *monks' graveyard* (kimitirio) and a 17C *church of the Taxiarkhis* (Archangels).

Kifisiá/ΚΗΦΙΣΙΑ

p.258☐E 4

This garden city, with its many villas, is a favourite summer retreat for the people of Athens, and is attractively

situated at the foot of Mt. Pentéli (see Pentéli), with pines and plane trees all around.

History: The old Attic deme of *Kephisiá* (Kifisiá in modern Greek) was probably named after the small *Kephisós* river (modern Greek: Kifissós), which rose near here, on Mt. Pentélikon, and debouched in the Bay of Piraeus (at Phaleron). Like the names of other rivers and mountains in Attica (such as the river Ilissós, Mt. Brilissós, or Mt. Ymissós), it derives from very ancient, pre-Hellenic settlers. The ancient deme belonged to the first administrative district of Athens, known as the Erechthean district because it circled the Erechtheion (the old name for the Acropolis). The temple on the N. edge of the Acropolis which bears the same name was itself called after the 'snake-man' Erechtheus, the legendary king and tribal hero of Athens, and it occupies the earliest site of religious significance on the hill. The nearby suburb of *Kefalári*, which contains a source of the Kifissós, probably derives its name from the mythical figure of

Kephalos, son of the King of Attica. He was said to have accidentally killed his beloved Prokris, who was spying on him out of jealousy, while he was out hunting.

Roman burial chamber: The only remnants of ancient times are these four *garlanded sarcophagi*, which date from the 2C AD.

Also worth seeing: The *Botanical Garden* contains some rare Mediterranean plants, and the *Gulandris Museum* (13, Levídu St.) has a natural history collection.

Environs: Agía Paraskeví (*c.* 8 km. NE of Athens): On the N. slope of Mt. Ymittós is the *monastery of Agios Ioánnis*, which can be seen from a great distance. It dates from the 13C, as does the small *monastery church* with its beautiful *dome* supported by two columns and pilasters.
Amarúsion (generally called *Marúsi*; *c.* 2 km. SW): This is a suburb of Athens and is the penultimate station on the Electric Railway. It contains some slight remains of the Attic deme of

Kaisariani, monastery

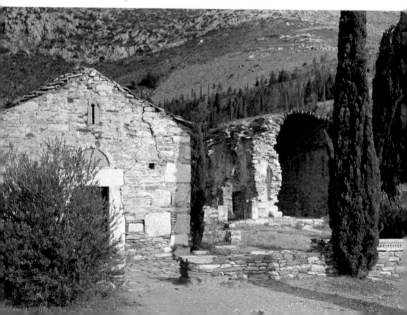

Athmonon, which had a well-known shrine to Artemis Amarysia (no remains), from which the modern name of Amarúsion derives. This shrine had close links with the temple of Artemis in Vravróna (Braurón) (*q.v.*). Today, Amarúsion has made a name for itself through its pottery and ceramic industries, and there is a permanent exhibition of ceramics (Ekthesi Keramikís, meaning 'exhibition of ceramics') which displays exhibits from all over Greece.

Khalándri(on): This is a nearby suburb, situated between the massif of Mt. Pentéli to the N. and Mt. Ymittós to the S. (*c.* 8 km. from Athens). This was the site of the protoattic deme of *Phlyaí* (Flyaí in modern Greek), which belonged to the Kekropian administrative district of Athens, itself named after Kekrops, the legendary king of Attica, who was also a snake-man, like Erechtheus. At that time, Attica was called 'Kekropia' in his honour. The only remnant of antiquity is a *late Roman chamber tomb,* dating from the period of Herodes Atticus (2C AD), which is housed in the *chapel of the Panagía Marmariótissa;* the apse has replaced the door front of the chamber, but the rest of it has been preserved.

Néa Ionía: This working class suburb (*c.* 7 km. NE of the centre of Athens) contains the interesting Byzantine church of *Omorfi Ekklisía* (meaning 'beautiful church'). This is a cruciform domed church dating from the 12C which contains a narthex and a rib-vaulted S. chapel. It has beautiful masonry and decorations which resemble reliefs. The octagonal *dome* is interesting and has fine columns and ornate marble arches. There are some beautiful *frescos* in the vault of the dome, including an impressive and youthful *Pantocrator* by the Macedonian School, and on the walls.

Lávrion/Laurion/ΛΑΥΡΙΟΝ

p.256□F 6

This small port and industrial town (population *c.* 8,000) is situated on the SE tip of Attica, about 54 km. SE of Athens. Some 4 km. N., on the Bay of Lavrion (Lavriotikós Kólpos), are the ruins of the ancient fortified town of *Thorikós.*

History: In ancient times, not only this town, but the whole district, was known by the name of Laurion (now Lávrion). The area was first settled around 1000 BC and soon became well known because of its silver deposits. Even though silver had always been considered less valuable than gold, it became all-important for Athens' economic prosperity following the introduction of a silver-based currency. The first Athenian silver coins, which were tetradrachms, or four-drachma pieces, were minted around 600 BC. They showed an image of the goddess Athena on one side and an owl's head on the other. In the years which followed, this 'owl coinage' became a symbol of Athens and her prosperity, whence the proverb, still in use, about 'carrying owls to Athens'. The silver needed for the mint was extracted from the mines at Laurion; and Aiskhylos (early 5C BC) was able to refer to Laurion, in his play 'The Persians', as the 'underground treasure-house' of Athens. It was this

source of wealth, owned by Athens, which enabled Themistokles to build and arm the fleet which won such a brilliant victory against the Persians at Salamis (*q.v.*). A large number of the magnificent buildings which Perikles erected in Athens were paid for, too, with silver from Laurion. The mines were exploited not only by the state, but also by private lessors, who had to pay the state interest at a rate of 4%, and sometimes used inhuman methods because the ore was difficult to extract. Thousands of prisoners of war (some of them Persian) and other slaves provided a labour-force which cost virtually nothing. During the Peloponnesian War, the slaves were liberated by the Spartans (413 BC), and the mines were temporarily closed. The importance of Laurion declined during the Hellenistic and the Roman periods as a result of the discovery of new and more promising mines (in Thrace) and Alexander the Great's seizure of the gold in the Persian treasury. For a long time the mines here were neglected, until in 1860 Greek, French, and American companies began to exploit the ancient slag-heaps and the remaining deposits for lead, manganese, and zinc. The modern mines are still being worked, and have brought Lávrion a certain prosperity.

Ancient mines (Metallía): The whole scene looks like a mining museum. Some impressive remains of the ancient mines can be seen, notably near *Kamárisa* (*c.* 3 km. NW), which corresponds to the ancient *Maronéa*; and there are others in the neighbouring *Verseko valley* (Megála Pévka) in the S., and in the *Legrena* and *Botsari* valleys. There are altogether some 2,000 *tunnels* and *shafts*, some sloping and some perpendicular, cut into the mountain; they measure roughly 6 ft. 6 in. by 6 ft. 6 in., and their depth varies from 100 ft. to 330 ft. The *galleries* were supported either by artificial wooden props or by natural stone pillars which were left in the rock.

The air was kept fresh by primitive ventilation shafts. The miners, most of whom were slaves, had to work in a crouching position. Often the ore was brought to the surface by children. It was then cut into small pieces (above ground) and cleaned in ore-washeries known as ergastíria (literally meaning 'workshops'). *Cisterns*, *ore-washeries*, and *smelting furnaces* are still extant in a number of places. The whole area has been greatly spoiled by man since the early classical period and thus consitutes one of the oldest examples of environmental pollution.

Environs: Makrónisos: The island of Makrónisos ('long island' in modern Greek; 8.5 square miles) lies about 3 miles offshore. It is a long, narrow, somewhat deserted island which has been used during recent times as a camp for political detainees (most recently during the military dictatorship of 1967–74).

**Marathónas/Marathon/
ΜΑΡΑΘΩΝ** p.258☐E 3

Marathon, today a small rural community, lies some 42 km. NE of Athens, on the protected Gulf of Petalion (Kólpos Petalion). The Plain of Marathon is about 6 miles long and

up to 2 miles wide and is bounded inland by the rocky spurs of Mt. Pentelikon, and, towards the sea, by the Kynósura Promontory (the name means 'dog's tail'). Today, its sandy beaches have made Marathon a popular bathing resort.

History: The district around Marathon was settled as early as prehistoric and Mycenean times and was one of the earliest Ionian areas of settlement in Attica. This is attested by the legend that Marathon, son of Epopeus, King of Sikyón (in the N. Peloponnese), originally built a city here. Theseus, the Athenian hero, was supposed to have slain the 'wild bull of Marathon' here and to have then used the Plain as pasture-land.

Its lasting fame, however, derives from the decisive Battle of Marathon in which the Greeks fought the Persian invaders in 490 BC. The Persians had anchored their fleet in the bay nearby; their army comprised *c.* 25,000 men (Herodotus' figure of 100,000 infantry and 10,000 cavalry is a severe exaggeration). The Greeks were defending the pass leading towards Athens, and had a force of about 10,000 men which was an Athenian citizens' militia, consisting of 10 units from each of the administrative districts of the city and its rural regions. Each district (phyle) had to provide a detachment (taxis) of 800 (or 1,000) heavily armed hoplites; this would be led by a strategos (commander), while supreme command of the whole army would be vested in the polemarch. Some of the outstanding strategoi at Marathon were Aristides, known as 'the Just', and Miltiades, later his adversary; the polemarch was Kallimachos, who was killed in battle. The Greeks, who were heavily outnumbered, owed their victory to the skilful tactics of Miltiades, who changed the usual formation of the phalanx ('line of battle'). Instead of having a unit of 8 men behind each other, he reduced the centre to 4 men and correspondingly reinforced the wings (or 'horns'). This indeed allowed the attacking Persians to break through the centre, but they then found themselves caught in a pincer movement by the unexpectedly strong Greek wings. In the panic of the ensuing retreat to their ships, the Persians lost about 6,000 men and several ships, while the victorious Greeks had only 192 dead (including the polemarch Kallimachos). Such, at least, is the account provided by Herodotus (Book 6, 107 ff.). This saved Athens, and with it the infant West, from the Persian threat for the time being. The next Persian invasion ended ten years later with the naval battle of Salamis (*q.v.*). Tradition has it that, after the battle of Marathon, a young Athenian named Diomedon ran across the mountain to Athens, still fully armed, broke the news of victory with his famous cry of 'Enikesame!' ('We won!'), and fell down dead. It was in commemoration of this feat that the modern Olympic Games (which began in 1896 at Athens) introduced the long-distance marathon, which is just 42 km.

Ancient battlefield: This lies on the Bay of Marathon, near the modern coastal road between the villages of Marathónas (to the N.) and Néa Mákri (to the S.). The position of the Greek army was quite close to the present-day church of Agios Dimitrios (Vrana village), at the foot of the ridge of Mt. Pentelikon called Agriliki (*c.* 1,800 ft.). It was here that the *Sanctuary of Herakles* mentioned by contemporaries (cf. Herodotus) was discovered. We may also presume that this was the site of the ancient *deme of Marathon*. The Persian camp was nearer the bay and the Kynósura promontory, quite close to the modern church of the Panagía Mesosporitissa and the stream called Charádra. It was from these positions that the two armies advanced to engage each other.

Sorós Athinaion/The Athenians' burial mound: The 192 Athenian

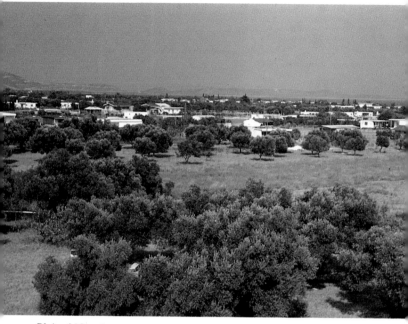

Plain of Marathon

dead were cremated and buried in a tomb of honour (sorós means 'tomb') some 550 yards E. of the modern road, close to the sea and on the bay. This broke with the tradition whereby those killed in war were buried privately at home, and expressed a special 'national' recognition, which to an extent is still felt today, of their sacrifice and their achievement. The mound (29 ft. 6 in. high and roughly 590 ft. round) was, and still is, seen as a national and European monument to the successful defence of the European spirit against the different values of Asia. It was adorned with a stela by the sculptor Aristion (490 BC) depicting the 'Fallen Warrior', which is now in the National Museum in Athens (Room 11). A modern copy has been set in the place of the original.

The Plataians' burial mound: The burial-mound (tumulus) of the Plataians was discovered in 1970 by the Greek archaeologist Marinatos. It lies a little way inland and close to the church of Agios Dimitrios, at the entrance to the village of Vrána. It has a diameter of about 100 ft. and is some 10–13 ft. high. Skeletons of young men about 20 years old and their 40-year-old commander, together with fragments of vases which were buried with them as grave offerings, have been discovered. The citizens of the Boeotian border town of Plataia (Plataiai) were the only Greeks to send Athens help (in the shape of a force of c. 1,000 men). The Spartans did send reinforcements, but they arrived late and could only view the battlefield.

Also worth seeing: Near the tomb of the Plataians there is a *necropolis* comprising four burial mounds dating from the middle Helladic (2000–1500)

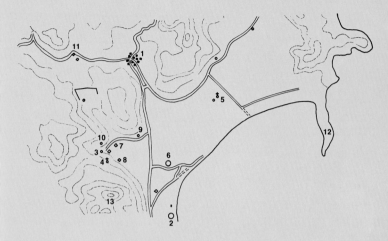

1 Marathon 2 Néa Mákri 3 Vràna (ancient Marathon) 4 Agios Dimitrios 5 Panagia Mesoporítissa 6 Athenian grave mound (soros) 7 Grave mound of the Plataians 8 Mycenean tomb 9 Early Helladic cemetery of Tsépi 10 Archaeological Museum (of Vrâus) 11 Pan cave 12 Kynísura foothills

and Mycenean (1500–1100) periods, and in particular a restored *Mycenean beehive tomb* (tholos) with a *dromos* (entrance to the tomb) 82 ft. long, in which were discovered two skeletons of horses – the guardians of the place.

Archaiologikó Musío/Archaeological Museum: This small museum (which is in Vrána, near the church of Agios Dimitrios) contains many archaeological discoveries from the Marathon district. These are arranged in chronological order from Neolithic up to late Roman and Byzantine times.

Room A: The display cases contain interesting *fragments* of Neolithic ceramics from the Cave of Pan near Oinóe (Inói in modern Greek).

Room B: Ceramics found in the early Helladic cemetery of Tsépi.

Room C: Burial objects (notably black-figure ceramics) from the two burial mounds at Marathon mentioned above.

Room D: Various *tomb reliefs*, marble tomb monuments, and ceramics from the towns of Néa Mákri, Agios Andréas, and Marathon.

Room E: Statues and *tomb reliefs* (also glass and lamps) from the Roman and Byzantine periods.

Environs: The remains of a *Mycenean acropolis* (stone rubble) have been discovered on Mt. *Agriliki* (1,825 ft.), SE of the Plain of Marathon. The ancient deme, or community, of **Marathon** was probably situated close to the *Plataians' burial mound*, near the village of *Vrána*.

Néa Mákri (*c.* 6 km. S.): Popular bathing resort. It was near here that a significant Neolithic-Helladic settlement was discovered (the finds are in the museum at Marathon).

Panagía Mesosporitissa (coastal plain): Near here are the remains of a medieval *watch-tower* incorporating a fragment of an Ionic capital. A monument to the battle stood here in classical times. It was called 'tropaion' (meaning 'trophy'; literally 'marking the turning-point'), since it was probably here that the fortunes of the battle turned decisively and the Persian rout began.

Cave of Pan (*c.* 2 km. W.): It was here, in 1957, that the archaeologist Papadimitriu discovered the *Cave of Pan and the Nymphs* mentioned by Pausanias and also in a local inscription. The cave seems to have been the site of a cult as early as the Neolithic period and through the Bronze Age. In the 5C BC, Herodotus reported that the cult of Pan had been re-established here. Pan was the god of the herdsmen who was himself represented with horns and the beard and legs of a goat; he was always chasing after pretty nymphs, and loved the music of the shepherds' pipe (pan-pipe).

Even today, there are still processions and ceremonial fires connected with Pan, especially during Holy Week.

Markópulo/ΜΑΡΚΟΠΟΥΛΟ

p.258☐E 5

This is the agricultural centre of the *Mesógia*, the fertile interior of S. Attica, and it lies some 30 km. SE of Athens.

It is worth seeing the small churches of *Agios Konstantinos*, *Agia Triáda*, the *Panagia* (vault with pointed arches), *Agia Kyriaki*, and *Agia Paraskevi*. Some of them contain beautiful *frescos* by Georgios Markos, the 17C Argive painter.

Environs: Keratéa (*c.* 10 km. SE): This village produces wine and fruit. Nearby, in a SW direction, towards the sea, is the convent of *Moni Keratéas*. Some 4 km. SE on the road to

Porto Rafti, on *Mt. Myrrenda* (or *Merenda*), close to a medieval *watch-tower*, the remains have been discovered of the protoattic; deme of **Myrrhinús**. They comprise, in particular, a *necropolis* of some 26 graves dating from the 8–4C BC and containing vases ranging from the Geometric to the Hellenistic period. These interesting objects are displayed in the museum at Vravróna (*q.v.*). The remains of an *ancient road* (10 ft. wide) have also been discovered here. The main items recovered from the site of the Sanctuary of Apollo and Artemis here were the *statues* of a *kouros* (or youth) and *kore* (girl) dating from archaic times; these were excavated in 1972 and are now housed in the National Museum in Athens. The neighbouring village of *Kalývia* (5 km. S.) also has some church frescos by the school of Georgios Markos of Argos. Nearby are the attractive but abandoned monastery church of the *Taxiarkhis* and the church of *Agios Georgios*, which incorporates reused Ionic capitals.

Mégara/ΜΕΓΑΡΑ

p.258☐B 4

This is a lovely little town with colourful, flat-roofed houses, situated at the N. end of the Saronic Gulf in the fertile rural area called *Megarís*. Today it is an agricultural centre known for its poultry breeding, wine making, and production of fruit and vegetables, especially olives, and has a population of some 18,000.

History: The first Cretan trading settlement was established here as early as 1700 BC, and was commemorated in the name of the ancient port, which was *Minóa* (after King Minos of Crete). Perhaps, too, the name 'Megara' itself signified a Cretan palace or temple, and was simply the plural form of 'megaron' (palace). After the Dorian settlement around

1000 BC, the port grew quickly and in the 8&7C BC it acquired great importance as an independent city-state. The Megarians founded important colonies including Mégara Hyblaia (728 BC) and Selinús (628 BC) in Sicily, and Chalkedón (685 BC) and Byzántion (658 BC), the future Constantinople, on the Bosporus. Theagénes, a popular leader who became tyrant, extended the city on a large scale about 620 BC. The ensuing period saw numerous conflicts with the rising power of Athens, notably for the possession of the island of Salamis (*q.v.*), most of which Athens won. The Megarians fought bravely during the Persian Wars (for example, sending 3,000 men to the battle of Plataiai in 479 BC). Perikles' decree in 432 BC excluding Mégara from trade with Athens was one of the reasons for the outbreak of the Peloponnesian War. The war lasted thirty years

(431–404 BC) and caused the city such harm that it never recovered its importance.

Fountain of Theagénes: The fountain of the tyrant Theagénes (around 620 BC), which Pausanias mentioned (in the 2C AD), has been preserved and stands in the town, near the church. The large *reservoir* is composed of limestone blocks and its walls have survived in places to a height of 16 ft. 6 in. The *cistern* (*c.* 60 ft. by 43 ft.) had a roof supported by five rows of octagonal columns.

Also worth seeing: The ancient *agora* probably stood on the same site as the main square, or *platia*, in the modern town; in any case virtually nothing of it is left. The town has two hills, *Karía* to the E. (885 ft.), and *Alkathoos* to the W. (941 ft.), each of which had an acropolis in ancient

Grave mound of the Athenians

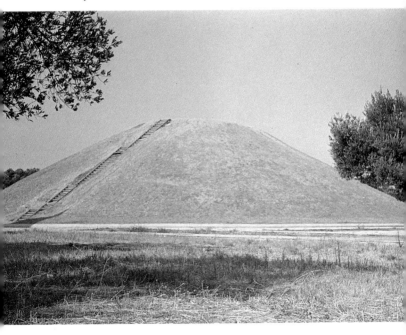

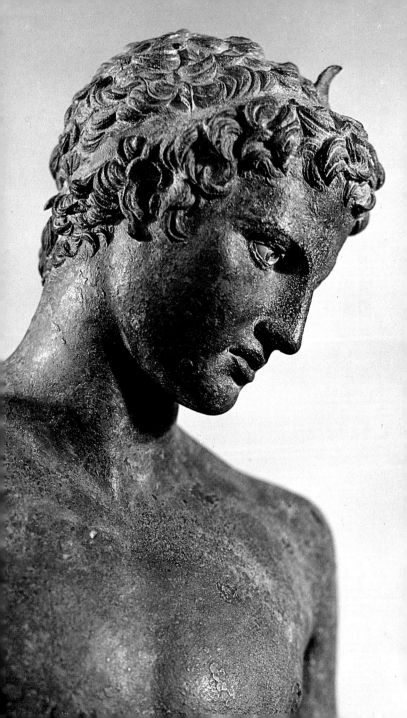

times. *Nísaia*, the port of ancient Mégara, was situated near the modern port, called *Pakhi*; and there are traces of Nísaia's acropolis on *Palaiókastro* hill.

Environs: Geránia Mts.: To the W. of Mégara can be seen the imposing range of the *Geránia Óri* (Geránia Mountains, 4,495 ft.), which extends from the Gulf of Alkionidon in the N. to the Saronic Gulf in the S. and forms a natural boundary between Central Greece and the Peloponnese.
Kakí Skála ('Evil Staircase'; *c.* 7 km. W.): Here can be seen the *Skironian Rocks* mentioned in the Theseus legend. According to this myth, the wicked Skiron used to rob people travelling from Corinth to Athens on the narrow path above and then hurl them down into the sea, where they were eaten by giant turtles. However, he met the same fate at the hands of the hero Theseus.
Kinetta (*c.* 12 km. SW): Close to this attractive resort (which has a pebble beach), and also to the neighbouring village of Agii Theódoroi, was the ancient town of *Krommyón*, some 20 km. SW (no visible remains). It was here that Theseus was supposed to have slain the man-eating sow. In the gulf opposite is the small island of *Evraionísi* (originally 'Oraionísi', or 'beautiful island'), which was fortified by the Franks around 1200.
Osios Melétios (*c.* 15 km. NE): This isolated *monastery* stands on the foothills of Mt. Pateras, which formed the old border between Attica and Megarís. It was founded in Byzantine times by a monk called Etios. Its complex of buildings includes chapels, living quarters, and, notably, a small (restored) *cross-in-square* church which contains four columns dating from the 11 or 12C and some beautiful *frescos* dating from the 16 or 17C. In the courtyard there is a two-storeyed stoa with ornate *arches*.

◁ *Marathon, Ephebe, 4C BC, N.A.M., Athens*

Oropós/Skála Oropú/ΟΡΟΠΟΣ
p.258☐D 2

The modern town is divided into two parts, the port of *Skála Oropú* on the Gulf of Euboea (Évia in modern Greek), and the village of Oropós, which is situated about 4 km. inland (*c.* 50 km. N. of Athens).

History: The name of the town, like that of the river *Asopós* which debouches nearby, originates from pre-Hellenic settlers. The town itself was not unimportant in classical times since its position on the sea offered the shortest crossing to the island of Euboea, which was rich in grain and livestock. Its inhabitants had the reputation of being particularly cunning and greedy, as Dikaiarkhos, the pupil of Aristotle, records. Control of the port alternated frequently between Athens and Thebes. Around 402 BC, the town is said to have been moved inland from its original position on theb sea to a new site approximating to that of the modern village of Oropós. This contains an attractive 17C church. However, there are only some slight remains of the ancient town (near the harbour).

Environs: There are also some scanty remains of the ancient deme of Oropós near the neighbouring town of *Néa Palátia* (2 km. E.).

Greek vases:
In ancient times vases were not primarily used for flowers, as is the custom today. Vases were vessels made of various materials, mainly of clay, and were used for various purposes, and each had particular significance. They could be funerary urns or cult vessels, containers for provisions, coolers or drinking vessels, jugs, mixers, ointment jars, or used for storing jewellery and cosmetics. There have been Greek vase finds dating as far back as the 12C BC. The various shapes of the vases are of interest, but above all they claim our attention as the most important surviving record of Greek painting. The National Archaeological Museum in Athens offers a very good survey of the development of Greek vase painting.

About the illustrations:
1–6 Amphorae, used above all for the storage of provisions, e.g. for wine, oil or grain, **3** is a characteristic Panathenaic prize amphora, **6** a lutrophoros, **7–11** were used as mixing vessels, also known as kraters; **12** hydra and **13** kalpis used for drawing water and pouring.

Amphiárion (*c.* 10 km. SE): The ruins of the Amphiárion (*q.v.*) are worth seeing. In ancient times it was both an oracle and a spa and was closely connected with Oropós.

Dílion (Dílesi): There was once a Delian sanctuary of Apollo (virtually no remains) close to the site of this coastal village. It was near here that the Thebans won a battle against the Athenians in 425 BC.

Inófyta (*c.* 12 km. NW on the motorway to Athens): This area was violently contested by Thebes and Athens in antiquity. It was near Inófyta ('Oinóphyta' in ancient Greek) that Athens won an important victory over Thebes in 456 BC.

Paianía (Liópesi)/ΠΑΙΑΝΙΑ

p.258 □ E 5

This lively town (pop.: *c.* 5,000) is situated on the steep eastern foothills of Mt. Hymettós (Ymittós, *q.v.*), some 18 km. E. of Athens. The old Attic deme of *Paianía*, which was one of the oldest in this region, was the birthplace of the famous orator Demosthenes (384–322 BC). Some traces of the ancient deme have been discovered in the E. part of the modern town.

This contains some beautiful churches, namely *Zoódochos Pigí*, *Agios Athanásios*, *Agios Dimítrios*, and *Agios Spyridon*, which are decorated with *frescos* by G. Markos and his school (17C).

The church of *Zoódochos Pigí* ('life-giving spring') contains some interesting *frescos* by the modern icon painter Kontóglu (namely his 'Dodekaeorton', a cycle depicting the twelve great feasts).

Environs: Some 4 km. to the W., on the slopes of Mt. Hymettós (Ymittós), is the *cave* of Paianía (Kutúki), which is worth visiting. It contains beautiful stalagmites and stalactites and covers about 41,000 sq. ft.

Agios Ioánnis Kynigós (near Agía Paraskeví, which is a suburb of Ath-

14 Pelike and 15 stamnos were used as containers for provisions. 16 and 17 were cooling vessels, 18, lebe was a wedding vase. 19–23 were jugs used for drawing water and pouring. 22 is a so-called head vessel and 23 a rhyton. 24–28 were used as drinking bowls.

ens; *c.* 8 km. N.): This interesting monastery is situated on the N. slopes of Mt. Ymittós. It has a Byzantine cruciform domed church dating from the 12C with a narthex.(also domed) dating from the 16&17C. The frescos, which have been whitewashed in part, also date from this latter period.

Korópi (*c.* 7 km. S.): This rural market town (pop.: *c.* 8,000) is situated in the Mesógia (which means 'interior'). The Byzantine *Church of the Transfiguration* (Metamorphosis) contains the remains of 10C frescos. Other churches in the town have paintings by the school of G. Markos of Argos. In 1949, excavations carried out nearby on the E. slopes of Mt. Ymittós revealed the remains of a *temple of Apollo* with a *peribolos*.

Pallíni/ΠΑΛΛΗΝΗ

p.258☐E 4

This small town (*c.* 15 km. NE of Athens) is set between the mountain ranges of Ymittós to the S. and Pentelikón to the N., on the site of the ancient deme of *Palléne*. In the early classical period it belonged to the phyle of Antiochís (the phylai were the ten administrative districts into which Athens and Attica were divided). The W. promontory of Chalkidike (N. Greece), which is now called Kassándra, was itself anciently known as Pallene, and we may suppose that it was linked to this Attic Pallene at an early stage by the colonizing process. The name is also connected with the Pallantides, the 50 sons of Pallas, a mythical Attic prince, who were overcome by the hero Theseus. There was also a temple here to Athena Pallenís, though virtually no trace of it is left. Athene's other name, Pallas, could be related to the Pallantides and to the name of this town.

Environs: Spáta (*c.* 6 km. SE): It was near here, in 1877, that a number of Mycenean *chamber tombs* were discovered which yielded some precious

finds now housed in the National Museum in Athens.

Párnis/Párnes/ΠΑΡΝΗΣ
p.258□D 3

This wild and rugged mountain range (Párnis Oros in Greek; 4,635 ft.) is the highest in Attica and forms its natural boundary with Boeotia ('Viotía' in modern Greek) to the NW. It is situated about 30 km. to the N. of Athens and extends altogether some 25 miles from E. to W.

History: The name is of pre-Hellenic origin, like those of many rivers and mountains in Attica. It is reminiscent, too, of the similar-sounding Mt. Parnassós in Central Greece ('Parnisós' in the ancient Ionian dialect). It was close to the summit that the remains of a *sacrificial pyre*, including some ceramic objects, were found in 1960 which date from early antiquity (*c.*

1000–600 BC). This was probably a *sacrificial altar* to Zeus Ombrios ('Zeus the rain-maker'). To the W. there is a path leading down to a gorge in which is situated the *Cave of Pan*, said to be the setting of Menander's famous comedy, 'The Curmudgeon' (Dýskolos *c.* 300 BC).

Environs: The ancient frontier forts of *Dekélia* (*q.v.*) and *Phylé* (*q.v.* Fylí in modern Greek) are set on the foothills of Mt. Párnis, to the N. and E. respectively.

Pentéli/Pentelikón/ΠΕΝΤΕΛΙ
p.258□E 4

The Attic plain is separated at its NE end from the Plain of Marathon by the bleak Mt. Pentéli (formerly Pentelikón; 3,640 ft.), which extends for more than three and a half miles. Its many marble quarries, ancient and modern, have made it really quite ugly, particularly to the SW.

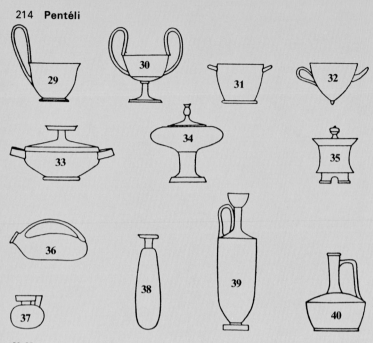

29–32 were used as drinking vessels, 33–35 as containers, with lids to seal them, 36–39 were cult and ointment jars, 39 being the so-called lek- ythos, 40 was known as lagynos and is a vessel from the Hellenic period.

History: The name is classical and originally belonged to the old Attic deme of Pentéli on the SW slope, after which the mountain itself was then called Pentelikón (Oros), meaning 'the mountain of Pentéli'. Its own original name had been *Brilessós* (Vrilissós in modern Greek), derived from the pre-Hellenic, Pelasgian settlers who lived here in Neolithic times.

In classical times, the steep slopes of Mt. Pentéli were inhabited by a considerable number of old Attic demoi, or village communities, which all belonged to Athens' sphere of influence. Its reserves of marble began to be extracted about 600 BC. The main buildings of Peisistratean Athens, which were constructed around 550 BC, and unfortunately destroyed by the Persians in 480 BC,

consisted largely of marble from Pentéli. The cult buildings of classical Athens (notably the Acropolis) were erected during the rule of Perikles (around 440 BC) from the same Pentelic marble, whose quality surpasses that of Hymettian and Parian marble for architectural purposes, although Parian marble (from the island of Páros, in the Cyclades) is more suitable for sculpture.

Ancient marble quarries: These are situated above and NW of the monastery of Moní Pentélis (see below), at a height of 2,300–3,300 ft. They can be reached on foot by an ancient paved way, down which the blocks which had been cut off used to be transported into the valley on wooden sledges. Ropes were used to

prevent them slipping off. The marble was first rendered smooth, then cut into pieces of an appropriate size with a stone-cutting saw, and finally removed carefully with wooden wedges which had been soaked in water. To the NE of the largest and most interesting quarry, known as *Spiliá* ('cave'), at a height of 2,300 ft. and just beneath a rock, is the entrance to a *cave with stalactites*. A Byzantine *double-headed eagle* carved in the wall (sculpted column) and some *inscriptions* cut out of the rock indicate that this was once an *early Christian shrine*.

Moní Pentélis/Pentéli Monastery: This is worth seeing. It lies beyond *Néa* and *Palaiá Pentéli* (meaning respectively New and Old Pentéli) on the SW slope of Mt. Pentéli, at a height of about 1,400 ft. It was founded in 1578, though most of the buildings are modern.

The *church* itself is older and dates from 1233; it was restored in 1858. In the narthex there are some Byzantine *wall paintings* which depict parables from the Bible. The church contains some beautiful 17C *paintings* and *icons*, and there are some 16C paintings and some fine *reliquaries* in the *sanctuary*. The bell tower and the attractive cloister of this wealthy monastery are more recent. There are still monks living here. Nearby there are *traces of terraces* which mark the site of the ancient deme of *Pentéli*. A little to the S. of the monastery is the *Palace of Rododáfnis* (meaning 'oleander'), which was built in the neo-Gothic style for the Duchess of Piacenza by the Athenian architect Kleanthis in the 19C.

Monastery of Daú Pentéli: The other monastery on Mt. Pentéli is situated on its wooded E. slopes, *c.* 5 km. W. of the port of *Rafína* (*q.v.*). It was founded in the 12&13C, rebuilt as a larger monastery in the 17C (around 1650), and restored in 1949, when the *fortified tower* was shored up. The

church is crowned by a high *dome* supported by six columns. Its architecture shows the influence of a number of different styles, including the Byzantine, Armenian-Georgian, and Anatolian.

Summit of Mt. Pentéli: The summit (3,640 ft.) can be reached by a 75 minute walk from the quarries. It affords a glorious view over the whole of Attica and the sea around its coast. In ancient times a large *statue of Athena*, the patron goddess of Attica, stood on the peak known as *Brilessós*. Unfortunately, the principal summit, *Kokkinarás* ('red head'), like the summit of Mt. Hymettós, is out of reach for visitors, as it is now the site of a radar station and has been declared a restricted area by the military. Although the entire S. and SW. face of Mt. Pentéli has been disfigured by the quarries, the N. slope is covered with pine forests which lend it an idyllic beauty (see Diónysos), like those around Kifisiá (*q.v.*).

Piraiás/Piraeus/ΠΕΙΡΑΙΑΣ

p. 258☐D 5

Piraeus (Piraiás in modern Greek) has today regained the position which it occupied during the Periklean 'Golden Age' (around 440 BC) as the main port of Greece and one of the most important ports of the Mediterranean.

History: There are only scanty remains left from prehistoric (Neolithic) times, some of them on *Kastella hill* (anciently known as Munychia; *c.* 290 ft.). Originally, the peninsula of Akti had been unsuitable as a harbour because of the presence here of impassable marshland. Its ancient name of *Peiraieús* was presumably connected with the similarly named harbour of *Peiraios* near Corinth. It could in fact have been used as a mooring by the Doric settlers

Old fisherman in Piraeus

from Corinth, Mégara, and the Saronic Islands of Salamis and Aegina. The Athenian fleet, which was fairly unimportant in early times, began by using the shallow Bay of Fáliron (*q.v.*) to the E. After their capture of the offshore island of Salamis (Salamína, *q.v.*), the Athenians began to cast their eyes on the natural harbours of Piraeus. Around 510 BC, a fort was built on Munychía hill.

It was Themistokles who first created an Athenian fleet and, having seen the advantages of having Piraeus as a harbour, began to develop it systematically in 493 BC. After his brilliant victory over the Persian fleet at Salamis in 480 BC, he fortified the three natural harbours of Munychia (now called Turkolímano) to the E., Zea (now Passalimáni) to the S., and the deep inlet of Kantharos Bay to the N., with moles and defensive walls (the Walls of Themistokles). He also built a series of ship-sheds (as dry docks for the winter) and storehouses (for the ships' rigging). His construction of the 'Long Walls' guaranteed security of access from Athens to its new port some 4.5 miles away; and the corridor of land which they enclosed made Athens virtually self-sufficient in the event of an enemy occupying its outlying territory. Perikles added a third Long Wall (beginning in 445 BC) which was known as the 'southern leg' and ran from Athens to the SE edge of the Bay of Phaleron (Fáliron), so that a narrow triangle was formed between Athens, Piraeus, and Phaleron, within which the entire rural population of Attica could take secure refuge while being supplied from the sea. The Long Walls were razed by the Spartans around 404 BC during the Peloponnesian War, but were rebuilt again ten years later, about 394 BC, by Konon, the commander of the

fleet. Piraeus prospered greatly as a port and as a trading city during the 5&4C BC. Its emporoi, or merchants, were the epitome of Greek commercial savoir-faire. It was only in the Hellenistic and Roman periods that it was overshadowed by the free ports of Alexandria, Delos, and Rhodes.

Sulla's destruction of Piraeus and looting of Athens' artistic monuments was an event from which the port proved unable to recover until modern times. In the Middle Ages it had dwindled to a little fishing village, which was called *Porto Leone* (Port of the Lion) after the ancient lion which stood at the entrance to the harbour until it was removed by Morosini in 1688 and placed in the Arsenal in Venice. After the country had won its freedom from Turkish rule, Piraeus, just like Athens, whose fate was so closely connected with its own, grew very quickly, so that it was soon repopulated and restored to its old position as the main port of Greece. Today it is the focus of operations of all the Greek shipping lines (having replaced the island of Syros, in the Cyclades, in this respect) and, with Athens, the most important industrial city in the country, enjoying administrative autonomy.

Main harbour (Kentrikó Limáni): This is the biggest and most important harbour in Piraeus and occupies the inner part of the NW bay, which, of the three bays, constitutes the deepest inlet. It was constructed as a commercial harbour (emporión) in ancient times, when it was called *Kántharos* (which means 'beetle-shaped vessel'), perhaps because of its enclosed appearance. Its NE end (where Karaiskáki Square stands today) was the site of Perikles' large *granaries* (Makrá Stoá, 5C BC), and it was here, too, that goods were transhipped. Today, this is the docking area for ships bound for the Cyclades and the islands in the Saronic Gulf (the offices are on the quayside opposite).

Piraeus, yacht harbour

To the N. of the bay is the peninsula anciently known as *Eetioneía* (Ietionía in modern Greek), on which there are some remains of the *Wall of Konon* (394 BC). Thukydides described this peninsula in the 5C BC as the 'mole of Piraeus'. The ancient *shipbuilding yards* (neória) and ship-sheds in this area have since been superseded by the modern docks. The wall of Themistokles passed some 220 yards to the NW. At the NW and SW outlets from the main harbour (inlet of Krommydaron, to the NW) there were docks, principally for the ancient fleet, whose size and equipment had grown dramatically thanks to the exploitation of the silver mines at Lávrion (Laurion, *q.v.*).

Zea harbour/Passalimáni (Limín Zéas): The ancient Zea harbour (now known by the Turkish name of Passalimáni, or 'Pasha's harbour') lies to

the SE of the main harbour, on the other side of the peninsula of Aktí (which means 'coast'). This round natural harbour, which faces S., was converted into a proper naval base by Themistokles' addition of strong *enclosing walls* and *moles* which almost closed it off and could actually do so with the help of chains.

During the winter, ships which needed protection were docked and repaired in *ship-sheds* on the shore. Some remains of these can be seen in the water near the shore, notably in the E. and W. areas of the bay. There were some 196 ship-sheds (neósikos means 'dock' in modern Greek); each was about 130 ft. long and 21 ft. wide, and all were connected to each other by rows of columns which supported the roof. To the NW was the large *naval arsenal* built by Philon around 340 BC, and known as the *skeuotheke* (skevothíki in modern Greek), where the ships' rigging was kept.

Turkolímano/Mikrolímano: This is the smallest of the three harbours; it is also round in shape, and is situated to the SE of the other two, with the Bay of Fáliron beyond it. It lies at the foot of the ancient *Munychía acropolis* (now called Kastella hill), and was known to the ancients as *Limín Munychías*. Its two *moles*, which rendered it almost wholly circular, had lighthouses at each end guarding the passage between them, which was only about 44 yards wide. Here, too, the remains of about 82 ancient *ship-sheds*, in which triremes were housed, can still be seen (in the water by the shore).

Munychia acropolis (now called *Kastélla*): *Munychía hill* (also called *Lófos Kastélla*) rises about 280 ft. above Turkolímano (Mikrolímano) harbour, and offers a magnificent view of Piraeus, Athens, and the coast. This was the oldest part of ancient Piraeus. There was an archaic sanctuary here of Artemis (Munichía), goddess of woods and nature. It

was probably connected with the shrine of Artemis in Vravróna (*q.v*; anciently Brauron), which was the main one in Attica. The Attic month corresponding with the modern April was called Munychíon after her because it was during that month that the spring festival known as the Artemisia ('festival of Artemis') was held. Unfortunately, as throughout Piraeus, virtually no ancient ruins are preserved, since they were built over during the reconstruction in the 19C. The only exception are the remains of strong *fortified walls*, 13 ft. high, which were excavated to the NW of the church of Agios Ilias (i.e. 'St.Elijah'). There was also an *ancient theatre* here which has been taken as a model for the modern Veákia open-air theatre.

Further W. along the coast can be seen the remains of *baths* which were hollowed out of the rock and are nowadays called the *caves of Zenon (spilaio Zínonos)*. Nearby is the place called *Freáttyda* (or Alexandra Point), which is supposed to have been the site of the ancient court of justice known as serángeion (sirángion).

Towards the NE and the Bay of Fáliron (see under Fáliron), near the Electric Railway station, is the memorial to General Karaiskakis, one of the heroes of the independence struggle, who was killed here in 1827.

Ancient city: The remains of the ancient town have been very largely lost because, during the 19&20C, the modern town has been built over them. The centre of the ancient city, ranging from Kántharos harbour in the N. to the Aktí peninsula in the S., was laid out during the rule of Perikles (around 430 BC) by Hippodamos of Miletus. He planned straight streets running from E. to W. and from N. to S., with an agora on the main intersection. This rectangular street plan was essentially retained by the Bavarian architect Schaubert and

Apollo of Piraeus, 525 BC, N.A.M. ▷

the Greek Kleanthes during their reconstruction of the city in the 19C. The westernmost part of the Aktí peninsula to the W. also had a rectangular street plan, in ancient as in modern times, which was, however, set at an angle to the grid of the rest of the city. There are also some remains here of the old *Wall of Themistokles*, which ran from NW to SE, traversing what is now the W. quarter of Agia Marína. The stretch of coast outside the wall used to be uninhabited; it is now the site of the city park, which contains the tomb of Miaoulis, the hero of the independence struggle, and the so-called 'tomb of Themistokles'. In 393 BC Konon, the Athenian admiral who defeated the Spartans, built a fortified wall along the length of the W. coast of Aktí as a defence against invasion from the sea (some remains are preserved).

Arkhaiologikó Musío/Archaeological Museum: This is of considerable interest. It is situated NE of the Zea harbour, at No. 38, Odós Filellínon, and contains objects dating from the classical, Hellenistic, and Roman periods which were discovered in and around Piraeus. These include a number of beautiful *tomb reliefs* dating from the 4–2C BC, of which the *stele* of the warriors Chairedemos and Lykeas of Salamis (dating from around 410 BC) is particularly worth seeing. There are also *bronze weapons* fashioned in the 6&5C BC, a *statue of Aphrodite Euploia* from the temple of Aphrodite in Piraeus, *Roman portraits* and *statues of emperors*, and a relief depicting the shield of Athena Parthenos (this is the so-called Piraeus Relief, which dates from the reign of Hadrian and is in the neo-Attic style). A number of other statues were discovered in Piraeus in 1959 which had been preserved beneath the rubble of the storehouse burnt down by Sulla in 86 BC, and thus saved from the fate of being looted by him. These include an archaic *kouros* (statue of a youth)

dating from the 6C BC which is evidently a representation of *Hermes*.

Navtikó Musío/Naval Museum: This interesting museum, which is situated on Odós Filellínon, facing Zea harbour, provides a picture of *Greek naval history* from ancient times to the present day.

Also worth seeing: To the NW of Zea harbour, near the Archaeological Museum in Filellínon Street, there are some scanty remains of the late Hellenistic *Zea theatre*, which was built in the 2C BC. This theatre, and in particular its stage house (skene), was modelled on the theatre of Dionysos in Athens. Near the Electric Railway Station, to the E., are the remains of the ancient *Asty Gate* (the old city gate) and of the *Long Walls* (N. wall) which began beyond it, to the NE. The Long Walls ran from here to Athens (*c.* 7 km.) in a straight line, roughly parallel to the track of the railway today. The 'S. leg' of the Long Walls began NE of the Munychía Acropolis (near Fáliron).

Póros (I)/ΠΟΡΟΣ

p.256□C 8

This island is a popular resort. It is situated in the Saronic Gulf, just off the E. coast of the Peloponnese (Argolis). It occupies 11.6 square miles, and measures *c.* 6 miles across from E. to W. The interior consists of low, rocky hills covered with pine trees and the island has a population of about 4,500, and forms part of the administrative district of Piraeus, with which it is connected daily by ferry services.

History: The island was known in antiquity as *Kalauria* (Kalávria in modern Greek), and in the 7C became the religious centre of a defensive amphiktyonic alliance of states in the Saronic Gulf. The members of this

Póros, view of the island capital

Kalaurian League were Athens, Aegina, Epidavros, Troizen, Hermione, Nauplia, and Prasiai, which were all ports or islands and all, except Athens, Dorian and Peloponnesian. The League was organized around the *temple of Poseidon* (Poseidonion) in Kalauria but it declined into insignificance after Athens and Aegina developed their sea power in the 6&5C BC. The island played a part in Greek history once more in 1828, when an international conference was held here to determine the formation of a Kingdom of Greece, following the War of Independence of 1821. In 1831, Admiral Miaoulis joined in the revolt against the government by blowing up the flagship of his fleet here.

Póros town (pop. 4,000): This is the capital of the island, and was founded in the late Middle Ages. It lies on the strait (which is only 330 yards wide), opposite the town of Galatás on the mainland. The island and its capital both derive their modern name from this strait ('póros' means 'strait' in Greek). The town's brilliant white houses have helped to make it a popular summer resort.

Sanctuary of Poseidon (*c*. 5 km. E.): The remains of this ancient sanctuary, once headquarters of the Kalaurian League, stand on a plateau (*c*. 600 ft. high) which offers a magnificent view. The site is now known as *Paláti* ('palace') and enjoys a picturesque and isolated setting. The temple was rediscovered in 1894, and its *foundation walls and trenches* can still be seen. It was a Doric hexastyle of 6 by 12 columns, built of bluish limestone; some of the columns have been re-erected. The entire precinct was built in the 6C on the site of an

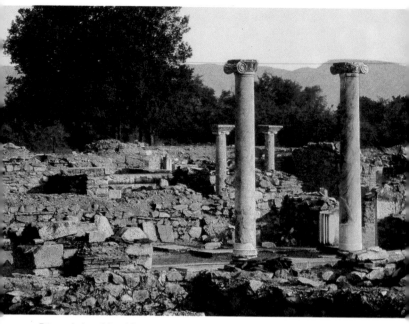

Póros, shrine of Poseidon

older, Mycenean sanctuary. Just to the W. was the starting point of the *Sacred Way* (hierá hodós), which led to the ancient city of *Kalávria* nearby. The famous orator Demosthenes fled here in 322 BC, but took poison when apprehended by his enemies. His grave is said to have been near the sanctuary. To the SW of the temple are the remains of four *stoas* which formed a quadrangular precinct.

Zoodochos Pigí ('life-giving spring'): This attractive monastery, dedicated to the Mother of God, enjoys a lovely setting in a green valley (*c.* 4 km. E.). It was built in the 16C and has a precious gilt *iconostasis* in quasi-Italian style. The courtyard contains the graves of Apostolis and Tombasis, heroes of the independence struggle of 1821 ('the captains').

Pórto Ráfti (Prasiaí)/ПОРТО РАФТН
p.258☐F 5

This small harbour lies on the SE coast of Attica (*c.* 35 km. SE of Athens, and 8 km. E. of Markópoulo), on a sandy bay with many inlets. It has become a popular summer holiday resort. The medieval name of Pórto Ráfti (meaning 'tailor's harbour') probably derives from the 10 ft. high Roman marble statue, popularly known as *Ráftis* or 'the tailor', which stands on the island of *Nisí Ráftis*, or 'tailor's island', nearby. This is a seated female figure, which is believed either to represent the Oikoumene (the inhabited world), or else to mark the burial place of the legendary hero Erysichton. This latter was said to be the son of Kekrops, the mythical first king of Attica; indeed, Attica was

originally known either as Kekropia or simply Akté ('coast'). Kekrops was Athena's favourite and was the founder of her cult in Athens. He was also believed to have ended the traditional practice of human sacrifice and to have replaced it with the use of sacrificial cakes (pélanos). (See Vravróna/Brauron).

Prasiaí: *Prasiai* was actually the ancient port (situated on one of the best natural harbours in Greece); the ancient town was higher up, on the S. slopes of the bay (where some remains of *Mycenean tombs* have also been discovered. Especially in the 7&6C BC, Prasiaí was a focus of maritime traffic with the Cyclades. It was from Prasiaí, too, that the Athenian theoria, or sacred delegation (literally 'seeing God') set sail each year to attend the festival of Apollo, known as the Delia, on Delos in the Cyclades. This was held to commemorate Theseus' legendary voyage to Knossós/Crete and his triumphal return after killing the man-eating minotaur. Attica then enjoyed a divinely ordained peace. In 1960, some extensive *fortified walls,* just over half a mile long and reinforced by 9 *fortified towers,* were excavated on *Koróni* headland (at the S. end of the bay). Above them stood the ancient *acropolis* of *Korónia* (the only remains are those of 6 gates). The coastal fortifications were probably built by Patroklos, admiral of the Ptolemies, around 265 BC, during the course of Egypt's war against Macedon (the Chremonidean War).

Environs: A large number of **tombs** has been discovered on the N. side of the bay. Those near Peráti hill (1,007 ft.) are Mycenean, while those found near Agios Spyridon date from the late Helladic period (around 1400 BC). These formed part of an extensive *necropolis* containing chamber tombs. Just offshore are the little islands of **Ráfti** ('tailor') with the Roman *marble statue* mentioned above, and, next to it, **Raftopúla** ('tailor's

daughter') and **Prasonísi** ('green island'). Helladic and late Roman sherds have been discovered on Ráfti and Raftopúla.

Rafína/ΡΑΦΗΝΑ

p.258☐F 4

This little port on the E. coast of Attica in the S. of the Bay of Marathon (about 27 km. NE of Athens) is a popular tourist attraction and a fine seaside holiday resort. There are ferry connections to S. Euboea (Kárystos) and the Cycladic islands of Andros and Tinos.

History: The area around the old Attic deme of *Araphén* (hence modern Greek Rafina) was settled in the Neolithic period (3–2 millennium BC). There are sparse remains of early fortifications (for example on the Askitário hill, 2 km. S.).

Environs: Lutsa (*c.*5 km. S.): In 1956 foundations of a 4C BC Doric *peripteral temple* were revealed near this popular seaside resort. The stylobate is 62 by 39 ft., and has 13 by 6 columns. It had a cella, but no opisthodomos. The shrine was dedicated to the goddess Artemis Tauropolos, who was worshipped particularly in nearby Vravróna (q.v.).

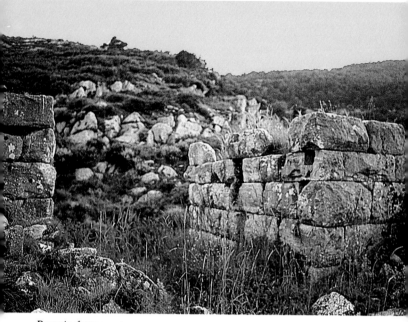

Ramnús, fortress gate

Pikérmi (7 km. SW): This village is known for its interesting palaeontological finds. Fossil remains of large mammals dating from the Tertiary and Pliocene ages have been discovered here (about 8 million years old). The finds are related to the fauna of E. Africa (tracks of apes, rhinoceroses, giraffes, antelopes etc.). These finds, including parts of the so-called dinotherion, the largest known fossil, can be seen in the Natural History Museum of the University of Athens.

Ramnús/Rhamnús/ΡΑΜΝΟΥΣ

p.258☐F 3

The important ruins of the ancient fortress city of Ramnús with the famous *Shrine of Nemesis* are on the N. coast of Attica (about 57 km. NE of Athens), at the narrow entrance to the Gulf of Euboea (modern Greek Évia). There is a splendid view of the sea from among these unspoiled and romantic ruins.

History: In classical antiquity Ramnús was a coastal bastion, controlling above all shipping traffic to and from Chalkis (Gulf of Euboea). The ruins of the acropolis of *Ovriókastro* show the extent of the former fortifications. The place was also the home of Antiphon, the founder of Attic court rhetoric (5C BC), but its real claim to fame is as the only *shrine of Nemesis*, the goddess of justice and atonement, other than the one in Smyrna (Asia Minor). From the earliest times (examples in Homer and Hesiod) Nemesis was considered as an allegory of divine retribution and the ideal of punishing justice, comparable with Dike. Anyone guilty of excess or crime went in fear of her. This could be somebody enjoying undeserved

Ramnús, priests' seats

happiness (wealth, power, beauty, blessing of children) or also the criminal who fell prey to hybris (overweening pride).

In Ramnús the cult of Nemesis was associated with the ancient goddess Themis, who in the actual and the archaic sense personified divine world order and justice. Themis ('order', 'world') the daughter of the Titans Uranos ('Heaven') and Gaia ('Earth'), bore in wedlock with Zeus the three Horae (seasons, ages): Hesiod names them as Eunomia (good government), Dike (right) and Eirene (peace); they were guardians of the Earth and sky. Antique philosophy from Anaximander to Aristotle saw them as the basis of all human society and every state (concept of polis). Themis, however, was also the mother of Prometheus, the mythical creator of the human race, who wished to overthrow the gods and their world order. Thus the *Nemesis-Themis shrine* should be seen not in the gloomy light of the revenge and punishment principle, but rather as an aspect of the fundamental philosophical and mystical concept of the order of the world and human beings (cosmos). The cult seems to have reached its height in Ramnús in the 5–4C BC (because of the Athenians).

Excavation site: The sacred precinct is about 500 yards S. of the old *coastal fortress* of Ramnús. It was first described archaeologically in 1817 and essentially excavated by Orlandos in 1922&3. The flat *temple precinct* is an artificial terrace and is supported by a fine *ashlar wall*. On the terrace are the ruins of two *temples*, almost parallel to each other and with their entrances in the E.

Naós Thémidos/Temple of Themis: The smaller and older temple

(6C BC) was dedicated to the goddess Themis ('world order' the equivalent of 'cosmos'). It was a small, undecorated building of 39 by 26 ft. and had a little cella in antis with 2 Doric columns in the pronaos. Remains of polygonal masonry (white marble) have survived (about 6 ft. high). In the interior were *marble seats* for Nemesis and Themis; three statues with inscribed bases, including a statue of Themis, have been taken to the National Museum in Athens.

Naós Némesis: The neighbouring larger temple of *c.* 75 by 39 ft. was a Doric peripteral temple with 6 by 12 columns (the stereobate with column stumps and drums has survived). It is said to have been built *c.* 435 BC by the architect responsible for the impressive Temple of Hephaistos ('Theseion') in Athens and the Temple of Poseidon on Cape Sunion. The fluting on the 6 column drums is incomplete, which suggests that the temple was never finished. In the cella, enclosed by pronaos (in the E.) and opisthodomos (in the W.) was the once-famous *cult statue* of Nemesis, Goddess of Right, made by Agorakritos, a pupil of Phidias, in Parian marble. The *statue base* with a representation of Helen, the mythical daughter of Nemesis and cause of the Trojan war, is now in the National Museum in Athens (Room 17). 2 incomplete *seated figures* have survived in front of the temple, along with other fragments.

Acropolis/Ancient fortress: An old path (about 400 yards long) leads from the temple precinct (with fragments of altars and portico) past the monumental remains of a late-Roman *necropolis* to the old fortress city of Ràmnús (in the N. towards the sea). The fortress ruins on a coastal hill about 170 ft. high are now known as *Ovriókastro* (oreókastro: 'mountain-fortress') as a substitute for the ancient title acropolis ('high fortress'). The only *access gate* had two square *defence towers* and was in the SE (land side).

Inside the town (lower terrace) are remains of Hellenic and Roman buildings (some houses), including a *circular building* (presumably a choregos monument), a kind of *gymnasion*, *cisterns*, and other such objects. There are remains of a *theatre* with a rectangular *cavea* with fragments of statues and steles; a little higher are the ruins of a small *Temple of Dionysos*. The *acropolis* was originally on the upper terrace (access above the theatre): it enclosed an area of *c.* 328 by 164 ft. and was surrounded by an irregular oval 6–5C BC rampart (still discernible). In the SE are the foundation walls of a *round tower* (about 16 ft. thick), also traces of ancient garrisons, watch towers and cisterns in the area of the acropolis. The *lower town* (Káto Pólis) and the *harbour* were on the sea side at the foot of the SE slope and at the mouth of the torrent.

Salamína/Salamis (I)/
ΣΑΛΑΜΙΝΑ p.258☐C 5

The half-moon-shaped coastal island of Salamína (modern Greek pronunciation) is 36 square miles in area, has *c.* 23,000 inhabitants and is the largest island in the Saronic Gulf. It is directly in front of the Bay of Elevsína (Eleusis) and, along with the straits in the E. and NW gives this something of the character of an inland sea.

Salamis is served by numerous ferries from Pérama (15 km. W. of Athens) and Piraeus and is now part of the Piraeus-Eleusis-Athens industrial triangle.

History: Like Mégara and the island of Aegina (qq.v.) Salamis was presumably also a Cretan/Phoenician trading post in the 2nd millennium BC. In Homer (Iliad II) the island is named as the home of the Achaean hero Aias (Ajax), who took part in the Trojan campaign. In historical times Salamis was a bone of contention between the sea-trading cities of Athens and Megara. Solon finally secured it for Athens *c.* 612 BC. Under the Athenian settlers the country was divided up as a 'cleruchy', a special kind of colony in which the settlers kept their original citizenship and did not form an independent community. Thus the Attic harbour of Piraeus acquired natural protection. The island became famous as the site of the sea victory of the Greeks over the numerically far superior fleet of the Great King Xerxes (480 BC). Exactly ten years after the Battle of Marathon (see Marathónas) the Persian king attempted to bring Athens and the Greeks to their knees. He had already taken possession of Athens and Attica, including the Acropolis. The population of Greece had fled, (some of them to Salamis). The Persian fleet, with ships from Egypt, Phoenicia and Asia Minor lay at anchor in the Bay of Phaleron (E. of Piraeus). When the Greek ships failed to appear on the open sea, Xerxes decided to seal off the straits of Salamis to the SE and NW, to force the Greeks and their leader Themistokles to make a decision. Themistokles tricked the Persians by false reports of a quarrel among the Greeks. In order to exploit this apparent weakness, the Persian ships forced their way into the straits of Salamis, getting in each others' way and making it difficult to manoeuvre. The more flexible Greek triremes destroyed large numbers of the Persian

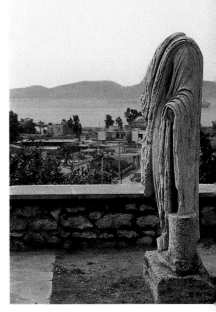

View of Salamis

fleet with their rams. Xerxes was forced to abandon his plan for the subjugation of Athens. This important victory for the West, actually more important than the victory at Marathon, was the subject of Aischylos' play 'The Persians', written *c.* 472 BC. The later history of the island was not particularly eventful; Salamis was a Macedonian base (318 BC) and returned to Athens in 229 BC.

Salamína (*c.* 19,000 inhabitants): The capital of the island is W. of the 4 km. wide isthmus in the middle of the island. The 17C *Panagía (tu Katharú) church* is worth seeing; it has fine *frescos* (in the crypt) and *icons* by Markos and Pulakis (Cretan school) on the iconostasis.

Ancient town (about 3 km. E.): Between the ferry harbour of Palúkia

and the villages of Kamateró and Ampelákia (about 4 km. SE on the coast) was the ancient island city of *Salamis*. Near Kamateró are remains of the former *acropolis* (parts of the walls) and traces of the old harbour installations (moles) have survived by the chapel of Agios Dimítrios.

Aiantio (6 km. SW): The village in the S. of the W. bay derives its name from the Salaminian prince Aias (Ajax), who in Homer is the strongest and boldest Greek after Achilles. In the quarrel over the weapons of the dead Achilles he became the irreconcilable enemy of the cunning Odysseus. Athene struck him down with madness, and Aias attacked a herd of cattle which he took to be the leaders of the Greeks. Finally he killed himself with his own sword. The village has two fine specimens from its Byzantine heyday: the *Kímisis church* (in the village square) and the 12&13C *Metamórfosis church*, with a cross-in-square design.

Monastery of Agios Nikólaos (about 10 km. SW): The *monastery of St.Nicholas* dates from the 17C and incorporates parts of a 12C church. The church of *Agios Ioánnis* (Kalvítis) is 15C and has some attractive frescos.

Monastery of Faneroméni (about 7 km. NW): This well-known monastery is on the NW tip of the island, opposite Mégara on the mainland. It was founded in 1661 and was important in the War of Independence (1821) as a refuge from the Turks. The *monastery church* is a domed building on a Greek cross plan. In the interior are fine frescos by the painter G.Markos of Argos, and his pupils from the Cretan-Italian school (*c.* 1735). The theme is the Last Judgement. Numerous antique architectural fragments have been incorporated, which suggests a former shrine on the site. The nearby fragments of ancient walls were part of the defensive works of the classical

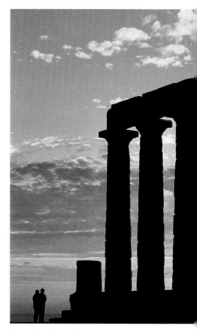

Cape Súnion, Great Temple

Búdoron fortress (modern Greek: Vúdoro) on the spit of the same name. It is a former Athenian coastal fortress from the time of the Peloponnesian War (built *c.* 430 BC), intended to keep an eye on the enemy town of Mégara. The long fortifying wall (W. to E.) was revealed and researched by the American School in 1960.

Selína (about 9 km. SE): Nearby is the Byzantine *church of Agios Ioánnis* with interesting frescos of the Markos school (18C).

Súnion/Cape Súnion/ΣΟΥΝΙΟΝ
p.256☐F 7

At the SE tip of Attica (about 70 km. SE of Athens) the rocky cliffs of Cape Sunion tower out of the Saronic Sea. On the windy acropolis rocks, almost 200 ft. high, are the ruins of one of the

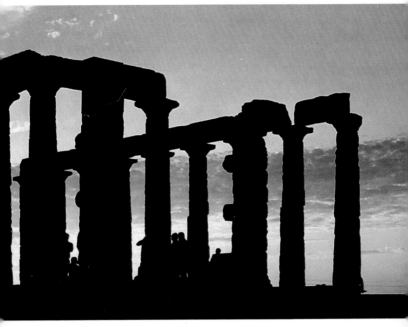

most beautifully sited of all Greek *temples*, the emblem of Attica.

History: In the early days of antiquity the towering 'sacred Súnion' (Homer, Odyssey, III, 278) was an important landmark for ships sailing in and out of the Saronic Gulf (Saronikós Kólpos). Finds of Cycladic idols and Mycenean seals have confirmed settlement in the 2nd millennium BC. In the Homeric period (*c.* 8C BC) it is presumed that there was a shrine of Apollo here, the finds from which include two fine 7–6C BC archaic *Apollo kuroi* (statues of youths, now in the National Museum of Athens, Room 8). Homer is probably also referring to this shrine when he writes 'And when we came to sacred Sunion, to the Athenian Cape, there Phoebus Apollo with his shining arrows approaching slew the helmsman of Menelaos' ('Odyssey',III,278). Like

the SW coast of Attica the 'Apollo Coast' (Aktí Appóllonos), the adjacent open sea is probably called the 'Myrtoic Sea' (Myrtóon Pélagos) after the (myrtle-crowned) Delian and Delphic god of light. The change to a shrine for the boisterous god of the sea and maker of earthquakes (Enosíchthon) Poseidon did not take place, if indeed it ever did, until *c.* 500, when the *poros temple* was built; it was never completed, and was destroyed by the Persians *c.* 480.

Great Temple: This impressive place of worship on the cliff top has only been associated with Poseidon since the discovery of an *inscription* in 1898. This would make it one of the very few temples of the sea god, who was more feared than revered.

Following pages: Cape Súnion, Great Temple

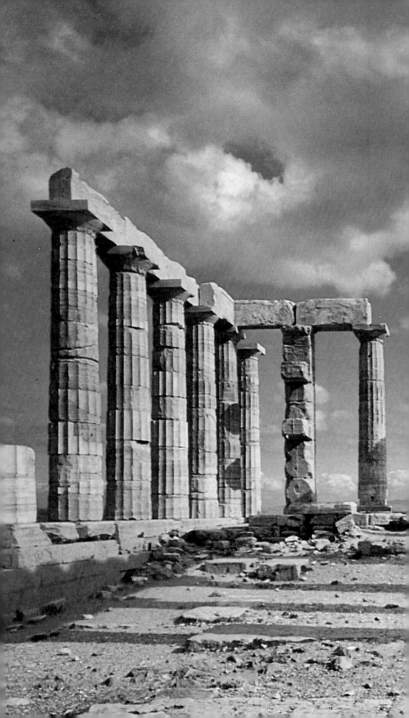

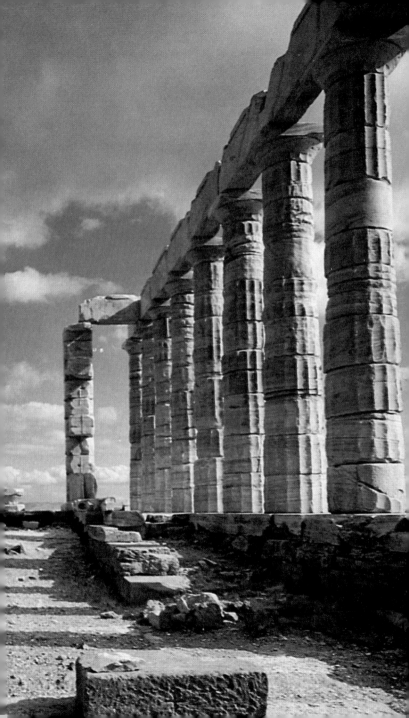

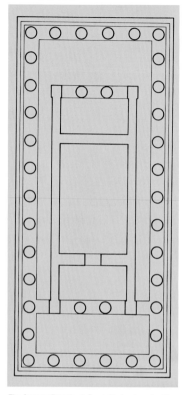

The famous Temple at Cape Súnion is a dazzling white marble structure dating from the classical Athenian temple-building period c. 444BC (Age of Perikles). The basic design was a Doric peripteros with a stylobate of 102 ft. by 44 ft. and 13 × 6 columns. Of these, 9 columns on the S. side and 2 on the N. are still standing (or have been re-erected).

According to the creation myth Poseidon, son of Kronos and brother of Zeus, was given the kingdom of the sea when the world was divided. His brothers Zeus and Hades were granted the heavens (Olympus) and the kingdom of the dead (Hades) respectively. In the most recent times, however, the opinion of scholars is that this was a Temple of Apollo, half way from Athens (Piraeus) to the Apollonian island of Delos. The festival delegates known as 'theoroi'

('observers') also used the harbour below Sunion as a staging post. Anyone who has seen a sunset through the columns of the temple, reconstructed in 1958, will have been reminded of the play of light and colour of 'shining' Apollo.

The classical temple in brilliant white local marble (from Agrilésa, 5 km. away) was built c. 444 BC, at the same time as the Parthenon on the Acropolis in Athens. It is thought to have been built by the same (Athenian) architect as the Temple of Hephaistos (Theseion) in Athens and the Temple of Nemesis in Ramnús (qq.v.). It is on the same foundations as the 490 BC poros temple, on a three-tier stylobate with a built-on area of c. 101 by 44 ft. In the N., because of the falling ground, the stylobate is supported by a *base* about 3 ft. high. The Doric peripteral building had 6 by 13 columns in the classical relationship (i.e. the total length of the walk around them was just over 111 ft.). In its dimensions and in the relationship of the columns it is almost exactly like the second Temple of Apollo on Delos, which was started shortly before it. On the S. side 9 of the Doric columns have survived upright, and on the NE side 3, with supporting pier and architrave; they look particularly slender and elegant, (relatively small diameter) are almost 20 ft. high, and have only 16 instead of the usual number of flutings. They are almost the archetype of Greek temple romanticism, and have been much painted, drawn and photographed. The coarse-grained local marble, although it is more easily eroded than the Pentelic marble in Athens, has retained its shining whiteness until the present day. Enclosed by the pronaos in the E. and the opisthodomos in the W., each with 2 columns in antis, was the *cella* with the cult statue (of Apollo?). Parts of the *antae* and *columns in antis* have survived, alongside other architectural fragments. On the *pronaos architrave* a *sculptural frieze* showed the deeds of the Athenian hero Theseus,

scenes from the Battle of the Giants and from the Battle of the Lapiths and Centaurs. Fragments of these can be seen at the entrance to the temple precinct (some also in the National Museum in Athens). Lord Byron immortalized himself here: around 1807 the famous philhellene and freedom fighter scratched his name (among those of many other 'sunset worshippers') on one of the Sunion columns.

Remainder of the temple precinct: SW of the temple are remains of the foundations of a later *portico*, incorporating parts of columns of the later (6C BC) poros temple.

In the SE, where a *peribolos wall* separates the temple precinct from the cliff, are the foundations of a so-called *Poseidon altar* cut into the rock.

Access in the N. is provided by the poros *propylaia*, dating from the 5C BC. They were clad in marble and had a portico with 2 columns at the front and at the back. Adjacent to this in the E. was a longer portico with 6 central columns, of which five bases survive. At right angles to this is a smaller portico (W. hall). Left of the propylaia parts of the *pronaos frieze* have been set up.

Fortifications: The whole of the temple precinct was surrounded from the NE and N. by a *fortified wall*; it was bow-shaped, and some of it has survived in good condition. It was built *c.* 409 BC, during the Peloponnesian War. In the NW are remains of a *gatehouse* (fortified tower), which led to the man-made anchorages cut into the rock on the W. coast. Slightly further to the N. in the little bay are the presumed remains of *harbour installations* and buildings (e.g. grain stores).

Temple of Athena: About 500 yards NE outside the precinct of the temple on a flat-topped hill (between the bays of the cape) is a 6C BC shrine which

was dedicated to the goddess Athena Suniás (Athena of Sunion).

Environs: Opposite the little seaside resort of *Legrená* (4 km. NW) is the little island of **Patróklu,** also known as Gaiduronísi ('asses' island'). Patróklu was named after the Ptolomaic General Patroklos, who in the 3C BC tried in vain to conquer the Athenian harbour of Piraeus (or Munychia).

Tanágra/ΤΑΝΑΓΡΑ

p.258☐C 2

This village near the fast road from Athens to Thebes (about 65 km. NW) is on the site of the ancient Boeotian city of Tanágra.

History: The area around Tanágra was settled even before the Greeks were here, which is suggested by the name of the nearby River Asopós. The main river of Boeotia was considered divine, and to be the son of Tethys and the world-spanning Okeanós ('Ocean'). Daughters of Asopós gave their names to various islands, towns and rivers: e.g. Salamís, Korkyra, Thebes. In historical times Tanágra was known as the home town of the lyric poetess Kórinna, a pupil of Pindar, perhaps

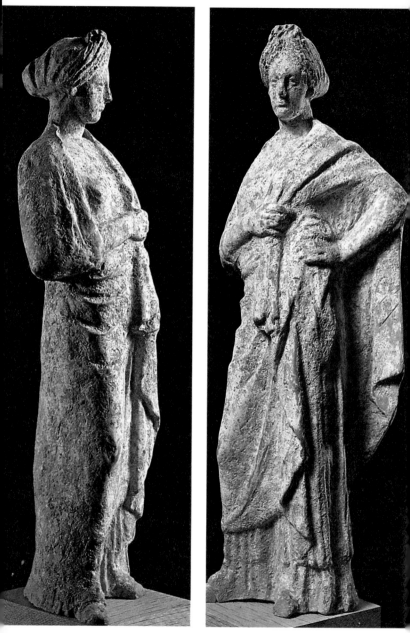

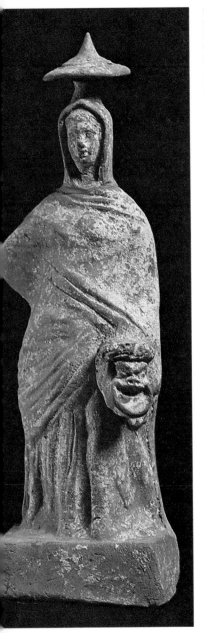

the best-known of the Greek lyric poets, who lived in nearby Thebes (*c.* 500 BC). The army of the Boeotian alliance defeated the Athenians here in 457 BC.

Excavation site: The ancient city was on a circular hill on the N. bank of the river Asopós. The ruins are inside a *curtain wall* dating from 385 BC with remains of a *theatre* which has yet to be excavated. In 1874 an extensive *necropolis* was discovered nearby, containing a large number of *terracotta figurines* (grave goods in baked clay), some of which are very fine.

Archaiologikó Musío/Archaeological Museum: In nearby *Skimatárion* (4 km. N. on the fast road) is an interesting archaeological collection with finds from the archaic to the Byzantine period.

Also worth seeing: On the Tanágra hill are remains of the foundations of an early Christian church with a *mosaic floor*.

Thorikós/Thorikón/ΘΟΡΙΚΟΣ

p.256☐F 6

The ruins of this ancient port, on the bay of the same name, are on the SE tip of Attica, about 4 km. N. of the modern harbour town of Lávrion (about 58 km. SE of Athens).

History: This village was settled in the pre-Hellenic period, (Neolithic) and several Mycenean beehive graves have been excavated. The name also points to pre-Hellenic origins: it was possibly a Cretan base. A variant myth suggests that Kephalos, whose wife was the Athenian Prokris, once ruled here as king. In jealousy he disguised himself as a stranger, and seduced his unsuspecting wife, in

< Tanágra, Tanágra clay women, Kanellopoulos Museum, Athens

order to be able to accuse her of unfaithfulness. She was also tormented by jealousy, and followed her husband out hunting, whereupon Kephalos shot her, under the impression that she was a deer (c.f. Kifisiá).

In the historical-classical period the town was centre and fortress (from 412 BC) of the surrounding mining area of Lávrion.

Excavation site: On the saddle of *Mount Velatúri* (just under 500 ft.) traces of dense settlement from the Neolithic (from 2900 BC) to the Hellenic period have been discovered. On the summit slope (to the E.) 3 *Mycenean beehive graves* have been discovered. The oldest dates from the 16C BC and is approximately 29 ft. long by 11 ft. wide. It is oval, and part of the tholos dome has survived. A smaller Mycenean *grave chamber*, which is cut into the rock and dates from *c.* 1200 BC has also been discovered. There are also remains of an oval *domed grave*, which later became the site of an archaic hero cult (sherds from the 7–5C have been discovered). On the summit remains of a *Mycenean wall* (curtain wall) have been found, along with a building which is the same age and was erected over a group of *pre-Mycenean dwellings* (2000–1800 BC).

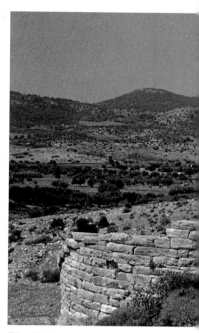

Thorikós, theatre

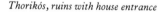

Thorikós, ruins with house entrance

Archaio Théatro/Ancient theatre: Within the S. wall of the ancient mountain fortress on the Velatúri ridge the ancient 4C BC theatre has been excavated. The cavea was a semi-oval of about 177 by 69 ft. It included a two-tier *auditorium* divided by a diazoma, and 31 rows of roughly cut seats. 19 rows have survived in reasonable condition. The thirty rows above the diozoma were reached from the top of the theatre. There was seating for roughly 5,000 people. The lower tier is divided by two flights of steps. Between these are the *seats of honour* in the front row (for important figures in the state and critics). The orchestra does not conclude

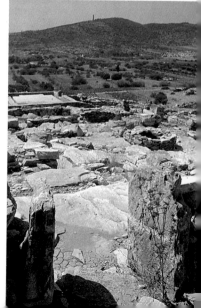

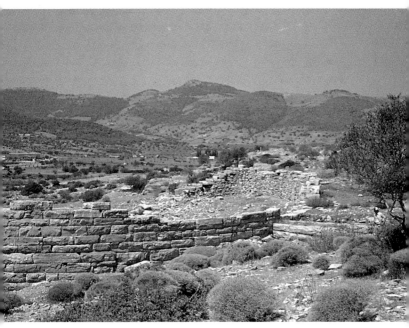

Thorikós, ruins of a house

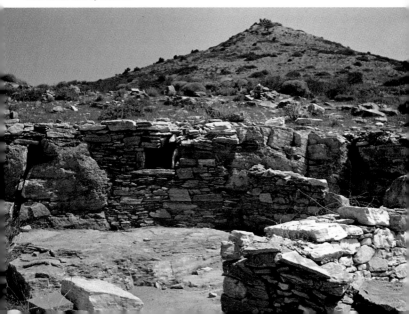

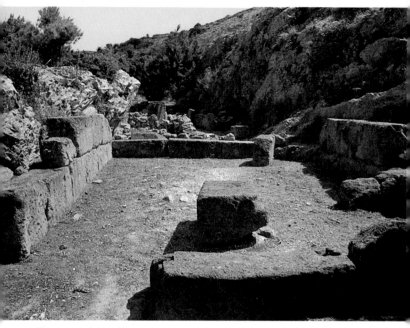

Vravróna, shrine of Iphigenia

in a stage building (skene) but is simply supported by a terrace wall. On the W. edge of the orchestra is a little *Temple of Dionysos*. It is a temple in antis, about 30 by 21 ft., and gives an idea of the form taken in early times by dramatic performances in honour of the god Dionysos at the popular Dionysia festival, which was in the early spring, rather like N. European carnivals (see also under Dionysos). Opposite, in the E. of the orchestra, was the essential *altar of Dionysos*, on which sacrifices were made to the god of masks at the beginning of the comedy or tragedy. Temple and altar date from the 5C BC. By the E. wing of the auditorium are 2 *rock chambers*, which were probably connected with the cult of Dionysos; to the N. was a cistern.

Ancient fortified town: The upper town (acropolis) was on the mountain slopes, and was surrounded by a *curtain wall* 2 km. long. Remains of this, including a square tower, have survived in the SW. Since 1963 the Belgian Archaeological Society has excavated numerous *ancient residential areas* with houses from the archaic and classical periods in reasonable condition. About 200 yards N. of the theatre are remains of *workshops* (ergasteria) or *ore washing plants* dating from the 5–4C BC. These were square buildings with washing systems for the ore, which was ground in mortars.

Also worth seeing: SW of the theatre are remains of a *Demeter-Kore-Temple* dating from the 5C BC. The Doric peripteros had an (unusual) arrangement of 14 by 7 columns. Remains of the ancient *harbour citadel* have survived on the Agios Nikólaos peninsula.

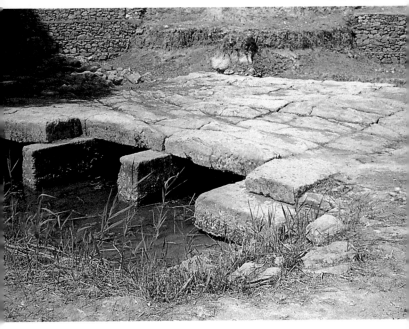

Vravróna, stone bridge

Vravróna/Braurón/BPAYPΩN
p.258☐F 5

The remains of the *Braurón shrine of Artemis* (modern Greek: Vravróna) are well worth seeing. They are on the

E. coast of Attica, about 38 km. SE of Athens (via Markópulo).

History: According to tradition this was one of the twelve oldest communities in Attica, the 'League of Twelve Cities' of the mythical King Kekrops. Kekrops, said to have been half man, half snake, is considered to have been the first king of Attica and the founder of Athens. He is held to have introduced the basic rules of civilized social life in 'Kekropia' (Attica). He is thus the legendary father of the 'Ur-polis'—before the historical law-givers Drakon and Solon (7&6C respectively). There have been finds from the Middle Helladic period (*c.* 1700 BC) on the temple hill.

The Braurón cult of Artemis may date back to the Homeric period (*c.* 800 BC). It was made the official state cult of the Athenians by the 'gentle' tyrant

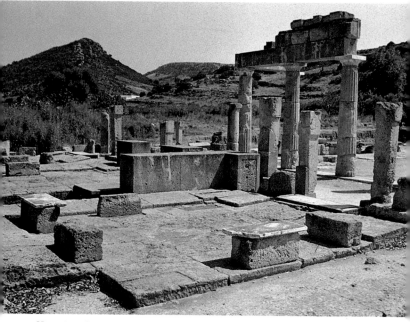

Vravróna, dormitories

Peisistratos (6C), who himself came from Braurón and owned lands here. According to myth Artemis was born on the island of Delos as the daughter of Leto and Zeus and twin sister of Apollo, the god of light. She was worshipped as the goddess of untouched nature and female chastity (virginity). Female animals such as the she-bear and the hind were sacred to her. The Homeric warrior king Agamemnon killed a sacred hind at Aulis (opposite Chalkis/Euboea) before the departure of the fleet for Troy, and as a result of this he had to sacrifice his own daughter Iphigenia to Artemis in her rage. The goddess took pity on the girl and carried her unharmed to the distant Crimean peninsula (Tauris), where Artemis also had a well-known shrine. Iphigenia served there as a priestess of 'Artemis Tauropolos' until her brother Orestes, visiting the shrine in atonement for the murder of

his mother, recognized her and brought her back home, along with the miraculous image of Artemis. Euripides' impressive Iphigenia plays (5C BC) and Goethe's play 'Iphigenie auf Tauris' are based on this legend.

In the classical period (5&4C) the 'virgin shrine' enjoyed its period of greatest success. The Attic spring festival of Brauronia took place here every five years: girls of ten to fifteen years of age dressed as bear cubs and performed the famous 'bear dance' in honey-yellow robes, as described by Aristophanes in his 'Lysistrata'. The temple maidens (arktoi) had their own halls and dormitories. In later times the cult site diminished in importance and fell into ruins.

Excavation site (temple precinct): Recent excavations by Greek archaeologists have revealed the shrine on the NE slope of a castle mound (with

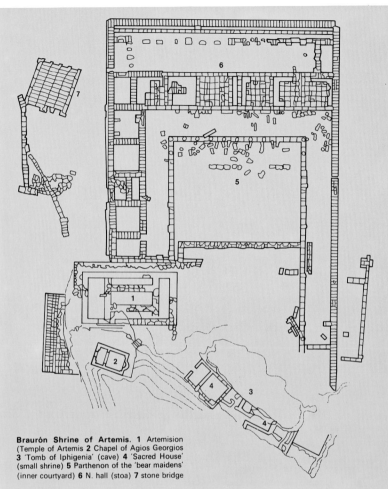

Braurón Shrine of Artemis. 1 Artemision (Temple of Artemis **2** Chapel of Agios Georgios **3** 'Tomb of Iphigenia' (cave) **4** 'Sacred House' (small shrine) **5** Parthenon of the 'bear maidens' (inner courtyard) **6** N. hall (stoa) **7** stone bridge

remains of a prehistoric settlement and Mycenean fortifications) and there is a rich display of finds in the museum.

Artemision/Temple of Artemis: N. of the chapel of Agios Georgios foundations of a Doric temple *c.* 33 by 66 ft. can be made out; it was built in the 5C. The former prostyle building with pronaos, three-aisled cella and adytum was built over an older 6C BC

temple (remains of the walls have survived), which had been destroyed by the Persians; they also carried off the old wooden cult image of Artemis Tauropolos to Susa.

Along the N. side of the temple a *temenos wall* ran towards the E., forming the N. boundary of the temple. In the SW remains of a *terrace* with supporting wall are visible.

Tomb of Iphigenia: What is

probably the oldest cult site in the shrine is about 32 ft. SE of the temple of Artemis, near a rocky cleft in the mountain slope. From time immemorial it has been assumed that the *tomb* of the legendary priestess of Artemis and daughter of Agamemnon is to be found here. Rich finds (including Attic vases with black and red figures) have shown that there has been a tomb or cave cult here since the 8C BC. After the cave entrance (vault) had collapsed, a small *shrine* with two chambers was built next to it to the NW over older rooms. The same is true of the so-called *sacred house*, (remains of foundations have survived) SE of the tomb cave; this was probably used as a dwelling, house by the priestesses of Artemis at certain times.

Parthenon of the 'bear maidens': In about 430 BC, at the height of the shrine's popularity, the temple

Vravróna

precinct was extended to the N. and NE by an extensive *yard and hall complex*. The *N. hall* was *c.* 120 ft. long and forms a stoa (portico) with fluted Doric columns; they have been partially reconstructed with their original architrave and are the modern symbol of the Braurón shrine. There were two further halls (side wings) to the S. in the shape of a horseshoe, surrounding a spacious inner *courtyard* ('courtyard of the she-bears'). Of these the foundations and some other fragments have survived. In the area of the *N.* and *W. hall* were a total of 9 *dining rooms and dormitories* for the 'bear maidens' (arktoi), most of whom came from Athens. The individual rooms (sleeping chambers) were approximately 20 ft. square and had a number of *stone couches* (klinai), some of which have survived. Behind the N. section was a narrow *stoa for votive gifts*; statue bases for koroi and tufa slabs have survived.

Between the *sanctuary* and the *cell building* were *points of access* (propylon) to the S. temple precinct.

Also worth seeing: behind the W. wing are fragments of a 5C BC *stone bridge* over the bed of the unpredictable Erasinós, which was prone to flooding, and often damaged the temple buildings. The *chapel of Agios Georgíos* (St.George) in the S. of the temple precinct dates from the 15C and has *remains of frescos* in the narthex representing St.Timothy and St.Spiridion.

Archaiologikó Musío/Archaeological Museum: This little museum shows interesting finds from the shrine and environs (the most important finds are in the National Museum in Athens). In the *entrance hall* are models of the *Artemision* and the *funerary stela* of a youth from Porto Rafti (4C BC).

Room I: In the cases are votive gifts, jewellery, small statues (including a 7C BC Artemis) and sacred vessels from the 8–4C BC.

Room II: Numerous *sculptures* from the shrine of Artemis, above all pictures of *'bear maidens'* (arktoi) and other 5&4C BC *representations of children,* also 4C BC *votive reliefs* with Artemis scenes.

Room III: A fine *votive relief* of the gods Zeus (seated), Leto, Apollo and Artemis (5&4C BC), various pieces of *terracotta,* votive reliefs, Artemis statuettes and a classical *circular altar.*

Room IV: In the cases are prehistoric and Mycenean finds from Braurón (acropolis) and environs (including Anávyssos and Peráti), also Geometric ceramics.

Room V: Fragment of a *marble sphynx* from Porto Rafti (q.v; 6C BC), a *tomb* (naiskos) from Merénda (4C BC); in the showcases protogeometric (9C BC), geometric (8C BC) and archaic vase finds (6C BC) from Merénda.

Environs: About 500 yards W. of the Artemis shrine are the interesting remains of a large **early Christian basilica** dating from the 6C (destroyed in the 7C) of the so-called 'Hellenic' type which was widespread at the time: the fairly wide *nave* with later chapel was separated from the aisles by two rows each of 7 greenish *marble columns* (2 have been reconstructed). Only the nave had an *apse.* Later a *chapel* and in the N. aisle a *side apse* were built. The *sanctuary* (bema) with priest's bench is continued towards the nave by two *antae.* The *reliquary* (enkainion) has survived. The three aisles are reached by way of the three-door *narthex* (to the W.) with *purification well* and remains of 7C tombs. In front of this is the two-door *exonarthex* as a portico with 6 columns (5 reconstructed) on the courtyard side. To the N. a *chapel* (sacristy) and a *pilgrims' room* (living room) have been added. At the S. end

Vravróna, chapel of Agios Georgios

of narthex and exonarthex are various side rooms (with circular stove room). Also (set above the narthex) a circular *baptistery* with *fonts* let into the floor.

Vuliagméni/ΒΟΥΛΙΑΓΜΕΝΗ
p.256☐D 5/6

This extensive harbour and holiday resort is about 15 km. SE of Athens on the so-called Apollo Coast (Aktí Appóllona) on a peninsula with various attractive bays.
On the narrow spit known as *Zostir*, the southernmost tip of the Hymettós range, the foundations of a 6C BC *temple of Apollo* (Apollo Zostérios) have been revealed. This had various subsidiary buildings like priests' and pilgrims' houses (sparse remains). It

was presumably this shrine which gave the whole coastline the name of Apollo Coast.
The present resort has a picturesque lake for bathing framed by steep limestone cliffs; the water contains salt and sulphur, useful for sufferers from rheumatism and arthritis. The area around the *Límni Vuliagménis* (Vuliagmeni lake) became a popular spa.

Environs: The coast road runs around the spit of land and the bay (resort of *Várkisa*) to the coastal town of **Anavyssós** (about 25 km. SE). There, near *Néa Fokaia*, are sparse remains of the ancient coastal fortress of *Anáphlystos*. It was probably intended to secure the nearby mining district of Lávrion (Laurion q.v.).

Ydra/Hydra (I)/ΥΔΡΑ
p.256☐C 9

This popular holiday island is at the S. end of the Saronic Gulf off the E. Peleponnese (Argolis), but for administrative purposes it is part of the harbour town of Piraeus. The island is a long, bare hump of rock (running NE to SW), 40 km. long and *c.* 5 km. wide.

History: The island of Hydra

(modern Greek Ydra/Idra) with the ancient name of *Hydréa* was relatively unimportant in antiquity (few finds). In the 16C it was inhabited largely by Albanian settlers (refugees from Mystras). Because of the poverty of the island they had to rely on navigation and piracy. In the 18&19C the seafaring merchants of Hydra became very rich because of their extensive trade (including grain to Russia and France). At the beginning of the War of Liberation (1821&2) the merchants of Hydra (Kunduriotis, Tombasis, Vulgaris and Miaulis) equipped a powerful fleet against the Turks (naval victory of 1822).

Town of Ydra/Hydra: At the time of the War of Liberation of 1821 the island capital in the N. was still a prosperous trading town with *c.* 20,000 inhabitants. The impressive *merchants' houses* above the harbour date from this time of prosperity. The *houses* of *Vulgaris, Tombasis, Vuduris, Miaulis* and *Kunduriotis* all date from the 18&19C. The *Tombasis house* is used as an artists' house by the Athenian academy. By the quayside is the

Panagía church (Kímisis Theotóku), a former 17C monastery church with a fine *sanctuary*, cloister and marble *bell tower* dating from 1808. The *church of Agios Ioánnis* (St.John) has 18C *frescos*. On the *Profítis Ilías* town hill is the monastery of the same name (St.Elias) with a splendid view from the summit (about 1640 ft.).

To the E. a coastal path leads via the village of Mandráki (old shipbuilders' yard) to the *monastery of Agía Triáda* (Holy Trinity) of 1704. At the E. end of the island is the *Survás monastery* (Zurvás), dating from the 16&17C. To the SW the Bay of Molo is reached via the villages of Kamíni and Vlychós; *Episkopí* with some Byzantine remains (Agía María chapel and monastery of Agía Iríni) is in the same direction.

Ymittós/Hymettós/ΥΜΙΤΤΟΣ

p.258☐E 5

Ymittós (ancient Greek: Hymettós) is the third-largest mountain range in Attica (*c.* 3280 ft.), after Párnis (*c.* 4590 ft.) and Pentelikón (*c.* 3600 ft.). It runs from NE to SW, dividing the Athenian basin from the SE plain of Mesogia and the tongue of S. Attica. In ancient times there was a shrine of Zeus Ombrios (Zeus the Rainmaker) crowned with a statue of Zeus on the summit (about 18 km. from the centre of Athens in steep hairpin bends). In a nearby *cave* are cult remains from the 10–6C BC, and in front of these *remains of an altar*. It is presumed that the long shoulder, with its plateau 18 km. long running from N. to S. and its pre-Greek name (in ancient times also Hymessós, like Parnassós etc), was a stone age settlement. The steep slopes are bare today, but in antiquity were known for their numerous bees and good honey. Unfortunately the summit plateau with its splendid view is closed to visitors because of military installations (radar station). There is a fine view of Attica and the Saronic Gulf however from a little below the summit on the site of *Mávra Vráchia* ('black rock'; *c.* 700 yards to the N.). The steep Pirnari gorge divides the massif into the 'Great Hymettós' (Megalós Ymittós) which is 3,280 ft. high and the somewhat lower 'Waterless Hymettós' (Anydros Ymittós) with the southern summit of *Mavrovúni* ('Black Mountain'), *c.* 2,130 ft. On the steep E. slope of the Hymettós range is the village of *Paianía* (q.v.), which is surrounded by fine Byzantine churches.

Ancient quarries: The ancient *marble quarries* are on the W. side near the former monastery of Karyés (S. of the monastery of Kaisarianí) below the Kakórevma gorge. They were exploited above all in the 6C BC. Between the villages of Kará, Trachónes and Chasáni are numerous remains of ancient *burial places*.

Asteríu monastery (*c.* 9 km. E. of Athens): The pretty Byzantine monastery *Moní Asteríu* (star monastery) is well worth seeing; it is on the NW slope of Hymettós, half way to the summit (at a height of about 1800 ft.). The well-restored 11C *monastery church* has a domical vault supported on 4 columns with ancient *capitals*. The *wall paintings*, some of which are damaged, date from the 16C. The remains of frescos in the *refectory* (notable Madonna) are of 17C origin. Hymettós was known in the Middle Ages as the 'holy monastery mountain' (little Athos): as well as the monasteries of *Kaisarianí* (q.v.) and *Asteríu* there are also the former monastery of *Agios Ioánnis Theologos* (now a Byzantine church) in the N. of Hymettós (Gúdi suburb), the monastery of *Ioánnis Kynigós* (also on the N. slope, with modern marble quarries nearby) and the ruined monastery of *Karyés* (in the SW). The 12C *monastery church* of Ioánnes Kynigós ('John the Hunter') has a remarkable dome and a 17C narthex.

Glossary

A

Abacus Square slab above the echinus of a capital and supporting the entablature.

Abaton or **Adyton** The sanctuary in a temple, within the cella and closed to all but priests.

Acanthus Leaf ornament on a Corinthian capital, modelled on the leaves of a Mediterranean plant.

Acropolis The hill-top citadel of a Greek polis.

Acroterion A plinth at the top or end of a pediment for statues or ornaments; by extension, the ornaments it bears.

Aegis Wonder-working cloak or shield of the Goddess Athena, decorated with the head of the Gorgon Medusa.

Agones Public festivals involving competitions, usually athletic, a pervasive feature of Greek life. The Olympic Games or the Dionysia of Athens are probably the best-known examples.

Agora The market place, assembly area and political centre of a Greek polis or city state.

Aisle Division of a church or other building running parallel to the long axis and divided from other such divisions by an arcade or arcades of columns or pillars.

Ambo A reading desk found by the choir screen in early Christian and Byzantine churches. The predecessor of the pulpit.

Amphiktyonie League of Greek city-states, centred on a shrine, for example Delphi.

Amphiprostyle A form of temple with porticoes at either end but not along the sides.

Amphora Large two-handled vessel for wine and oil, etc.

Ante A pilaster placed at the end of a projection of the cella wall of a temple.

Antis, in an early form of temple in which the columns at the front are between antae.

Apse Semicircular projection behind the choir or sanctuary.

Aqueduct Ancient water channel, often borne by a series of arches. development of the Greek Hydrogogeion.

Arcade A series of arches borne by columns or pillars.

Arch forms See diagram.

Archaic period Period of Greek architecture and sculpture in the 7&6C BC.

Architrave Lowest section of the entablature, resting on the capitals of the columns.

Archon High official in a Greek polis.

Ashlar Squared masonry.

B

Basilica Originally the royal hall (Stoá Basiliké) with a double colonnade and used as a court or for trade. From the 4C on it became a form of church with a nave and two

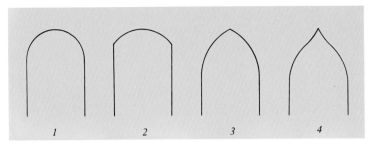

1.Round arch 2.Basket arch 3.Lancet arch 4.Ogee arch

or four aisles, a pitch-roof over the nave and lower lean-to roofs over the side aisles.

Base Pedestal for statues or for Ionic and Corinthian columns.

Bay Division of space by columns, pillars or arches; the distance between the axes of two columns in a temple.

Bema The raised sanctuary in Byzantine churches.

Bomos Square or rectangular ancient sacrificial altar.

Bothros Sacrificial channel by ancient sacrificial altars.

Bouleuterion City council chamber.

C

Capital Uppermost part of a column, supporting the entablature or arch. See diagram for various forms.

Caryatid Carved female acting as a column and supporting the entablature.

Cathedra Decorated bishop's throne in the Byzantine church.

Cavea The scallop-shaped auditorium of a Greek or Roman theatre.

Cella The main internal room in an ancient temple, containing the cult-image.

Cenotaph Monument to a person buried elsewhere.

Chiton Tunic.

Choir Normally at the E. end of a church, containing the altar. In the Middle Ages the choir was often partitioned from the body of the church by a choir screen or, in Byzantine churches, an iconostatis.

Choregos A rich citizen who met the expenses of producing dithyramb, tragedy and comedy.

Chthonic Deities The Earth Gods, Demeter, Persephone, Gaia and Pluto.

Classical High point of Greek (Athenian) culture and art (*c.* 480-330 BC).

Clepsydra Ancient fountain house, water clock.

Cloister Courtyard on one side of a church, surrounded by arcaded and vaulted walks.

Coffer Square panel framed by the beams of a ceiling.

Column Wooden or stone upright with a round cross section. For the accepted orders of columns see the entries for Composite, Corinthian, Doric and Ionic orders.

Composite order Roman combination of elements from the Corinthian and Ionic orders.

Conch Semicircular apse with a half dome.

Corinthian order Base and shaft similar to Ionic order, goblet-shaped capital, with a double row of acanthus leaves.

Crepidoma The three steps forming the base of a temple.

Crossing The intersection of the nave and transepts.

Crypt Lower church, usually beneath the apse. Often an old burial place over which a church

248

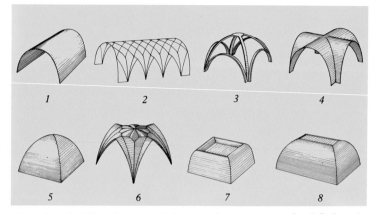

1.*Barrel vault* 2.*Tunnel vault split into bays by transverse arches* 3.*Sail vault* 4.*Groin vault* 5.*Domical vault* 6.*Stellar vault* 7.*Coffered vault* 8.*Mirror vault*

has subsequently been built.

Curvature Slight rise in or arching of the horizontal parts of a building.

Cycladic culture Island culture of the Cyclades (3rd millennium BC).

Cyclopean walls Massive walls built of irregular blocks, named after the Cyclops.

D

Deme Village, the smallest political division of the state.

Diakonikón The right (south) side apse of a Byzantine church.

Diázoma Passage between the rows of seats of the cavea.

Dimíni Culture Greek continental culture from the first half of the 3rd millennium BC, named after the excavations at Dimíni, near Vólos, Thessaly.

Dipteros A double colonnade around a temple.

Dipylon Ancient double gateway.

Doric order Column without a base, a maximum of 20 flutes separated by arrises; capital with echinus and abacus; entablature with triglyphs and metopes.

Dromos Entrance or passage into Mycenean beehive tombs.

E

Echinus Moulded section of a Doric capital.

Entasis The slight swelling of the lower third of a Doric column.

Ephebos Youth.

Epiphany Manifestation of a god or Christ; a feast to celebrate this.

Epistyle Entabulature directly supported by the capitals of the columns.

Epitaph Memorial tablet or stone in the wall or on a pillar, often above the tomb of the deceased.

Eschara Ancient altar for burnt offerings.

Eso-narthex Inner narthex of a Byzantine church.

Euthynteria Lowest step of the crepidoma.

Exedra Normally a semicircular assembly room with benches. In Byzantine churches it takes the form of a domed apse.

F

Fluting Vertical grooves on the shaft of a column.

Frieze decorative strip above a temple architrave. In the Doric order it comprises metopes and

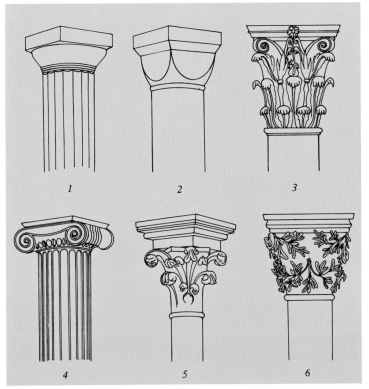

1.Doric capital 2.Cushion capital 3.Corinthian capital 4.Ionic capital 5.Crocket capital 6.Foliate capital

triglyphs; in the Ionic it may be plain or sculpted continuously.

ings (changing and wash rooms) surrounding it.

G

Geison Cornice of the roof of a temple.

Geometric style Early phase of the archaic (*c.* 950-700 BC), so-called because of the geometric ornamentation on the vases of the period.

Gigantomachia Battle of the Olympian Gods and the Giants, a favourite theme of Greek sculpture.

Gymnasion A sports ground, often with colonnades and other build-

H

Hekatompedon From the Greek meaning 100 feet. Ancient temple 100 feet long.

Helladic Culture Mainland Greek culture from around 2600 to 1200 BC; Early Helladic up till 2000, middle Helladic until 1600 and Late Helladic/Mycenean up until about 1150 BC.

Hellenism Greek art and culture at the time of Alexander the Great

(from about 300 BC).

Heraion Shrine of Hera, on Samos, for example.

Herm Four-sided pillar normally decorated with a head of Hermes. Herms stood along streets and in squares.

Heroon Shrine of a hero (demigod such as Herakles).

Hierophantes Mystery priest in antiquity, at Eleusis and Samothrake, for example.

Hippodamus's plan Ancient town lay-out with a regular grid of streets. Hippodamus was a town planner from Miletus in the 5C BC.

Hippodrome Elliptical horse racing track, at Olympia, for example.

Hoplite Armoured foot soldier. The heart of a Greek army.

Hydria Large water vessel.

Hypocaust Under-floor heating in ancient baths.

Hyposkenion Lower part of the stage.

I

Iconostasis Screen decorated with icons dividing the sanctuary and the naos of a Byzantine church.

Illumination Small, hand painted-picture in old manuscripts.

Impluvium Open, inner courtyard in Hellenistic and Roman houses containing a cistern.

Ionic order Column with subdivided base, shaft with 20 flutes separated by fillets; typically, the Ionic capital has two volutes.

K

Kanephoroi Maidens bearing baskets

Kantharos Drinking vessel with handles and high foot.

Katholikón Main church and nave of a Byzantine monastery.

Kore Statue of a maiden.

Kouros Statue of a youth or young God, Apollo for example.

Krater Two-handled vessel for wine and water.

Kylix Two-handled, shallow drinking vessel.

L

Lékythos Oil flask with a narrow neck.

Leskhe Assembly room.

Logeion Centre, front of the stage

Loggia An open gallery, often on an upper storey.

M

Meander Right-angled pattern forming a frieze, named after the winding river Meandros near Miletus in Asia Minor.

Mausoleum Large monument, often in the form of a house or temple, named after the tomb of King Mausolos.

Megaron Main room of a Mycenean palace, possibly the model for the ground plan of the Greek temple.

Metope Rectangular relief between two triglyphs on the frieze of a Doric temple.

Metróon Shrine of the mother goddess Cybele.

Minoan culture Pre-Greek Cretan culture, c. 2600-1100 BC, named after King Minos of Crete.

Monopteros Small, usually round temple with no cella and a single row of columns.

Mycenean culture Early Greek or late Helladic mainland culture, named after the excavation site of Mycene, Peloponnese (c. 1600-1150 BC).

N

Naiskos Small temple.

Naos Interior of a temple (see cella); Byzantine church and the main area inside it.

Narthex Vestibule of a Byzantine church; usually divided into an exonarthex (outer vestibule) and esonarthex (inner vestibule).

Nave The central, larger aisle to the W. of the crossing in a normally

oriented church, separated from the side aisles by arcades; by extension the whole W. arm of the church.

Necropolis Burial ground.

Nymphaion Shrine dedicated to nymphs; richly decorated grotto with well.

O

Obelisk Free-standing pillar with a square ground section and a tapering point.

Odeion Normally round (roofed) structure for musical performances.

Oikos Cult-room in a sanctuary.

Octagon Eight-sided building.

Opisthodomos Enclosed, rear hall in a Greek temple (behind the cella), containing votive offerings or used as a treasury. The opposite of the pronaos.

Orchestra Area in front of the stage house used for the dances of the chorus. Later used by the musicians.

Order One of the standard forms of column and entablature developed in antiquity.

Orthostatic Ancient substructure with upright stone slabs.

P

Palaiastra Normally square, colonnaded courtyard for wrestling and other sports.

Palladion Cult- and protective image of the Goddess Pallas Athena.

Panagía The All Holy, Mother of God and common name for churches, icons dedicated to the Virgin.

Pantocrator The image of Christ the Lord in the domes of Byzantine churches.

Paraskenion Sides of the stage.

Parodos Side entrance to the orchestra.

Peplos Long female outer garment (frequently on statues of women).

Peribolos Sacred precinct or the wall surrounding it.

Peripteros Temple with a circuit of columns. See also dipteros.

Peristasis Outer colonnade in a peripteral temple.

Peristyle Colonnade or the inner colonnaded courtyard of a house.

Pillar Upright pier with a rectangular or polygonal cross section.

Pilaster Engaged pillar.

Pinax Painted wooden, clay or stone tablet.

Pithos Large pottery storage jar.

Polygonal wall Wall built of polygonal, as opposed to squared, stones.

Poros Tufa, limestone, used as the basic building stone in many Greek temples; hence poros as opposed to marble temples.

Portico Colonnade, similar to the stoa.

Prohedria Seat or gallery of honour for the judges in a theatre or stadium.

Pronaos Vestibule of a temple, opposite of the opisthodomos.

Propylaia Monumental entrance to a temple precinct. The Propylaia of the Acropolis, Athens served as the model for later buildings.

Propylon Gateway.

Proskenion Front of the stage in a theatre.

Prostasis Projecting portico.

Prostylos Temple with colonnaded portico at the front.

Prothesis Left (normally N.) side apse of a Byzantine church, as opposed to the diakonikon.

Protome Heads of men or animals decorating buildings or vessels.

Prytaneion Form of town hall. Court, official seat of the magistrates.

Pylon Entrance to Greek temples and palaces.

Pyrgos Tower, fortification, bastion.

Pyxis Shrine.

Q

Quadriga Four-in-hand chariot

R

Refectory Dining hall in a monastery; Trapeza in Greek.

Relief Sculpture which is not in the round but attached to its background; the degree to which it projects determining whether it is classed as alto- mezzo- or bas-relief.

Reliquary Structure of some form containing a relic of a saint.

S

Sekos Longitudinal wall of the cella in a temple.

Sésklo culture Mainland pre-Greek culture and art (*c.* 3,500-2,900 BC), named after the finds at Sésklo near Vólos in Thessaly.

Sima Moulded eaves, often decorated with water-spouts in the form of lions' heads along the flanks of the temple.

Skene Stage house behind the orchestra, originally used as a changing room and to support the scenery.

Stela Upright funerary slab or column, bearing inscriptions and reliefs.

Stereobate Stone base of a temple.

Stoa Hall with one side in the form of a colonnade; similar to portico.

Stylobate Top step of the substructure supporting the columns of a temple.

T

Temenos Sacred precinct, as at Delphi, enclosed by a peribolos.

Terma Stone finishing line in a stadium.

Terracotta Fired, unglazed pottery.

Thesauros Store room, treasury, at Delphi or Olympia for example.

Tholos Round building or temple (Delphi); vaulted and domed in the Byzantine church.

Triglyph Stone slab with three grooves above the architrave of a Doric temple and separating the metopes.

Tripod Three-legged kettle, dedicated as a votive offering.

Triumphal arch Decorated arch.

Tunnel vault Continuous, normally semicircular, vault.

Tympanum Panel at the top of an arch or on a pediment decorated with reliefs.

V

Volute Coiled ornament, found on Ionic capitals.

X

Xoanon Carved wooden cult-image.

Xystos Roofed colonnade in a gymnasion.

The Orders of Columns

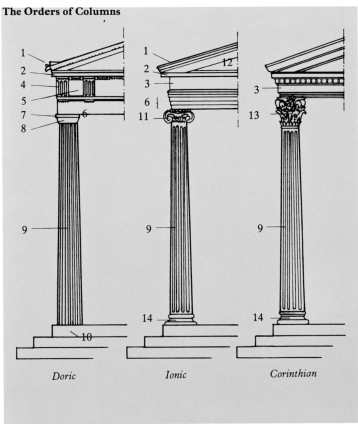

Doric Ionic Corinthian

1.Sima 2.Geison 3.Frieze 4.Triglyph 5.Metope 6.Architrave (Epistyle) 7.Abacus 8.Echinus 9.Shaft 10.Stylobate 11.Volute 12.Tympanum 13.Acanthus 14.Base

Index of places mentioned in the text. Those which have a separate entry are marked △, while those which are listed in the environs sections are indicated by the → symbol.

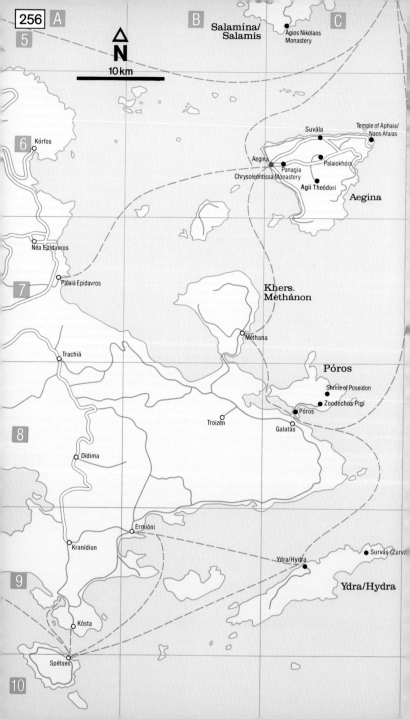

B

C

5

△
N
10 km

Salamína/
Salamis

● Ágios Nikólaos
Monastery

6 Kórfos ●

Temple of Aphaia/
Naós Afaías ●

Suvála ●

Aegina
●
Palaiokhóra ●
● Panagia
Chrysoleóntissa Monastery
● Agii Theódori

Aegina

● Néa Epídavros

7

● Palaiá Epídavros

**Khers.
Methánon**

● Méthana

● Trachiá

Póros

Shrine of Poseidon ●
● Zoodóchos Pigí

8

Troizén ●

● Póros
○
Galatás

● Dídima

● Ermióni

● Kranídion

● Survás (Zurvá

Ydra/Hydra ●

9

Ydra/Hydra

● Kósta

● Spétses

10

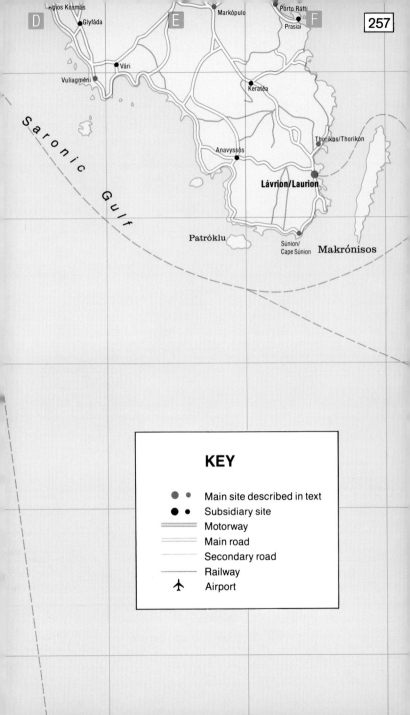

D E F

Agios Kosmás
Glyfáda
Markópulo
Pórto Ráfti
Prasiai

Vári

Vuliagméni

Keratéa

Saronic Gulf

Thorikós/Thorikón
Anavyssós

Lávrion/Laurion

Patróklu

Súnion/
Cape Súnion **Makrónisos**

KEY

● • Main site described in text
● • Subsidiary site
━━━ Motorway
━━━ Main road
━━━ Secondary road
━━━ Railway
✈ Airport

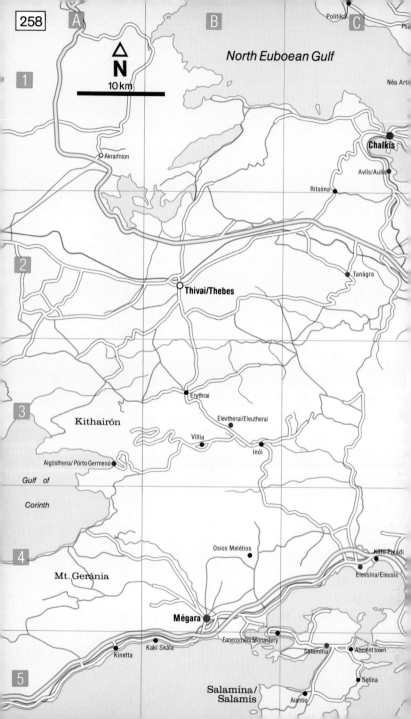

258

A B C

Politiká Ps

North Euboean Gulf

Néa Arta

1

△
N
10 km

Akraifnion

Chalkís

Avlís/Aulís

Ritsóna

2

Tanágra

Thívai/Thebes

Erythrai

3

Kithairón

Elevtherai/Eleutherai

Víllia

Inói

Aigósthena/ Pórto Germenó

Gulf of

Corinth

Osios Melétios

4

Káto Pháádi

Elevsína/Eleusis

Mt. Geránia

Mégara

Faneroméni Monastery

Kinetta

Kakí Skála

Salamína Ancient town

5

Selína

Salamína/
Salamis

Aiantio

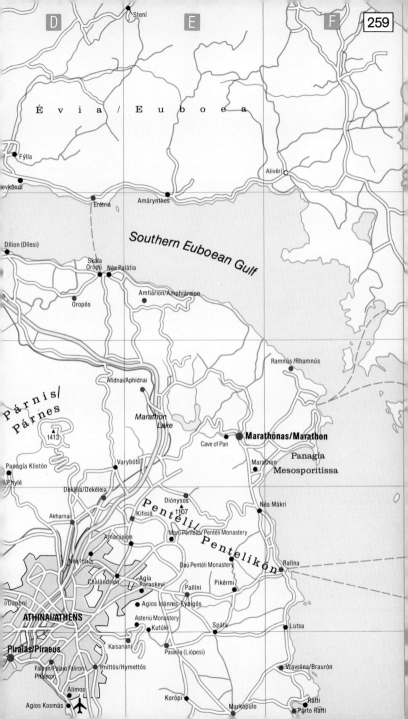

Stení

Évia / Euboea

Fýlla

evkándi

Alivéri

Erétria

Amárynthos

Dílion (Dílesi)

Southern Euboean Gulf

Skála
Oropú Néa Palátia

Oropós

Amfiárion/Amphiáreion

a.

Ramnús /Rhamnús

Afidnaí/Aphidnai

*Marathon
Lake*

▲
1413

Cave of Pan

Marathónas/Marathon

Panagía

Marathón

Mesosporitissa

Papagía Klistón

í/Phylé

Varybóbi

Diónysos

Néa Mákri

Kifisiá

1107

Dekélia/Dekéleia

Akharnaí

Penteli/

Moní Pentéli/ Pentéli Monastery

Amarúsion

Pentelikón

Néa Iónia

Daú Pentéli Monastery

Rafína

Agía
Paraskeví

Chalándrion

Pallíni

Pikérmi

í/Daphní

Agios Ioánnis Kynigós

ATHINAI/ATHENS

Asteríu Monastery

Spáta

Lútsa

Kutúki

Píraías/Piraeus

Kaisarianí

Paianía (Liópesi)

Falíron/Palaío Falíron/
Pháleron

Ymittós/Hymettós

Vravróna/Brauón

Álimos

Korópi

Ráfti

Agios Kosmás

Markópulo

Pórto Ráfti

BUGLE'S WAKE

BUGLE'S WAKE

Curtis Bishop

BE	Bi 4/14	CH 10/14	MA	SE 10/15

GUNSMOKE

First published in the US by Dutton

This hardback edition 2013
by AudioGO Ltd
by arrangement with
Golden West Literary Agency

ISBN 978 1 471 32062 0

British Library Cataloguing in Publication Data available.

Printed and bound in Great Britain by
MPG Books Group Limited

TO BARBEE ANN—

AUTHOR'S NOTE

Before any reader decides that the writer has let his imagination run completely wild, there was actually a "valley of tears," and to it Mexican dons came to trade trinkets and guns for slave labor and horses and cattle.

There was also a "whisper trail" and the big spring still gushes out of the rocky crevice.

There are also *ciénagas*, and men who are alive because of them.

CHAPTER 1

THERE was an easy informality about Fort Clark. No sentry stood on guard before the squat pine-board building which served Colonel Mark Hanna as a headquarters; his daughter Susan walked into his office unannounced to discuss a household detail of almost no importance.

She walked out again, and stood in the building's shade a moment, reluctant to step forth into the full fury of the July sun. She was a tall slim girl, but full-breasted enough to draw and hold the eye of any man, with hair that varied in color from tawny to a rich chestnut, with a direct even look in her eyes which came from a lifetime of association with men, active vigorous men. She wore a simple gingham frock in this heavy wave of heat which swept up from the valleys each afternoon, only to recede swiftly with the sunset. With nightfall she must dress again, in longer sleeves and in heavier texture . . . one of the many adjustments one had to make to endure assignment at Fort Clark.

She took a few steps toward the bungalow, which only recently she had supplied with domestic touches such as struggling vines and window curtains, then stopped to watch an approaching horseman. Fort Clark stood on high ground, the road winding slowly upward, and an oncoming horse and man could be watched for a mile or more. He came on at a firm trot and Susan waited to gratify her curiosity. He wore an officer's uniform and none of the three officers assigned to the fort were out. Thus he must be a replacement or a lone patrol; for nobody ever came to Fort Clark on a visit. It was called the "jumping off place" for very good cause.

7

There was something familiar about his way of sitting a horse, his body limp in the saddle rather than the stiff posture of a man West Point trained. Susan stared at him and even before he was near enough for her to make out his features she knew who he must be—no other army officer rode so.

Her lightly-covered bosom heaved and her eyes welled with quick tears which she immediately blinked away, while she restrained her first impulse to turn and seek the cover of the house before he saw her. Instead she retreated again to the building's shade and purposefully waited for him, forcing herself to calmness, attempting even to achieve casualness. What had happened in Fort Stanton must not carry over into Fort Clark, or to anywhere else. She would never forget it as long as she lived, nor would her father, but she must not let it be of permanent concern. Nor should her father, nor Phil Dudley. They could be sure that Lieutenant Cam Elliott had not followed them of his own volition. They were part and parcel of the frontier army, all of them, and personalities must be subjugated to discipline and duty.

He swung slowly from his saddle and walked toward her. If he was surprised to see her, or aroused as she had been, his face did not show it, not one particle. But that was still another quality of Cam Elliott's which set him apart from the other young officers Susan Hanna had known. Nothing about him ever showed expression except his eyes, and no one could be sure what was read there, not completely. Only once had Susan ever seen him when he did not seem in calm control of not only his emotions but even his thoughts.

He lifted his head and his voice came, cool, casual: "How are you, Miss Hanna?"

Her answer came before she could control it, in much the same tone: "Nice to see you again, Lieutenant Elliott."

Then she smiled, with less effort than she had expected it would take, and she held out her hand. "We're too old to act like this, Cam," she declared. "How are you? And what in the world brings you to Fort Clark?"

His pressure upon her hand was firm but fleeting.

8

"Orders, Susan," he answered. He had spoken to her in this tone before, many times. So, in fact, he had spoken to her on every time except the one evening when, in shocking suddenness, he had ceased being a tall mechanical man, slow and even of emotion and of speech, and had been rushing, demanding, persuasive, overpowering. "I've been on the go quite a bit lately."

"You're the man for it," she told him.

She could say that and mean it. He was not a Point man and thus praise from his fellow officers came begrudgingly, but it came nevertheless. Cameron Elliott had won his commission on the battlefield and had held it, had held it despite more than one embarrassing situation. He held respect also for his exploits in the field, even though over their whiskeys envious officers sneered that Elliott's successes merely proved that it took an Indian to catch one.

"You're by yourself," she observed. "You didn't run . . . into . . . ?"

He shook his head to her unspoken question. "Riding single," he explained. "Is your father—Colonel Hanna —in?"

"Yes."

"Then I'd better report," said Elliott, putting on his hat. His way of wearing a hat also set him apart from the usual army lieutenant. It seemed to fit far back on his head, the only jauntiness he ever portrayed.

"You'll be with us a while?"

A faint smile touched his face, but that kind of a smile could mean anything.

"I'm afraid so," he said softly as he walked past her.

She watched him disappear through the doorway, then in sudden decision swiftly crossed the parade ground to another single-story frame building. Here Captain Philip Dudley and Lieutenants Ashwell and Cunningham made their reports, kept their records and waited in resentful boredom for the rare breaks in their dull routine.

She wanted to tell Phil that Cam Elliott had come to Fort Clark. She wanted Dudley to be prepared for the meeting with the tall lieutenant he had once sworn to kill.

She did not have to worry about her father. Mark Hanna was not a man of rash or violent action.

Colonel Mark Hanna stared a moment, then came slowly to his feet. His hesitation was brief, then he held out his hand and he asked, "How are you, Lieutenant Elliott?" with very little show of feeling.

His answer was as casual, as impersonal. Cameron Elliott saluted, then accepted the outstretched hand and the offer of a straight-backed chair.

"My orders, sir," he said without the waste of another word.

The envelope was thick and somewhat soiled. Colonel Hanna broke its seal with one hand and fumbled for his reading glasses with the other. He read deliberately, never raising his eyes from the neat precise scrawl. Finished at last, he skimmed back over the pages as if to confirm what he had read.

"I see you have been very busy, lieutenant," he remarked. There was no warmth in his tone or manner. There was approval, even a note of commendation; never had Mark Hanna voiced anything but praise of Lieutenant Elliott's military record.

"It's been a rugged summer," nodded Elliott.

The colonel studied the papers again, though he had laid aside his reading glasses and the handwriting was not legible to his farsighted vision.

"Much of this," he admitted, "is disturbing. Very disturbing."

His reluctance to have Lieutenant Elliott assigned to Fort Clark, even temporarily, was a small part of his concern. The same thought occurred to him as had to his daughter—Phil Dudley must be cautioned to an unusual restraint—but a personal difference was trivial compared to the scope of these general orders.

"I had hoped," muttered Colonel Hanna, "that I'd never hear of Black Cat again."

Cam Elliott nodded again, and a strange smile flickered for a moment across his leather-brown face.

"I suppose it is possible for us to accommodate another troop," the fort's commander mused aloud, "but the men certainly won't be comfortable. As for yourself, lieu-

tenant . . . the situation will be almost as bad. I have no choice but to put you in with two other officers."

He mentioned neither by name but his tone seemed to warn Elliott that one of them would be Captain Phil Dudley.

"That is all right, sir," Elliott agreed. "It seems likely that we'll be in the field more than in the fort anyhow."

"Yes," conceded Hanna. The colonel sighed. He was past the age when the bugle's call set his veins to tingling for immediate and furious action. The rugged nature of this tangled westland crushed any desire for heroic assignment or for history-making detail. This was not soldiering, not scientific studied warfare according to military pattern. The test was not of a man's ability to command or maneuver his brigade but of sheer hardiness, of enduring blazing heat and thirst one day and bitter cold the next. This was not war as the high command at West Point had promised it would be.

He held up the papers. "This is a most detailed plan of campaign," he declared approvingly. "Am I wrong, Lieutenant, in guessing that you had much to do with its drafting?"

"I'm sure quite a bit," insisted the colonel. "It is a bold plan, even daring. On the other hand . . . well, for two years Black Cat has eluded us, mocked us and dared us to come after him again. When did he move his people into Texas, lieutenant?"

"Some months ago. I'd guess about March."

"Clever of him," growled Hanna. "Damned clever. I don't see how he can feed his people in these mountains, but I suppose he'll find a way."

"That is Black Cat's nature, sir," the lieutenant pointed out. "He'd rather starve in the mountains as a free man than accept the limits of a reservation. This will be a chase to the death, no doubt of it."

"No doubt," Hanna said after him. Then the colonel gave his consideration to the immediate problems created by Elliott's arrival and the orders from Colonel Robert E. Lee.

"When do you expect the troop?"

"They may possibly get here tomorrow. It was my understanding that they left Fort McIntosh Monday."

"It is a hard trip," recalled Hanna. "Perhaps tomorrow, perhaps the day after."

He brooded a moment over his unexpected responsibilities, forgetting Elliott's presence. Then with a smile he apologized for his absorption.

"I shan't keep you longer, lieutenant. You are tired, I know. You'll be unhappy with our accommodations, but so are all of us."

"I've slept in a bed three nights in sixty days," Elliott answered. "Anything you have will be better than what I'm used to."

The lieutenant saluted, then followed Hanna's orderly across the barren square to a two-room frame building. Elliott had brought few personal belongings with him; unpacking his saddlebags took only a few moments. He studied the building's interior uncertainly. The two rooms were apparently occupied by as many men, and were divided as sitting and sleeping units. He could not be sure whether the other two officers would wish to continue this arrangement. He could guess that one of them wouldn't.

Footsteps sounded behind him and he turned to face Captain Philip Dudley.

There was more color than usual in Dudley's dark countenance and a metallic gleam in his black snapping eyes, but he had been cautioned to control his feelings and he did.

"How are you, Elliott?"

He did not offer to shake hands, nor did Lieutenant Elliott. Cam saluted; Dudley returned the gesture.

"*Bueno*, captain," answered Cam to his question.

Deliberately he used the Spanish word, though once he had been reprimanded by Dudley for mixing commonly-used Mexican phrases in with his talk.

Dudley could not bring himself to be affable, or even casual.

"Lieutenant Ashwell and I will share one room," he said curtly. "You can have the other."

"That is going to a lot of trouble," Cam pointed out. "I'll be here only a short time, and you seem to be set up fairly well. If you'll have a cot brought in for me I'll try to be as little trouble as possible."

Captain Dudley weighed his decision a moment.

"Besides," Cam added, "we've a lot of riding ahead of us. More than likely one of us will always be out on detail."

That was more than a prospect, as Cam well knew; that was a positive order to Colonel Hanna. Colonel Lee had called for an unceasing pursuit of Black Cat's warriors.

"That's right," Dudley said finally. "I'll have a cot set up for you."

The captain's dark eyes studied Elliott. "What action is coming up?" he demanded. "I'm ready for it. I'm going to seed lounging around this hell-hole."

"I don't know," Cam shrugged. "But it's sure to come. Whenever I'm assigned somewhere it's bound to be action."

His voice was calm, showing no bitterness, no resentment. Dudley scowled at him, unsure whether or not the lieutenant was purposefully insinuating that his fellow officers were in collusion, and that invariably Cameron Elliott received the most hazardous and most uncomfortable assignments. Dudley's eyes gleamed. His dislike for Cam Elliott was not just because of Susan Hanna. It was deeper than that; with Philip Dudley it could be.

"You have seen a lot of action," mused Dudley. "And done well, too, from all accounts. Yet still a lieutenant after . . . how many years, Elliott?"

Cam grinned. He was immune to such talk, even from Philip Dudley. It rolled off his sloping shoulders like water off a duck's down.

"I'm high enough," he said cheerfully. "If I ranked any higher I'd have to spend all my money buying uniforms."

Philip Dudley stared at him a moment, then turned on his heel and strode off to order a cot set up. His eyes and face were dark with his anger and he cursed under his breath. He could never be sure how Elliott meant a speech, nor could other officers on the frontier who resented the tall man's rise from the enlisted ranks. Elliott was quick with his talk, but apparently carefully so, damnably so. There was his reply to Dudley, for instance, his remark concerning expensive uniforms. Other

army officers could barely eke out an existence on their pay and allowances but somehow Lieutenant Elliott had managed to buy land in West Texas, ten sections of it, with two all-weather rivers flowing through it, and was a partner with John Chisum, the wealthy cattle baron. Was Elliott throwing that—the means he had accumulated on a lieutenant's pay—into Phil Dudley's face? Dudley brooded and decided it was possible. No officer in the army could keep his personal affairs a closely-guarded secret. It was quite likely that Cameron Elliott knew that Dudley's marriage to Susan Hanna was postponed until Phil could pay his debts.

CHAPTER 2

THE troops clattered into Fort Clark just before sundown. A sergeant led them, the biggest soldier Susan Hanna had ever seen, so big as to be grotesque, more gorilla-like than human. The troopers were dusty and dead weary, and Susan was pleased that her father waved them to ease without any semblance of a review.

Lieutenant Elliott walked among them and Susan could not help noticing that the dust-streaked fatigue-lined faces lit up before him. Low talk obviously passed between Elliott and his subordinates; troopers grinned and shook their heads as he walked on. This was talk that was not military at all, Susan mused, but instead was a secret between one man and another. Captain Phil Dudley came to stand by Susan and she nodded to something he said and wished that Dudley could achieve such a companionship with his enlisted men.

"They're a bedraggled lot," Dudley remarked. "Fort Clark is the place for them."

No one enjoyed assignment to Fort Clark, but Dudley's desire to be transferred had swelled into a mania, of such proportions as to seriously interfere with his duties. At times he sorely taxed Susan's powers of patience. His dislike for the place was understandable and also his

14

impatience to be sent elsewhere, to a post which had more ample accommodations for married officers. Even with his personal debts paid up it would have been most awkward for Phil and Susan to know marital bliss at Fort Clark. They could ignore all military custom and share her father's quarters, but, fortunately for Susan, Dudley had never suggested that. She had never decided whether or not she would agree if it were proposed, or if her father's consent were given. The latter was by no means certain. Mark Hanna loved the army and its ways; he had chosen it in preference to continued marriage to Susan's mother. He might cling as stubbornly to custom despite his daughter's pleas and reproaches.

"Phil," Susan pointed out, a little edge in her tone, "those men are tired. I came from Fort McIntosh by stage and I know what that trip is."

"Still," he insisted, "they could have tidied up before riding into the post."

"Where?" she demanded. There was ample water at the fort but none other within at least ten miles.

"There's always a way," he declared.

Now Lieutenant Elliott was presenting the massive sergeant to Colonel Hanna.

"Colonel Hanna, sir, may I present Sergeant Christopher Zanoba?"

They stood no more than five paces from Susan and Dudley; she could see the big man's face plainly, could observe his placid expression and mild soft eyes. He was huge, she thought, but he had all the gentleness of a spaniel. He was not a brute at all, but a gentle shaggy St. Bernard.

Salutes were exchanged, then Hanna said warmly:

"I asked that you be presented, sergeant. I know of no enlisted man with a finer record than yours."

"Thank you, sir," mumbled the sergeant. Zanoba stood there for a moment, uncertainly shifting his weight from one foot to the other.

"That's all, Chris," said Elliott. "Find a bunk and flop."

The tired men filed off.

"They'll be ready for duty day after tomorrow, colonel," Susan heard Elliott tell her father.

"Surely they need more rest than that," Hanna protested.

"No," Cam said firmly. "They've lost weight. They're used to long riding and rationed water. I want to keep them that way."

The lieutenant strode after his men; Phil Dudley and Susan walked slowly to the porch of Colonel Hanna's quarters.

"I wish I knew what was up," grumbled Dudley.

"I didn't know it was a secret," Susan told him. "Father volunteered the news to me. Black Cat has moved his village into the Puercita Mountains."

"Yes, I know that," Philip said impatiently. "Black Cat has moved his camp and we're to keep a detail after him all the time. But there's more up than that. You know how talk gets around. Ashwell heard last week that the high brass is watching this operation, whatever it will be eventually. Even the Secretary of War has been in on it."

"I can't imagine anything else," Susan said.

She couldn't. But yet, like Philip Dudley, she knew that this was no ordinary pursuit. She had lived with her father most of the last ten years, since her parents' separation, and nothing could ever be kept entirely secret. The exact nature and details of a planned campaign could be known by only a few men, or even one, but the tension was always immediate and felt even by those in complete ignorance of the strategy. Mark Hanna could withhold military knowledge from his daughter, and did. But Susan could always sense when her father had something to conceal.

Philip Dudley left for the traditional change of uniform at nightfall. He kissed Susan lightly at the gate; she looked after him and her fingers touched the flesh still damp from his lips. For a year now she had been betrothed to this swarthy-faced Virginian. Caresses had passed between them, of course, but never any passionate exchange. At times she could not help wondering if Phil was actually capable of genuine affection, but in the next instant she would thrust such speculations into the background. Phil was a Southerner, gallant enough but determined to elevate the woman of his choice to a

pedestal. He was an officer ever aware of rank and she was the daughter of his commanding officer. In his mind it would be heresy twice over to cast aside all reserve and not only regard Susan Hanna as a desirable woman but treat her so.

Only one junior officer, in fact, had ever done so. Standing there, watching the darkness swallow up her fiancé, Susan Hanna could not help but think of that man. Some of the fault had been hers; she knew that now. The light flirtatious patter which characterized every social gathering at any army post should not have been dealt out to Cameron Elliott. He was no man to while away the minutes with meaningless strolls in the moonlight.

She touched her cheek, and she shuddered as she recalled lips crushing hers, strong arms pressing her bosom against unyielding metal buttons, insistent fingers having their way with her bodice. There were other horrible memories, too—of her father's trembling anger but still calm-voiced denunciation of the presumptuous lieutenant, of Phil Dudley's heated insistence that only a duel would do, of Cam Elliott's impassive silence, but never his regret or apology. Only once had he answered back; then Dudley had taunted him for being a cowardly half-breed. Cam Elliott had drawn back his hand as if to strike his superior officer. Then he had remembered in time and he had walked away with the words flung over his shoulder: "You can have your duel whenever you want it."

There had been none. Soberness had come with morning. Cam Elliott readily agreed to a leave and then a transfer, and was gone from Fort Stanton by nightfall. . . .

Colonel Hanna was leaving his office; Susan waited at the gate for him, though the night chill was already there and she was shivering a little. They walked to the door with his arm around her shoulders.

"Honey," Hanna said when they were inside, "I suppose we must do something for Lieutenant Elliott. A get-together of some kind."

Susan hesitated, then nodded. Of course it must be done. An officer could not arrive for duty at a frontier

post without receiving some courtesy from the commanding officer.

"Let's make it tomorrow night," she decided.

"No dinner," said Hanna. "Nothing formal at all. Just the least we can do—a get-together. An introduction to the officers and ladies. That's all."

Susan smiled. The only "lady" Cam Elliott hadn't met was Lieutenant Cunningham's wife, Cecilia. She pondered her arrangements while her father eagerly devoured the weekly mail. Suddenly a frown came to her forehead.

"Father, is he really half-Indian?" she blurted out.

"Who?"

"Lieutenant Elliott."

He thought a moment. It was like Mark Hanna to say nothing about a man he was not sure of.

"I don't know," he answered finally. "Gossip says he is. His cheekbones are high but his eyes are light. So is his hair. I just don't know."

He added a little more, but very little. "Elliott got his commission in the Mexican war," he explained. "His was a volunteer company. Used mostly to fight guerrillas. I remember something about their records being burned or something. But I really don't know much."

Lieutenant Elliott's men were lazily checking their gear and guns. Mostly they were sitting, each man where and how he chose. Cam Elliott walked up and a militarist such as Philip Dudley would have been indignant at his reception. The first words spoken to him came from a red-faced bushy-haired corporal.

"Lieutenant," he complained, "this saddle of mine ain't gonna last forever. It was some shakes twenty years ago but . . ."

Elliott examined it. "It'll do with a new strap," he decided. "Take it down to the forge; Chris will fix it."

The corporal, whose real name was Clarence Burke, but who was called "Irish" for obvious reasons, shouldered the worn saddle and strolled toward the blacksmith's shop. Cam walked around observing his men's preparations.

"Don't overlook anything," he warned. "We start rid-

18

ing bright and early in the morning, and we'll keep going."

Then Cam followed Burke to the smithy. Big Chris Zanoba was working at the forge, stripped to the waist, beads of perspiration showing on his dark skin. He put down his hammer and gestured toward his helper.

"You haven't met my kid brother, lieutenant," he said. "This is Tony. Just joined up last week."

"Glad to know you, Tony," Cam said heartily, shaking hands with the recruit.

Except for the darkness of their coloring there was little physical resemblance between the two brothers. Tony was slight of stature, with handsome features, even sensitive. His eyes glowed and his smile came quickly in response to the officer's cordiality.

"It's easy to see who did all the eating at your house, Chris," Cam remarked.

The elder brother chuckled. "Oh, he always was a runt, lieutenant. But you ought to hear him play a fiddle. We always figgered on making a musician out of him but he jumped up and enlisted last week."

"Chris has been sending me money for my lessons," Tony explained slowly. "I decided that wasn't fair. I can make my own way."

"Sure you can," Elliott approved.

Then he turned his attention to Chris Zanoba's handiwork, lifting the hooves of the horses waiting patiently nearby. He had ordered that every worn shoe be replaced, and all nails driven deeply. The mountainous terrain they must ride took a heavy toll of hooves. And a lame horse meant a dismounted rider, perhaps a fatality. With Black Cat on the prowl there was small chance of a man straggling far afoot.

The day passed swiftly, and busily. Cam Elliott trusted no detail of these preparations to an enlisted man, not even to Chris Zanoba, the paragon of a sergeant. The other two troops were checking their equipment and horses, too, but not under such close supervision by their officers. Several times Captain Dudley and Lieutenants Ashwell and Cunningham strolled down to watch their men, but most of their time was spent inside their overcrowded office.

It was dark before Cam Elliott left the smithy to eat an unsavory meal, then shave, wash as best he could and don a fresh uniform. Lieutenant Ashwell walked with him across the parade ground to Colonel Hanna's quarters. Some polite talk passed between them, but not very much. Cam Elliott had already appraised Ashwell as an officer who would perform an uninspired but creditable duty. Cunningham, the other lieutenant, was more high spirited but without Ashwell's steadiness; Cam Elliott, bearing a responsibility out of proportion to his rank, hoped that Colonel Hanna would assign Cunningham only the least important details.

"I hope Cunningham's wife isn't in one of her whining moods," Ashwell grumbled as they turned in at the gate. "I know it's hell on the women here but her complaining just makes it worse. And it isn't any picnic for us."

Cam had no comment. He had never been accepted by the mixed society of any post and would have held aloof anyhow. He was as aware as his fellow officers that he did not fit into the army's regular pattern. He had no desire to do so. He did not relish the evening ahead. In the first place he was tired. Second, he had no taste for hours of idle chatter. The men talked of nothing but service rumors and the stinginess of Congress. The women might reward a guest with glances and even phrases but they meant it to be no more than a pittance. Once Cam Elliott had believed one of their women different from the regular pattern. Recollection of his error did not haunt him; he had never brooded about it. He had been able to face her again, and could tonight, with no troubled calm. He was simply not interested in the kind of woman she had turned out to be.

His bow to her was low, the pressure of his hand on hers slight, his words polite but few. Cecilia Cunningham tried immediately to engage him in talk; he answered a question with a twinkle in his eyes, conscious of the disapproving scowl upon Lieutenant Cunningham's face.

Cecilia was a pretty girl, blond and doll-like. She seemed overdressed, even more so than Susan, but that was to be expected. Even the most informal of receptions brought out a woman's finery, even though the quarters were unpainted and frame and the post itself separated

from all other kindred gatherings by two hundred miles of uninhabited domain. Until Black Cat had fled from Mexico not even the red men had wanted it.

The only purpose Fort Clark had formerly served was to protect shipments of silver bullion coming by wagon up the Chihuahua Trail.

Not even Cecilia Cunningham could make it a lively evening. She tried hard enough; she took it as a personal challenge that the tall newcomer to the post was so taciturn. Her efforts were in vain; Cam Elliott answered politely when replies were necessary, but not for a moment did he completely relax. He made his excuses early; his troops would leave at daybreak, he explained.

The other officers lingered on, Philip Dudley and Robert Ashwell trying to draw out their commanding officer, Cecilia Cunningham wearying Susan with her complaints. They could not possibly made ends meet on a lieutenant's pay, Cecilia wailed, and life at Fort Clark wasn't worth it anyhow. Jed Cunningham, obviously embarrassed, tried to hush her but not very successfully.

"What that girl needs," growled Colonel Hanna when they had gone, "is the application of a belt to her well-rounded rear."

Susan smiled and patted his cheek. The cruel answer she could have made never came. Mark Hanna had also married a woman who couldn't endure army life. Some were made for it, some weren't. As were men.

CHAPTER 3

THE bugle's sound stirred all from slumber. In the crisp cool dawn light Mark Hanna appraised Lieutenant Elliott's troop. He liked what he saw. Colonel Hanna had spent most of his service years on the frontier and he had deliberately forgotten much of what he had been taught. His concessions to necessity and conditions were as many black marks against him as far as his superiors were concerned; Mark Hanna was a colonel to be assigned

where younger and ambitious officers did not want to go. But it was not lack of ambition; it was understanding of reality. Hanna looked over Elliott's detail and was both jealous and pleased. These troopers were ready for the campaign, ready physically and mentally, ready as no other Fort Clark troop was.

He could not conceal his opinion. "A fine looking troop, lieutenant," he said to Cam. "My congratulations."

Elliott nodded his thanks. Then the tall lieutenant swung into the saddle; the bugle sounded again and forty ghostly riders clattered away, melting into the bleak gray curtains of breaking daylight.

At first their ranks were even, orderly. The men of Company D were in full sympathy with their leader. They gloated among themselves over his cool indifference to ceremony and paper regulations. They were a privileged lot and they knew it. They made a better appearance on the parade ground than their commander expected; they labored to do so.

They rode hard for two full hours, then paused as the sun arched high and their mounts began to tire. Cam Elliott called Sergeants Zanoba and Conway aside and sketched routes for them in the sand. He was splitting the troop into three details. The immediate duty was to locate Black Cat's Seminole warriors. The mountain chain known as the Puercitas covered several hundred square miles; the wily chieftain would never be found except by skillful trailers.

"Remember," Cam warned the sergeants as they split up, "hold to the low ground."

He counted off the troopers, dividing them evenly into three groups. From Sergeant Zanoba came an apologetic protest.

"Can't my brother come with me, lieutenant?"

Cam nodded, and Tony Zanoba rewarded him with a quick flashing smile.

"He's kinda green to this country," explained Chris. "I want to keep my eye on him. Thanks, lieutenant."

The lieutenant led his handful of men along the sandy bottom of an arroyo. They rode slowly, taking their ease in the saddle, but alert. The choice of the low country as against the ridges was in direct bold contradiction

of usual army strategy. But Cam Elliott had his reasons. Men plodding along a canyon's bottom were not clearly visible for miles away. He did not hope to escape detection; he knew too well the vigilance Black Cat exacted of his followers. But he knew, also, that a trap could not be set, or an assault launched, without communication among the red men. He was not hoping to spy red men; no white man's eyes could do that if the Indian did not wish it. But they were watching for telltale wisps of smoke floating up from the horizon.

The long day passed slowly. The troopers complained as they followed Cam down one arroyo and up another. The lieutenant ignored them; theirs was idle talk, not indicative at all of waning morale. "He lets us bitch all we want," Corporal Burke had said in praise of Elliott, "and never pays a damned bit of attention to us." There were other things he did which his troopers talked about. He went off at sundown to hunt for game and in an hour he came striding back with a slain doe on his shoulders. He dressed the animal himself and they gorged on broiled venison and highly-seasoned beans.

Their fires blazed up with what another officer would have called unpardonable recklessness. But Cam Elliott was not perturbed. He knew Indians, knew them as other officers didn't. He knew that red men did not constantly rove the countryside formed as war parties. It took an Indian chieftain almost as much time to gird his warriors for warfare as it did a white man, perhaps longer. An Indian also had a home and a wife and children. The red men did not live together in barracks but apart in tepees and huts. A bugle called white soldiers together, and they came out at once; they had no reason not to be ready. An Indian leader summoned his warriors with smoke messages and they responded when they could.

And also Cam Elliott knew Black Cat, the Seminole who spurned the white man's reservation. He knew Black Cat was not reckless but the opposite. Black Cat blended the strategy of a savage with the science of warfare. A smile touched the corners of Cam Elliott's mouth as he wondered which would make the highest mark if examined upon the cavalry tactics of Francis Marion—Philip Dudley or Black Cat. The Seminole

23

chieftain would not reveal himself or his troops until he had fully appraised the strength and strategy of the troops moving into his mountainous refuge.

By firelight Cam Elliott drew rough charts of the terrain they had crossed. Guards were posted and warned to caution, though Elliott did not expect attack. There had been no smoke signals all day and there would not be enough warriors in Black Cat's personal retinue to endanger them.

Elliott spread his blankets in the very midst of his men and smoked several cigarettes before falling into slumber. The talk of his troopers, floating over and around him, was a soothing chorus. Soon, he mused, this would be all behind him. Soon he would discard his lieutenant's uniform for the less imposing garb of a cattle-man. He had nursed his cattle along for five years now, selling off only the culls, buying more when prices dropped and his small pay permitted it. He sighed as he crushed out the glowing tip of his cigarette. These years had not been easy. They had not dragged by without their bitterness. Yet he did not regret them. They had brought some measure of satisfaction.

They were stirring before daybreak, frying their ven-ison strips in their pans, grumbling at the cold, voicing their dread of the heat which would come. But all of the time they were readying their horses and their gear, and Cam Elliott had them in motion before the sun came edging over the rimtop.

Fresh heavy tracks in the sand caught his eye; he dis-mounted and studied them with a frown. Never had he seen such tracks. Then there was a crashing in the brush and a queer-looking animal lumbered toward them a few paces, then stopped and studied them curiously.

"By Jesus!" exclaimed Corporal Burke. "That's a camel! Ain't it, lieutenant?"

Elliott nodded, though he had never seen one before. The ungainly beast watched them a moment longer, then with a toss of its head shuffled away.

"What in the hell, lieutenant?" marveled Burke. "There ain't supposed to be camels in this country."

Cam shrugged his shoulders and explained the camel's presence to the wondering soldiers.

24

There were also Indians. Just before noon the first smoke signal floated up. Lieutenant Elliott pulled up and studied it. He had a great advantage over any other army officer; he could interpret these signals. He knew them as well as the red men who made them. From another horizon came an answering column, then another.

"What are they saying about us, lieutenant?" Burke asked anxiously.

The eyes and expressions of the other troopers echoed his question.

"It's all right," Cam reassured them. "They are just warning Black Cat. They've just spotted us."

Now they left the arroyo bottoms and veered their direction. Now they rode the ridges, even mounted a shaggy crest which protruded fully a thousand feet into the sky. Sergeant Conway's detail joined them, then Chris Zanoba's. So Cam had instructed them—at the first smoke signal to come together. He was pleased with them and said so. In a totally strange terrain, and a most baffling one, they had carried out their assignments to the letter.

Now there was only one smoke column and that far away, several miles. Lieutenant Elliott made more sketches with his pencil. Then he gestured the full troop back into their saddles and set a brisk pace, keeping to the ridges, holding a beeline course when the country permitted. He permitted only a brief halt for a midday meal, moving at the same hurried pace through the languid heaviness of early afternoon. There was nothing else to be accomplished on this first detail. He had confirmed Black Cat's withdrawal to the Puercita Mountains and he had marked the approximate location of the chieftain's camp. That had been simple—for a man who knew Black Cat's ways and also could interpret the smoke talk of the Seminoles. But no other mission would be as easy. Now Black Cat knew that his retreat had been discovered. Not again would a cavalry unit ride out of the fort's gate unobserved.

Darkness came and Lieutenant Elliott kept riding. A night attack was almost out of the question, but there was no point in taking a chance. They reached the post by nine o'clock and even Cam Elliott, as tireless a rider

as any, was stiff and weary when finally his feet touched the ground.

Young Tony Zanoba was on the verge of collapse; big Chris lifted him out of the saddle and helped him into the barracks.

"Don't worry about your horse," said the sergeant. "I'll look after him."

Lights gleamed in both of the residences and in the offices. Not in a long time had Fort Clark stirred with activity; curious eyes and tongues demanded to know what they had found. Mark Hanna congratulated the men upon their safe return and then heard Elliott's report in his office. Dudley, Ashwell and Cunningham listened also. Cam drew a crude map of the country they had covered, estimating that Black Cat's camp was so near to the fort.

"The cheeky devil!" growled Cunningham. "All this country to hide in and he has to squat right in our back yard."

"For good reason," Cam explained. "There's water. And also the passes leading into Mexico. The country gets rougher south of here. The Rio Grande cuts some deep gorges. You can't cross the river just anywhere you take a notion."

There was some discussion of the terrain, then Cam added:

"And we saw one of Mr. Davis's camels, colonel."

"Camels!"

Only Colonel Hanna was not astonished. "Was it tame?"

"No. It watched us a moment, then broke and ran."

"What about the camels, sir?" Philip Dudley demanded.

"Oh, that happened some time ago," smiled Hanna. "Four or five years. Jefferson Davis was in charge of the War Department. The desert was baffling our westward expansion. Davis decided to experiment with camels. Thought perhaps they might replace the horse and mule as beasts of burden in this country. Quite a few were brought over and I believe a detail made a trip or two on them. But the idea was abandoned. Their feet couldn't stand the rocks. Some got away and the rest were sold."

26

While the faces of the other officers showed their surprise Cam Elliott said calmly: "A friend of mine saw the camel brigade. He always said the beasts were well adapted to this country. Said their hooves would have toughened with time. He tried to buy one for his own use."

"It was a preposterous idea," scoffed Dudley. "How would a troop look on parade? Camels!"

A twinkle came to Cam Elliott's eyes but he offered no reply.

The campaign against Black Cat moved slowly, cautiously. This was no informal pursuit but a carefully weighed plan of warfare, approved not only by Colonel Lee but by the War Department. Black Cat had been routed more than once, only to rally his warriors and to fight again. The objective was not merely to drive the Seminole chieftain into another locale but to destroy him completely.

There was another purpose also—one known only at Fort Clark to Cam Elliott and Colonel Hanna.

Lieutenants Ashwell and Cunningham shared the command of one troop, Dudley the other. Their details seemed pointless and unnecessarily strenuous and the muttering among enlisted men mounted. But Colonel Hanna was pleased with their progress. Their chartings were being developed into an overall map which assumed respectable proportions with the passing days, and all the officers, even Dudley, were showing commendable caution. After two weeks the only wear was upon the endurance of men and horses.

Cunningham and Dudley were out the morning that Cecilia Cunningham burst excitedly into Colonel Hanna's residence.

"Susan!" she exclaimed excitedly. "Why didn't you tell me about Lieutenant Elliott!"

"Tell you what?"

Susan pretended innocence but her flushed cheeks showed otherwise.

"That he's the one who tried to rape you."

"The story has been exaggerated," Susan answered angrily. "He didn't try to rape me."

27

"But I heard . . . somebody said . . ."

"I don't care to talk about it," Susan said firmly. "It's been forgotten."

"I wish you'd talk about it," sighed Cecilia. "I'd like to talk about *something* exciting."

Then she added, accepting a cup of coffee: "But I should have known that it wasn't so. If Lieutenant Elliott started to rape a woman I bet nothing would stop him."

"Don't use that word again, Cecilia," Susan snapped. "Cam may have been a bit over-ardent but nothing else. Lieutenant Elliott is a gentleman."

"He isn't," Cecilia denied softly. There was a far-off dreamy look in her eyes as she stared out the window. "He's a savage," she added in the same tone. "He's all savage."

Then, in a more casual voice: "Jed says all the other officers want him to resign. Is there anything against him except his Indian blood and that he isn't academy-trained?"

"I don't know," Susan answered shortly. "I know very little about Lieutenant Elliott."

"No one does," murmured Cecilia, indifferent to the wish clearly expressed by Susan's manner. "You can find out the intimate details about anybody else, man or woman. But him . . . he's downright mysterious, Susan."

"I don't want to talk about him," Susan repeated.

Cecilia at last changed the subject. She went back to her favorite topics, self-pity for her loneliness, and her inability to stretch her husband's pay and allowances. Susan was glad when her father came from the office for the noon meal and Cecilia left.

In early afternoon Susan borrowed the only light buggy at the post to drive Rosita, their Mexican servant, to her father's house four miles away. This weekly visit with her family was the only respite from duty Rosita demanded. She would return afoot, and by mid-morning. The house was only a hovel, of rock and adobe. Rosita's father and brothers were shepherds, tending flocks for Daniel Favors, the ranchman whose peach brandy was served at many an army social function.

Rosita delivered, and candy distributed among her

bright-eyed younger brothers and sisters, Susan turned the buggy homeward. The road was little more than a rutted trail leading from one wash to the next, and her progress was slow and uncomfortable.

She thought of Cam Elliott, but not in connection with the episode of a year ago. Colonel Hanna's intentness was not lost upon his daughter. Hanna had the easy-going temperament which his station called for until important duty beckoned; then he was a different man entirely; then everything had to please him. Of late he had trivial criticisms to make of the way Susan managed his domestic life. She understood the symptoms and bore no resentment, but she was puzzled by the cause of his concentration. She, like Philip Dudley, was convinced that there was more astir than a pursuit of Black Cat, and that Cam Elliott played a strange role in it. Talk floated up from the barracks to the officers. Lieutenant Elliott had been absent from Fort McIntosh for four full months and other officers had alternated in command of his troop. Then, without explanation or warning, his troop was ordered to join him at Fort Clark. The enlisted men also brought the gossip that several officers at Fort McIntosh had voiced their jealousy of Colonel Lee's "favoritism" for Lieutenant Elliott, though Elliott had taken no part in the Taylor campaign.

Phil Dudley and his detail overtook her before she returned to the post. Cunningham was with him; Phil surrendered command to the lieutenant and rode with her. He was in high spirits. They had intercepted Black Cat and had pursued the Seminole chieftain a full ten miles.

"This isn't going to be as serious as I thought," he declared. "Black Cat had only a handful of warriors with him."

"That isn't what Father thinks," Susan said slowly.

Of late certain faults in Phil Dudley were becoming more and more distinct. He could not completely conceal, not even from Susan, his impatience with Colonel Hanna's cautious plodding ways. His expression showed that now he valued his own opinion more than he did his superior's. Self-confidence was all right, mused Susan,

vital to any successful army career. But other young officers had been guilty of brashness on the frontier.

"I want to be in on the kill," Philip said. "Maybe that would wake up the high brass."

Susan knew what he meant. Dudley was already eligible for a majority, but the promotion had not yet come through. Everywhere promotions had been held up, and there was no overall relief in sight until Congress met again. Susan sighed. Much of Philip's impatience was so justifiable. There were many things he eagerly desired just beyond the reach of his clutching fingers. An ambitious man could not help straining.

Philip went directly to Colonel Hanna's office with his report. Lieutenants Elliott and Cunningham heard it also; Ashwell and his troop had not returned.

"I believe I could have landed him today, sir," Dudley said. "If I get another chance like that is it all right to cut loose?"

Hanna hesitated. He did not like to hamper field commanders with positive orders.

"If I may, captain," Cam Elliott put in, "I'd like to recommend caution. Black Cat is perfectly capable of setting traps. He is a different Indian from most tribal leaders. He doesn't just leap up and fight. He studies war, and he is part-white with an education. To my knowledge he has turned and wiped out two cavalry details."

"Three," Hanna corrected him. The colonel frowned. "Captain, it's a matter of judgment," he said slowly. "Certainly I don't expect orders carried out to the letter regardless of conditions. If we did that, we'd never . . ."

A commotion outside interrupted Hanna's reasoning. A distressed man had galloped into the post; he stood before the officers and blurted out his pitiful story.

He was well-known to them; his land holdings were almost as extensive as Daniel Favors'.

"I saw 'em from two or three miles away," explained Tobe Wilson. "There were eight or ten of 'em, none of 'em wearing war paint."

He went on. His house and barns were heaps of ashes; his horses stolen or driven off, a son massacred and his wife and daughter taken captive.

30

"You gotta get 'em back for me, colonel," he begged. "The house and the horses, I don't reckon they matter. Nothing can be done about 'em anyhow. But my wife and baby, my Louise. . . ."

Tears streamed down his cheeks and he made no apology for them.

"We'll do all we can, Mr. Wilson," Hanna promised quickly. "Rest assured of that, sir; we'll do all we can."

"May I have the detail, sir?" Philip Dudley asked. "I know we're just in, but we had an easy time of it."

Hanna hesitated a moment, then nodded.

"At once, captain. Will you go with our men, Mr. Wilson?"

"I sure will," was the quick answer. "And if we catch up with 'em, I want the first shot."

"You'll get it," Dudley promised.

The unhappy ranchman followed the swarthy captain and Lieutenant Cunningham out of Hanna's office. The parade ground was shortly astir with clatter and voices as Dudley's troop quickly formed. Hanna watched out the window a moment, then turned to Cam Elliott. His face seemed to have acquired new worry lines in these past few minutes.

"I didn't believe it, lieutenant," he murmured. "You said so, but I didn't believe it."

"I didn't expect him to take women," Cam said slowly. "But I suppose they have some value, too."

"Mrs. Wilson is not unattractive," Hanna grunted. "She would have a value."

He looked out the window again. The troopers were forming into ranks. They were ready for duty in an incredibly short time. Dudley should be complimented for that, and also the men.

"Do you have any suggestions, lieutenant?" Hanna asked without turning.

"Only one, sir," Cam replied immediately. He had been hoping for this question; he had already carefully framed his answer. "We might rescue Mrs. Wilson and her daughter, though it's dangerous. Black Cat would kill them before he would let them go. It seems to me our only hope is to capture some hostages."

"Would he exchange them?"

"Yes. Black Cat loves his people, colonel."

Colonel Hanna frowned. "I'm not sure I have the authority to do that," he considered. "I agree with you; it's the thing to do. But sometimes . . ."

He snapped his fingers. "It's the only thing to do," he snapped. "Have you located the village yet, lieutenant?"

"Approximately. It's in a canyon, of course."

"Accessible?"

"Not very."

"Take your troop out in the morning," ordered Hanna. "We have to find it. And soon."

"Yes, sir," Cam Elliott agreed.

CHAPTER 4

THE sun blazed down upon Philip Dudley's tired detail. The captain ate his cold meal with no more shade than the sweat-streaked body of his horse. His men watched him silently, anxiously. Their mounts were weary beneath them and human flesh had endured about all it could. For three days they had pursued a copper-skinned will-o'-the-wisp which they occasionally sighted on far-off rimtops but could not overtake. They were a full half day's ride from the post and if Dudley did not soon turn back they would have to spend another night in this tangle of brush and rock and chasms.

Their rations were almost gone; no man would completely appease his hunger this noon. Dudley knew what they were thinking and he resented their muteness. He was well aware that no babble of talk flowed back and forth through his ranks. There was none of the profanity, the informality which he could observe in Elliott's detail, or even in Cunningham's. But damn them. He wanted them that way. When they were out with him he wanted their full attention focussed on what they were doing. Companionship, conviviality could wait until they had returned to the barracks.

Blacky Crouch, the ageless scout who had been as-

signed to Dudley against his wishes, proposed that they turn back.

"Can't stay out forever, cap'n," drawled Blacky.

Such careless informality was the reason Dudley resented Crouch's attachment to his troop. Also Blacky was part Negro, and showed it. Philip Dudley was a Virginian and very aware of it.

He hesitated, then reluctantly agreed. His troop remounted and Dudley led them at a trot along the same trail they had come. Blacky suggested they follow a high shaggy peak which served the scouts as a dependable landmark but the captain refused.

"I don't want to take a chance on getting lost," he said curtly.

Blacky glared at him. The scout's shaggy white mustaches were in humorous incongruity with his dark skin.

"Ain't ever got a detail lost yet," he grumbled.

"No need to take a chance," Dudley repeated, enjoying the opportunity to put a scout in his proper place. Such veterans as Blacky Crouch honestly thought that differences of rank did not apply to them.

For two hours they held a steady pace, keeping to the ridges, moving at a jogging gait. Once they glimpsed a troop moving to the south. That would be Elliott, mused Dudley, Cam Elliott and Troop D returning from reconnoiter. A scowl touched Dudley's face as he thought of the tall lieutenant. Not only Dudley but Ashwell and Cunningham had observed Mark Hanna's confidence in Cam Elliott, this despite what had happened between Elliott and his daughter. He's running the show, brooded Dudley. Hanna is conferring with him behind our backs.

Blacky Crouch was riding a yard or so behind Dudley and also musing upon personalities. The scout resented Dudley as much as he was resented. But his senses were still alert; he raised his hand in warning and reined up.

Dudley stared in the direction Blacky pointed. There were horsemen crossing the ridge, and they were not cavalry troopers. Soldiers did not move through this region driving spare mounts ahead.

Philip Dudley's first reaction was to curse. Apparently Black Cat had circled wide to the north, daring to swing closer to Fort Clark. Who, thought Dudley, is pursuing

whom? Then he studied the uneven terrain and saw that if Black Cat held his direction the Seminole chieftain must dip downward into a wide sprawling canyon. Dudley had ridden through that canyon and had given it an intent study. Instinct had warned him that here was a likely place for an ambush.

His dark features glowed and his eyes sparkled.

"We can bottle him up in that canyon," he told Blacky.

The scout calmly shifted his tobacco cud from one jaw to the other.

"Could be," he admitted unenthusiastically. "But it ain't gonna be easy. Seems like we got an edge on 'em, but not too much. And we ain't in the best fighting shape."

"We're ready," declared Dudley.

He quickened his pace and did not take his eyes off the horsemen. The distance between them lessened and they were Indians beyond any question. For a time they disappeared from view and Phil Dudley was afraid that the red men had veered their direction. But there they were again, in full view now, sixteen of them.

"They're bound to see us, too," Blacky Crouch shouted over the clatter of iron horseshoes on rocky terrain.

That Philip Dudley conceded. But he kept on anyhow. This was no time to muse upon any uncertainties. If they could only get close enough to charge before the red men found cover! He waved to the bugler and the ringing sound made his blood tingle. This was warfare as he liked it, cavalry fighting between two groups of men in the open, neither afraid of the fight, neither fleeing from it. The Indians, he observed, were even quickening their pace, as if eager to meet them headon. The red men gained the canyon's sandy floor first, but the troopers were so close behind that the Seminoles had no chance to gain cover. The red men stopped and their fire screamed close to Phil Dudley, almost in his very face. His horse trembled beneath him and with a curse he leaped clear.

Then there came another burst of gunfire. This sounded from above them, from tiers of rock and shale a hundred yards high. Realization burst upon Philip

34

Dudley. He yelled to his troopers to break ranks and retreat. His voice could not be heard above the uproar but Blacky Crouch snatched the bugle from Eddie Howard and blew a loud if tuneless blast. Bullets thudded into the milling ranks and a corporal went tottering sideways. Dudley appropriated his horse and swung it around. He pushed his way back through the enlisted men still coming on.

He was no coward. He led his men in flight but he led them. He did not permit a disorganized riot. Hatless, face even darker than usual in his chagrin and anger, he spurred his horse back and forth until finally he had formed the weary confused men into even ranks again.

Out of range from the rimtop, Philip Dudley appraised the damage. Six men were down, killed or wounded. Others had been hit but kept in the saddle.

"Damn 'em!" yelled Blacky Crouch. "There they come."

The Seminoles were storming out of the canyon, the same sixteen horsemen Dudley had so confidently pursued. The troopers had no choice but to make a stand. Dudley set the example, swinging out of the saddle, throwing himself face downward on the ground. Hurriedly the soldiers reloaded carbines. The Seminoles, half-naked creatures, riding bareback, veered sharply and fired without dismounting. Their shot fell short. Dudley ordered no return fire. The distance was still too great, particularly at rapidly moving targets.

Their plight was not precarious, not at the moment. It was more embarrassing than perilous. The swiftness and unexpectedness of this countercharge had caught them fully unprepared. Ranks formed, men in the saddle, Dudley would have hailed this chance to fight in the open. But as it was . . . he did not dare risk reforming. It could be done, but at loss of life. Thirty-four troopers were surrounded by sixteen savages. Then from the high ridges came another Seminole band and Dudley could only regret that he hadn't reformed when he still could. There were at least a half-hundred Indians in this second wave. All of them bore rifles and the fire pouring down upon the troopers became more intense.

Desperation showed in Phil Dudley's eyes and on his

35

swarthy features. This was an almost incredible situation. He assured himself that no man had anticipated it. The Seminole charge which had caught him off guard was beyond the wildest of speculations. His lips formed muted oaths. Only a savage would have ordered it, an ignorant pagan possessed of the physical powers of cavalry but without training in the tactics of mounted warfare. But the effect was as complete as if it had been a carefully planned maneuver. Outnumbered and without protection from rifle fire he must form his patrol and fight out, those who could.

He gestured to the bugler and his command floated out, high, clear. His troopers hesitated. He did himself.

The second bugle sounded so quickly after the first that for a moment Philip Dudley believed it was a faint far-off echo. Then it sounded again, and over the southern horizon came faint moving specks. Quickly Dudley canceled his order. Back they fell to their bellies and their carbines chattered hoarsely as their captain set them firing at will.

The Seminole circle swept around them once more, then galloped toward the canyon. The red men had disappeared into its emptiness long before Lieutenant Elliott dismounted and saluted Captain Dudley.

The tall lieutenant was smiling but not Dudley. Phil had wanted help—had breathed a silent prayer for it. But why couldn't it have been Ashwell or Cunningham? Why did it have to be Cam Elliott, who could stand in apparent respect before him, and yet could remark without fear of reprimand:

"You were in a pretty bad way, captain."

Philip Dudley could only nod his dark bare head. There had been no doubt of his predicament. Company D had come up in time to avert heavy loss of life and perhaps complete annihilation.

There was no criticism of Philip Dudley, not directly.

"We can consider ourselves fortunate," said Colonel Hanna. "It hurt to lose six men; we haven't any to spare. But from now on we can be certain that we are in danger every moment we're out. I'll ask for another company,

but I know better than to expect it. I'm sure we'll have to do the job with what we have."

Though no single direct reference was made to him Philip Dudley felt that he had been reprimanded. Unjustly so, he decided. He had been aware of danger. He had been zealously performing his duty. What was the point of pursuing Black Cat if they were not to attack him when they found him?

"Don't be so touchy, Phil," Susan cautioned him. "Nobody has blamed you."

"It doesn't look very good on my record," he pointed out. "Six men gone, the *rest* rescued in the nick of time. I can't say positively that the Seminoles had a single casualty."

"Put it out of your mind," she advised. "It didn't go so well this time. There'll be another time. Let's see if the Cunninghams want to play pitch."

He finally consented. He wanted to do something besides sit in the Hanna living room and glumly defend his ill-fated assault. But he couldn't look forward with any relish to an evening of meaningless card play and Cecilia Cunningham's complaints.

Susan took his arm and they walked slowly across the parade ground. The night was cool—one wondered where the icy touch went at each dawn. She wore a light wrap over her shoulders, though she was bareheaded.

"Listen!" she suddenly commanded.

The strains of violin music came to them out of the night, came from the barracks where lights were gleaming in the windows.

"Who in the world?"

"Oh, the music," Dudley said indifferently. "That young brother of Chris Zanoba's. I think his name is Tony."

"He's marvelous," declared Susan. "Let's walk over closer."

They neared the frame structure assigned to Company D and could see through the windows. Tony Zanoba was standing proud and straight, his posture and the movements of his bow those of the carefully trained musician. A dozen or so men lounged on their cots or on the floor, their eyes upon him, their senses intent upon

his playing. Chris Zanoba sat shirtless on a cot and watched his young brother with beaming eyes.

"We'd better walk on," Phil suggested. "Some of those fellows are apt to start undressing. The first thing an enlisted man wants to do is to take off his clothes."

Susan agreed, but with unconcealed reluctance.

"I want to hear him again," she said. "I had no idea we had such a musician at the post."

"That's about all he's fit for," Dudley shrugged. "He's too frail to ever make a soldier."

The evening was not successful. The Cunninghams were arguing over financial affairs again; after an hour's listless play Susan pleaded fatigue and they returned to her father's quarters.

"I hope we never argue like that, Philip," Susan said. "They never let up. I'm afraid Cecilia is going to leave him."

"He would gain by it," Dudley pointed out. "She is hurting him as an officer. He's doing a lot of worrying and stays behind on his paper work. Most of them do for that matter."

Dudley was qualified to make that criticism. His own reports were full, prompt and precise. His handwriting was even, neat and easily legible.

"Besides," Philip said ruefully, "it doesn't look much like we'll ever have the chance to start domestic quarrels."

"Oh, don't be so gloomy," Susan reproved.

"I am out of sorts tonight," he apologized. "Maybe I'd better turn in and come another day."

"Good," she agreed.

Tobe Wilson reappeared at the post the next morning. There were four other riders with him, hard-faced men, all wearing heavy six-guns. The ranchman nodded when Colonel Hanna regretfully told him there was nothing to report.

"It ain't easy," sighed the cattleman. "I know that."

Wilson pointed to the four riders lounging in the building's shade. "I picked up these *hombres* and got 'em trailing," he explained. "They're pretty mean characters, got notches all over their guns. I figger them for owl-hoots

but they know their way around this country. Anything they find out I'll pass on to you."

"I certainly hope we can learn something," Hanna said. "I'm keeping two patrols on the move, Mr. Wilson."

"Your boys are hustling," conceded the ranchman. Wilson stood up, fire burning in his grey eyes, his face set in harsh lines.

"I'm gonna deal them redskins some hell on my own, colonel," he avowed. "I'm some shakes with a six-gun and them boys there are rough."

Colonel Hanna chose to ignore this threat. Now was not the time to remind Tobe Wilson that the army was there to protect the Indians from the white men also. Wilson was near crazy from grief and worry; he would not be reasonable to deal with. Hanna would postpone until another time his warning against Wilson's taking matters into his own hands.

Cam Elliott and Company D were already many miles from the post. Ashwell was out also, bearing a role as important in their daily maneuvering. Ashwell and Company C were dogging Black Cat's trail, trying to draw the Seminole's attack, while Elliott wove back and forth through the tangled land seeking to pin down the location of Black Cat's village. They had ridden many weary miles without learning any more than the canyon in which the Seminole had apparently settled the remnants of his people. It was an almost inaccessible arroyo, except from its entrance, and Elliott would not lead his troop into it headlong. He did not doubt for a moment Black Cat's watch over his people.

Small wisps of smoke held his attention; they rode toward them, and again were halted by the brink of yawning space. Cam lay on his stomach, cautiously waving his troopers back, and studied the canyon below him. The smoke still wafted upward, but not in any column, not from any visible source. He lay there and wondered if all his searching had been wasted. For days he had maneuvered carefully and skillfully to reach the source of these smoke wisps. Now he was directly over them, yet there were no signs of village or camp, no evidence of human habitation at all. He rolled a cigarette and pondered this dilemma. If Black Cat's village was not in

this canyon then he had no notion where it was, or if it existed at all.

He squatted and smoked and continued to regard the smoke wisps. Were they caused by some natural phenomenon? Apparently they floated out of the very bowels of the earth, as if inside a great cave a fabulous giant was smoking just as Cam Elliott was doing and at intervals blowing out smoke in deep puffs. Then suddenly Cam started and the cigaret dropped from his fingers. Some two hundred yards below him, halfway up the opposite cliff, stood an Indian woman. One instant she had not been there at all, the next she was in plain view. She stood framed there for a moment, staring off to the north, shading her eyes with the palm of her hand. Then she was gone as abruptly as she had appeared.

But Cam Elliott was no longer baffled. Now he could identify openings in the bleak side of the canyon wall. Now he understood why Black Cat had chosen this particular canyon as a haven for his fugitive people. Others before the Seminoles had sought safety here. This canyon had been inhabited centuries before the white man came, or the Indian for that matter. These openings undoubtedly led into chambers hollowed out in the rock and shale by a prehistoric people. Cam Elliott had seen caves built by cave dwellers in New Mexico; from across the canyon's yawning gap he could see that Black Cat had appropriated unused caverns for the Seminole women and children.

For a long time he lay there contemplating the problem ahead—of reaching the caves practically unobserved. The wily Seminole had found a hideaway that was almost inaccessible except from the canyon's mouth. That, Cam could be sure, would be heavily guarded. He remounted and led his troop southward, stopping periodically to look for a way to cross the jagged gorge. For, he reasoned, the only safe approach to the cliff houses was from the other side.

Several miles southward he found a break in the shaggy bluff and boldly led his detail downward. They rode along the sandy bottom and another half-mile search produced a way to mount the other side. Cam Elliott was

satisfied. He led his detail back to Fort Clark and reported to Colonel Hanna that he had located Black Cat's camp.

The other officers were called in and Lieutenant Elliott explained the position of the caves.

"They seemed unguarded," he pointed out. "Apparently Black Cat is sure that we can't reach them except by a direct approach. I wouldn't advise that. I'm sure he can crush any force which tried to fight its way into the canyon."

"I'm sure of that," nodded Hanna. "The thing to do is to fake with two units, draw his warriors away from the canyon, and send only a small detail to get the hostages. How many men do you think you will need, lieutenant?"

Cam Elliott regarded the colonel, then looked off. "I agree with the suggested strategy," he said slowly, picking each word carefully. "Four or five should do. If it isn't a complete surprise a hundred men couldn't do it. But I . . . have no desire . . . to command the detail."

There were several moments of silence. Philip Dudley spoke first.

"And I'd like very much to do it, sir," the captain said eagerly.

It was incomprehensible that Lieutenant Elliott did not want the assignment. There might be danger, but any detail had its risks in this tangled land with Black Cat and his Seminoles determined to fight to the death. This was the type of assignment which earned recognition from Washington, which was described fully in formal reports, which would be printed in newspapers, which might bring promotion.

Colonel Hanna's eyes gravely studied Cam Elliott's impassive features. Then suddenly he was satisfied.

"All right, captain," he acceded.

Actually he was pleased with his selection. Otherwise Phil would lead a detail which Hanna positively did not want engaged in action, and that would not sit too well with the swarthy captain. Now Hanna would not have to worry about Dudley's plunging headlong into rash and unnecessary action.

"You must reconnoiter the canyon until you know the lay of the land," Hanna advised Dudley.

Philip agreed.

"And," the colonel said firmly, "we must have no outside talk about this. None whatsoever."

CHAPTER 5

PHILIP DUDLEY meticulously began his assignment. And with enthusiasm. The success of this coup would more than wipe out recollection of his blundering assault upon Black Cat's ranks. He led his detail along the trail Lieutenant Elliott had blazed and confirmed what Cam had reported.

Tobe Wilson returned to the post and sadly announced that his hirelings had uncovered no trace of his kidnapped wife and child. Hanna could not resist giving the ranchman a faint hint of the planned operation.

"We're going to do our best to get your wife and girl back," the colonel explained. "Also to stop other kidnappings. We have reason to fear others in the next thirty days. If we can get our hands on some of Black Cat's people we will hold them as hostages."

"That ain't worked yet," Wilson pointed out, recalling Indian raids of other years.

"No," agreed Colonel Hanna, "but we have good cause to believe Black Cat isn't the average Indian. Anyhow that seems our only hope at the present."

"He's a tricky customer," conceded the ranchman, "and this country is against us. Them redskins must know more water holes than we do. They seem to come and go just as they dang please and us white men. . . . We gotta keep to the trails we know."

"It's an endless problem," agreed Hanna.

Wilson rose slowly to his feet. "I ain't shot my whole wad yet, colonel," he declared in a trembling voice. "My wife and little gal meant the world to me. Them damned Indians are gonna settle with Tobe Wilson before the shooting's all over."

His high-heeled boots rang sharply as he strode to his

horse, swung up into the saddle and was gone at a dead run.

"I feel sorry for the man," Hanna sighed. "He's awfully worked up and I can't blame him. I hope you can find out something about his wife and daughter, Phil."

"Ought to," nodded Dudley. "Probably Black Cat carried them to the caves."

"If you learn anything," the colonel instructed, "swing by his place on your way back. It's only about ten miles out of your way."

Dudley nodded. He had camped once by the Wilson spring, had slept in the ranchman's house.

The colonel and his future son-in-law were alone, and Hanna took advantage of that to venture some advice.

"This must work, Phil," he said in a fatherly tone. "This is just the beginning of some important business. It's your opportunity. Things seem pretty quiet everywhere else. If we deliver down here I can strongly recommend you for decoration and promotion. Unless the appropriation is hiked—and nobody expects that—promotion won't come automatically according to seniority."

"I know that," nodded Dudley. "I'm going to do my best, sir."

He shot a sidewise look at Hanna. The old boy is in a confidential mood, he mused. Maybe he will open up and give me a hint about the rest of this business.

"I've been wondering what this will lead to," he murmured. "Perhaps you could give me a hint, sir?"

"No," Colonel Hanna firmly denied. "You have the best assignment, Phil. You must be satisfied with that."

"I am," Phil answered quickly, but not quite truthfully.

The captain stared out the window a moment, mulling over a question which had bothered him for three days.

"Perhaps there's one thing you can tell me," he said. "You offered Lieutenant Elliott this assignment. That was the thing to do, of course. He found the caves; he knows the country better than anyone else. I was a little taken back when he obviously expressed his dislike of the assignment."

"So was I, for a moment," nodded Hanna. "Then I remembered some of the talk about Lieutenant Elliott. I

recalled that he is supposed to have lived with the Indians as a boy . . . with the Seminoles."

"That's right," Dudley agreed. "I've heard the talk, too. Isn't he supposed to be part Seminole?"

"I've heard that." A smile came to the corners of Hanna's mouth. "You know they say it takes an Indian to catch one. It took Lieutenant Elliott to find Black Cat's camp."

"That it did," Dudley cheerfully conceded.

The staccato sound of iron-coated hooves upon the sun-baked parade ground awakened all at the post. Susan hurriedly pulled on her dressing robe and waved to Phil Dudley from the window. He responded with a salute. Then the gray dim dawn swallowed up their moving shapes and there was another hour of stillness before the usual day's routine began.

Susan did not return to bed but sat with her father and drank several cups of coffee. Mark Hanna was not very successful in concealing his concern. Should anything go wrong Phil Dudley and his six troopers would be easy victims of the Seminoles. And never before had any army man found Black Cat napping. Hanna did not explain the nature of Dudley's orders and Susan did not press him, though she was completely mystified. She could not imagine anything but a routine assignment calling for such a drastic reduction of Phil's troop.

Two hours later Ashwell and Cunningham led a single force from the fort, leaving only Company D to man the post. The men presented a pretty picture as they clattered forth, in sufficient numbers to make an impressive parade. Seminole sentinels watching from the hills must view this as a serious incursion. At least so the maneuver was planned, to offer Philip Dudley all the possible protection of the post.

In mid-morning Cecilia Cunningham came over, her eyes dancing with excitement.

"He's promised, Susan!" she exclaimed. "He's going to resign. We're going back to Ohio."

"I hope you never regret it," Susan said slowly. "Maybe it'll work out. But usually when the army gets into a man . . ."

She shook her head. Mark Hanna had loved her mother. Did still. Never considered for a moment taking another wife. But Hanna was still attached to his duty and her mother was in New York and the distance between them would never be spanned of his volition.

"Oh, he'll get used to it," Cecilia predicted. "Father can find him something to do. He can manage a farm or one of our stores. Think of it, Susan! Civilization again. People. No drab army post. No houses with cracks in them."

"When is this going to happen?"

"Pretty soon. There's some kind of campaign going on . . . you know that. As soon as it's over."

"It'll be accepted," Susan mused. "I think Washington would like more officers to resign."

"I can't see why they all don't," Cecilia declared with a toss of her blond head. "It's worth real money to live out here and chase Indians!"

"It's the way you look at it," Susan pointed out. "I'd rather live out here than in New York."

"I suppose you mean it; you keep saying so."

Both women were silent a moment, then Cecilia caught Susan's shoulder. "You should be tickled pink yourself. You and Philip can get our house, so there's nothing to keep you from getting married."

"That's right," nodded Susan. Lieutenant Cunningham's resignation would settle the problem of living quarters. She did not explain about Philip's debts.

Cecilia left—to write her mother the great news. So Jed finally surrendered! That was the beginning of the end, Susan mused. Jed Cunningham had spirit; no young man came through West Point without it. He might surrender himself to Cecilia's moulding—for a time. But he would grow to hate her and probably she would return the emotion as intensely. But, anyhow, Cecilia had finally won out. There would be a house available at Fort Clark for Captain and Mrs. Philip Dudley. Actually nothing stood in their way now. He could repay his gambling losses as a married man as well as he could as a single officer.

She suppressed the desire to break the news to her father. That was Lieutenant Cunningham's privilege, and his duty. She hoped Cecilia would remember that.

Afternoon came, and it was the day for Rosita's weekly

visit to her family. Susan delivered the servant at her father's hut and drove slowly back over the uneven roadway, lurching back and forth in the seat as the wheels bounced crazily from one boulder to the next.

Then her coal-black mare shied away from a five-foot rattlesnake which came slithering across the ruts. Susan was almost thrown from the seat as the light buggy was jerked into a wash. The mare strained and the vehicle rolled slowly out, its rear axle snapped in two and she was stranded there fully five miles from the fort.

She climbed out of the buggy and ruefully surveyed the damage. Her fear of the snake gone, the gentle mare waited patiently for her decision. Susan hesitated for only a moment. She could return to the post afoot, or she could unharness the mare and ride the animal. She started fumbling with the leather gear. She preferred the ride, even though it would be without a saddle and meant an entrance into the post with her skirts askew.

She made little headway with the intricacies of the harness and searched the buggy for a knife or some instrument with which she could slash it. She found none, and in despair returned to her fumbling efforts with the leather fastenings. Then she saw a single horseman riding away from the fort. She ran to a rise, waved her arms and cried for help. She could not hope to make herself heard at this distance but whoever it was might possibly see her.

He did. He turned immediately in her direction and again she recognized the way he sat in his saddle.

But she wanted help from anyone. Cam Elliott would know how to unharness a horse.

"You're a godsend, lieutenant," Susan told him with a smile as he dismounted. "My fingers seem to be all thumbs when it comes to unharnessing a horse."

He did not answer. He appraised the damage, then took a hunting knife from his saddlebag.

"Do you have to cut the harness?"

He did not seem to hear her. He walked toward a mesquite clump, moving with long slow steps, and in a few minutes returned with a bough fully two inches thick.

"Oh, you're going to make a new axle."

He nodded.

"Someone would have to come after the buggy," he explained. "Might as well save them the trouble."

He made two mounds of rocks and the buggy's weight rested on these while he removed the broken axle and replaced it with the make-shift mesquite support. Susan sat and watched and finally the words came which she should have spoken to Cam Elliott a long time ago.

"Cam," she said, "I've owed you an apology a long time. My father does, and Phil Dudley."

"Why?" he asked without pausing in his labor.

"Many people have the wrong impression of you . . . because . . ."

Her voice dropped off.

"I know," Elliott shrugged. "I'm not a gentleman. I lured the colonel's daughter out into the dark and tried to attack her. Forget it."

His tone hurt her. She had not considered it so unimportant.

"It hasn't hurt me," Cam Elliott went on, his voice dry, flat. "Not as you think. I wouldn't have been promoted anyhow. It's been a nuisance in just one way. All the unhappy wives drool over me. All the jealous husbands distrust me."

Susan's lips tightened and flecks of color came to her cheeks.

"Most of your trouble," she pointed out, "you've made for yourself. Talking just like that. Reacting just like that."

Now he had finished. He stood up, towering over her by half a head.

"I haven't had any trouble," he denied. "I've been an officer and a good one. My superiors have watched me like hawks and still they couldn't find anything to chalk up against me."

"No," Susan conceded. "I've never heard anything but praise of you as a soldier. You've been discriminated against, I know that. But still, Cam, if you'd be different . . . and try . . ."

"Try what?" he demanded. "Try to be a stiff pompous stuffed shirt? Try to imagine myself a little tin god like your beloved Philip Dudley?"

He chuckled. "I couldn't do that if I tried. Remember I'm part Indian."

"Are you really, Cam?"

He nodded. "A fourth at least. Maybe more. There's no way of knowing."

"But you've had schooling," she protested. "How could you . . . if . . ."

"A white family adopted us. There were three of us, two boys, one girl. We don't know what happened to our parents."

"Your brother and sister?"

"We don't know. We were very young."

A grin came to his lips. "Want the rest of the story?" he asked. He continued without waiting for a reply. "The people who took us in died, too. Not very long afterward. I herded sheep until I was near grown and then helped drive some cattle to the Colorado gold fields. The war came and your precious army needed men. Your pompous officers had to get off their rear ends and earn their pay for a change. They didn't like the prospect. So they put aside their snobbish notions of what it takes to lead men and took in some fighting men. They even made some of them officers. Me, for instance."

He made a gesture with his hands. "That's it, Miss Hanna," he said lightly. "The war didn't last long. When it was over your stiff-backed West Pointers wanted to get rid of hombres like me. We shouldn't be officers and wear braid, not unless there's a war on or there are Indians to chase. I haven't chosen to get out, not yet. Soon, perhaps by the end of the year. But not until I am damned good and ready."

There was spirit in her eyes, too, and resentment.

"Some of that is true, Cam Elliott," she admitted. "But not every officer is like that. My father isn't."

"No, he isn't," Elliott granted quickly. "Colonel Hanna will do to ride the river with. Any day. He's honest, capable and devoted to his duty."

He tilted his head slightly and the earnestness left his tone; he was mocking again.

"For a while I thought his daughter was made of the same pattern," he went on, slowly, cruelly. "She felt passion once, genuine wholesome feeling. She quit acting like

48

a talking china doll and gave herself up to being a woman. But that didn't last long. Just a moment. She wasn't up to it. She remembered just in time that she was an engaged woman. She remembered that she was engaged not to a man, but to an army, a sewing circle, a tea party. She didn't dare throw all that away . . . just to be a Seminole's woman."

Tears welled into Susan's eyes. She wanted to hurl back her furious denials but the words just didn't come to her.

Cam Elliott spoke again. "I have always regretted that I made that mistake. It hasn't happened again."

Now Susan found words. "Why hasn't it?" she demanded. "You're strong, and you have no scruples about honor. Except for my father and Phil Dudley you would have taken me . . . as an Indian takes a woman. Why hasn't it happened?"

Now his was no impassive face. Now his features were dark and his pagan strain was there to see plainly, in the curve of his lips and the glow of his eyes. Susan anticipated his move. She knew he would seize her in his arms, and roughly. But she could not retreat before him. She was held there by some irresistible force, rooted dead in her tracks. The arms caught her and she flinched and closed her eyes. Then he released her. His arms dropped from her and he stepped back and she opened her eyes again. That look had gone from his face and his grin was there again, and that faint dancing twinkle in his eyes.

"Your buggy is ready," he said calmly. "It'll do all right, if you take it easy. I'll ride along with you just to be sure you make it."

"That isn't necessary," she snapped, glaring at him through tear-splashed eyes.

"Oh, but it is," he returned. "Any lieutenant jumps to serve the colonel's daughter."

CHAPTER 6

PHILIP DUDLEY led his small detail down the canyon's northern drop, across the sandy bottom, up the steepness of the far. side. Thus far they had not sighted a single Indian. Blacky Crouch, wise to the ways of the red men, with the keenest vision of any man Dudley had ever known, was sure they were unobserved. But still they sat their saddles tensely, no man quite at ease.

Midway up the incline Dudley dismounted and motioned his men to do likewise. Here was a pathway in the side of the rocky crest, either carved out by whimsical nature or else chiseled out by a forgotten people. Philip took a few steps and his boots made a ringing noise on the smooth stone.

"That's the trouble with them fancy boots," snorted Blacky, whose moccasined feet made no sound. "Better strip 'em off, cap'n."

Dudley nodded. Barefooted, tenser still, the troopers moved cautiously forward.

The sun had not yet breached the rimtop and at times they gingerly felt their way through heavy banks of shadows. They had camped the night before on the opposite crest, camped in some misery without the solace or assurance of a fire, had slept only fitfully because there was no way on such terrain that a man could make himself comfortable. But Philip Dudley had not minded that. When such an opportunity beckoned to a man he did not reckon physical discomforts.

Slowly, carefully, he picked his way, Blacky Crouch close at his heels. Ahead of them sounded voices, of women and children. Dudley paused behind a jagged intrusion and waited until all the troopers were even with him. He peered around the ledge. The caves were no more than ten paces away. Just before them the path widened into a ledge, perhaps also fashioned by human hands. Dudley raised his hand and walked swiftly forward.

An Indian woman emerged from the nearest opening and screamed as she saw them. Dudley sent her sprawling

with the flat side of his saber. Boldly he strode into the first cavern, which widened before him, which reeked of smoke and human odors. Blacky Crouch led three soldiers into the other chamber.

Indian women and children of all ages cowered before them. There was only one male, a toothless white-haired old man who did not even rise when Dudley entered. The Seminoles lined up obediently at Phil's orders, children clinging to their mothers, eyes wide in terror. The troopers held carbines trained upon them but none attempted flight. They stood there, stolidly and impassively awaiting their fate.

Dudley searched the interior of the caverns until convinced that neither a woman nor a child had eluded them. The caverns were deep and high; a hundred families might live in each. Ovens had been hewn in the rocky sides and crude chimneys built to bear the smoke away. The floors were of packed white sand, probably brought by the basketful from the canyon's bottom. Dudley studied them a moment longer and then grunted. Had he found the Seminoles living in tepees or huts he would have ordered them burned. But there was no way to destroy these habitations, not with any means he had at his command.

He walked back to the ledge, which was nothing less than a huge sprawling verandah which the Creator had designed and cast. There were a half-hundred women and maidens and only half as many children. They wore garments of all types, some of skins, others of roughly-woven cotton.

His instructions were to choose two captives, as many as Black Cat had taken.

"Talk to them," he directed Blacky Crouch. "See if you can pick out Black Cat's squaw."

Crouch addressed the women in a jargon that was part English, part Indian. For a long moment there was no answer. Then forward stepped an Indian woman clad in fringed buckskin. She wore ornaments around her neck and on her wrists.

She faced Dudley proudly and her gesture was unmistakable. She was Black Cat's wife.

Philip nodded. He should have been able to pick her

out at a glance. She was easily the most handsome of the Seminole women, not as squatty as the others, her features not as wide or coarse. Her dress was of soft doe skin, cut close-fitting to the waist, setting off her high bosom. A boy of perhaps three years ran to her with a small cry and caught her hand. She bent, calmed the child with reassuring whispers, then stood erect. Dudley's eyes gleamed. He had captured not only Black Cat's wife but a child as well.

"We'll take these two," he told Blacky Crouch. "Tell her to pack a bundle if she likes."

He decided there was no need to take other captives. The wife and child should be enough. He ordered their hands bound tightly behind them.

"Now," Dudley instructed the mustached scout, "tell them how Black Cat can get back his wife and boy. Tell them when the two white prisoners are safe at the fort we shall release them."

Blacky Crouch tried—in the Lipan dialect also when no understanding expressions rewarded his efforts.

"I ain't sure they got it all, cap'n," apologized the scout. "But they'll get it finally figgered out."

Dudley nodded. Now he instructed the enlisted men to make a thorough search of the caverns. There were small crevices everywhere; some of them seemed to have been hewn out. From one cranny a trooper produced four rifles. They were of modern make and unused.

"How in the blamed hell do they get them guns?" asked Blacky.

Philip shook his head. No one seemed to know for sure, but Black Cat's warriors were well armed.

"There might be ammunition somewhere around," he told the troopers, "so look close."

But no cartridges of any kind were found. Philip methodically made a note of this fact.

"Captain! Captain Dudley."

The cry came from inside the second cave. Out of it came a trooper gingerly holding a gruesome burden. Attached to a leather thong were a half-dozen scalps!

Philip Dudley could not bring himself to handle them but the case-hardened Blacky Crouch had no such qualms. The soldier dropped the trophies and Blacky squatted over them. His observations came one after another.

"Ain't none of these old ones, cap'n—two men, three women, one child—two women old uns, gray-head—"

"One child?" asked Dudley.

"Yep. Little girl. Lay you ten to one it's the Wilson girl."

No one accepted the wager. No one doubted it, for their search had produced no evidence of any captives.

Finally Dudley was satisfied that their inspection was complete. "Bring them along," he told Crouch, motioning to the string of scalps. He signalled the bound Indian woman to walk ahead of him. She obeyed stoically; the child pattered behind her, eyes wide with fright, whimpering every now and then but never crying out.

They redonned their boots and retrieved their horses. Phil had the bonds removed from the woman's hands but stout cord pinioned her legs to the saddle and her feet in the stirrups. Then he unbound the small boy also and handed the child up into his mother's arms. She thanked him with a flicker in her eyes and a quick small smile. He ordered his men to take turns at riding double.

He could not help feeling uneasy as they rode down one slope and into the sandy bottom. They were visible for a long way to any pair of eyes watching from the rim-top. Thus far it had been easy, ridiculously easy. Then they were climbing upward with still no evidence of detection and Philip Dudley sighed in relief and elation showed on his dark face. Luck was certainly with him. This canyon stretched for miles and its jagged breadth protected him from the Seminoles. A strong detail, the remainder of his unit and all of Ashwell's, would meet him where the gorge broke upward and melted into rolling hills, where pursuing Seminoles could overtake them. Black Cat's very wile had been turned against him. The Seminole leader had intended that the canyon's vastness would protect his women and children; instead it insured the safety of their captors.

Then horsemen showed on the horizon, three of them.

Dudley pulled up and stared.

"They ain't Injuns, cap'n," Blacky Crouch said quickly. "Injuns don't sit a hoss that way."

Philip rode on cautiously. Now the three riders apparently sighted them also and veered toward them. The

distance narrowed until Dudley could recognize Tobe Wilson. He frowned. He could not look forward to the ordeal ahead, of showing the scalps to the cattleman, of probably accepting a distressed father's recognition.

With Wilson were two of the hard-faced men he had apparently employed only to help in the search for his missing kin. They reined up and held aloof while Wilson exchanged greetings with Captain Dudley.

The sad-faced ranchman volunteered the information that they had found the bodies of his wife and child.

"No call to look any more," he said grimly. "Found 'em yesterday. Took 'em home and buried 'em."

"Scalped, weren't they?" Dudley asked.

"Yep."

"We just came from Black Cat's cave," explained Philip, "and found some scalps there. I was afraid that . . ."

His voice fell off.

Wilson shook his head. The cattleman was staring at the Indian prisoners.

"If they were alive," Dudley said, "we might have got them back. This is Black Cat's squaw and his boy."

"No call to take 'em in now," muttered the cattleman. He stared a moment longer, then said to Dudley, his voice low and strained: "Ride over here a piece with me, captain."

Dudley obeyed. Wilson waited until their words could not be overheard before launching any explanation.

Then he demanded: "What you gonna do with the red-skins, captain?"

"Take them in, of course. Why?"

"What's the use?" asked Wilson. "Why not let me have 'em?"

"You!"

"I got a score to settle," the ranchman said harshly, biting off each word. "I know that ain't gonna bring my wife and kid back but it'll make me feel some better."

"I couldn't do that," Dudley said firmly.

"Sure you can," argued Wilson. "I'll make it worth your while, captain. You don't need to hand 'em over to me. You were going to hold 'em so Black Cat would bring in my wife and kid to get 'em back. My wife and kid are

gone. You can get by with turning 'em loose. And I ain't asking this just as a favor. There's a thousand dollars in it for you. I'll get it to you at the post in gold coin inside a week."

Dudley bit his lips. A thouand dollars! That would pay up his debts and more.

"Who's to know?" persisted the cattleman. "I'll back your play. I'll tell the colonel I asked you to turn 'em loose. It'll stand up. It ain't the army's way to hold prisoners. And don't you fret none about the thousand. I'll get it to you."

"I'm sure you will," Dudley conceded.

But still he hesitated. Except for his pressing financial difficulties he would have refused. But this unexpected proposal offered an almost immediate solution to his personal difficulties. He could pay off his debts and press Susan to marry him very soon. He could explain the extra money easily enough—an inheritance from a relative. No, why not a gambling triumph? He had acquired his debts at a poker table. What was more reasonable than that he should dispose of them the same way?

"Who's to know?" repeated Wilson. "This is just about the middle of nowhere, captain. And, hell, they're just Injuns. One squaw, one young buck."

"What will you do with 'em?" Dudley asked.

"That ain't your worry," snapped the ranchman. "I'm asking you to turn 'em loose. Right here. Three miles from their camp, I reckon. I won't make a move at 'em till you're outa sight. What happens after you're out of sight ain't on your head. You won't ever know what happened. Nobody will suspect me and these two galoots with me. And we ain't the talking kind."

Dudley's eyes gleamed with his decision. Why not? There was no risk, not if he could trust Wilson; and he was willing to take a chance on that. For a thousand dollars anyhow.

"Ride on," he said tersely. "Let me do this my own way."

"*Bueno*," agreed Wilson. "And you'll get the thousand in a week. In gold."

"Don't bring it to the post," decided Dudley. "Meet me Saturday night in Brackettville. At Romero's saloon."

"You ain't so dumb," nodded Wilson. "I'll be there."

He waved to his two followers. Then he and Dudley rode back to where the troopers stolidly waited.

Wilson played his act well. "Tell the colonel that's the way I feel about it," he said loudly. "My wife and kid are gone and nothing will bring 'em back. Bringing women and kids into it, that's Injun style. We ain't Injuns. Tell him I'm plumb grateful for the way you boys got out and hustled."

"I'm sorry we were too late, Mr. Wilson," Dudley responded.

The cattleman and his two followers rode leisurely off.

"Turn her loose," Dudley instructed Blacky Crouch as the three men became mere specks in the distance. "The child, too. It isn't too far back; it won't hurt them to walk."

"You ain't taking them in?"

"I see no point in it now," the captain said crisply.

"Then we've shore wasted our time," murmured the scout.

But meanwhile Blacky was carrying out Dudley's instructions.

The Indian woman slipped out of the saddle, at Crouch's gesture, carefully holding her small son. In his mumbled jargon, some of it Lipan, Blacky told her to go.

She stared at him a moment. Then her eyes went to Philip Dudley with the same question in their dark depths. She took a hesitant step with her child, as if still not convinced that she had correctly interpreted Blacky's speech.

Dudley swung into the saddle and led his men away at a brisk trot. He looked back once. Black Cat's squaw and son were trudging toward the yawning brink of the canyon. For a moment remorse gripped him. Then he shrugged his shoulders and instead directed his musings to consideration of the future, when he had been paid his thousand dollars in gold.

Ashwell and Cunningham joined him and they also reported no menace of any kind. They had sighted the Seminole warriors but had failed to overtake them.

That night's camp was more pleasant than that of the previous evening. Guards were posted and their fires rose

high and Philip Dudley slept undisturbed until dawn. Just before noon they reached the fort and Dudley reported to Colonel Hanna.

"Perhaps I was wrong to release the prisoners," the captain said smoothly. "But it would be awkward to have them here . . . well, sir, I was thinking mainly of your position."

"Yes," agreed Hanna, "it would have been awkward. You can never tell, Phil. I might have been reprimanded for holding them."

He thought a moment, then added: "And Wilson wanted you to release them? He must have calmed down since he last talked to me."

"He has," nodded Philip. "He asked me to convey his thanks to you for our efforts. He was sorrowful, of course, but not as bitter as you would expect."

Hanna brooded again. "There were no cartridges anywhere?"

"Positively not. We made a thorough search."

The colonel rose to his feet and walked to the window. "Ashwell and Cunningham were not molested," he mused aloud as he stared at the sun-baked parade ground. "Can it be that Black Cat is low on ammunition, maybe even out?"

"Possibly," guessed Phil. "Even probably."

"We'll get a little bolder," decided Hanna.

"In that regard, sir," volunteered Dudley, "isn't there something we can do about intercepting the source of his guns and ammuntion? There aren't many trails into this country. It looks like we could so something . . ."

The colonel interrupted him. "With God's help," he said slowly, "we'll do that in the next thirty days."

The comely Indian squaw and her bright-eyed son had needed no second invitation.

The instant she was handed down from the saddle and Dudley's intention made clear to her she started walking briskly. She carried the child for a hundred steps or so, then she put him down. He pattered behind her, taking two steps to her one, but for a time keeping up with her.

Then she heard hoofbeats behind her, horsemen unmistakably bearing down upon her. She gathered up her

child again and started running. Her instincts had warned her all along that this was only a temporary respite. She had not been lulled into any reassurance. Captives were not taken with such difficulty only to be turned loose again.

She looked around desperately for a hiding place, but Tobe Wilson and his two hirelings came upon her in an open benchland. There was not a tree or even a crevice which could shelter her. She ran as far as she could and she dodged when she could. But on the third cast of his lariat Tobe Wilson caught her and she went crashing to the ground.

She scrambled up quickly, but there was no escape. Red Ike Donley caught her roughly. Tobe Wilson swung out of his saddle and retrieved his rope.

She faced him standing as straight as when Philip Dudley had studied her but now her fright showed in her dark limpid eyes. She knew full well that a different fate was ahead for her.

Tobe Wilson's eyes went from her to the whimpering child. He hesitated a moment, then turned to Red Ike and the other rider, a man every bit as hard of look and spirit.

"You boys do the job for me," Wilson muttered. "I've paid you for dirty work. It's time you earned some of it."

"Call the deal," Red Ike shrugged.

"I'm riding to Brackettville," the cattleman said grimly. "I want their scalps handed to me when I get back. I'll show them redskins two can play that game."

Red Ike regarded him a moment in some uncertainty, then nodded his shaggy head.

"You're calling the deal," he said again.

Wilson clomped to his horse, vaulted into the saddle and was off at a gallop.

Red Ike looked after him a moment, then turned to Slim Browning.

"I ain't got much of a taste for this," muttered Browning. "What in the hell does he want their hair for?"

"He's a tough hombre," said Red Ike. "I ain't looking forward to using a knife myself. But we took his money and . . ."

Another expressive shrug showed that Red Ike intended to carry out his grisly orders.

Now Red Ike appraised the Indian woman and a grin spread across his face. She cowered before that look; she did not have to understand his next words to know his intent.

"Tobe won't be back 'til tomorrow anyhow," he mused, "so there ain't any special rush. And she's a fancy wench for an Indian."

"Yeah," Slim beamed in full approval. "Let's mosey over toward Tobe's line camp. I got a bottle cached away there."

CHAPTER 7

MOST nights at Fort Clark came like that one, cool and crisp with not a cloud in the sky to scatter the shafts of moonlight. A light wrap covered Susan's shoulders as she walked across the parade ground to the Cunningham's quarters; any summer night brought its pleasing chill. Two enlisted men were walking in the opposite direction. The contrast in their sizes was almost comical.

"Evening, Miss Hanna," big Chris Zanoba said respectfully.

"Hello, sergeant."

Tony Zanoba had his violin case under his arm.

"Is this your brother, sergeant?"

"Yes'm. Miss Hanna, my brother Anthony. We call him Tony, of course."

"I've heard you play," Susan told him, "and you're wonderful."

"He can write music, too," Chris proudly volunteered.

"I want you to play for me some time," Susan said. "Would you?"

"Any time you say, Miss Hanna," Tony agreed.

She hesitated. She was going to the Cunninghams' for no reason except her own loneliness.

"Would you come over and play for me now, Tony?"

"Gladly, Miss Hanna," the recruit answered readily.

They followed her to the Hanna house. She meant to

59

ask them inside but Tony stopped her as she opened the door.

"Couldn't I play out here, Miss Hanna? Unless it's too chilly for you."

"He likes to play out in the open," explained Chris. "He likes the hills and the night and the moon."

"So do I," smiled Susan. She sat on the porch steps and waited for him to begin. Big Chris lounged against one of the pillars which supported the roof.

"Play that one you wrote yourself," suggested Chris.

"Oh, no," Tony declined.

"I'd love to hear it, Tony," Susan assured him.

He hesitated, then smiled his acceptance.

"I had another purpose in coming here besides joining my brother," Tony explained. "I was told in San Francisco that I have some ability at composition and interpretation. My professor suggested that I work on something native to our country, even our west. An art student I knew gave me the inspiration to attempt an interpretation of the American Indian. He had done some paintings of Indian life and they were well received. So I've worked on this. I call it *The Death of a Seminole*."

With another smile he raised his violin. Susan was a student of music and an appreciative patron; she could follow the artist's presentation. That was Seminole life as it once had been. Susan closed her eyes and Tony's playing brought to life the sweep of the wind across the prairie, the thrill of the buffalo chase, the glow of a campfire. Then the music was harsh and savage and Susan knew that red men and white were locked in mortal combat. Abruptly the tempo changed and there was the lonely beaten warrior disappearing over the horizon.

Not until he had finished did Susan notice that Cam Elliott was standing at the gate listening intently.

Susan applauded when Tony lowered his bow.

"That is magnificent," she declared, and meant every word of it. "It's thrilling. I've got goose bumps all over me."

Tony smiled his thanks.

Susan called to the tall man standing at the gate.

"Come in and listen, Cam," she invited.

He seemed to hesitate before accepting. Then he came

and leaned his weight against a pillar also. Tony played on and Susan sat and mused that Philip Dudley would disapprove of such a gathering. And of the music also, for Tony's bow was light on the strings and his interpretations, now that he had played his song of the Seminoles, were soft and gentle. She looked up at Cam Elliott and she was surprised at his intentness. She had never considered Elliott as a man who would be held enthralled by a violin's sound. A faint smile came to her lips. This was at once incongruous and ridiculous. The fingers skillfully guiding the bow were those of a cavalry trooper, a private in the ranks of a frontier company destined to know thirst and hunger and blazing heat and perhaps even violent death. But as incredible, as strange, were his enrapt listeners. Both were towering men, and one broad also, one immense and slow of speech and thought, a man on whom the Creator had lavished physical might but little else. The other was a spawn of the very shagginess of the fierce jagged terrain, of uncertain birth and sparse schooling, half-way between what this land had once been and what restless ambitious men wanted it to become.

Finally Tony put his violin back in his case. Susan thanked him appreciatively.

"You did me a favor by listening," he insisted. "A musician always performs better with an audience. I'll be glad to play for you again."

The moonlight showed the pride on hulking Chris Zanoba's features.

"Ask him to play for a party sometime," urged the sergeant. "He'll do it."

"I will," Susan promised, and meant it.

The two enlisted men bade them good-night. Cam Elliott stirred as if to leave also.

"Sit down, Cam," Susan invited. Suddenly she was near desperate for someone to talk to. A violin's strings had told her of the bleakness and the loneliness and the savagery of what lay around her. She shivered and not from the evening's chill. She shivered because at that moment there was nothing to be coveted more than the reassurance of a voice that could speak calmly and unafraid.

He obeyed. He took papers and sack from his blouse and slowly fashioned a cigaret. Susan watched him, still somewhat fascinated by his skill. She recalled that this was another of his habits which irritated Phil Dudley.

"Isn't he wonderful!" Susan murmured. "I could sit and listen to him by the hour."

"I had heard his own composition before," Cam answered. He lit his cigaret and took a quick deep puff and then stared at its glowing tip, a man obviously remembering something he held important. "He asked me to listen," he explained. "He wanted to know if he had put into music what this country is. He knew I could tell him."

"Yes," admitted Susan, "you can."

Then she added with a low laugh, the words coming from her lips before she had considered them: "But I'd never have thought to ask you. I think you would have been the last one I'd have asked."

She raised her eyes to meet his and she was pleased at the way he was regarding her. There was neither harsh condemnation nor resentment in his eyes. His voice came low, even.

"Why not?"

She had an answer ready but she withheld it. Instead she leaned her head back against a porch pillar and for a moment stared off into the darkness.

"For two reasons, Cam," she said finally. "First because I would never get to know you well enough. How would I ever know that you think of anything but war and lust and self-preservation? That the music of mountains and canyons and pagan people sounds in your heart and stirs your soul?"

He did not seem eager to answer; she went on, now smiling.

"Men know men, Cam. A man knows more about another man from just a casual word or a small action than a woman can learn in a lifetime."

He crushed the fragment of his cigaret beneath his bootheel.

"What is the second reason?" he demanded.

"You wouldn't do it for me. You'd be ashamed or something. No man poses before other men. He wants

62

them to know him for what he actually is. But for women . . . he never is himself. He is somebody else. A woman marries him and then she either bends herself to what he is or tries to shape him into what she wants or . . ."

Her voice fell off. She didn't care to refer to her father's broken marriage. Or to Lieutenant Cunningham's surrender to Cecilia.

"You know a lot about men," he said slowly.

"They've been my life," Susan answered. "What else is the army? Men. And some of them, Lieutenant Elliott, very fine men."

"I know that," he nodded.

"I'm too curious about men for my own good," she went on. "It was that curiosity which started . . . which got us together in the night . . . which . . . well, it's water under the bridge now. But you were different, Cam. I'd never met a man like you. I wasn't luring you . . . or flirting with you. But I did want . . . I had to learn more if I could."

A low laugh came at her own expense.

"I haven't learned much yet," she confessed.

He showed no disposition to talk and she studied his face. What she saw pleased her. Some of the grimness seemed to have left his gaunt features. His eyes came back to hers and there was no glint in them, but even a twinkle, as if he were amused with both himself and her.

"You are a dangerous woman, Susan," he declared. "You know men entirely too well for their good. At this moment I am not sure I hold any envy for one Captain Philip Dudley."

She had heard his voice before when it was pleasant, humorous. So he spoke to the men of his company, which was why, as Susan well knew, they would follow him to hell and back. But never had he so spoken to her.

He sat down on the steps also, and their heads were almost on a level, the full width of the porch steps between them. He made another cigaret and lighted it. Then he began slowly, still in that same tone.

"I am sorry to have puzzled you so long," he said. "Actually there is nothing very strange about me. I don't

63

like the discipline and the pomp and the pretense of the army. I don't like its confinement. I don't like it because a man's future is settled by someone he doesn't know and who doesn't know him. But that's not unusual. That's really the usual thing. Wars bring men like me into association with men like you're used to. Otherwise we would just pass each other with nothing more than a nod or a casual handshake."

He paused to pull in a cloud of smoke and blow it out again.

"I'm just average, Susan," he pointed out. "The men you've known are the ones in the great minority. I see an opportunity for myself in a country where the land is still open and can be bought for a song. I want to move on ahead of the settlements. The chances are better there. That's usual. My father was that kind of a man."

He hesitated again, but just for breath. "I've stayed in the army too long," he conceded with a shrug of his shoulders. "Most men like me got out after the peace. As quick as they could. I've hung on. I've put up with it. I had to. The money for one thing. I don't get much but I have managed to buy a few more cattle all along. They're dropping calves and my herd gets bigger all the time. There's another reason too. What hope is there in this country until the Indian is whipped? Why build a house and give birth to children only to have the home burned and the family scalped? I would have quit the army a few months ago . . . after our little interlude . . . but the chance came . . . well, a talk with a high officer . . . I can't say much about it, Susan. But there's a job ahead that the average lieutenant wouldn't have a chance at. If I can't do it no other army officer can. If I *can* do it, then we can see the end of these raids, these slaughters, these long chases after red men who know the mountains far better than we ever will."

Susan studied him. He had told her much but still not enough. In her eyes he could not so lightly dismiss himself as an average man. Sure she knew the urge of American men to move westward. Always westward. They moved faster than the army could clear the way for them. The army must wait for Congress to vote an appropriation. The men moving westward waited for noth-

ing. They would not wait for flooded rivers to run down but swam their horses through muddy torrents. They brought their women and children with them and they settled on land that Indians claimed as their personal hunting grounds. When the army that was bound by solemn treaty to protect the Indians also offered protest or suggestion they told the army to go straight to hell. Only after homes had been razed and bloody scalps taken did they want anything to do with the army.

Cam Elliott was not such a man. Cam Elliott was moving, yes, but with caution, with concession to what an army could do, with understanding of what lay ahead, with even some patience for the time it took to do so much with so little.

She leaned forward and smiled. "You haven't anywhere near satisfied me, Cam Elliott," she told him. "I have a hundred more questions to ask. Where were you educated? You choose your words well. Your reports are brief and original in form but accurate. How in the world do you do it?"

"My father taught us to read. The people who took us in were well-educated. He was a preacher, a born missionary. I've always read everything I could get my hands on."

She did not press him with another question. She was still curious but it was difficult to approach the query she wanted to make. He seemed to anticipate her. The lightness left his voice.

"I am a freak among your kind," he said, his words coming slower now, "because I have Indian blood. That is not unusual either. Men must have mates. Some marry Indian women. Some take them only because of lust and use them only as a temporary convenience. Others seek them as wives and treat them as wives. There are many men in this country who are part Indian."

Susan nodded. She did not add what she could have, that such men, part white and part Indian, did not hold commissions in the regular army. No matter how eloquently Cam Elliott reasoned he could not make himself usual.

"Some men of mixed blood," the tall lieutenant went on, "are loyal to the Indians. There is no such thing as

a man who is part Indian and part white. He must be one or the other. There can be no compromise between them. There is no mutual ground upon which they can live in friendliness. Breeds have led Indian wars. The Creeks, The Cherokees . . . Billy Weatherford of the Creeks was only one-eighth Indian. Breeds who turn all Indian are terrible men. They will not believe the white man's lies. They will not be beguiled by his false overtures. They won't . . ."

Susan nodded again. "That's right," she interrupted. "Black Cat is said to be part white."

"He is," Cam confirmed. His tall frame heaved in a big sigh. "He is part white," he repeated. "He is part white and in his camp there are books on cavalry tactics. He left his tribe and fought a year with the Comanches to learn about war from them. No men ever lived who could maneuver on horseback as well as the Comanches. For a time the white man could beat the Indian because rifles can beat bows and arrows. But now the Indians are getting guns. Better guns than our men carry. The white men will never conquer them as long as the Seminoles are getting guns and ammunition."

"Where in the world do they buy them?" asked Susan. "I've heard Father ask that question a thousand times. They don't steal enough to matter too much, not from the army anyway. What's your idea, Cam?"

He parried her question. "Oh, there have been a number of theories," he said casually. Too casually. "None of them have panned out."

He came slowly to his feet.

"Your curiosity should be satisfied by now," he said. There was a twinkle in his eye again.

"I feel a lot better," Susan admitted, rising to her feet and smiling. She held out her hand. "I feel *much* better. We must talk again, Cam. You see farther than most men. You're a welcome relief from what I usually hear."

She was thinking about Cecilia, Cecilia Cunningham's invariable dissatisfaction. But Cam Elliott could not know that. Cam could only know what she had said and how she said it.

He stared down at her without taking her hand and of a sudden Susan realized that she had seen that look

on his face before. Her hand came up to her parted lips and she took a half-step backward.

But this time he did not reach out and seize her. This time he did not even take a step forward. For a moment his eyes seared hers with their intentness, then slowly the look changed. It ebbed from his bony face as a slow tide leaves a sandy beach. For another moment there was nothing there at all. So she had always before seen his face except just now, and that one other time in the past. This was Cam Elliott's reaction to what he did not want but would for a time endure. This was the expression which baffled all his fellow officers and irritated them most.

But it did not last. It left in the wake of that other ebbing and a look came instead which she had never seen before. Nor had any other. Nor would any other. Not ever.

He kept his voice low, even. Later she would brood about the effort that had cost him.

"We will not talk again," he said flatly. "It would not be wise. Not for either of us. Once I lost control of myself just over what you seemed to be. Just over the woman you are with your eyes and your lips and your bosom. That feeling you can arouse in any man. But any man can hold such an urge under tight rein. But to hear you talk as a real woman, to sense that if you had your life to live over again you would dare to be a woman . . . the woman my kind of man dreams about and even sees in a flickering campfire . . . we must not talk again, Susan."

That tone did not last long. Then he was casual again, pleasantly so, lightly so.

"You must remember, Susan, that I'm part Indian. An Indian doesn't argue with the woman he desires. If she's of his own tribe he trades horses for her. If she isn't, he steals her, throws her over his saddle horn and is gone with her."

She forced a reluctant smile to match his tone. For the time being she could do that.

"And, Susan," he went on in the same way, "not even your Captain Philip Dudley could get you back. He couldn't find us."

He put on his hat and turned.

"Remember," he said over his shoulder, "it takes an Indian to catch one. Good night, Susan."

She stared after him and her fingers touched her lips again. She sat there a long time after he was gone, sat trying to adjust her confused thoughts, striving mightily to regain the evenness of emotion she had enjoyed all of her life, save for two interruptions. Finally it was done. But not easily. She concurred with Cam Elliott's verdict. They must never again talk as man to woman and woman to man.

CHAPTER 8

LIEUTENANT CUNNINGHAM's troop left the fort first, moving briskly toward the maze of canyons where Black Cat had sought to hide his people. Dudley's detail followed, then Cam Elliott's, leaving only a small garrison to man the post.

Cunningham's orders were to feel out the stubborn Seminole, to test his supply of ammunition. None had been found at his hideout; Colonel Hanna dared to hope that the red men had only the cartridges they could carry. If so, and constant patrols could prevent his rearming, they might force Black Cat to fight the white man as had his father's people, with only the weapons of the wild.

Lieutenant Cunningham had insisted on the assignment. He had already submitted his resignation and Colonel Hanna could not resist his plea.

"Let me get all I can while I can, sir," begged Cunningham.

Hanna consented. It was not a hard thing to do, for in these recent days of hard riding and cautious action Cunningham had matured as an officer. Colonel Hanna honestly regretted that the lieutenant had resigned. Now, he mused, there must be another academy-trained prod-

uct to suffer first disillusionment and then unhappiness, to suffer before he could ever hope to learn.

Their skirmish plan seemed bold, but was actually not. Cunningham was to draw fire from the Seminole warriors but he was to do more than feint a headlong charge. Dudley's troop would not be behind or away, in position to effect a swift reinforcement if Black Cat should stage an unexpected counterattack. So he had done once—as Philip Dudley could well remember. Lastly, Cam's detail would be near enough either to back up a wavering line or to intercept Black Cat's retreat if the Seminole ranks were shattered. Of the three officers only Elliott had an option . . . a fact not without its impression upon Philip Dudley.

Actually Colonel Hanna knew far more of Black Cat's plans than he had revealed to his junior officers. Cam Elliott knew . . . the tall lieutenant had not only borne the orders from Colonel Lee but had gleaned most of the information which had inspired the campaign. Black Cat's plight was desperate and growing more so daily. It was almost time for the wily Seminole to lead his warriors westward, to an annual assignation Indian tribes had kept for a long time, since the earliest days of Mexican rule over Chihuahua. Black Cat was not ready to go—there was no food for his people; his sanctuary for them was now known to the white man. Yet he *must* go. He must shake off these dogged pursuers and cross a hundred miles of unwatered wasteland with his warriors, some of them anyhow.

There would have been pity in Cam Elliott's heart if he had brooded about Black Cat's predicament. But Cam refused to think about it. Such thoughts he could control. Others he couldn't. As he rode ahead of his cluster of horsemen he thought about Susan Hanna against his will. Once before he had thrust her out of his thoughts. He had managed that before. It had not been easy to put out of his memory the softness of her flesh and the feel of her lips but he had done it. He had done it by convincing himself that any attractive woman could produce such a feeling in a man celibate by grim necessity. A man in this tangled land who would not avail himself of Indian women when the opportunity

69

came was a celibate . . . who else besides Cunningham had persuaded a woman to share the discomfort and loneliness of Fort Clark? Cam Elliott would not ply an Indian squaw with liquor and use her ruthlessly. He had been an Indian once. Part of him still was.

But he had heard her voice as she had never spoken before and the moonlight had shone upon her face and he had looked into her eyes. All women had eyes, of course, and most of them voices, but no two women spoke alike or looked at a man in the same way, and Cam Elliott could only ache with his thoughts of her and even the small comfort that his feeling for her might be a passing fancy was denied him.

Women had never been important to his life, not until now. He could look back and realize how empty that life had been. He had never thought so, not until he met Susan Hanna. For a time he had drifted with the back and forth trickles of humanity through the wide empty land that was Western Texas and Eastern New Mexico. He had trapped wild horses and he had broken them to the weight of a saddle. He had drunk at bars in hell-holes and if he had been temperate it was not on account of any moral qualm, but rather the dread of facing a new day with his senses dull from liquor's after-effects. On its surface this was a land of no social differences, where all men lived as free as the wind which tinted their faces a leathery brown. But it was never that and never would be. There were men who drifted and men who dug in; for a time Cam Elliott was content with the former. He admired the shadows his tall frame cast on widely-scattered trails and he rode into the Mexican War already case-hardened to recklessness and danger. Then had come maturing soberness and awakening ambition and, in typical coincidence, opportunity also. A fleshy jovial man named John Chisum approved of the way Cam led a raid against Mescaleros and a partnership resulted. No longer did Cam Elliott spend his money in saloons or let it filter away in a poker game. Almost overnight he became a man with a purpose and a patience, and also an enigma to his fellow soldiers, men who for the most part had neither.

Then he had met Susan Hanna. He had already be-

come a man who could see afar, who could fashion a scheme of enterprise. Now he was also, through no fault of his and even against his wishes, a man who could dream.

Those dreams he could not restrain; they came again and again. John Chisum had built a rambling white house in a spring-fed valley and in less than a decade tall cottonwoods shaded it and crackling logs in a huge stone fireplace warmed it when the blue northers swept down from the mountains. That was a house to grace any woman, as it did Chisum's niece, and as it could Susan Hanna.

Riding at a brisk trot, watching closely each rock-strewn horizon even though his thoughts roved afar, Cam Elliott regretted his words of the previous evening. They *would* talk again, he and Susan. The promise between Susan Hanna and Philip Dudley was a strong barricade forever holding Cam Elliott's desires in merciless prison. But he would at least hurl his weight against that wall in an effort to crash it down. He might fall back bruised and bleeding and fractured. But why not? What could that matter?

A bugle's sound floated to him, startling him even though he had been subconsciously listening for it. Another answered; Cam motioned his own bugler and spurred his horse into a gallop. Apparently Cunningham had made contact with Black Cat and Dudley's detail was moving up.

Gunfire sounded now, irregular, staccato. Cam's horse breasted a ridgetop and the battle's panorama was laid out clearly below him. Some two hundred Indians were advancing upon Cunningham's troop, riding wide apart, hanging low over their horses' manes. Most were naked except for breechcloths, and as Elliott pulled up to momentarily appraise the situation he observed that some of them bore bows and arrows instead of the expected rifles. He watched as Dudley came up to join Cunningham and the patch of blue widened out.

Cam made his decision. The odds were no greater than two to one and the advantage of the first close volley would go to the troopers. He chose to exercise the option Hanna had conceded him, to gamble that

the combined details could throw back the Seminole onrush. He led his troop in a circling movement to come into the arroyo behind Black Cat's forces. If the stratagem worked the Indians would be caught between two fires. But one thing puzzled him as he prodded his horse with his spurs and motioned his men to keep closer bunched. Wasn't it a little strange that Black Cat was forced to fight on a terrain not of his own choosing?

The gunfire was a chattering sound now, rising in volume as Cam slid his horse down the ridge and swept closer. There were riderless horses mingled with the savage horde and still bronze shapes sprawled on the ruffled sand. Firing from the ground, unconcerned with their supply of ammunition, the troopers were pouring a literal hail of bullets toward the Indians. Cam waved his men to a faster gait; this might well be the battle for which they had all been waiting, and which Cam would have wagered would never come.

Arrows against rifles! Every passing second added to the white man's confidence. If indeed the Seminoles were caught without ammunition the toll of them would be brutal and decisive.

Twice the Indians circled the blue-clad troopers. Then, either by design or because they had observed Cam's detail clattering up, the Seminoles reformed their ranks and galloped toward the arroyo's mouth. Bugles sounded and the soldiers swung back into their saddles. Their pursuit was vigorous, and, considering the circumstances, quite orderly.

Then suddenly the Seminoles whirled, almost as one man, and into the ranks of the troopers came crashing a single volley. Horses went tumbling, some of them screaming in terror and pain. Lieutenant Cunningham was one of the first to topple from his saddle. He fell beneath the hooves of his frightened horse, was dragged a few frantic jumps, then lay still while his horse stood trembling over him. Other men fell, also; riderless mounts milled and added their screams to the confusion.

Black Cat did not press the assault. The Seminoles, instead, galloped off in retreat, leaving only a small number of dead. Philip Dudley's detail pursued them

for a short distance, but it was more a display of anger than a serious intent to overtake them. For another time the wily Indian had outwitted his adversaries. He roved still as free as the quickening breeze and he left in his wake chagrin and pain and tragedy. Stark tragedy.

For Cecilia Cunningham was wrong; the wavy-haired handsome man she had married would never discard the uniform he had worn so proudly. In time it would fall from his body, but only in rotting shreds, and no human eye would observe the disintegration. He lay there a crumpled heap, a lifeless one, but he held in death the full respect of the men he had wanted to impress. They stood over him and stared down at what was left and their verdict of what he had been was warm and kind.

There were others to take back to the post . . . limp bodies dangling across the backs of unwilling horses, mute reminders that the red man had not yet yielded this mysterious twisted land, that menace was not yet gone from each hazy horizon.

Cecilia Cunningham showed a surprising fortitude. Her eyes welled with tears and her lips trembled as she heard Colonel Hanna's official report of what had happened. But she suppressed the full flood of her grief until the colonel had gone, until she was alone with Susan. Then she lay face downward on her bed and she cried until her every muscle ached from the physical strain of her sobbing.

Then she washed her face and eyes free of tears and went about the necessary preparations with full efficiency. There was much to be done, and in a short time. She seemed determined to speed that accomplishment. Her belongings must be packed, and his. She did not hesitate as to where and how he would be buried. He was laid to rest in the newly-cleared cemetery along with his troopers who had fallen before Seminole bullets. She stood straight and unquivering as Colonel Hanna spoke slowly and gravely, and with an unexpected fervor considering that Hanna had never been a demonstrative man. Her head bent when the bugle's clear sorrowful tone sounded taps. Other heads bent also. There, but for the grace of Almighty God, lay each man present.

There was a bullet made for every man and no man knew when it would come whining out of empty space.

One small incident marred the ceremony. All on the post were there, and others drawn by curiosity, including a handful of Indians. The presence of red men was by no means unexpected; the Great White Father was at peace with most of the tribes. Small groups of Lipans visited the fort often, and occasionally some Jumanos. This cluster of stolid-faced savages followed every detail of the burial with unconcealed curiosity. They, too, greeted death with beauty and pomp.

They were hanging in the background, apparently harmless, and no attention was paid to them until Cam Elliott gave quiet orders to Chris Zanoba that one of them be seized. Later Cam tried to question him in Colonel Hanna's office.

"I'm positive he is a Seminole, colonel," Cam declared.

The red man shook his head. "Me no Seminole," he muttered. "Me Lipan."

"I don't know what we can do about him," Cam reasoned. "I know he's a Seminole. I can tell by the beads on his buckskin trousers. And I'd bet my last dollar he can speak English, too."

"Me no Seminole," repeated the sullen prisoner.

"He's been hanging around here a day or so," volunteered Ashwell. "I didn't think anything of it. I can't tell one of 'em from another."

"There is a difference," Cam insisted. "Look at his eyes, colonel. He's an intelligent Indian; you can tell that."

They discussed Cam's identification, then finally Hanna ordered the red man released.

"I'm sure you're right," the colonel told Cam. "But I hardly see how we can hold him. There is no charge against him, except that he looks like a Seminole."

"I suppose not," Cam conceded. "And I don't suppose it's too important what he can tell Black Cat about us."

"You actually think he is a spy, lieutenant?"

"I can only reason," Elliott shrugged. "Black Cat is a clever strategist; we have full proof of that. It would not surprise me to learn that he has taught some of his war-

riors how to at least understand English. A good commander values his intelligence reports."

The Indian, if Seminole, showed neither fear nor any haste to obey Colonel Hanna's ultimatum to leave the post. He went, but deliberately. . . .

In other ways Cecilia Cunningham made it easier for them with her intent haste. She seemed to begrudge every moment that she had to stay. She performed every act expected of a widow, did them dutifully, efficiently. Then she was gone, riding eastward on a lumbering stagecoach, never to see a fronter again except in reminiscence, taking nothing with her except an ache, and leaving nothing but a memory.

"You would think," mused Philip Dudley, "that she never cared much for him."

Susan shook her head. In the last few days she had come to better understand Cecilia Cunningham. Susan Hanna herself was no longer so sure that she wanted this life for the remainder of her days. Doubt had waited a long time to seize her and confuse her, but now she was tightly enmeshed.

Dudley had not told her of his unexpected windfall and that he could now pay his debts. The only explanation he could devise was to claim success at the gaming tables and that meant a confession that he had violated his promise of months ago never to play poker for high stakes again.

"There's something I have to own up to, Susan," he said after a moment. "I broke a promise I made. But when you hear what happened I don't think you'll be too provoked."

"What did happen?"

"You know I went into town Saturday? I had only ten dollars with me. I stopped for a drink and there was a poker game going on . . ."

"And you played, of course."

"Yes. And was lucky for once."

He hesitated for effect, then added:

"I won over nine hundred dollars, Susan. I can wipe out everything that's against me and have something left for us to start on. Now it's any time you say."

She studied his face a moment. Eagerness was shown

there, that was certain, shown in his eyes and his expression. But Susan looked away from him and she was more confused than ever and she resolved that not this night would she make any definite commitment. Something was wrong, wholly and completely wrong. Nothing was right. It was not right that the barrier to their ambition should so suddenly and unexpectedly melt away. Marriages should not be achieved so easily, on the turn of a card. Marriages should be earned as commissions were, and as a cattle herd was built up. Yes, she thought of that, a cattle herd. It popped into her mind when it should not have.

Nothing was right at all. He should not have so announced his good fortune. He told about it casually, passing it on to her as casually as it had apparently come to him. That was no way for a man to seal his compact with a woman. That was not how Cam Elliott would have done it. A faint curve of a smile came to Susan Hanna's lips but it was not for Philip Dudley. It was because she thought of Cam Elliott and she was wise enough to know that she could not make plans to wed one man even while her thoughts were of another. Of what Cam Elliott was to her she could not be sure, not then, but she did know that what Philip Dudley meant was not near enough. A woman ready to wed a man does not make instinctive comparisons of him.

"Well?" Philip Dudley demanded, obviously a little piqued. "You don't seem very excited."

She could have faced it then and there, for her decision was made. But she wanted to do it another time, when she had pondered over what she must say and had rejected some words for others. She must not hurt Philip. What had come was no fault of his. He was what he had been all along and he must be spared any remorseful doubt in himself, any feeling of failure.

She came to her feet, regretting the necessity of a retreat, doing it more for his sake than for her own.

"We've lots to talk about," she said slowly. "It wouldn't be fair to you to talk now. I'm worn out from worrying about Cecilia. I'm so tired I can hardly think. Let's hold it, Phil, till tomorrow night."

A smile replaced the darkness of his expression.

"Of course," he granted quickly. "I should have thought, honey. We'll go over everything tomorrow night."

He took her in his arms and she did not deny him her lips. He patted her shoulder and was gone. Susan stepped to the window and her eyes followed his brisk stride across the parade ground. Tears came to her eyes as she watched. She had certainly made a mess of things. She had pledged herself to one man, imposing only one condition. That he had accepted and had met. But now she didn't want him. Now her thoughts were of another man and she couldn't be sure she wanted him either. She had acted like a silly school girl infatuated by men but ignorant of them, she who knew them so well, who had always preferred their casual company to that of her own sex!

The clatter of horsemen silenced her speculation. They galloped into the post, three of them, and her father was framed for a moment in the light behind him as he came to the door. Other lights came on quickly in the frame building which served as headquarters. Dark shapes moved hurriedly across the parade ground and back again. In the span of a few moments Philip Dudley and Cam Elliott had joined Mark Hanna and then the unruffled Ben Ashwell also.

Susan undressed slowly and made a small effort at sleep. But there were too many things to wonder about for her to slumber. Who had come galloping into the post at this hour and why? What message had been brought which called for such a hurried conference? Had another atrocity been reported? Had another ranchman offered up his innocent kin as human sacrifice? Would they go out again and face the wile and menace of the Seminoles? And would other men come in hanging limply across their saddles, perhaps Cam Elliott, perhaps Philip Dudley?

For a long time she lay there wide awake. Then she dozed off, only to be quickly aroused. Her father stood over her.

"How about making some coffee, honey?" he asked. "All of us are sleepy and we still have some things to go over."

77

She pulled on her dressing robe and put water on to boil. The three junior officers joined Hanna at the kitchen table but there was little talk between them as they waited for the coffee to brew. It clearly showed on their faces that important business lay ahead. Mark Hanna drummed on the table with his fingers and it was not usual for him to register impatience. Philip Dudley's dark eyes showed a deep-set gleam and his speech was pleasant . . . Susan had known no other officer who anticipated action so eagerly. She tried to avoid his look, for there was gloating in his glance, as if to proclaim: my debts are paid, I have a woman to wed, I have an exciting fight to make. Cam Elliott sat still and quiet, staring at the tablecloth, and there was no concealing that he did not share at all in the relish for the task ahead.

Her father broke the silence. Colonel Hanna gulped down his coffee without waiting for it to cool and said:

"Phil, let's get back, you and Ben. Lieutenant Elliott has been over this before; I'm sure he knows it by heart."

"Yes, sir," Dudley readily agreed, rising quickly to his feet.

"Take your time, lieutenant," Hanna told Cam. "Join us at your leisure. My daughter makes good coffee. Enjoy it."

"Thank you, sir," Cam accepted.

Susan poured a cup for herself and came to sit across the table from him.

"When do you go out?"

She could assume that, a patrol and soon.

"Dawn."

He was absorbed in what lay ahead for them and for a time she did not disturb him. Then she offered to refill his cup and he came out of his musing with a start and accepted with a smile.

"Your father is right, Susan," he declared. "You do make good coffee."

He sprawled his weight over the chair and the gesture made her feel closer to him.

"Oh, I'm handy for a lot of things," she answered lightly.

His eyes roved over her as he made a cigarette, noting

78

the swell of her bosom, the whiteness of her skin. She was not abashed by his eyes. That had come, too—her willingness for his bold admiration.

"I don't doubt it," he murmured. "But could you pound corn into meal, Susan? Could you learn to jerk venison and make a buckskin shirt?"

He answered his own question, his voice and eyes teasing. "I'm afraid you couldn't, Susan. Things like that stop me every time I get the notion to steal you."

He did not anger her with this mood as he had in the past. She smiled back at him, met his tone with one every bit as calm and as light.

"You worried me for a time," she replied. "I couldn't sleep for being so frightened. But now I'm over the worst of it. Tell me, Cam, do you put on war paint when you go stealing women?"

"Depends," he shrugged, grinning now and his eyes twinkling. "Depends on the woman. With you now, yes. For I'd expect you to fight and scratch."

He pushed back his chair and rose slowly to his feet.

"Dudley had better hitch you up in a hurry," he drawled. "You're too pert a filly to be riding single."

She walked past him with the empty cups and deposited them in the sink. The temptation was strong within her to tell him that she was not going to marry Philip Dudley. But no, that must wait. She must tell Philip first. She could not treat a man so—to hold him affianced and then to tell another man before him that it was over.

"Any secret about where you're going, Cam?"

It was an idle question, asked while she took precious seconds to examine her thoughts.

"After Black Cat."

"Who were the men who came in?"

"Blacky Crouch. He's been out studying the smoke signals."

"You taught him that, didn't you?"

He nodded. "I'd better be getting back," he said, his regret obvious.

She could guess that there had been few such times in his life, when he was comfortable because of another's solicitude.

79

He drew himself up to his full height. There was so much of him that it took some time. She told him so, and his grin came again. It was a quick-forming smile, splattering so suddenly the leathery impassiveness of his face.

"I haven't grown an inch since I was fifteen," he told her. "I was quite a kid."

She walked with him to the gate, though she could not help shivering in the chill of early morning.

"Thanks again," Cam said. "And if you ever see me coming with my war paint on, you'll know to hide."

Susan laughed softly. "You'll never do that, Cam."

"You can't ever tell. Sometimes I do the dangedest things."

This lightness no longer bothered her. She had suffered some under his teasing, and more under his accusations. But before she had been afraid, of herself as well as of him. Now she looked at him in the thin gray light and her chin came up and her eyes danced and she was afraid of neither.

"You'll never do that, Cam," she said again. "You could, of course. But you never will. You'd never take me until I asked you. And I'll never do that."

"No," he agreed, and the casualness had left his voice. It was harsh and grating as she had heard it before. "No, you'll never do that. You'll marry Philip Dudley and flit from post to post. You'll do well, both of you. In time you'll be the colonel's lady."

This time she could not resist the temptation to tell him.

"I'm not going to marry Philip," she declared, the words rushing from her lips before she could stop them. "I'm available for kidnaping, Mr. Elliott. Or for trading. How many horses will you give my father for me, Mr. Elliott?"

He stared down at her without answering. She could see something of his face and she wished she could recall her surprising announcement and her taunting challenge. But she could do neither. Nor could she take the opportunity to flee while he was still considering what she had said, and how she had said it. An invisible

force held her rooted there, as motionless as if she were not a human being at all, but instead a fantastic statue carved by man, all of her shaped from gleaming lifeless marble except for her bosom, which rose and fell with the lure and the warmth of life.

She closed her eyes and she felt the tightness of her fingers and then the pressing force of his arms. She did not protest when he raised her head. She steeled herself for the roughness of his kiss; so he had kissed her before, leaving her lips aching and swollen. But not this time. His lips were soft and gentle against hers. They left her mouth to rest a moment against her forehead.

Then he loosed her, and a low sound came from him. It was almost a laugh, but not quite.

"Good night, Susan," he said softly.

For a minute they stood apart and simply looked at each other. Then he turned and went quickly across the parade ground, to the small office in which Colonel Hanna and Lieutenant Ashwell sat poring over maps.

Philip Dudley joined them shortly. Dudley sat down and pretended to be intent on Hanna's words. There was nothing about his expression or manner to show that he had crossed the ground to get Cam Elliott, and had witnessed the embrace at the colonel's gate.

CHAPTER 9

COLONEL HANNA went over their assignments again and again.

"This may be the most important campaign of our lifetimes, gentlemen," he told them gravely at the beginning of their talks, before he had led them to his own house for a midnight pot of coffee. "Colonel Lee thinks so. The Secretary of War thinks so."

For a moment he seemed uncertain how to begin the

explanation of what lay ahead of them. Then he said slowly:

"For some years now we have wondered how the Indians were able to secure guns and ammunition. Some three months ago Colonel Lee assigned an officer to make a private investigation. That was Lieutenant Elliott, of course."

Philip Dudley's face went even darker. He could not relish a campaign which would prove the worth of Elliott's efforts.

"Elliott had something to go on, an idea," continued Hanna. "He has lived in this country most of his lifetime and even among the Indians. From his early childhood he had heard some talk which might provide the answer. He was not sure if these rumors were facts or legends. He did some investigation and he found enough to justify an expedition."

The colonel hesitated a moment, then sighed. "This is not my plan of campaign," he admitted. "I would not order it, for it seems to me almost impossible. But Colonel Lee has supplied a full brief, even to details. Blacky Crouch's reports—he just rode in—show Black Cat moving eastward, breaking camp. So we had expected. Now we begin our maneuvers."

He unrolled a huge map, one which neither Captain Dudley nor Lieutenant Ashwell had seen before.

"All details will combine for the first march," he explained, "leaving only a skeleton force at the post. Our first march is to this waterhole . . . some maps show it as San Estaban Lake. There the force will divide. Captain Dudley will take his regular detail and execute a ten-day maneuver to the west. This is a strategic move, captain, which might impress you as of little importance. It is doubtful that you'll see any action. But there is reportedly an annual movement of Indian tribes along Capote Draw. Here it is, captain. It is our hope that the maneuver of a cavalry troop through that region will discourage some of them. Under no conditions, captain, are you to attack. Your positive orders are to avoid action if humanly possible, even to retreating when conditions might make a withdrawal seem unwarranted."

Philip Dudley scowled. That was not the kind of

82

assignment he liked, nor the type he was fitted for, as Hanna well knew. The colonel's orders had been general, not as specific as he represented. Assignment of the various details had been left to this own judgment, except for one restriction. Because of that single condition Hanna had no choice but to order Dudley as he had, to the flanking maneuver. For it would be harder still for Captain Dudley to yield temporary command of himself and his men to Cameron Elliott.

"San Estaban Lake," went on Hanna, "is the key spot of our campaign. Lieutenant Elliott reports that it is usually dry by mid-August. Sometimes earlier. If it is dry when you reach it, you have no choice but to turn back at once and abandon the campaign for another twelve months. If there is enough water there for Lieutenant Elliott to refill his tanks . . ."

"Tanks, sir?" questioned Dudley.

"Tanks," nodded Hanna. "We'll spend most of tomorrow equipping our wagons with canvas water tanks. Build them under the beds. We have received some extra canteens from Fort McIntosh and every man will pack three each. That is the key to this whole thing, captain . . . water."

"There is some leakage," Cam explained, "but they can be a life-saver. Drain the tanks before touching the canteens."

"You won't have the problem of water," Hanna said, addressing himself directly to Phil. "You can refill your tanks and canteens at San Estaban Lake, then again at the Conejo water hole. Just fifteen miles away."

The colonel hesitated, then slowly shook his graying head. "Ashwell and Elliott won't have it so easy. They have a sixty-mile march and return. They may find Alamito Creek running, they may not."

"May I ask what's the purpose of these maneuvers?" Philip Dudley queried.

"Of course," Hanna nodded. "We are hoping to intercept a shipment of guns and ammunition to the Indians. We are hoping to prove that Mexicans have been supplying the red men with rifles and cartridges for some years now."

"They've been getting them from somewhere," Ashwell murmured.

"If we can supply proof," Hanna pointed out, "our government can put pressure on Mexican authorities to stop the trading. Then maybe we can have peace on this frontier."

Philip Dudley pondered this with a darkening look and with a bitter reaction. Now the strange actions of Lieutenant Elliott were added up for his analysis. Somehow Cam had won the confidence of Colonel Lee. Elliott had uncovered some hints of collusion between Indians and Mexicans. The campaign they were launching was Elliott's doing. Elliott would be in on the kill while Dudley was leading a detail in the opposite direction under the most absolute of orders. There could be recognition earned in this maneuver; if it were successful, Washington headquarters would be abuzz with talk of the expedition. But there would be little comment of Captain Philip Dudley. How could there be a citation for an officer who had marched away from the spot of destiny?

"We hope to take captive some Mexican dons," explained Hanna. "If we do, and Alamito Creek is not completely dry, Lieutenant Ashwell will escort them to Presidio and make contact with Mexican authorities. Lieutenant Elliott will return to San Estaban Lake with what other prisoners they have taken. One of them, we hope, will be Black Cat."

Dudley's lips tightened. So Elliott was to get that chance also? No matter who wrote the report, or even how, this would go into the records as the campaign Lieutenant Cameron Elliott led.

"It is a desperate chance," the coloned analyzed. "The odds are that San Estaban will be dry when they return. Lieutenant Elliott estimates the march to Paradise Valley and return will take ten days. Philip, your assignment is to return to the lake on the tenth day with tanks and canteens full. Wait there for seventy-two hours. Then if you have not heard from Lieutenant Elliott . . ."

His voice broke off.

84

"You will know the story," Cam finished for the colonel, with an expressive shrug of his shoulders.

Philip Dudley nodded. His dark even features showed little hint of the resentment he felt. So his was a relief assignment pure and simple! So his main responsibility was to bring water for another detail, men who had crossed the desert and had seen action and returned. He stood up slowly, struggling to keep his self-possession. That was not easy to do. It was hard to look at Cam Elliott and not let hatred show in his eyes. There had been ill feeling before, but an impersonal resentment. Now it was very personal. Now it was something so strong that Philip Dudley was eager to be away from this study of maneuvers ahead. Now he wanted to be alone with his feeling, to brood over it, to speculate on what he could do about it. First Susan in Elliott's arms, apparently willingly, not crying out when she was released, showing no indignation that she had been seized. And now their assignments—Elliott to take the risk and the glory, Dudley to execute an unimportant maneuver and then to wait seventy-two hours beside a desert water-hole!

"That is all," Hanna said, rising, "unless you have questions."

There were none, to Philip Dudley's relief. He saluted, then strode quickly to his quarters. Then he lay silent and motionless as Elliott and Ashwell undressed for what little sleep there could be until the bugle sounded again. But there was no sleep for Dudley. A man holding an inward rage could not sleep.

The bugle's sound was a shivering one, sharply breaking the brooding silence of early day. A din of noises came in its wake—the clatter of hooves on the sunbaked parade ground, the low murmur of exchanged jests between battle-hardened men, the excited barks of dogs protesting against what they could not understand. Then the shapes were swallowed up in the cool grey banks and Mark Hanna walked slowly to his quarters for another round of coffee. A heavy load seemed to have fallen from his shoulders. He was a fatalist, as all men must be who rode this wide-sprawled frontier. He would

not brood over whether he had ordered his men forth into glory or to death. His orders had come; he had carried them out. All his responsibilities were gone, were riding off into the mounting day, all except one.

"I'm afraid Phil isn't too happy," he confessed to Susan. "I gave him the worst of the assignments."

Briefly he gave her an idea of what the three details were expected to accomplish. Susan agreed with him; Dudley would not relish his role.

"But I couldn't do anything else," Hanna defended himself. "He wouldn't have yielded command to Elliott, not willingly anyhow. And Phil isn't the man to bring a detail through a torture march."

Susan agreed again. "No, he isn't."

Hanna studied his daughter. "Philip has paid his debts," he said quietly. "When will it be?"

She looked away a long while. She had dreaded this task; it was not easy to explain, even to an understanding person, why one day she had been willing to marry a man and the next day she wasn't. Also while she was about it she might as well partially prepare her father for what seemed the inevitable, that the day would come when she would hear a proposal of marriage from Cameron Elliott.

"I'm not going to marry Phil, Father," she said slowly. "I wanted to tell him before he left, but the chance didn't come."

That was true. The previous day had been a busy one for the officers and men of Fort Clark. And Phil Dudley, sleepless the night before, had fallen on his cot like a log once he had eaten.

"I felt that was coming," Hanna remarked. "And I am glad. Very glad. I had nothing to say against it; I felt you knew your own mind. But I wasn't enthusiastic over Phil as a prospective son-in-law."

He studied his daughter's face again, gravely, intently. "Are you sure?"

"Yes," she answered firmly.

"Then I'll add some of my other reactions. Phil won't be in the army long. He isn't geared to it. He'll crack."

"Yes," nodded Susan. "I believe he will."

There was a brief silence, then Susan murmured: "But

86

you would probably prefer Philip to the other candidate."

"Lieutenant Elliott?"

"How did you guess?"

"I'm not blind," smiled Hanna, "and, besides, who else could it be? Phil's competition has been limited these last few months."

"Yes," she admitted, "Cam Elliott. I know that'll make you unhappy, Father, but . . ."

"Why should it?" the colonel demanded.

Her face showed her surprise.

"Look, girl," snapped her father, "I haven't been a fuddy-dud all of my days. I've done more than study military tactics and write out reports. I've read a few books and thought a few thoughts that did't have anything to do with the army. I know all about knights on white chargers and Lochinvars riding in out of the west. I've just got one warning for you, young lady."

"Yes, colonel," she smiled, raising her hand to her forehead in mock salute.

Hanna ignored her levity; he was dead serious in both mood and his choice of words.

"I think Cam Elliott is everything you dream he is," he declared. "I know more about Elliott than I've told you. I've watched him develop from a mountain man and a ladino hunter into an unusual kind of man. He has taken on some education and polish. Most of that has come since he's been in the army, for he was a pretty ignorant man when he first put on the uniform. But since then he has taken advantage of every opportunity the service has offered, except the temptation to waste time. Right now he is superior to Phil Dudley not only in natural intelligence, but in actual knowledge. A few more years can do a lot for a man if he will let them."

Hanna gestured for another cup of coffee; she brought it.

"But he is still a frontiersman," Hanna warned her. "He won't stay in the army; we can't hold men like him. He is going to move out ahead of the army, and he'll take you with him. Don't think you can hold him back. Don't think for a moment you can keep him spic and span in a blue uniform all set for dress parade. Build up

all the dreams about him you want to, girl; he's man enough for them. But don't be like some women. Don't fall in love with a man on a white charger, and then raise cain with him to swap that horse for a jackass."

Tears formed in Susan's eyes; she turned her head quickly so that he wouldn't see them. So her mother had done with Mark Hanna, with Mark Hanna who had once been young and handsome.

"I won't do that, Dad," she promised huskily. "Whatever I do, I won't do that."

CHAPTER 10

THE nature and disposition of no two men was ever the same; yet as the hours passed and chill became heat and then chill again each troop took on an individualistic personality. One was eager and tense, another stolid, a third quiet and sullen under the scowling discipline of its leader. Both of the other officers sensed the ugliness of Philip Dudley's mood and only the most necessary talk passed between them. Cam Elliott spent most of his time with Blacky Crouch, though the scout was poor company while in the saddle. Blacky reasoned there was a time for riding and a time for gabbing.

They camped early and in some comfort; the need had not yet come to conceal their movements. Besides, as both Elliott and Crouch knew, this was not the season for hostile red men to expect attacks from the cavalry. The Indians everywhere would be a-move, but not to war. They would be moving with every feeling of security, confident that the mystery of these mountains would shield them from any harm. And who would want to attack them? This was the period of the long moon and red men were not concerned with war.

Lieutenant Elliott walked among his men and some light talk was exchanged. Red Burke was boasting of the women he had possessed, Troy Cullinan was recalling

farm life in Indiana, Chris Zanoba was helping his brother arrange his bedroll.

"When you gonna quit wet-nursing that kid?" another trooper demanded good-naturedly. One didn't question Chris Zanoba in any other manner.

Cam walked off with a chuckle. The younger Zanoba was doing all right as a soldier but Chris's solicitude and anxiety had not ebbed in the slightest.

The three officers ate and slept apart from the enlisted men but not in any spirit of comradeship. Hardly a word passed between Cam Elliott and Phil Dudley.

The tall man lay awake in his blankets and thought about Dudley's attitude. But not for long. Why brood over one man's unpleasantness when there was Susan Hanna to think about? So she had broken her engagement to the swarthy captain? So she was available and how many horses would Lieutenant Elliott offer for her! Cam Elliott smiled for his own benefit and at his own expense. Not many. No more than all the horses that roamed the mesas between the Nueces River and the stubborn Colorado! And if she were willing to wait, Cam Elliott would promise to capture them singlehanded.

Cam permitted his men to be leisurely about breakfast and saddling up. He seldom had to upbraid them for lagging but he realized the cause of their deliberation and secretly enjoyed their slowness. Philip Dudley had hurried his own men with sarcastic speech and both other troops were already mounted and formed before a man of Company D was in the saddle.

"We're waiting, Lieutenant Elliott," Dudley finally pointed out. His voice was sharp and he made no effort to keep enlisted men from hearing.

"Sorry, sir," Cam apologized quickly. "We'll try to do better in the morning."

Philip Dudley studied him coldly but spoke no further. This became another instance in which the tall man was suspected of mockery but escaped reprimand because of expressionless features and eyes. Then Dudley saw the looks pass among Elliott's enlisted men and he resolved next time to leap at the slightest pretext. That chance would come; an alert superior always found opportunity to humiliate an inferior.

In the early afternoon they sighted Indians moving slowly southward. The soldiers reined up and waited while their officers discussed the unexpected development. As superior officer Philip Dudley made the decision. The troopers moved to intercept the red people, riding in formation, ready for a charge.

But Dudley slowed his gait to a trot after they had covered a mile of the uneven terrain. By now it was obvious that the Indian party contained no warriors and did not intend mischief. Most of them were women bearing children; the other adults were old bent men. Dudley pulled his horse to a stop.

"Go have a powwow with them," he ordered Lieutenant Elliott. "Find out where they're going and why."

Cam motioned to Chris Zanoba and Blacky Crouch and the three trotted over to where the Indians had stopped and were waiting. Cam recognized them as Seminoles and guessed aloud their destination and identity.

"Black Cat's people," he reasoned. "He is sending them into Mexico."

"They're riding good horses," Blacky pointed out. "Looks like he'd want to take those horses to the valley for trade."

"Any other chief would have made his women walk," shrugged Cam. "The white man taught him that."

One old Indian came forward as the three white men dismounted, obviously intending to speak for the red people. Cam had seen him before, on a reservation during one of those intervals when the Seminoles had consented to confinement. He was Eldocah, called White Horse by the white man. Black Cat was his adopted son; it was by his patronage that Black Cat formally ruled the tribe.

"I come," Cam Elliott said slowly, speaking the Seminole tongue. The words never fell easily from his lips; he had never regained the glibness of his childhood.

"You do," nodded White Horse.

Cam's eyes moved over Eldocah's followers. Nearly every one was laden with all manner of personal possessions—blankets, extra garments, utensils.

"You are taking your people away?"

White Horse nodded.

"Across the river which divides the two nations?"

Another assent.

The elderly red man hesitated, then asked a question of his own. His voice was sharp, bitter, proud. Was it the intention of the white soldiers to stop or molest them? They bore only two rifles for hunting and sought only to go in peace.

"You go," Elliott replied. "We do not make war upon old men and women."

Words came tumbling back out of the wrinkled face, quick resentful words. So all the white men said. So some of the white men did. But some white men didn't. Some white men who wore the cloak of the Great White Father made war on women and children.

"Some of those you ride with," finished Eldocah.

Cam's denial came as instantly. White Horse laughed derisively, shortly. It was strange that the white men never knew of the crimes other white men committed. The white man was wise in some things. The red man could do something wrong and white men many moons later found out about it and sent soldiers to punish the Indians. But why didn't white men know about other white men?

Elliott heard the tirade through respectfully. He knew that Eldocah had a particular grievance in mind, and a personal one. He framed his question carefully. White men did not know everything. What had happened to make Eldocah so bitter against the white men who wanted only to be friendly with the Seminoles?

The explanation came as readily. The white man had stolen into the caves where Black Cat had led their women and children for protection against the wind and the sun. A chief of the white men had come; it had not been the act of men crazed by firewater. The white men had taken the wife and son of their war chief as prisoners. Then they had handed over the innocent woman and child to evil white men, one of them the white man who herded horses, cattle and sheep around the flowing wells and had forbidden Indians to camp there and satisfy their thirst. The white men had used the war chief's wife as some white men always used Indian wom-

en. They had killed the child, and the woman too. But she lingered on despite bullet wounds and other hurts and she lived until Black Cat found her—Black Cat, the war chief of the Seminoles, the warrior who would never again talk of peace with the white man.

Cam Elliott listened and rage swept his tall frame, especially as the elderly chieftain added that the leader of the white soldiers had sold his prisoners to the other white men. For a price that one who spoke for the Great White Father had resigned an innocent woman and child to torture and death. It seemed, commented White Horse, that there were always some of the White Father's men who would do anything for a price.

The muscles in Cam Elliott's neck swelled and his hands twitched at his side. But he held to his calmness. How did Eldocah know that the white man had received a price?

The woman had lived a while, explained White Horse. She had overheard the talk among the white men and she had known what they said.

Cam Elliott protested no further. Black Cat's wife would have been able to understand the gist of talk between white men. The war chief himself spoke fluent English.

Blacky Crouch had come to stand by Cam and listen attentively.

"What's he squawking about?" the scout demanded.

Crouch knew some Seminole phrases but could not understand such a quick rush of words, especially since Eldocah had not illustrated his outburst by the usual gestures.

Cam hesitated and looked back to the slope where Philip Dudley was waiting impatiently. Even now Dudley rose up in his stirrups and gestured to Elliott to cut short the talk. Cam's eyes hardened as he considered this startling story of an officer's perfidy. Then and there Cam resolved that Philip Dudley would get full punishment. This time a white man would make full report of another white man's crimes. But the next few days were important, made more so by what Cam had just learned. Dudley's punishment must wait.

For Eldocah was still speaking. He was threatening.

Black Cat, the war chief of the Seminoles, would exact full vengeance for the white man's crime. Black Cat would drown his grief in the blood of white men, women and children. The smoke of burning houses would rise high on far-flung horizons. The Seminoles knew well the white man's might. The white men had driven them from their home, except those who had fled into the great swamp. The white men had herded them like sheep and had driven them across the continent. Already they were speaking of Black Cat as the last of the Seminole war chiefs. But he would be the greatest. Mark well the words of a man who was old and wise, Black Cat would be the greatest.

Cam Elliott was not inclined to shrug off the old chief's predictions. Black Cat was indeed a potential menace. At the moment the Seminole was handicapped by the lack of guns and ammunition. But Cam had also noticed that the Indian women and children were riding good mounts. That meant the war chief had ample horses to trade for rifles and cartridges. And probably runaway slaves and captured Indians.

No, this was no trifling matter, but Cam decided to forget it for the time being, until this maneuver was over. An Indian woman had been raped and slain and a child slaughtered also . . . it did not occur to Cam to doubt Eldocah's accusation. That was bad and Cam Elliott would see that a cavalry officer was broken for it. But that had to wait. Must wait. Until they had returned to Fort Clark, Cam Elliott would keep what he had learned to himself.

And he did. Blacky Crouch asked another question or two, then abandoned any notion of finding out what Eldocah had said. The scout had understood some of the words. He sensed, too, that Cam Elliott was both enraged and disturbed by what he had found out. But he kept his silence also, until directly questioned.

That was a full day later. Their orders were to hold intact until they had reached San Estaban Lake. But Dudley changed those orders. After all, this was a field maneuver. The ranking officer was entitled to some discretion. Phil Dudley was determined to demonstrate that *he* led this expedition, not Lieutenant Elliott. They di-

vided for a day's march and Dudley ordered Blacky Crouch to accompany his detail. He did that to show that, despite Blacky's fondness for Cam Elliott, both scout and lieutenant were under his command.

But his gesture completely failed as far as its psychological purpose was concerned. The enlisted men of all three details believed that Dudley conscripted the veteran scout to make sure that he didn't get lost!

Dudley rode along with Crouch and glumly brooded upon all the objections he had found to this entire campaign. His resentments mounted as he brooded upon Colonel Hanna's orders, and also looked back upon the events of the past month. A man riding leisurely along from dawn to dusk either dozes or broods in the saddle. Philip Dudley thought; Blacky Crouch dozed.

Dudley had much to brood about. Mostly his thoughts were of Susan Hanna. It enraged him that as he rode he must speculate on whether or not his fiancée was interested in another man. It should not be so. A woman who had pledged her troth should be indifferent to other men. Yet he had seen Susan Hanna in Cam Elliott's arms and they had parted without any display of resentment on her part. He could not help but doubt her, and Philip Dudley was not a man who could live with doubt. Things were either so or they weren't. There could be no compromise between what was and what wasn't.

Their trail led them downward, and, in mid-afternoon, Blacky Crouch stirred awake and pointed out San Estaban Lake, their rendezvous. Philip Dudley squinted to see. He did not have the eyesight of a man raised to this frontier, nor did other army officers. Such men as Blacky Crouch or Cam Elliott could make out clearly what to Philip Dudley was not even visible.

One of the other details was already camped alongside the dry country waterhole, which in this season was only a muddy seep.

"Cam Elliott's detail," announced Blacky. "They beat us there."

The scout bit off a respectable hunk of thick-cut tobacco.

"They're the dangest guys," he remarked, and not in-

nocently. "They seem to take their own sweet time and yet they're always the first to get any place."

Dudley had no real purpose for his question, no real suspicion. He was merely leaping at an excuse to criticize Elliott.

"We wasted a half hour while he talked with the Seminoles," he grumbled. "What were they talking about— their mutual friends and relatives?"

"Dunno for sure," answered Crouch, and this time innocently. "I heard 'em but they talked too fast for me. Something about a woman and a kid."

Philip Dudley whirled in his saddle and scowled at the mustached scout. But Blacky's face was the picture of bland innocence, partially so by intent, mostly because of the little he knew. Philip Dudley straightened himself again. But he had betrayed something—just what, Blacky Crouch wasn't sure. Like another man, like many other men, the scout resented Dudley's type of officer.

"That Elliott," he murmured cruelly, "he's a slick one. He knows the Seminole lingo. He got the whole story out of the old chief, whatever it was."

He knew he had shocked Dudley. He gloried in it. He sat off and watched as the two officers exchanged greetings, one now as coldly formal as the other. He chortled to himself over this thing that he didn't understand either. But he knew men. He knew that between Philip Dudley and Cam Elliott had arisen an unexplained hatred which was no small feeling. He chortled because he had no doubt as to the eventual outcome. But he completely underestimated the dark-faced Virginian. A fear with Philip Dudley would be transformed into hatred. Whatever the swarthy captain lacked, it was not courage. Whatever qualities he had which inspired men to dislike him, a reluctance to fight was not one of them. And, despite his bearing, despite his own ideas as to what he actually was, Philip Dudley was seldom hampered, when it came to fighting, by any kind of rules.

It was Rosita's day to visit her family and Susan drove her to the adobe hut in which the sheepherder had reared a half-dozen healthy children. Rosita's mother met her with the usual present, small red and green peppers which were very hot to the taste. Some comforts were unknown to Mexican sheepherders but they were seldom without these peppers.

Susan was in no haste to return to the post and she permitted the horse to pick its own gait. The day was still pleasant; the full force of heat seldom arrived before noon. In the distance were the so-called Phantom Mountains, high rising crests which appeared absolutely real to the naked eye. It was almost impossible to realize that they did not exist at all, but were merely figments of a whimsical nature's imagination. There were other miracles also in this strange land to brood upon—why varieties of evergreen native to the far north flourished in the valleys and why the shy deer darting away from her buggy had black tails. Cam Elliott, mused Susan, could explain those things to her satisfaction. Cam could identify the tiny bright flowers which blossomed forth in dry seasons and died off with moisture. Cam would not dismiss these inquiries as of no consequence.

The faint road led through an arroyo small by comparison with nearby canyons but still of some proportion, deep enough for the buggy to disappear from the sight of anyone following Susan's progress. The rocky sides were splashed with many shades of color, mostly vermilion but also streaks of orange and chalk white. Susan tried identifying the different tints, but that was impossible.

She was so absorbed in her study of the arroyo wall that she did not see the Indians until they were almost upon her.

But she could not have escaped them anyhow. They came galloping from each direction, six of them, wearing shapeless garments discarded by white men. Their costumes made her hope for a moment that they were In-

dians "civilized" by attachment to a reservation, but that hope died quickly as several of them leveled their rifles upon her and one of them swung from his pony and seized her mare's bridle. Another reined up beside the buggy and motioned her to step out.

She made no move to obey. She was powerless to do so. Fear held her rooted to the buggy seat. Her wide eyes went from one grim coppery face to the next, seeing only hatred and menace.

A voice barked sharp guttural commands—the Indian who had ordered her to step out of the buggy. Quickly two savages vaulted from their scrawny-maned horses. One leaped into the buggy and seized Susan roughly. With a scream she twisted free of his clutching hands and scratched at his face. The second Indian came to his assistance and the two quickly subdued her. Her hands were tied behind her with strong rawhide and a strip of her own dress served as a gag.

The same Indian barked other orders. Her mare was unhitched and Susan was thrown across it. Rough hands forced her to sit astraddle the horse. Then she was bound tightly there and led behind the Indian chief by a makeshift rawhide halter and horsehair lead rope.

She prayed that they would be seen from the post and a detail sent dashing out to investigate, but the savage who led them veered carefully away from the wider ridges and open plains. They rode at a fast trot, Susan bobbing up and down with every motion of her pony, suffering agonies she did not believe she could endure. She kept her eyes closed tightly and struggled to suppress her sobbings. Then suddenly her horse was yanked to a quick stop and the Indian leader untied her bonds and jerked her to the ground. Low guttural talk passed between the red men; their chieftain took richly-shaded blankets and more rawhide and fashioned a crude semblance of a saddle for her. She was bound on again, but much more loosely; her arms were left free and the ends of the hackamore thrust into her fingers.

"There," the Indian leader shocked her by saying, "you'll ride easier."

97

He spoke in English and in good voice, not merely with grunts. The red men mounted again and rode on at a slower gait. Susan was left free to guide her own horse but the savages kept her closely surrounded. Escape was impossible.

A thousand fears swept through her mind, each one more horrible than the last. Then brooding brought her some ray of hope. This had been no accidental capture but a planned maneuver. Perhaps she was being taken as a hostage; if so, she could hope for gentle treatment and perhaps eventual release. That they had not tomahawked her on the spot was of some significance. So was their attitude, their behavior. There had been no blood-curdling yells, no display of hostility, but swift co-ordinated action as if this had been carefully planned. And Susan could not help being impressed by the coppery-skinned Indian leader. He was savage, from his tiny bright headdress to his moccasined feet, heavily beaded moccasins which looked soft and new. He rode bareback as did his followers; Susan observed their grace and recalled arguments between officers as to which were the better horsemen, the Seminoles or the Comanches. All of them had rifles and scabbards, guns as new as those issued to the frontier dragoons. Only the chieftain did not carry bow and spear also.

For two hours or more they held doggedly to their course, pausing neither for water nor to let their horses blow. It seemed to Susan they were riding toward the southeast, but she could not be sure; she had not learned to figure her direction by the sun's position. They stopped briefly beside a desert water hole and the Indian leader freed her legs of rawhide and helped her off her horse.

"You may walk about," he conceded. Again he spoke in English.

Susan was grateful for the chance to ease her cramped muscles. She made no attempt to flee, though she walked away as far as twenty yards without objection. They would surely overtake her if she ran and her hopes were rising all along. She walked back to her horse and the Indian chieftain offered her water from his own canteen. It was of U. S. Army issue; as she gulped gratefully she wondered whether it had come from the lifeless body of a

cavalry trooper or been stolen from a careless quarter-master.

The Indian's eyes watched her as she drank. His gaze traveled the full length of her body, observing the tear in her dress, and lingered for a second on her bosom. Her lips tightened. She had heard contradictory reports of what happened to women taken prisoner by the Indians.

"You are pretty," murmured the savage.

Her cheeks flushed. She did not look away from him but she trembled slightly. She could not understand his tone. His voice was almost sad, almost gentle.

They held the same unrelenting pace until dark. When Susan was unbound and set on the ground her legs would not hold her up. She toppled over and for a moment could not rise. The Indians showed her no particular sympathy; she was left to chafe blood circulation back into her own limbs. But neither was she molested. She was handed a canteen and strips of cured venison. The meat she did not want; the water she gulped down.

Once there was apparently some discussion of her. She guessed that some of the Indians thought she should be bound more tightly—only a loose rawhide hobble was affixed to her legs. But the Indian leader ruled otherwise and she was left to spend the night in what comfort she could. The same blankets which had been made into a saddle for her served her as a bed. She was not comfortable nor even warm but she lay awake and listened to the guttural voices of the Indians and she was not overwhelmed by fright.

She wriggled until finally she was in a position to sleep, fitfully at first, then soundly. She awoke once, near midnight. All the red men except the chieftain were breathing heavily. The leader was squatting before the glowing remnants of their fire, a motionless brooding figure.

They were riding again with daylight. Susan shivered in the early morning chill but no wrap was offered her and she could only endure the discomfort. She wondered how the Indians stayed warm; all rode naked to the waist, except for silver and brass ornaments, and only two of them wore buckskin trousers.

They climbed higher, even among the great shaggy heights which Susan hadn't known were passable. In mid-

afternoon they were following a narrow winding trail, sometimes skirting precipices which took her breath away when she looked downward. Once she was sure she saw, far below them, two other bands of Indians. And, near sundown, just before they made camp, she was positive she detected wisps of smoke floating upward from the uneven tiers beneath them.

But the Indians showed no concern at these signs of other horsemen in the vicinity. Susan was shown the same treatment and she devoured all the cured venison. It was stringy, tough, but nourishing. She lay awake for a brief period and wondered where they were bound. For almost two days they had ridden briskly and without a letup. They were many miles from Fort Clark now; she had watched closely and she was positive they had done no circling. They had, when the terrain permitted, ridden as straight as the crows flew. This night she so arranged her blankets and her weight that she lay in some sense of comfort. Cam Elliott should see her, she thought. If he could see her sleeping here and eating jerked venison he would no longer doubt her strength to follow him on any trail he might ride.

They rode out of the high passes and down among the valleys, and Susan Hanna caught glimpses of other things that amazed her. Once she saw a half-dozen wooden-wheeled wagons preceded by a carriage. Oxen pulled the *carretos*, jet black horses the coach. Susan studied the faces of her Indian captors but the red men seemed neither surprised nor concerned. Then just after noon they rode into a valley divided by a clear running stream. Here a half-hundred warriors were keeping a careful watch over four times as many horses. Most of them Susan recognized as mustangs, probably wild ponies taken in a recent hunt. But not all. There were horses feeding in this calm valley which obviously had been captured from the United States Army.

The Indian leader helped her dismount, gestured in the direction of a campfire, then mounted again and rode among the grazing horses. Susan watched him a while, wondering if his authority extended over this entire tribe, then timidly approached the fire. A potful of savoury

substance simmered there and after two days of only dried venison Susan was famished.

A middle-aged portly squaw presided over the pot. She stared at Susan a moment, features stolid but eyes beady bright with hatred. Susan asked for food and the Indian woman raised an arm as if to strike her. Susan did not cringe. Susan glared back at her, then moved defiantly closer to the stewpot. Sharp angry words came from the squaw's lips, a regular tirade, and Susan turned to meet her menacing approach. Then a voice rang out in sharp authority and the Indian woman's arm dropped to her side. The same chieftain who had taken her prisoner rode up at a gallop and barked out several phrases in his native tongue. Susan helped herself to the potage. Instead of dipping in with her hands, however, she found a stout twig for use as a spoon. The food was soft, pulpy, almost tasteless, but welcome after dry tough meat. An awful thought came to her after several bites. She remembered talk among the officers concerning the red man's food habits. No flesh was considered more edible than that of a dog.

But she was not sick at her stomach. She could even smile about it. I have slept on the ground, Cam Elliott, and I have eaten dog meat!

The chieftain was still talking with the Indian woman. What he wanted done did not seem to be very welcome; the squaw was firm in her protests. Then the savage spoke even more sharply and the squaw accepted his command with a grunt.

The Indian woman motioned Susan to walk ahead of her. The girl hesitated. The squaw seized up a stout cudgel and spat out her command.

"No," Susan refused defiantly.

The Indian chief rode his pony between them. From his saddle he glared down at Susan Hanna and there was a scowl on his dark face.

"You are to go with her," he ordered. "You are to do as she says. If you do not she is free to beat you."

The squaw gestured with the cudgel to indicate that she would welcome such a pastime. Susan hesitated again, then decided to obey. Thus far she had escaped torture or abuse of any kind. It would be folly to bring on a beating through her further defiance.

She walked as ordered. She walked to the edge of the stream. Now the squaw gestured for her to undress and bathe in the stream. Susan shook her head. She had already been tempted by the water but here she was in plain sight of a half-hundred Indians.

The Indian woman raised her stick. Susan dodged the first blow. A second one struck her about the shoulders. Susan broke and ran.

There was a quick clatter of hoofbeats and down upon her swooped the angry chieftain. He caught her up without leaving his horse's back. He bore her back to the Indian woman at a gallop and swung with her to the ground. Words passed between the two savages.

Then Susan felt strong fingers tearing at her soiled disheveled dress. She tried to reach his face with her desperate fingernails but the Indian woman caught her arms from behind and held her tightly. In a moment's time Susan stood cringing and stark naked on the creek bank.

"Now into the water," grunted the chieftain. "You are dirty."

He pushed her away from him and she went floundering into the knee-deep current. She cowered there, keeping all her body except her head below the water. But the chieftain did not stay to gloat over her. He mounted his pony again and rode to a skin lodge pitched beneath a grove of trees. In a moment he returned bearing something in his hands. This he dropped at the Indian woman's feet. Then he rode off again. Apparently he bore the weight of all responsibility upon his broad naked shoulders.

The squaw held up what he had brought and Susan saw that it was a buckskin dress, decorated with both beads and brass ornaments. The squaw motioned for Susan to wash herself and then don the borrowed costume. Susan lay in the water a while longer and then obeyed, but not until the Indian woman had made a threatening gesture toward the skin lodge. At last she forced herself to obey, even to stand completely bare of any garment until her body had dried. But if any of the Indians milling about the valley, riding restlessly among their herd, paid her any attention she could not tell it.

Seemingly a woman's nakedness made no impression upon them.

The buckskin dress fitted fairly well. Susan walked ahead of the squaw without protest. She was marched into the skin lodge; there squatted the Indian leader and two bare-chested braves. The warriors surrendered the lodge immediately and the squaw went to work on Susan's hair with sharp-pointed shells. One awful thought came to her as she submitted to the Indian woman's ministrations. Was she being bathed and groomed for marriage to the Indian chieftain? Indian chiefs had been known to make brides of their white captives. What was the name of Nocona's wife? Cynthia Parker, Cynthia Ann. Susan's lips went tight and tears came to her eyes. She would kill herself first.

CHAPTER 12

THE next morning the Indians started driving their herd of horses downstream. Susan was bound again to her black mare, which now limped slightly after the hard effort of these recent days. The Indian squaw rode by her, impassive, hostile.

The Indian leader who had captured her was every-where, changing horses as one tired beneath him. They moved slowly; the wild mustangs gave their red herds-men a hard time. Noon came, and also Susan's hunger, but the Indians did not stop. A high barrier rose before them and into a rocky hillside the stream completely vanished. But Susan was given no time to speculate upon this natural phenomenon. Somehow the savages drove the horses up the arroyo's side and onto a broad level mesa. For another hour they pushed on, then a valley opened right beneath them, and there was the stream again, casting off its shackles of granite and clay, pour-ing clear and wide through a valley bordered on three sides by high walls and merging into a narrow twisting canyon through which the water raced in gurgling rapids.

These things Susan observed at once, and others more slowly. Across from them, down the opposite bluff, slowly moved a human procession which for a time she could not understand. The valley floor was level and a pale green with deep grass and there were other herds of horses, and cattle also. She saw tents pitched in shady glades with wooden-wheeled wagons clustered nearby and several carriages such as had mystified her the day before.

Downward scrambled the mustangs, the Indians behind them, all choosing their way carefully. Deep ruts showed how the wagons and carriages had painfully mastered the decline. At times the trail was so steep that Susan closed her eyes and clung to her horse's mane with both hands.

The bottom finally, and the same skin lodge was raised for her use. Also food at last, a porridge thick with chunks of meat. Susan ate heartily though she was sure it was not beef.

The Indian chief stood outside the lodge, arms folded, until she had finished. Then he barked orders to the squaw and more rawhide was brought and Susan's hands tied behind her again.

"Why are you doing this?" she demanded.

A shrug and a grunt was his only answer.

The squaw pushed her outside the lodge and tethered her to the trunk of a Spanish oak. The rawhide bonds made anything but a sitting position uncomfortable. So Susan sat, her spirit dejected, her hopes fading. She no longer dared to believe that she was being held as a hostage. It was not necessary to tether a hostage as one did a vicious watchdog.

She saw the Indian chief riding toward her accompanied by two men. At first she thought his companions white and her heart leaped. Then they came closer and she saw they were Mexicans . . . or Spanish dons, richly dressed men, riding fine horses, silver conchas gleaming on their saddles and bridles. They pulled up and dismounted and the Indian motioned to her.

One of the Spaniards was white-haired and stately, the other young and handsome in his swarthy black-haired fashion. Both wore spotless linen and suits of velvet and

the elder one carried a thin sword swung from his waist. Both men studied her with interest but it was the younger one who stepped closer and whose eager burning eyes mentally undressed her. Susan's dismayed look went from him to the Indian and back again, and of a sudden she knew why she had been bathed and fed, and why she was so displayed before the skin lodge. She was being offered for sale to these Spaniards who had mysteriously appeared out of nowhere! The three men were standing there discussing her as if she were a yearling or a pony! She could not understand a word they were saying and for that she was grateful. Most grateful.

She closed her eyes, then opened them again. The older Mexican was shaking his head and smiling; the younger one was talking earnestly, persuasively. Susan bit her lip and fought to hold back her tears. She did not have to understand Spanish to sense the import of their talk. The younger one was pleading, the older refusing. She could guess they were father and son, or at least guardian and ward. Susan addressed a silent prayer to the stately white-haired man. Please refuse him. Don't give in to him. Don't so indulge him!

The young Mexican came very close and for an awful moment Susan feared he would touch her. But he didn't. More talk passed between them and then the two Mexicans mounted their horses and rode off slowly. Not for one moment did the young abandon his pleadings.

Susan watched them out of sight, then her eyes came slowly back to the bare-chested Indian. He stood with arms folded, looking after the Mexicans, a small hint of a smile about the corners of his mouth. He turned slightly and became conscious of her eyes upon him. He hesitated, as if considering whether or not he should speak. Then he said finally, emphasizing his words with a shrug of his shoulders.

"Don Miguel will pay the price," he predicted. "He is very rich and never denies his son a thing."

Her words came as so many hisses, in indignation, in despair.

"You will sell me to him . . . like a slave?"

Another hesitation, then his answer, slow, even-toned:

"I will trade you," he said. "I will trade you for guns and ammunition for my people."

"Oh, you . . . you!"

Words failed her. That suggestion of a smile came to his coppery face again.

"I am a savage," he admitted. "I am a cruel heartless savage. I am a Seminole."

His voice rose slightly, a gleam to his eyes.

"But for the horrible fate that is ahead of you," he added slowly, biting off each word, "you have your own race to blame. What the white man can do, the Indian can do. The body of an Indian woman should mean as much as yours. And Don Carlos will not use you once and then kill you. He will keep you well."

She stared at him and knew who he must be.

"You are Black Cat!"

"I am Black Cat," he nodded. "I am the war chief of the Seminoles."

"You speak English well and . . .!"

"Fight well," he finished tersely. "I have learned many things from the white man."

"Such as the use of guns," he added grimly. He waved toward the other end of the valley. "My people have learned many things. Perhaps too late, perhaps not. Once we traded the horses we had caught and the cattle we had stolen for cloth and baubles. For gleaming trinkets we even traded the prisoners we had captured in war. But not longer. The dons who want our horses and our cattle and our slaves must bring us rifles, and good ones, and powder, and not the worthless kind they gave us at first. We have learned something about trading. Our price for you, Miss Hanna—five hundred rifles!"

Susan stared at him unbelievingly. Here he stood, every inch of him a savage Indian, bare-chested, moccasins on his feet. Yet he spoke English glibly, not in any jargon, and he addressed her as "Miss Hanna!"

"How did you know my name?" she demanded as soon as she could find words.

"Some of my people slip into your post," he shrugged. "They pretend to be Navajos and they sit and eat your food and listen. For days they watched you. I did not

want to take just any white woman and sell her. I wanted only you . . . Miss Susan Hanna!"

"Why?" she whispered.

"Because I am an Indian," he answered, both pride and bitterness in his voice, "and the heart of an Indian cries out for revenge. At first I meant to violate you myself, then leave you near dead and bleeding where you could be found in time to tell your story. But I knew some don would pay well for you, and my warriors need guns and powder."

"Why did you single me out?" Susan asked. She was amazed at her own calmness, the evenness of her voice.

"None else would do," Black Cat answered readily. "It was my wife whom Captain Dudley turned over to the ranchman. It was my son who was scalped. I am war chief of the Seminoles. The wife of the white war chief would have served but he had no wife. Thus his daughter must do."

"Your wife and son were released," Susan protested.

"My wife was tortured and raped," the Seminole snapped. "My son was scalped."

"My father never knew that," Susan asserted heatedly.

"Never do the white men know when other white men do wrong," Black Cat philosophized moodily. "The white man knows many things, but never that. And to the white man, his ignorance justifies anything."

Susan wondered how she could be so cool, so clear-thinking. Here she was engaged in talk with the Seminole war chief, who had terrorized this country, who had scalped and looted and killed, and yet their tones were growing more casual with each exchange of words.

"There could be peace," she pointed out. "The white man has offered the Seminoles an honorable peace."

"No," Black Cat denied in the same brooding voice. "It is not a peace. It is subjection. We must live where the white man says. We must eat what the white man gives us. If it is not enough and Indians die of want, then we are evil. Indians and soldiers are sent against us. Peace we would accept, Miss Hanna. But not subjection."

"Aren't you part white?" she asked, unable to hold the question any longer.

"Some," he shrugged. "About my knowledge of your

107

speech? I could speak it as a child. For a time I was a guide. Along the Santa Fe trail. I speak Spanish also, and write both languages."

"And you . . . you're Indian of . . ."

"My own choice," he nodded.

Her strange calmness left her as he started away.

"Look . . . Black Cat . . . couldn't my father . . . couldn't you ask a ransom and . . .!"

"No," he said firmly, perhaps regretfully. "The red man does not need money. The white men would not trade guns for you. And we must have guns."

Calmness again, words coming to her lips, to her own surprise.

"And here . . . in this valley . . . the Mexicans trade guns and . . ."

"Every August," he confirmed. "This is the Valley of Tears. The dons want slaves for their silver mines and cattle and horses for their haciendas. We want bridles and guns and cartridges. It is a valley of misery, Miss Hanna."

"What slaves . . . what other slaves?"

"Piutes, Navajos, all prisoners of war. And some blacks who have escaped."

"You send them . . . to the misery of . . ."

"Yes," he said gently. "We send them to the misery of whips and hard labor. Then we take the guns we have traded for them and go back to *our* misery."

He was staring at her, some of the stiffness gone from his posture, but still with his arms folded across his chest.

"She was cold when I touched her," he said softly. "The little happy warrior lay sprawled where they had thrown him. This, Miss Hanna, is not the only valley of tears."

He turned and strode off. Now darkness was dropping over the rimtops which made this valley almost unapproachable. The Seminole squaw brought food but Susan Hanna could not swallow it. Nor could she sleep when led into the lodge again and laid upon a thick comfortable pallet of blankets and skins. Of course they would care for her well! She had caused a covetous gleam to come into the eyes of a rich Mexican's son. To please a pampered child a wealthy parent would deliver many

rifles. Guns to be handed out to Seminole warriors, grim Seminoles aroused to a last-ditch fight. Guns to be used against blue-clad army troopers! Guns with which to terrorize a frontier! Susan dozed off for a moment but her father's voice aroused her. She heard him speak as clearly as day. She saw him also as vividly. He was pacing back and forth in his office and he was raising his hands before his face and he was demanding over and over again: "Where do they get the guns? In the name of merciful God, who is smuggling guns into their camps!"

Now Colonel Hanna's daughter knew. But could she ever tell him?

For a half-day they rested at the water-hole which the map-makers described as a lake, but which actually was nothing more than a sandy recess that held stagnant pools of water. There was little doubt it would be dry when they returned, it took almost every drop of water to refill the canvas water tanks.

Then they were moving again, Philip Dudley's detail to the westward in that maneuver which the swarthy man believed absolutely senseless, Cam Elliott and Ashwell bearing eastward and south, away from the occasional mesas, into the shaggy mountains. They held a deliberate pace, pausing to rest in mid-day when a canyon or convenient mountain provided respite from the burning sun. The sand was torrid hot by day and bleak chill by night. Sweat-soaked uniforms were not fully dry when twilight's coolness came rushing down. In an hour's time a man both perspired and shivered.

Cam Elliott carefully doled out their water. There was little grumbling; his men were inured to that and the trust they put in him spread to Ashwell's company also. And a man drank only what he must have; the water was tepid and brackish and tainted with sand. Even the coffee was not fit to drink. No throat wanted a single sip and the discomfort of this palled on their spirits and by the time they had ridden a full day they had changed into quiet brooding men, men plodding along as if alone and each absorbed with his own thoughts.

This wasn't desert, for it was more rock than sand.

This was wasteland, sometimes chalky white, again a furious red as a clay ridge appeared out of nowhere. Some things grew here—scrawny patches of greasewood, tall stalks of yucca standing lonely watches over the emptiness, and scattered maguey with fragile yellow blossoms in almost incredible contrast to the harshness of the adjacent horizons. But no game fled before them, nor were there tell-tale tracks to show animal life had been there. They ate their rations as they sipped water, aware of its tastelessness, eating only to survive.

When they spoke it was to complain, and Lieutenant Ashwell's men became as free with their talk as Elliott's were allowed to be. They cursed the sun and the night and the food and the water. They cursed each other. They cursed Washington and Fort Clark. But on they plodded and at the end of every day they abandoned a wagon, unhitching the mules when a water tank was emptied and driving the animals along with them.

For three days they moved through this monotonous rolling country. Every horizon was fringed with blue-crested hills but they were farther than the naked eye could estimate. What had first appeared would be a short march dragged into its fourth day, and still the mountain range which was their apparent destination was not at hand. They were closer, yes; by the next day they would be moving among the outcropping swells. Even that came as a relief, though the footing was often uncertain and there was no relief from the heat. But anything was more endurable than tedium, and ledges of shale provided mid-day shelter and coolness for men whose nerves were worn thin and whose morale was ebbing.

Then, just before sundown, they clambered over a sharp rise and their sun-weary eyes feasted upon a valley spread out before them. A gleaming ribbon wove through it, the first running stream they had found since leaving the post.

But water was the only comfort Cam Elliott allowed them. They could not light a fire, nor fish nor wash in the stream he identified as Alamito Creek. Instead they spread their blankets in thickets of pine and juniper and talked only in low voices.

With daylight they increased their precautions. Ser-

geant Chris Zanoba supervised their efforts to screen this temporary camp, for both officers and Blacky Crouch went warily upstream.

"Hell, I didn't figger we come this far just to hide," grumbled Red Burke.

"Me, I wanna stay here forever," declared another trooper. "Good shade, fresh water, and nothing to do. You ain't ever had it so good, Red."

Blacky Crouch and Cam Elliott exchanged talk as they rode along.

"This is just about as it was told to me," said the veteran scout as he studied the terrain. "I ain't seen any of them stone mounds they talk about but . . ."

"I'll show you one," Cam agreed.

The wondering Ashwell followed them a half-mile from the river, to a sharp jagged crest which was distinguishable for miles. At its foot was a mound of stones obviously fashioned by human hands. Elliott swept some of the rocks aside with his foot and revealed a small hole. Ashwell bent over and picked up a rusted pistol.

"What in the world?" he exclaimed.

"The whisper trail," Crouch grunted. The scout bit off a sizable chunk from his jet-black tobacco plug. "Owl hooters lighting a shuck for Mexico."

"The Comanches used it first," Elliott explained to Ashwell. "Somehow they located the water holes. They passed on descriptions of landmarks by word of mouth. You can start five hundred miles north of here and by hard riding and pulling in your belt you can just make it . . . to the headwaters of Alamito Creek. Some of the white men learned from the Comanches and passed the word on to their *compadres*. They would leave notes for each other in caches like this, and goldpieces and spare bullets and even cans of food. Sometimes a little thing meant the difference between making it and not."

"The hombre I knew was called Ginger," recalled Crouch. "He claimed he could follow the trail plumb from Tascosa to the valley."

Ashwell nodded. "And we'll intercept Indians and Mexicans in this—Paradise Valley, isn't it?"

"The owl hooters named it that," said Crouch. "It musta looked like paradise to 'em after fanning the

breeze for five hundred miles. Water, fresh game, fire-wood . . . I reckon it shore looked good to 'em."

They rode on, screening themselves whenever possible, though Elliott minimized their danger.

"Straggling horsemen shouldn't get too much attention," he pointed out. "Not now. Too many people coming and going. As long as we keep the troop under cover . . ."

They saw other horsemen. They saw wagons pulled along by stout mules, clumsy wooden-wheeled *carretos,* and once a coach lurching over the uneven terrain. Elliott motioned his companions to pull up and they watched the carriage's progress. It wove back and forth as its driver searched for smoother ground. Behind it lumbered two *carretos,* both covered by canvas tarpaulins. Mules strained to pull the vehicles up the steeper grades; apparently they were heavily laden. Elliott watcher the small procession struggle up a sharp rise and then disappear through a break in the shaggy heights.

"We can go back," Elliott said to Crouch. "There is just one way in."

"So the talk goes," nodded the scout. "One way in and one way out."

Before they turned their horses Ashwell pointed southward.

"Look, Elliott!"

The shapes were small and dim in the distance but distinguishable. Human shapes moving afoot, closely hunched, horsemen leading them, surrounding them.

"We've timed it just right," Cam said. "We'll rest another day, then move up before daylight."

Ashwell offered no comment. The calm quiet officer had accepted the leadership of his junior without resentment. His was an attitude of helpless acceptance. He could not have found this place and he was not even sure he could lead a troop back over the trail they had come. He was content to let full responsibility rest upon Cam Elliott's sloping shoulders.

THE delay did not sit too well with the troopers. There could be no full relaxation, not when another twenty-four hours would find them launching an attack which was still a mystery to them, which apparently only the two officers and Blacky Crouch understood. Nothing about this maneuver made sense to them. For a month they had chased Black Cat and they had believed they would keep after the Seminole until they caught him. Then of a sudden they were ordered onto their horses and they rode over a hundred miles away from where Black Cat had last been contacted. They spanned a desolate waste and reached a running stream and then they crouched in thickets and waited for a day to drag its baffling course. They huddled in groups and they were denied even the comfort of tobacco. Elliott said that smoke odors would drift up. To where? To whom? Those addicted to nicotine had unpleasant tastes in their mouths and edgy dispositions and could not sleep away the hours, as did the stolid Chris Zanoba and Blacky Crouch, who apparently awoke at regular intervals only to spit heavily and slumber again.

No bugle call roused them; instead, Sergeant Zanoba and Lieutenant Elliott went from man to man shaking each awake.

"Leave your bedrolls," they were told.

It was chill in these hours before daylight and they fumbled clumsily with their buttons and their straps. Elliott's voice called sharply for them to hurry. Some were still struggling with their trappings when they mounted and followed behind their tall lieutenant, a dark bobbing shape when he could be seen at all.

Morning was coming in small splashes before they reached the rimtop. Elliott ordered them to dismount and lead their horses. Even so a clatter preceded them which weighed heavily upon tingling nerves. They could not hope to surprise anyone like this. They were making enough noise to awaken the dead.

Now there was light above them and a paling of the gray banks below. They could see that they had gained a high crest which looked down upon an oval-shaped valley.

Lieutenants Elliott and Ashwell talked apart. There could be another way out of the valley, the creek. It cut a twisting fissure through the rocky bluffs, and Ashwell nodded to Elliott's suggestion that he take his troop and prevent any escape downstream. There was no upstream opening; the creek formed in this valley, the overflow of a spring which poured out water by the millions of gallons.

Daylight had come to the rimtop but not yet to the valley below, where it was only beginning to come. The banks rose slowly and the smell of smoke drifted up to the troopers and then the gleam of fires. Lieutenant Elliott waved them into their saddles again. They drew up in battle formation and the flag bearer took his place and the bugler waited for the word to blow.

"Nobody knows what we'll run into," Elliott said tersely. "Don't shoot first, but shoot back at anybody. If there's serious fighting, scatter out and it's every man for himself."

Cam lifted his hand and touched spurs to his horse and down the ridge the troop charged, still not sure into what, much less why.

A whimsical nature had carved out this approach eons before, almost like a roadway but wider and more irregular. The footing was uncertain but not a horse fell, though several stumbled, and they gained the valley's floor with lines still even. Lieutenant Ashwell veered southward, spurring his horse into a gallop and waving his men to hurry.

Now there was gloomy light ahead of them and they could make out the shapes they passed and some of those ahead. But they did not halt to marvel at what they passed—the silken tents, the carriages, the wooden-wheeled wagons, the naked Indians fastened to each other by chains. Gunfire flashed in their faces and shot riddled their ranks and they broke formation to fight as their lieutenant had taught them. They fired back at the flashes and the gray banks began to lift and they

114

saw the full effect of their plight. There were many dim shapes around them scurrying for safety and shelter but there were other horsemen in the dimness who were fighting back furiously.

Cam Elliott saw them form and struggled to reach his bugler. He ordered the call to form again and his troopers spurred their horses back into formation. Across the valley stormed the Seminoles, ranks close, rifles blazing. Black Cat had called upon the knowledge of cavalry tactics he had learned from the white man's manuals. Another detail might have been swept aside before this furious onslaught, but Elliott had ridden into this valley holding his adversary in full respect. The blue line gave ground but held. And, ironically, somewhat tragically, Black Cat's quick decision worked against him.

He had executed a maneuver that was in the white man's books. Down the valley, moving ahead at a gallop, Lieutenant Ashwell analyzed the battle correctly. Ashwell might have been slow to form his own strategy but this was a plan of combat he recognized at once. He gestured to his bugler and the sharp sound to charge brought all his detail close behind him. Their rifles clattered and riderless horses screamed as the helpless Seminoles caught the full force of their assault. Before Black Cat could wave his warriors out of close-hand fighting the army troopers were upon them with gleaming sabers. The advantage of numbers had been lost in these furious few minutes.

"Keep firing," yelled Cam Elliott.

He set an example. That was the superiority of the white men—one volley after another. The trooper could handle his weapon better. He could throw two shots to the Indian's one and shoot straighter.

Black Cat pulled back his warriors. Black Cat wheeled his buckskin pony around and his Seminoles followed him into the timber. But this retreat cost him more men. Also gone was any chance to lead his band out of the valley. For Cam Elliott shouted to his bugler and the call sounded in time to halt the army's countercharge. So Black Cat had tricked them before—fall back, pretend riot, draw them almost to cover, then shatter their ranks with an unexpected rally. The troopers did not follow

into the timber, not then. First Elliott consulted with Ashwell. Ashwell accepted a suggestion as a command and took his detail out of the valley fighting.

Ashwell galloped up the winding rutted road and turned back the Mexicans already in flight with their *carretos* and carriages. Then his men spread out along the ledges and waited, guns ready, senses alert.

Cam Elliott waved his men out of their saddles. They fanned out in groups of three's. They began to steal slowly and carefully into the timber. So the frontiersmen had learned to fight the red men. So Elliott had trained his detail.

The tall lieutenant carried his own rifle. Burke and Tony Zanoba were with him. A shot came from cover, quickly three guns answered in retaliation and Black Cat had lost another warrior. Groans came from blueclad men who felt the agony of Seminole fire but the advantage mounted in favor of the white man. Cam took Burke, waving Tony away, and they skirted the timber, drawing fire several times but escaping untouched. They worked in close to the frightened but well-trained Indian horses and directed their rifle fire upon the animals. They shot to main, not to kill. Several beasts screamed and danced in pain and the Seminole mounts began to bolt, to scatter in wild confusion among the herd of wild mustangs which Black Cat had intended to trade for rifles and ammunition. Terrified, bawling cattle thrashed about also.

At the rimtop Lieutenant Ashwell was also having his hands full, but not with fighting. The other red men who had brought their wares to the Valley of Tears were leaving the fighting to the Seminoles. They made their surrender and they squatted under the careful rifles of their guards and watched stolidly, apparently with indifference. Or was it resignation?

The Seminole gunfire died off to nothing more than an occasional clatter. Cam Elliott, his face as black as gunpowder itself, made his way from one group to the next and his troopers began to carefully draw back from the timber. A fire was built and coffee put on to boil and the tired soldiers munched on their rations while holding their guns ready to meet any countercharge. Cam Elliott

116

did not expect any. He detected movements out of the brush and trees and sent forth men to shoot down any Seminoles who might dart after horses. Some shots sounded and then there was another long interval of silence.

A courier rode to Lieutenant Ashwell and men of his detail came cautiously down the rim, tightening the net around the Seminole war chief and his dwindling warriors. For a long hour the blue-clad soldiers held their tight vigil. There was little gunfire; the Seminoles held to cover except for occasional daring, foolhardy movements. Those ended in further loss of life. The trap was as complete as it could be. Black Cat was at bay.

The Seminole knew it. He and two warriors walked out of the timber and dramatically threw their guns to the ground. One shot was hurled at them before Cam Elliott could stay the troopers. Elliott gestured to the chieftain and across two hundred yards of blood-stained grass the Seminole came walking slowly. As deliberately Cam walked out to meet him and Lieutenant Ashwell came down to join the conference.

Black Cat stopped and stood with arms folded across his chest. No hint of recognition gleamed in his eyes as he waited for Cam to stop also, and then for Lieutenant Ashwell to dismount.

The Seminole spoke first. What terms of surrender did the white man ask?

Both officers had been instructed as to terms. Cam let Ashwell explain them.

"Each Seminole will be permitted to select one horse and leave," recited the lieutenant. "He may carry his tomahawk and his bow and arrows but not his rifle and ammunition. If he will return to the reservation he will receive food for himself and his family."

Black Cat tilted his head and his dark eyes studied Ashwell intently.

"One horse?" he asked after a moment.

"One horse each," was the firm reply.

"And I, Black Cat?"

"You, Black Cat, will be taken to Fort Clark in chains. We do not know what will be done with you after that."

As Black Cat considered this Ashwell added half-

apologetically: "That is as far as our orders go. We are not war chiefs, merely lieutenants."

Black Cat nodded to show that he understood this.

"We have many horses," the Seminole said slowly. "What will happen to them?"

"We have our orders," Ashwell shrugged.

Black Cat turned and walked quickly to where the two other Indians waited. They talked a while, squatting, ignoring the two officers. Their voices were low; Cam, who could have understood them, overheard only fragments of their talk. Then Black Cat rose and came back to Ashwell and Elliott.

"So be it," he said tersely. "My warriors will take one horse each and leave in peace."

"Good," nodded Ashwell. "Will you see about the chains, Lieutenant Elliott? Your man Zanoba is the best blacksmith we have."

"It would be well," Black Cat advised, "if you did not put the chains upon me until my warriors are away."

"He is right, lieutenant," approved Elliott. "I'm not sure they would leave him in chains."

The two Seminoles whom Black Cat had considered his advisers were now walking back to the timber. Slowly the Indians emerged from their cover and began pursuit of their milling horses. No one made a move to help them. It would have been unwise to relax their vigilance. Black Cat stood between Elliott and Ashwell, indifferent to Sergeant Zanoba and Corporal Burke, who watched him closely with rifles ready.

Black Cat finally broke the silence.

"There is a woman tied in there," he announced to Ashwell, pointing toward the skin lodge. "There is no reason for her to suffer more discomfort."

"Woman! White?"

"Very much," nodded the Seminole. That flicker of a smile broke his face for a fleeting second. "She is the daughter of Colonel Hanna."

Ashwell and Cam stared at the savage, shocked by this casual announcement and identification. Elliott spoke first.

"Good Lord!" he exclaimed. "Susan!"

And he ran toward the lodge as fast as his long legs could carry him.

"God help you if you've harmed her," growled Ashwell.

"She is not harmed," shrugged the Seminole.

CHAPTER 14

GRIMLY Lieutenants Ashwell and Elliott carried out their orders. First, the Seminoles were dealt with. One by one they filed out of the valley, riding into the horizon, each warrior with only the horse under him and the weapons he knew before the white man came—a bow and a quiver of arrows, and some with lances. Then chains were hammered on the wrists and ankles of their beaten chief.

Then the other Indians who had come to the valley where each August red men and Mexican dons had met for peaceful barter. Their guns were taken from them and they were lectured sternly. Let this serve as a warning to them. Let them henceforth stay on their reservations and never again doubt the might of the white men. The red men listened impassively and then, too, filed away into the distance.

Now the Mexicans. They had been vehement in their first protestations against their treatment but they lapsed into sullen acceptance of their lot as Ashwell sharply reminded them of the international treaty they had violated. Their wagons were stripped of all contents, even the articles which by no means could be classified as matériel of war. Bolts of bright cloth and leatherware and garments became gray smoking ashes. Cases of new gleaming rifles and cartridges were dumped into the creek, in hollows where the water ran deep. The wooden wagons were burned also. The dons had come laden with food supplies; most of these were seized and passed among the Piutes and Navajos and Lipans, less war-like Indians who had been taken in battle and driven in

chains to the valley. For a century their tribes had been fed into the maws of Mexican silver mines, where men were worked until their collapse and then were kicked aside.

Confessions were framed for them and the dons required to sign. Then they were herded into a meager train and Lieutenant Ashwell's detail guarded them on the beginning of a long march, to Presidio. Again rose the protests. Haciendas could not be neglected for so long. *Banditos* would pillage their silver mines. But there was no concession. They would be turned over to proper Mexican authorities and the U. S. Government would demand their punishment. And also the guarantee of Mexico that never again would such dons cross the river to trade guns and ammunition for horses, cattle and human flesh.

Next the cattle and horses milling about the valley. The cattle were merely driven to the basin's lower end and turned free to shift for themselves. There was water here and ample grass. A generation later some intrepid cattlemen would push across the mountains to claim this tangled terrain and would find a herd of fat cattle theirs for the taking. Several were killed for beef but none would be driven back.

Then the horses. Hundreds of them, some stolen animals, but most of them wild mustangs trapped by rawhide *reatas*. Elliott selected several spare mounts for the return march across the desert and mountains. The others were herded together and driven over a precipice so deep and so abrupt that the fate of the animals was certain. Eerie screams rent the air as the horses were compelled by the press behind them to leap off into empty space. The Seminole was now not only disarmed but almost afoot! [1] Their wealth was their horse herd, and now that was destroyed. It would take a long time to capture another.

All this took time. Two days passed, three. Their wagons were driven into the valley and the canvas tanks refilled.

"You would think," Susan remarked, watching the

[1] This disposal of horses captured from Indians has its factual basis. In 1874 General MacKenzie ordered the slaughter of 1,450 mustangs near Tule Creek.

preparations, "that we were going to the end of the world."

"We're there now," smiled Cam. "We're going to try to get back."

He had proposed that she go with Ashwell's detail, for Ashwell would trace Alamito and Cibolo Creeks to the Rio Grande River and then follow a beaten trail to El Paso del Norte. But Susan had chosen the shorter route, if the more hazardous. For that Cam Elliott was grateful; he would have her company these long days ahead. And he learned of another blessing—she already knew that Philip Dudley had taken a bribe to release Black Cat's wife and child to torture and murder.

"What will happen to Philip?" she asked. "Court-martialed, yes. Will he be dishonorably discharged?"

"I can't see anything less," the tall man shrugged.

Their caravan formed, the extra horses being led behind the wagons. Cam Elliott sat in one and completed his report of the attack in swaying discomfort. They had lost only seven men, with two more so badly wounded that their fate was in doubt. They had taken a brutal toll of the Seminole warriors—forty-three slain, others injured. He estimated that they had destroyed some twelve thousand dollars worth of merchandise and vehicles . . . the financial loss alone should make the dons hesitant to return to the valley. With Blacky Crouch's help he drew maps of the route they had followed. The scout's gnarled fingers could hardly hold a pencil but he could follow Elliott's chartings and propose corrections from memory.

Black Cat was given his choice of riding inside a wagon or on horseback. He chose the latter, and at night slept padlocked to a wagon wheel. Except for one brief conversation with Elliott the Seminole refused to speak, not even when Corporal Burke taunted him.

Cam stopped the Irishman and delivered an ultimatum to the rest of the detail. The next man to badger their captive would also end up in chains.

The tall lieutenant fashioned a bunk for Susan, of canvas and deerskin, and she divided her riding between the wagon and a small mustang taken from the Indians. Cam would not let her ride during the full heat of day,

though she pointed out that Black Cat had showed her no special consideration and she had survived that travel.

Each day was hotter than the one before it. August was moving toward September, but autumn was a long way off; despite what the calendar read this was summer in its fullest fury. They left the high country behind with its scattered clumps of juniper, pine and oak and rode across arid basins. Most of the tobosa and chino grass had died in these burning months of drouth; only lechuguilla, yucca and catclaw had survived. Their horses suffered, both from hunger and thirst; Cam Elliott ordered long rests in mid-day and stops for grazing whenever creosote and tar bushes offered any semblance of vegetation. Some animals wilted and were mercifully destroyed; except for the spare mounts screened out of the Indian herd there would have been troopers plodding on foot before they reached the San Estaban waterhole.

Their tanks were dry two days before, but the two canteens each man carried would suffice them. They had learned from Elliott to ride with chunks of raw meat between their teeth and moistened kerchiefs protecting their lips. Black Cat scorned such practices; the Seminole bore the sun bareheaded and with no visible suffering. The prisoner was allotted as much water as any trooper and showed no ill effects from heat and scant water.

Slowly they plodded from one barren rise to the next. They were beginning to strain their eyes from each ridgetop; surely the next swell would reveal to them the coarse sandy basin where Captain Dudley should be waiting, with water and supplies, especially with water.

That long-awaited rise came and a hoarse cry came from Chris Zanoba, riding ahead with Blacky Crouch. There, no more than a half-mile from them, was San Estaban Lake. No reflection of water shimmered before their eager eyes, but that had been expected. That brought no gasp of despair from any throat nor any curses from any lips nor any whispered prayer for sustenance from above. They had known all along that San Estaban would be bone dry in late August.

But they had anticipated, eagerly, confidently, seeing wagons drawn up at the basin's edge and men dressed

like themselves waiting for them to ride over the horizon. And there were neither.

Philip Dudley's mood had not lightened as he led his company away from San Estaban Lake. The first uncertainties of mingled fear and chagrin had passed, giving way to sullen grim musing. His conviction grew that Cam Elliott knew of his dealing with Tobe Wilson. Blacky Crouch's sly remarks were more than confirmed by Elliott's attitude before the rangy lieutenant and Ashwell rode off with their details. There was a change from indifference to contempt. Elliott's face showed the usual minimum of expression but the lieutenant's eyes revealed what his features did not portray, a cold scorn.

As he rode toward the westward sun Philip Dudley resolved that Lieutenant Cameron Elliott must not return alive from this maneuver.

More than ever he regretted Colonel Hanna's division of assignments. Had their details been together in battle, particularly in assault, an opportunity might have come to perform the deed with his own hand, and with no fear of any consequence. His decision to kill Cameron Elliott was not a hard one to make. He had considered such a step after witnessing the embrace at the Hanna gate. Only Cameron Elliott had ever aroused his jealousy since his betrothal to Susan Hanna. The man seemed to have some sort of charm which Susan found irresistible. During the months Elliott was not around—from the time Hanna and Dudley had found her struggling in Elliott's arms and the tall man's appearance at Fort Clark —Susan had been a devoted fiancée, concerned only with his debts and the lack of comfortable quarters at Fort Clark.

Dudley was not a warm suitor. He had not proposed to Susan because she had aroused in him a feeling so deep and overwhelming that he could not exist without her. His whole being did not cry out in thwarted desire for the touch and fragrance of her body. No woman could do that to Philip Dudley, nor any ideal or cause. He yearned for a wife because he was aware of his loneliness. The life of a married man was happier than that of a single man, especially so at frontier posts where

social life could not absorb all of an officer's leisure. Too, there was his own advancement in rank to consider. Married officers resented single men, particularly handsome ones. The ways of army wives were light and often flirtatious; Philip knew of more than one young officer whose career had suffered because of a superior's jealousy.

Nor had he been indifferent to the military prestige of Susan's father.

He had cautioned himself, following the scene at Hanna's gate, that he mustn't regard that as the end of the engagement. Susan was strangely affected by Elliott but she had never regarded the tall man, some part Indian if gossip was true, as a prospective husband. With Elliott out of the way, transferred or dead or out of the army, he could anticipate a smooth fulfillment of their betrothal.

Then had come Elliott's conference with the aged Seminole chieftain. Philip Dudley had killed already in cold necessity. He was ready to do so again. But he would profit from that previous experience. He would be more cautious and shun all consequences if he could.

That decision reached, Philip Dudley's humor changed. He even hummed an occasional tune as they rode along, to the astonishment of his enlisted men. His company rode over the crests of the Rancheria Hills, then rested a half-day at the hamlet of Galgo, a cluster of Mexican hovels. They drank warm beer and feasted on *cabrito,* goat meat. They moved leisurely toward Conejo, a small and unimpressive village, and turned southward to the mountain range identified on the maps as Cuesta del Burro. Then along Capote Draw, a wide winding arroyo which in prehistoric times had been a river bed. They found water holes regularly; Dudley's men congratulated themselves on for once getting the easiest assignment.

The days did not pass as easily for Philip Dudley. It was not a simple plan, this scheme to destroy a man and yet escape not only blame but even suspicion.

Then, as they returned to camp beside the bone-dry San Estaban Lake, Philip Dudley realized the means were at his disposal. The canvas water tanks had been

refilled and supplies bought at Galgo. Dudley had returned to the "lake" on schedule. When a day passed and then another without any bedraggled troop appearing on the horizon Philip Dudley made his decision to leave them to their fate. Perhaps they were lost anyhow; more than one army detail had perished trying to span these trackless wastes.

His own men had emptied their canteens and were dipping greedily into the contents of one canvas tank. Dudley laid his blankets beneath the second wagon, and, just after midnight, when he could be sure that all were sleeping except for the two guards, he ripped away one corner of the damp canvas. The water's own weight did the rest. The precious fluid poured forth onto the sand. Dudley returned to sleep. To sound untroubled sleep. Now he could justify his action to anyone. Not only had he waited longer than his orders called for but his own water supply was now dangerously low. He could state in his report, and logically, that he had no choice but to return to the post.

The loss of the water was not discovered by the others until daylight. Philip Dudley pretended surprise and dismay as well as any man could have.

"The damned canvas gave," explained Sergeant Cullen, who had roused his commanding officer to report the damage.

"So it seems," nodded Dudley.

"Figured it would," went on Cullen. "Wet canvas rots quick. And all the sand in that water didn't help."

Dudley's eyes gleamed appreciatively. Yes, his report would appear logical.

Dudley pretended an absorbed study.

"Begging your pardon, captain," Sergeant Cullen ventured, "but this puts us in a pretty bad way."

"It does indeed, sergeant," the officer nodded. "We have barely enough water ourselves. We would not accomplish anything by staying out here and dying of thirst ourselves."

He took off his hat and stared off to the west. "They're three days overdue now," he murmured for the sergeant's benefit. "Poor souls, I hope they decided to take another trail. That is all we can hope."

"All we can do, sir," Cullen agreed.

"We'll start back right after breakfast, sergeant," ordered Philip. "Tell the men to get ready."

He ate apart from the enlisted men, then further impressed his troopers by riding to a nearby height and using his glasses. He came back shaking his head and motioned the company to fall in behind him.

Dust-spattered, unshaven, he delivered his grave report to Colonel Hanna. The post commander heard him out, and agreed his was the logical act, before informing Philip that Susan had been captured by the Indians.

"I'll take my troop out again in the morning," declared the swarthy captain. "We'll find her, sir. I won't come back until I do find her."

Mark Hanna shook his head. He was a crushed man, totally so. There was no life in his eyes and his once ruddy features were gray and wrinkled. Tragedy and worry had left a heavy stamp upon him.

"There's no use," he refused. "We've done all we can. It's been two weeks. There is little chance that she is alive."

CHAPTER 15

FOR long moments nobody spoke. They sat their horses, weary and dusty and thirsty men, and stared down at the damp spot in the sand.

Then a hoarse sound came from Chris Zanoba's lips, either a sob or a snarl.

Cam Elliott dismounted and examined the stain and the abandoned camp site.

"I would say," he mused aloud to Blacky Crouch, "they've been gone about forty-eight hours."

The scout nodded. So he would estimate from the color of campfire ashes.

"I don't think there's anything to worry about," the lieutenant told his men, feigning a confidence which he did not heartily feel but yet which he could not honestly

doubt. "As you can see, one of the tanks burst open. Probably Captain Dudley has repaired it and has gone to refill it again. We'll keep moving and let him overtake us."

"That had better be quick, lieutenant," grunted Sergeant Zanoba. "Some of us can't go on much longer."

"We can go on a long way," Cam snapped. "Pull up the wagons and let's rest until sundown."

Some of them lay on the dampened sand, grateful for its coolness. Cam Elliott made himself a cigaret.

"Anybody who wants a smoke can have one cigaret," he told the troop. "One last one. Then tobacco is out."

He smoked slowly, his eyes appraising the scattered men. Chris had been right; some of them were near collapse. Tony especially. Cam sighed. The sergeant's younger brother never should have joined the army. A rugged constitution was not acquired in a single season. Tony lay with flushed face and Cam was sure the youth had fever. But there was no point of estimating his temperature; fever or not, they must go on as far as they could. That would not be all the way unless relief came, either from Philip Dudley or from the heavens in the form of miraculous rainfall.

He brooded over the wasted water. Such a canvas tank would eventually rot and burst, of course; all cloth rotted. But Cam had seen them endure for a month and even longer. The canvas had been securely fastened to the wagon bed; he had checked each one. They were overdue returning to the "lake"; the destruction of horses and matériel had taken longer than he had expected and he had permitted his men to rest and regain strength. But still . . . to march off . . . leaving no message, no supplies whatsoever!

Burke came over to sit by him.

"Looks bad, Elliott," murmured the corporal. "If Dudley fails us completaly . . ."

He shook his head slowly.

"We'll have to keep going," shrugged Elliott, "and trust he overtakes us."

The hours passed slowly. Those who dozed did so fitfully. An hour before sundown Cam motioned to Blacky Crouch and Chris Zanoba and the three of them ex-

amined their tired fading horses. They killed the weakest looking animal. They butchered its flesh and it was handed out in raw chunks. From now on there would be no other food for them. They would not use up the moisture left in their bodies digesting bread and cooked meat.

Elliott ordered the wagons unhitched.

"You'll have to ride with us," he told Susan. "The horses will last longer that way."

He insisted she use his saddle, riding barebacked himself.

"That's the way I learned," he answered when she protested.

They rode for three hours, then rested and rode again. Elliott began to look for an arroyo as dawn broke but none was near. Everywhere he looked he saw only salty flats. Hills rose high around him in all directions but distances were deceptive in this country; the mountains were a two-day ride away. They slaughtered another horse, one which had pulled up lame, and Cam made each man—and Susan, too—rest with fresh chunks of raw meat in their mouths. Raw blood dripped over the unshaven chins and few bothered to cleanse themselves. Elliott did not order them to do so. This was no time for discipline.

Cam and Chris Zanoba and Red Burke cut mesquite roots and trimmed them into torches. They burned the spines from prickly pear and offered the pulpy branches to the horses. The animals nibbled at them but would not eat heartily.

"They'll learn," Cam predicted. "They won't get much out of it. Now cattle . . . a cow can live a long time on prickly pear."

"How about a human?"

"Too bitter," the tall officer explained. "The human stomach won't swallow the juice."

They moved again with sundown and Cam ordered them to walk after a few miles. The horses were tiring rapidly. They would pull the animals behind them for flesh and for blood. They forced themselves to drink more warm raw blood. Susan vomited up hers almost

instantly. Others retched also. Tony Zanoba could not even hold chunks of meat in his mouth.

"One good thing about walking," croaked Burke, "Dudley can overtake us quicker."

But that hope was not left them long. They intercepted wagon tracks and the signs were clear for all to read. Philip Dudley had abandoned them to thirst and hunger and the desert. A stream of oaths came from Red Burke's lips as he realized this. The lieutenant did not attempt to restrain the troop's fury.

That afternoon, in the midst of a fitful sleep, Tony Zanoba died.

For a long time his giant of a brother sat and cradled the lifeless head in his arms. Chris did not weep. He did not sob. He stared off into empty space, his look intent, strained. Every now and then his eyes dropped to his brother's pale face. Even with all this exposure to the elements Tony Zanoba had never acquired any degree of brownness.

Sundown neared and Cam laid his hand lightly on big Chris' shoulder.

"We'll have to bury him," the lieutenant said softly.

The sergeant nodded but made no move to arise.

Cam took his saber and started digging. Burke joined him and then other troopers. They dug with whatever they could find, some scooping up sand with their bare hands. Still Chris did not move. Still the sergeant sat and held his brother's lifeless body.

"We're all ready, Chris," Cam told him finally.

The big man lifted the corpse and tenderly placed it in the shallow grave. Then he turned to Susan, who was standing near him with tears streaming down her cheeks.

He struggled for the words that finally came forth.

"Would you, Miss Hanna? Would you kinda talk . . . about him . . . a little? You liked his playing. You said so."

"Yes," gulped Susan. "I liked his playing."

She lowered her head and prayed for words to come to her.

"Private Anthony Zanoba," she said solemnly. "Soldier, gentleman, musician. He felt in his heart the song that could fill the world. His spirit was as gentle and as

beautiful as his music. But when danger came, and hardship also, he met them without a murmur. In death his is the peaceful beauty of . . ."

Her voice broke off.

"That's all I can say, Chris," she apologized.

The big man raised his head. "Thanks, Miss Hanna," he murmured gratefully.

Until then no one had noticed that Black Cat had come close to the grave. The Seminole's chains had been lightened when Cam ordered them all on foot; his movements were hampered very little. The Indian spoke to Elliott in his native tongue. Cam hesitated and turned to Chris.

"He wants to drop a feather into the grave," he explained. "The Seminoles do that to show their respect for a brave enemy."

Chris nodded; Black Cat pulled a feather from his scanty headdress and placed it on the dead trooper's chest. Then the Indian watched from the background as the hole was slowly filled.

Susan leaned against Elliott; he put his arm around her. She turned and sobbed against his shoulder.

"We'll end up that way, Cam," she whispered. "All of us."

He could not deny it. They were still a long way from Fort Clark, several days as they were moving now, stumbling along like so many drunken men, pulling horses behind them that were thinner than themselves. They started walking again and Cam Elliott had an added responsibility—to keep the troopers together. Men so near to delirium and then to collapse did not heed where they were going. They did not hear another voice. A horse fell and big Chris helped Elliott butcher it and then force blood down parched throats. Morning came and the men slept with their eyes open. It was not a restful sleep. The long hours dragged and Cam Elliott knew that the next day's march would be the last for most of them. For Susan. He could go on himself and so could Chris and so could Black Cat. They were hardened to this land and its rigors.

Sundown came at last and Cam roused the soldiers.

"Go on," Susan whispered painfully through parched

130

lips. Speech was almost too much for her. "I can't go any farther. Save yourself, Cam."

He supported her for a while, then when she fell he lifted her weight to his shoulders.

"I'll spell you off," Chris Zanoba said hoarsely. "We'll get her in. You and me, lieutenant, we'll get her in."

But the added weight was no small matter even though Zanoba bore Susan at least half the time. The soldiers straggled and Cam could not keep them together. To have done so he would have had to have kept a steering hand on each man's shoulder.

Near midnight Cam set Susan down and rested himself. He was almost to the end of his own strength. A red sea ebbed back and forth before his eyes and invisible hammers pounded incessantly on his forehead. Susan was conscious one moment, in a stupor the next. Only Chris Zanoba and the silent impassive Black Cat were fit for further travel. They no longer led the surviving horses but a few of the animals still trailed after them, gaunt wall-eyed creatures eager for company in their misery.

Chris Zanoba did not stop with Cam and Susan. The big sergeant did not even notice that Cam Elliott had flopped to the ground. Chris went lumbering on in the direction of the post, seeing nothing to right or left of him, guided by instinct rather than vision.

Black Cat squatted near Elliott. His taunting words sounded in Cam's ears.

"You are near death, white chief. When you are dead Black Cat will take the keys from your pockets and free himself."

Cam Elliott rose to his feet. He stood there as if he felt no weakness at all. He had not considered how he would deal with his prisoner. He could not permit Black Cat to die in chains. But yet . . . unbound, trusting his savage instincts, the Seminole might make his way to water, then return to his people and take up his raids anew.

"You cannot free yourself," Elliott told him. "I can give you the chance to live, Black Cat. I will unlock your manacles if you'll pledge yourself and your people to live in Mexico and never cross the river."

"Why should I make such a pledge?" demanded the

Seminole. "You are dying, you white men. Only Black Cat can ever get out of this desert."

"Will you risk your life on that, Black Cat?" Cam demanded. "Will you risk your life that we die before you do?"

Black Cat scorned to answer.

"Perhaps you would," conceded Cam, "except for your people. They will perish without you, Black Cat. They have only the weapons of your fathers now and this is a stern land. Give me your pledge, Black Cat. And your promise that you'll try to get Miss Hanna to a white man's house. Any house."

"No," the Seminole said firmly.

"You don't go free without that pledge, Black Cat." Cam growled. He took his revolver out of its holster. "We have chased you a long time, Black Cat. This is the last one. You have the choice of death or a chance at life."

"You cannot dictate the terms," Black Cat said calmly. "You are near to collapse yourself."

Cam did not deny that. He dropped to the sand again. "But I can still shoot a gun, Black Cat. And I'll live longer than you might think. It's too big a risk, Black Cat. The odds are all against you."

"I am used to that," muttered the Indian.

For a long moment he stood there with his features impassive, his dark eyes studying Cam Elliott intently. The lieutenant forced himself to a show of strength that was not at all real. He struggled to hold the pistol dead-level, to keep his eyes from closing.

Then, slowly, softly, came Black Cat's acceptance: "I give you my pledge," he decided.

Cam groped in his pockets until he found the key to unlock the manacles. He could do nothing about the light chains slightly hampering the Indian's stride, but, with his hands free, Black Cat could remove those himself.

"Your word is good," Elliott muttered. "I leave Miss Hanna with you."

Susan had not moved since sinking to the ground. Cam looked down at her and he turned his head so that Black Cat would not observe his emotion. Then he pushed his

head and shoulders into the breakers of that red sea that was churning up again. He would not go much farther and he knew it. Perhaps Black Cat would not either. But the Seminole was a hardier man and once a Seminole chieftain had given his word . . . Cam stumbled, struggled to his feet, tottered on, fell again.

In a few moments he did not rise from where he had fallen.

Behind him Black Cat glanced at the motionless Susan Hanna, then looked after the weaving white man. Then he caught one of the drifting horses, swung up on its back, pitilessly kicked the animal into motion. He rode slowly in a wide circle until he found what he sought— a strip of rubbery-like white sand. He forced the weary horse to walk back and forth across it. The mustang's hoofs broke through the surface crust and made cup-like indentures. Slowly these small holes filled with water. The animal stopped to drink; Black Cat swung to the ground and drank himself. Then he squatted on his haunches and watched as the horse pounded out more cup-like holes without further urging, drank slowly, stamped again. Like the mustang Black Cat did not try to quench his thirst all at once.

Now the animal was appeased for the time being. The Indian remounted and rode to where Susan lay. He started to dismount, then changed his mind. He kicked the horse into motion and rode to where Cam Elliott was sprawled out on the ground, lying face downward. He struggled with the tall man's weight until finally Cam hung sideways across the horse. The Seminole led the animal to the strip of white sand and slowly fed the lieutenant water from his own campaign hat. In a moment Cam's eyes opened and consciousness returned to him. He watched as Black Cat led the horse back and forth and brought more muddy water oozing to the surface. The Seminole handed him the half-filled hat and he drank with the same caution the Indian and horse had shown.

"Why do you do this, my brother?" he asked after a moment.

The Seminole squatted by him. Black Cat's eyes upon him were dark and brooding.

"I could let you die," he mused with a shrug of his bare

shoulders. "But there would come others. There are too many white men. I am through fighting them."

"I am glad of that, Black Cat."

"I will keep my pledge," the Indian declared. "I will take my people and we will cross into the Mexico and this time we will not return. There the Seminoles will die and be forgotten."

"The story of the Seminoles is a sad one," agreed Cam.

"Once we were a great nation," murmured Black Cat. "Now there are only a handful of us, some out here a thousand miles from where we were born, others in the great swamp. But it does no good to hate. Nor to make war. I am glad you made me give my pledge, my brother."

"It is good," nodded Cam. "Now the white men who killed your wife and child . . . they will suffer for that, Black Cat. I give you my pledge on that."

"I take it," Black Cat answered quickly. "It will make me happier that a brother I can trust will deal with them for me."

Black Cat rose slowly to his feet.

"You can carry the white woman back yourself," he said. "And some of your soldiers, those who have not already died. You know now how to find water."

He pointed to the white sandy strip.

"There are many such sands between here and the fort," he explained. "The Indians have known about them a long time. The Comanches taught me about them. I would have thought my brother knew of them."

"I didn't," Cam confessed. "I remember now hearing some talk of them. But I wouldn't have recognized them."

"The Mexicans call them *ciénagas,*" added the Seminole. "You must prize this knowledge, my brother. You must spread it among other white men. Now that you know about the *ciénagas* you can follow the Indian anywhere."

"Yes," nodded Elliott.

Then Cam stood up also.

"I am through wearing the uniform of war, Black Cat," he said slowly. "I have bought land and I'll raise cattle and sheep. I hope I can live at peace with the Indian."

"White men such as you are could," conceded the sav-

age with another shrug. "But then you are part Indian, in spirit anyhow."

"You are older than I, Black Cat. How much Indian am I?"

"You are all white," the savage assured him. "Your people died of disease. We found you crying inside the wagon. My mother nursed you and you lived with us until my father was killed. Then my mother left you with the family who raised you and we . . . my blood brothers and sisters . . . went back to my mother's people."

Black Cat studied Elliott and a faint smile came to the corners of his mouth.

"You are all white, my brother," he said softly. "And may the white man's God smile upon you."

With that he turned to the waiting horse. First he disdainfully stripped off saddle and blanket. Then he swung up on its back. He rode a short distance and dismounted again, to take rifle, cartridge belt and canteen from a prostrate soldier. Then he disappeared over the horizon, riding toward the emptiness of the tangled hills.

Cam Elliott came slowly to his feet. Moisture had revived him but every muscle in his long frame ached. It was no trouble to catch a horse for himself. The three animals that had survived this ordeal of drouth and starvation had scented water and had stumbled toward it. Cam treated Susan as Black Cat had done him, except that he tore a strip from his shirt and sieved the water through it before forcing moisture down her throat. She revived slowly. The lieutenant brought others to the *ciénaga's* edge and let life-saving water trickle between their lips. But for most of them relief had come too late. Only a handful of men would ever make their way back to Fort Clark.

They moved on, this ragged handful. One *ciénaga* was drained of its mysterious moisture but Elliott found another nearby. They slaughtered a horse and ate gingerly of cooked meat, tough and stringy, but nourishing. They screened sandy water into canteens and sipped the contents as they marched, Susan on horseback, tied there as her strength did not come back all at once. Several miles further on they overtook Chris Zanoba. The big sergeant

was floundering, weaving, but he was still on his feet. Cam fed him water and meat and made him rest.

"Take it easy, Chris," the lieutenant advised. "We'll make it all right."

The giant nodded. "Would have made it anyhow," he whispered hoarsely. "Got something to do there."

They reached a sheepherder's adobe hovel and for each of them there were a few swallows of goat's milk and then tortillas. And water, spring water. Now Cam let them drink all they wished and they swallowed one gourdful after another. Color came back to Susan Hanna's cheeks and light into her eyes. She managed a smile as Cam pressed milk and tortillas upon her.

"You'll never take me anywhere worse than this," she told him.

She could even manage archness. The expression in her eyes caused Cam Elliott to smile, and not because he was amused. Amusement wasn't the word for it at all.

CHAPTER 16

DARKNESS found them several miles from the post but no one wanted to stop. They were weary, yes, but not in spirit when they could see the lights of Fort Clark gleaming in the distance. Not when only a few more miles would mean the end of this long tortuous march of death. They went lurching on, drinking from their canteens without slowing their pace.

It was almost midnight when they heard the pleasing challenge from the fort's sentry. The gates swung open for them quickly and they stumbled through them.

Lights came on as the word spread rapidly. Cam Elliott sent them on to their quarters and he led Susan's horse across the parade ground. Colonel Hanna's voice called out in challenge before they reached the gate.

"What is it?" he demanded from his bedroom window.

"Dad!"

Susan slipped down from the horse before Cam reined up the animal. She fumbled with the gate fastening.

"What is it?" Colonel Hanna called out again.

"Dad!" she cried again.

"Susan! Merciful God above!"

A lamp gleamed quickly. Susan reached the door but it was locked. In a second Hanna threw back the latch and father and daughter were locked in tight sobbing embrace.

"Girl, I never expected to see you again," the officer whispered. "Are you all right?"

"Give me a bath, some clean clothes, and I'll live," Susan smiled.

Then she remembered the tall officer waiting discreetly at the gate.

"Come in, Cam. I'll make a pot of coffee. Think of it! Coffee!"

"Elliott!" exclaimed Hanna. He started out to meet the lieutenant but his daughter restrained him.

"You'd better put on some clothes, Dad," she smiled.

Hanna agreed. He had rushed to the door clad only in his nightshirt!

His eyelids were so heavy he could hardly prevent their closing. But he gulped gratefully of the hot coffee and began.

"First, sir, I want to file charges against Captain Dudley."

"But Phil's action was understandable," protested Hanna. "One wagon tank burst open and with no more water . . ."

"I'd like that brought up at the court-martial, too," Cam said grimly. "But I have a more specific charge."

He explained what the aged Seminole had told him of Dudley's "trade" with Wilson.

"I can verify that, Dad," put in Susan. She had washed the grime from her face and had donned a fresh frock. "That was why Black Cat kidnapped me—for revenge. He told me so, not angrily, but sort of apologetically. And you remember about Phil's paying up his debts with money he was supposed to have won gambling."

"I remember," nodded Hanna. He studied his daughter's face. "Will you testify against him?" he asked.

"I will," Susan said firmly. "And he mustn't get off with just a mild sentence, Dad. The Indians claim the army never punishes white men, only them. Fighting will never be stopped as long as there are white men like Philip Dudley."

Hanna sighed. A short time, he was thinking, had brought its great changes.

"I'll rouse a sergeant and have him arrested," the colonel announced.

"I'll do it, sir," Cam offered, rising to his feet .

"Lord, no," refused Hanna. "After what you've been through you don't need to run errands."

He went out into the night. Susan pushed back her chair.

"I'm going to take a bath," she apologized to Elliott. "I know it's rude, but I'm so filthy I'm miserable."

"I could use one myself," nodded Cam. "And a shave."

He slouched back in his chair as the door shut behind her and closed his eyes. He meant only to relieve their ache for a moment but the effort of opening them again was too great. He was sound asleep, still sprawled there in his chair, when Colonel Hanna returned.

Hanna did not rouse him. The colonel sat quietly and drank another cup of coffee. Susan returned, scrubbed clean, the knots of her hair untangled. She was humming to herself as she walked in; her father motioned to Cam.

"He couldn't stand it another minute," the colonel smiled.

"It's no wonder," Susan declared. "Those of us who got back, the few of us . . . we owe it to him. He is responsible for all of us."

She began an account of her own experience but was interrupted by a knocking at the door. Hanna opened it. Standing there was the sergeant he had awakened to arrest Philip Dudley.

"What's wrong, man?" the colonel asked sharply as he saw the strange look on the enlisted man's face.

"You'd better come with me, sir."

The sergeant's voice was muffled, tense.

"What's wrong?" Hanna demanded.

138

"It's . . . Captain Dudley, sir."

"I told you to put him under arrest."

"Yes, sir," the soldier stammered. "I went to do that, sir. But he's . . . he's dead, colonel."

"Dead?"

Susan gasped out the word also.

"Yes, sir. Somebody . . . choked him to death. There are marks . . . fingermarks . . . on his throat."

Hanna swore softly and went with the sergeant. They walked swiftly across the parade ground to Dudley's quarters. Lamps were burning in the room but the soldiers roused from their bunks to form an arresting squad were standing around outside. Hanna strode into the room and confirmed the sergeant's report with a single look. In death Philip Dudley's face wore a horrible expression. Deep dark handprints on the officer's throat were mute evidence that the man who had strangled him was a strong one indeed.

Hanna pulled a blanket over the corpse and went back outside.

"Post a guard," he ordered the sergeant. "We'll see about details in the morning."

Cam Elliott was still sleeping. Hanna poured more coffee for himself.

"Strangled in his sleep," he explained tersely to his daughter.

Susan stared at him. "Murdered?"

"Certainly," Hanna replied. "I'll drink this coffee and then I'll call in the sentinels for questioning. I don't see how anybody could have slipped by them."

Susan thought a moment. The image of a man's face danced into her thoughts, a rough scarred face. Dark eyes staring worshipfully down at a small handsome man weaving musical patterns with violin and bow. She knew that man's strength well; he had borne her weight in his arms as if she were no heavier than a knapsack. She remembered that he had stumbled onward even after Cam Elliott himself had given up. The look in his eyes came back to her and she shuddered.

"No one slipped by them," she said tonelessly. "Big Chris killed him. Chris Zanoba."

Hanna frowned at her a moment, then whirled on his

heels and strode out into the night again. He was back almost immediately.

"You're right," he snapped. "Zanoba didn't turn in with the others. He is gone completely. I put out a patrol for him."

"Wasted effort," Susan told him. She pointed to the hard-breathing man still sprawled asleep in his chair. "There's the only man you have who could find him. And he won't do it."

She was right in that also, this girl who had been raised among men, but who had learned more of them and their ways in the last two weeks than in all the other years put together. They never saw Chris Zanoba again.

Three days of rest and a fresh uniform had worked wonders in Cam Elliott's appearance. Except that he had lost weight—he who never had had a pound to spare—he showed little evidence of the ordeal he had survived.

He had given Hanna a full oral account of his experience. His formal report was not yet written; he would present that to Colonel Lee at San Antonio.

"And you think Black Cat will stay off the warpath?" questioned Hanna.

They were in the colonel's office, cool in this early morning air.

"I think so, sir. So he told me."

"And you two were raised as brothers?" murmured Hanna. "Amazing."

"For a time, sir. Until the war I used to visit among the Seminoles every now and then. Black Cat and I went on long hunts into the mountains. Then I became a soldier and he the Seminole war chief."

"Where did he get his education? Susan tells me he speaks perfect English."

"Many Seminoles are educated," Cam explained. "Once they were a nation and honored as such. We were taught as children and he has mingled back and forth with the white men. He hasn't been at war always."

"It seems like it," Colonel Hanna sighed.

He drummed thoughtfully on his desk. "I'd like to see you stay in the army, Elliott," he appealed. "We need men like you. We need officers who know the country

. . . know about things like the *ciénaga* sands and the cactus. There isn't another commissioned officer in the army who could have come back alive, much less bring a woman with him."

Cam's glance roved off a moment, then came back. "I was particularly interested in that woman, sir," he said softly.

His eyes and his tone showed that he meant this for no idle remark. Hanna understood so, and the colonel chuckled.

"Don't flatter me by asking my consent, Elliott. I have as much to say about it as this desk here."

"Thank you," Cam grinned, "for at least not threatening me if I approached her."

"You would have done it anyhow," Hanna shrugged.

Elliott rose slowly to his feet. Hanna stood also.

"And you won't even seriously consider staying in?" he asked again. "I can't promise a promotion for sure but Colonel Lee . . ."

"No," Cam refused firmly. "I want to look after my cattle, colonel. And build a house and corrals and . . . oh, so many things, sir. My land lies in the country the Seminoles raided. Now I think it's safe to drive my cattle there."

"Thanks to you," nodded the colonel. He held out his hand. "Good-bye, Elliott. I trust I'll be visiting that ranch of yours someday. In fact, I predict so."

Elliott shook hands, saluted and walked out. Colonel Hanna stood at his window and looked after him a moment, then turned back to his desk. He must put his own report into writing. Must send to San Antonio for a relief detail immediately. Must recommend soldiers for decorations.

These had been busy days. Philip Dudley had been buried at the post with military honors. Elliott had insisted on that, claiming truthfully that he had never officially filed charges. A wagon had gone forth to retrieve what bodies could be located, and were left undevoured by buzzards and coyotes. All of the men Cam Elliott had led back had been sent to hospital ward. Most of them had recovered speedily. Susan herself had rallied after sleeping a full twenty-four hours.

Mark Hanna was slow with his paper work, but methodical. Captain Philip Dudley strangled in his sleep, presumably by Sergeant Christópher Zanoba, who had deserted. Lieutenant Cameron Elliott reporting to Colonel Robert E. Lee at San Antonio. Lieutenant Ashwell and troop escorting Mexicans to the Rio Grande, there to deliver them to proper authorities. They would not be punished, Hanna mused. They would be released as soon as the Americans had left. But their traffic in slaves was over. The army knew now how the Indians had kept themselves armed with guns of the latest make. The colonel would recommend a larger garrison at Fort Clark and more permanent installations. He would advise a closer patrol along the Comanche Trail. . . .

. . . . Cam Elliott called for his horse and was slightly surprised when Corporal Burke brought the animal. His regular "striker" was a lanky private named Pickens.

"Hear you're gonna pull out, lieutenant?" asked the red-haired corporal.

"That's right, Burke."

The Irishman cleared his throat. "Hate to see you do it, sir. I've told the boys more than once. You're my kind of officer."

"Thanks, Burke. And you're my kind of corporal. I hope you get Chris's sergeancy."

He held out his hand; the corporal gripped it tightly.

Cam Elliott rode across the parade ground to the colonel's quarters. He dismounted, opened the gate and started up the walkway. Rosita called to him from the back yard where she was hanging out clothes.

"Miss Susan, she went for drive in buggy."

Elliott frowned. He had very definite plans for a talk with Susan Hanna.

"Which way did she go?"

Rosita pointed to the San Antonio road.

After a few moments he saw the buggy ahead of him and galloped to overtake it. Susan reined up when she heard hoofbeats behind and recognized the horseman. She pulled over to the side of the road and sat waiting, her eyes twinkling, a smile playing about her lips.

Cam swung out of the saddle. But before he spoke a

greeting he purposefully studied the buggy. A grin was threatening to splatter the impassiveness of his lean face.

Then he spoke.

"Luck is running with me," he said slowly. "I was wondering if we could ride double all the way to San Antonio. I'm very grateful for the buggy."

She held her features tight but she could not repress the sparkle in her eyes.

"At least," she said in mock severity, "Black Cat didn't steal my father's buggy."

"Me," Cam grinned, "me learn much from white man."

He hitched his horse's bridle to the buggy's rear axle.

"Squaw move over," he ordered.

Then he climbed into the buggy seat beside her. They looked at each other and their laughs came simultaneously.

"Seriously now," Cam Elliott said. "Let's go back and tell your father. And you have to pack a bag."

"It's behind the seat," Susan told him archly. "And I left Dad a note."

She slowly put her arms around his neck and laid her head against his shoulder.

"And Princess is a well-trained mare," she whispered. "You don't have to hold the reins."

THE END

Curtis Bishop was born in Tennessee but lived most of his life in Texas, where he traveled with rodeos and worked for several daily newspapers as a feature writer. Much of his newspaper writing dealt with characters, landmarks, and institutions of the Old West. In 1943 he also·began writing fiction for the magazine market, especially Fiction House magazines, including *Action Stories, North-West Romances,* and *Lariat Story Magazine.* During World War Two, Bishop served with the Latin-American and Pacific staffs of the Foreign Broadcast Intelligence Service. His first attempt at a novel was titled "Quit Texas—or Die!" in *Lariat Story Magazine* (3/46). Subsequently he expanded this story to a book-length novel titled *Sunset Rim,* published by Macmillan in 1946. "Bucko-Sixes—Wyoming Bound!", which appeared in *Lariat Story Magazine* (7/46), was expanded to form *By Way Of Wyoming,* also published in 1946 by Macmillan. These were followed by *Shadow Range* (Macmillan, 1947), an expansion of "Hides for the Hang-Tree Breed" in *Lariat Story Magazine* (11/46). Although Bishop continued to write for the magazine market for the rest of the decade, his next novel didn't appear until 1950 when E. P. Dutton published *High, Wide And Handsome* under the pseudonym Curt Brandon. The pseudonym was necessary because Macmillan claimed it owned all rights to the Curtis Bishop name for book publication. *Bugles Wake* by Curt Brandon followed, published by E. P. Dutton in 1952. *Rio Grande* under the byline Curtis Bishop was published in 1961 by Avalon Books, the last of his Western novels. Living in Austin, Texas for much of his life, where he was able to study many of the documents of early Texas on deposit at the University of Texas' Special Collections, Bishop's Western fiction is informed by a faithfulness to factual history and authentic backgrounds for his characters, while he also was able to invest his stories with action and a good deal of dramatic excitement.